live, laugh, celebrate

FERDINAND PROTZMAN

 NATIONAL GEOGRAPHIC

WASHINGTON, D.C.

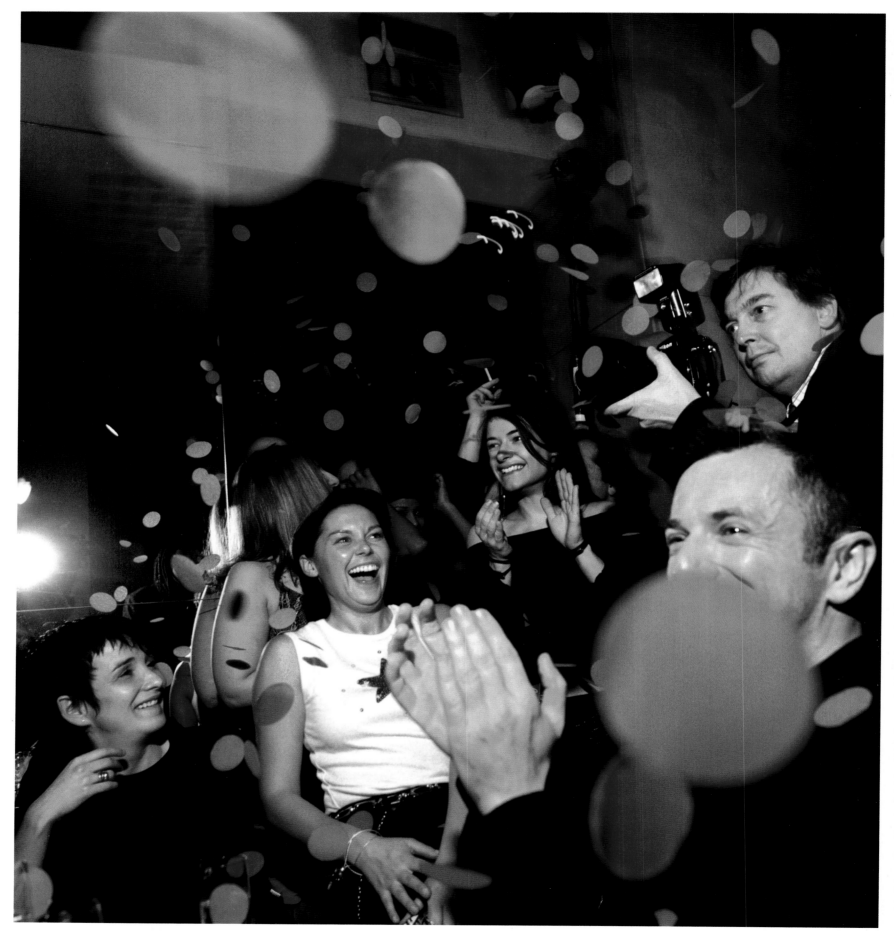

p. 4: JOHANN ROUSSELOT I Paris, France I 2002. A crowd rings in the Russian New Year at Club de l'Etoile. pp. 6-7: ZHANG TIANLIN I Wuhan, China I 2009. A performance of the Dragon Dance during the Lantern Festival, which marks the close of celebrations for the Chinese New Year. pp. 8-9: AMY TOENSING I Ocean Grove, New Jersey I 2000. Young girls in stage makeup and costumes pose for the photographer. pp. 10-11: SPENCER PLATT I New York City, New York I 2008. An explosion of fireworks over the Brooklyn Bridge during a celebration of its 125th birthday. pp. 12-13: DAVID ALAN HARVEY I Arizona I 1992. Ceremonial dancers compete at a Native American powwow. pp. 14-15: SZILARD KOSZTICSAK I Budapest, Hungary I 2007. Cyclists hold up their bikes during a demonstration on European Car Free Day.

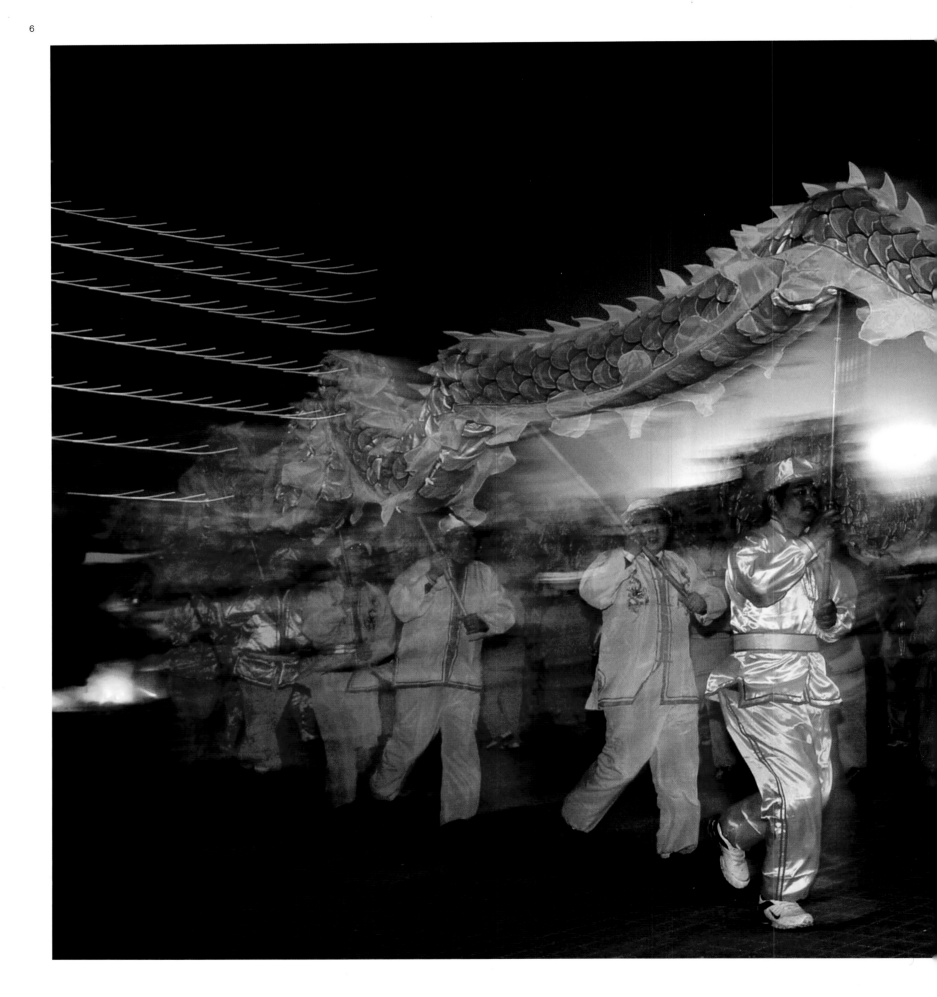

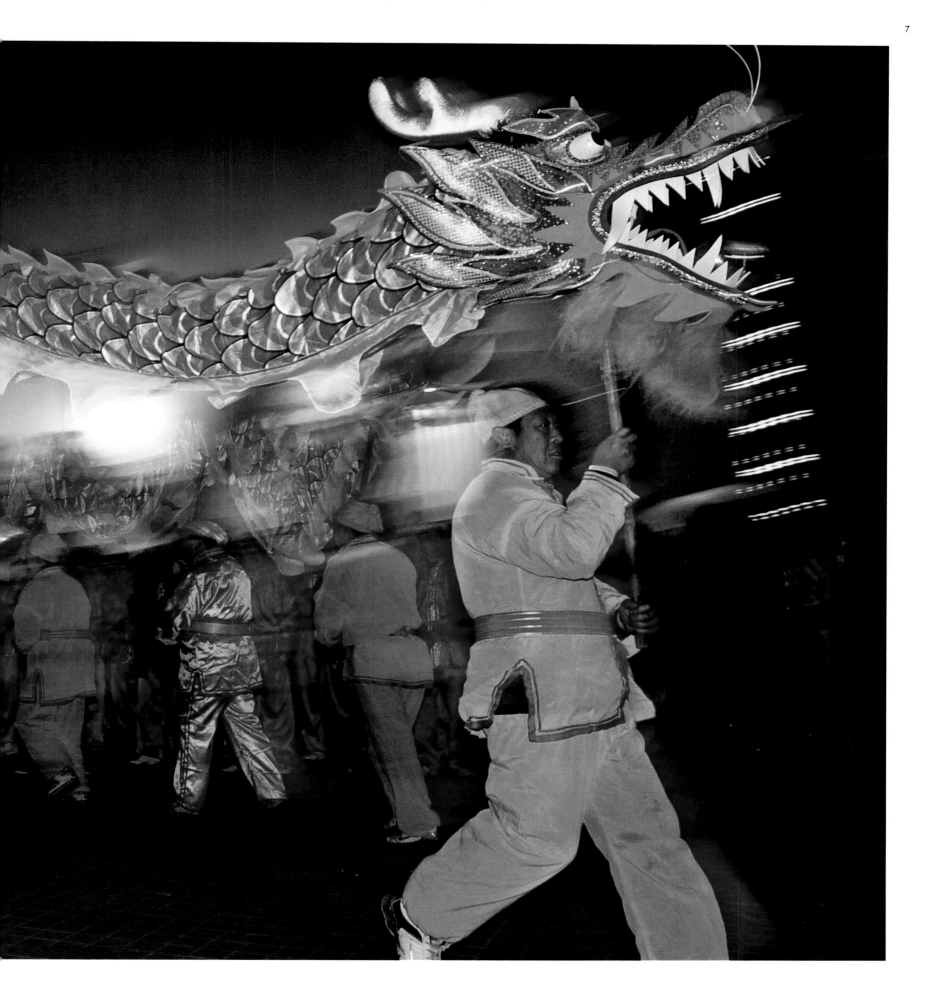

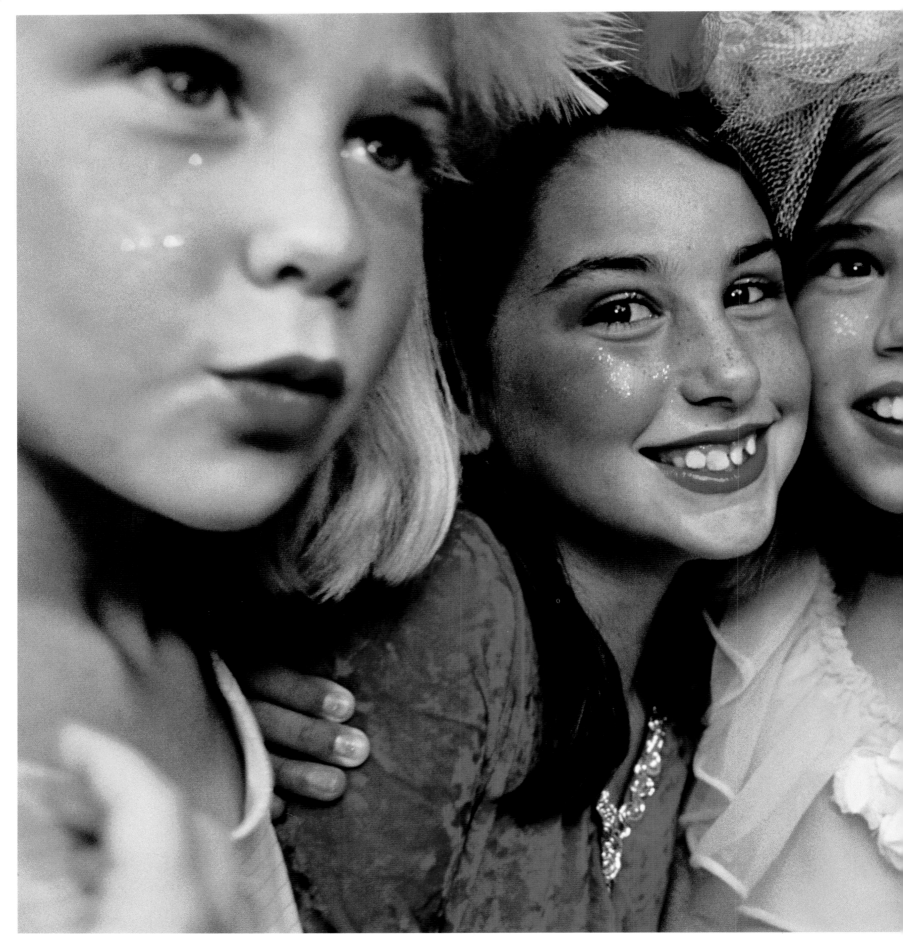

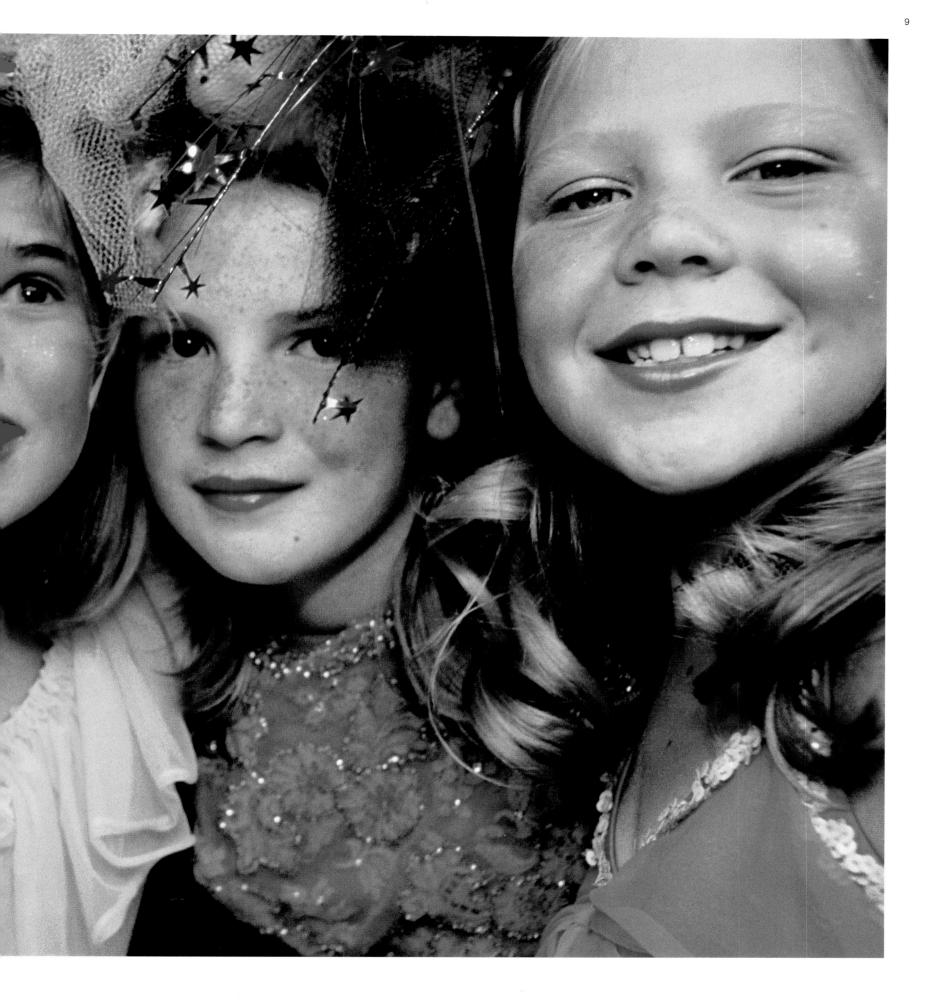

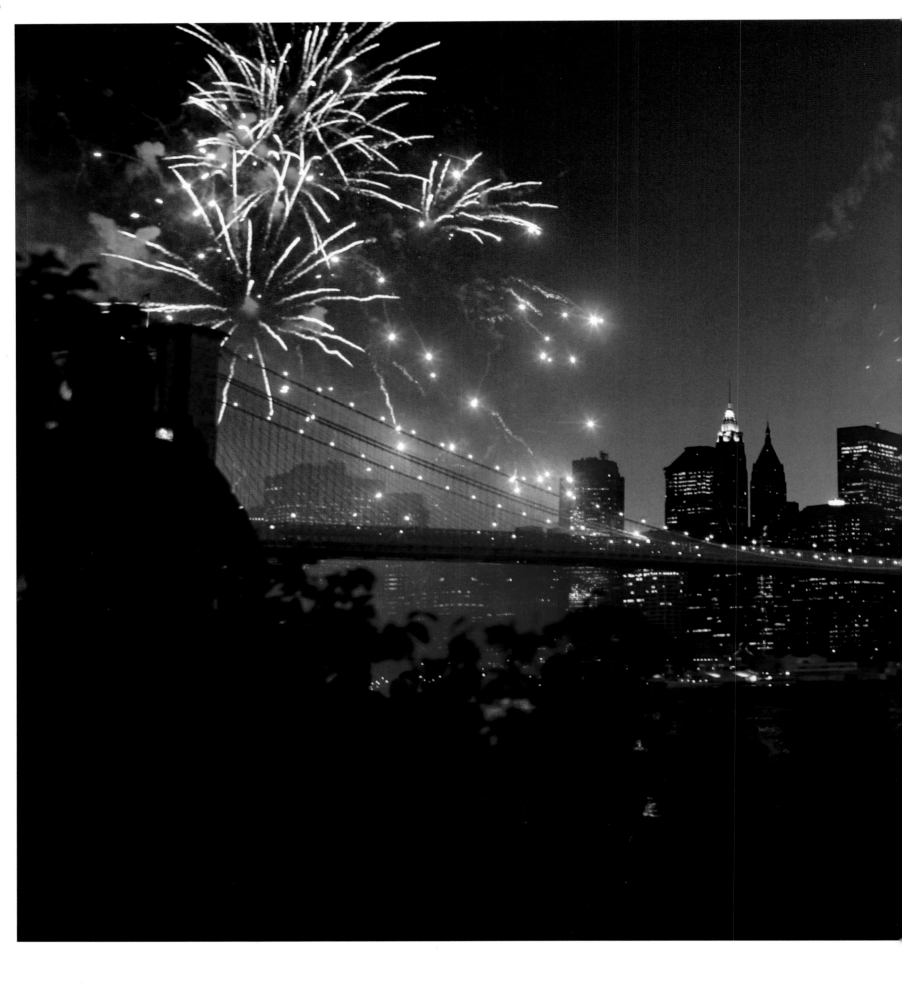

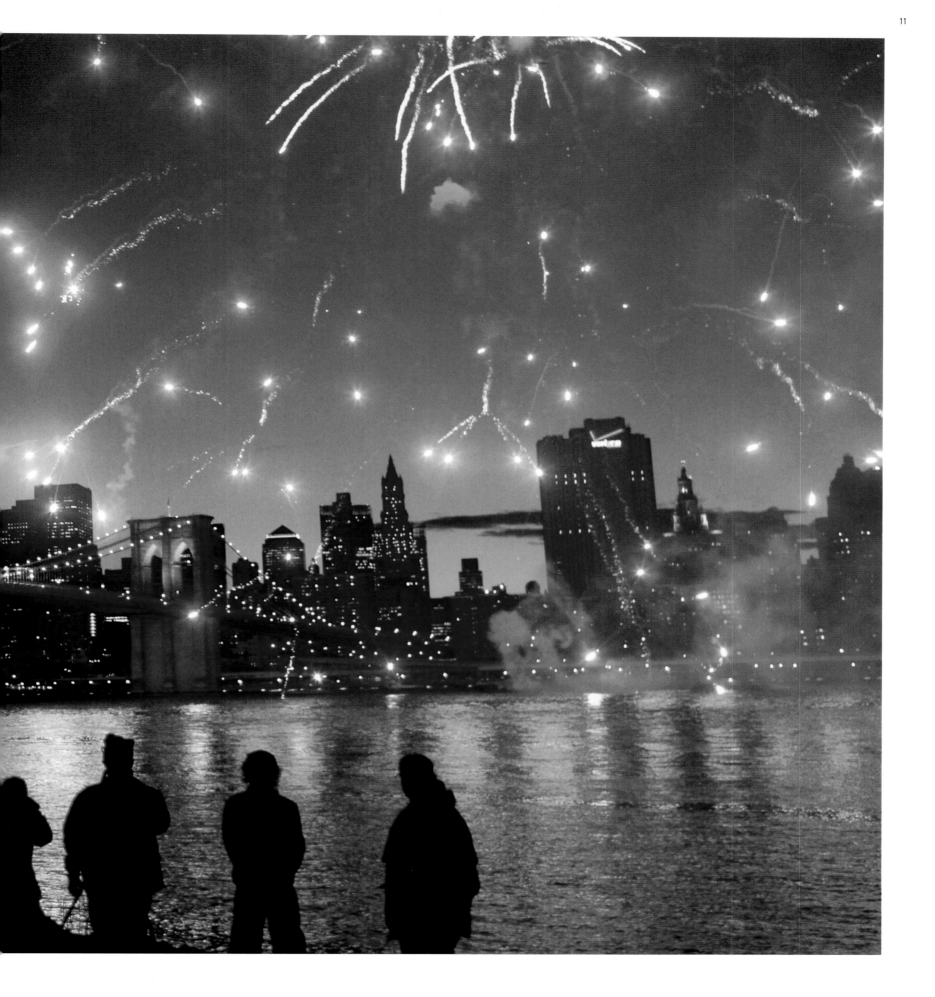

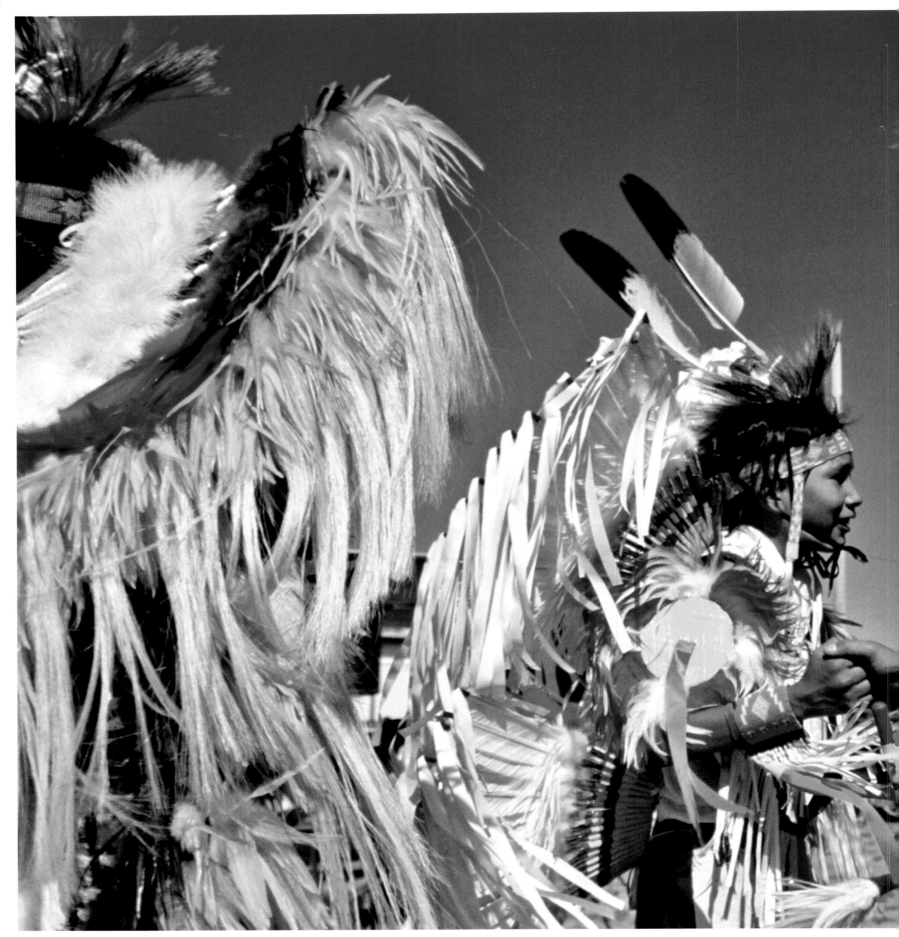

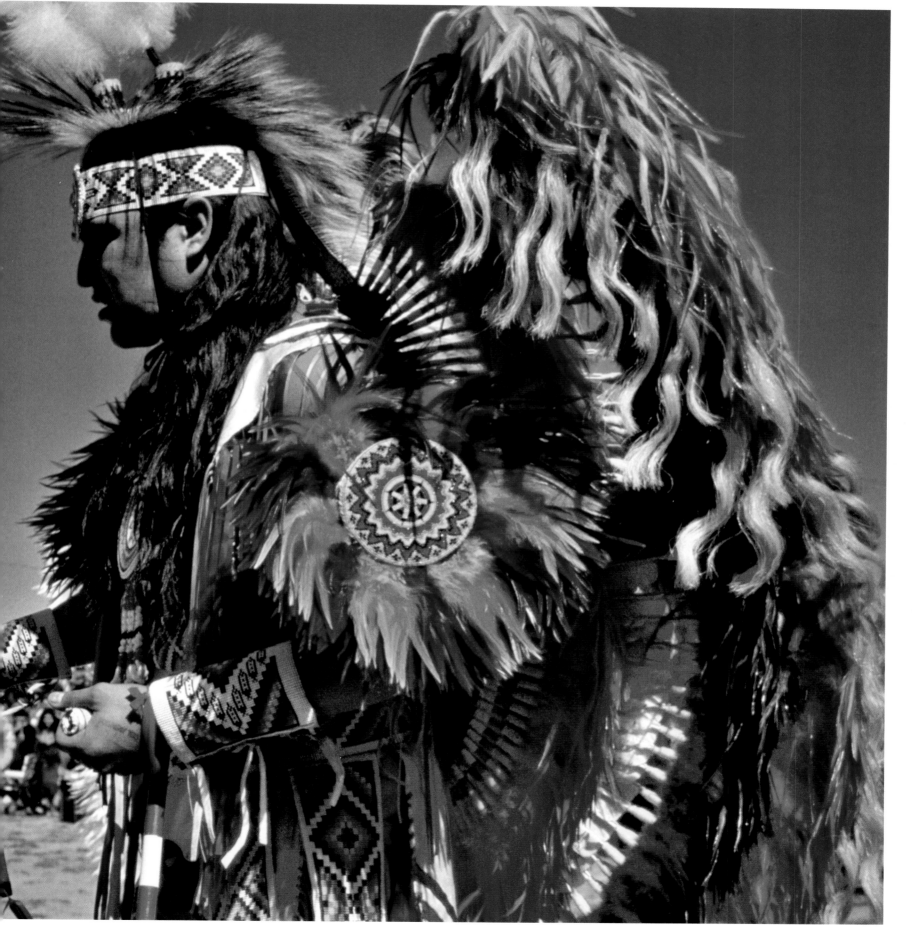

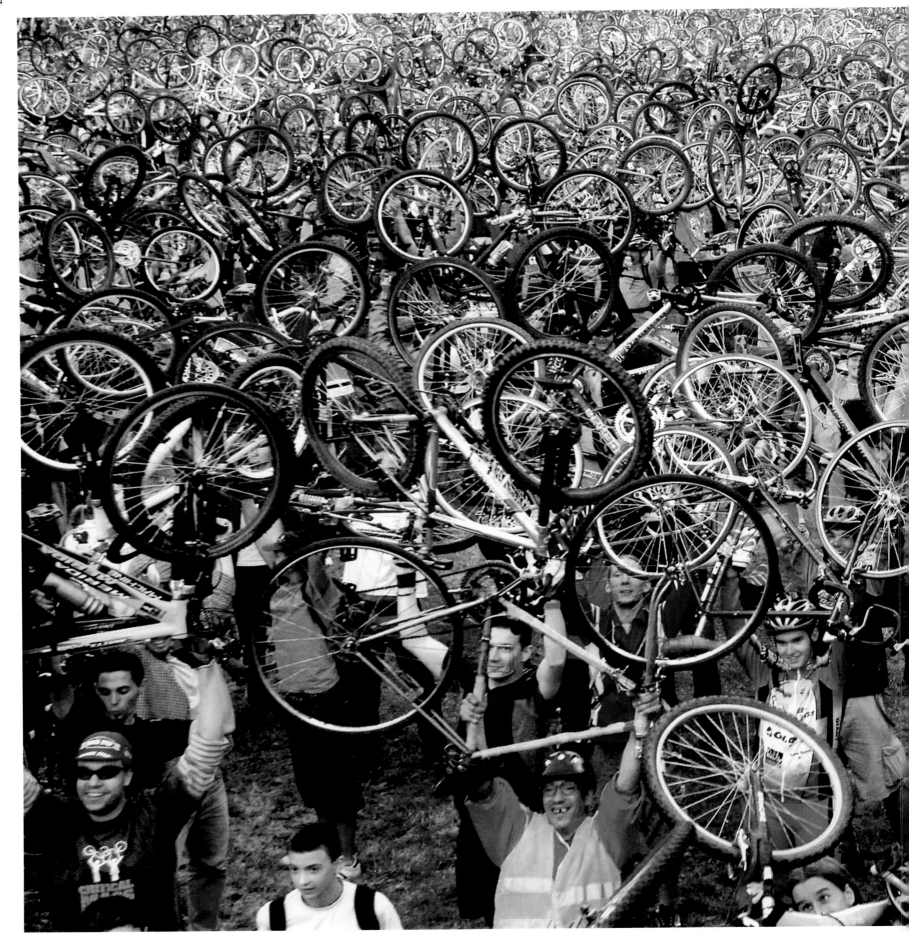

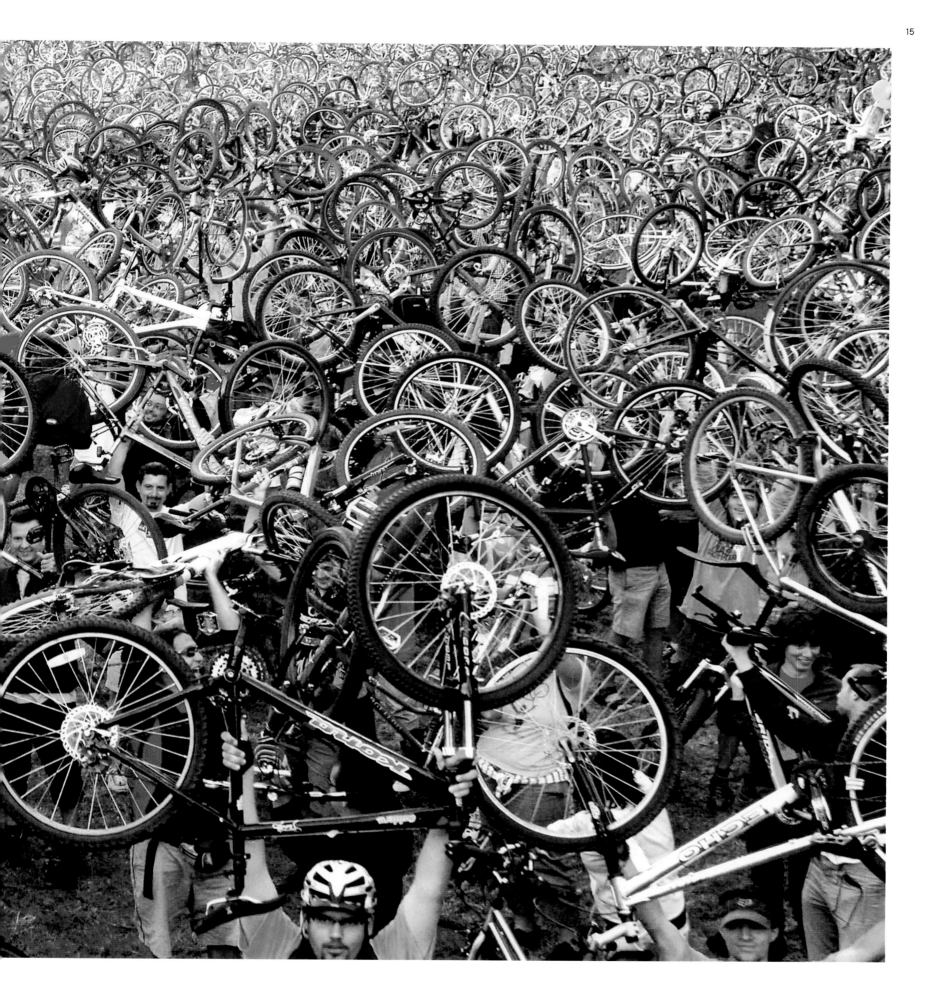

At any given moment,

Like love, celebrations are an integral part of the human experience, practiced by every culture on the planet. Whether it is birth, birthday, graduation, victory in sport or battle, or a rite of passage, regardless of the country, the occasion, the place, the time, the number of participants, or the ceremony, human beings everywhere celebrate.

This raises some obvious questions, beginning with: Why? Where does the urge, the impulse, the instinct that causes us to celebrate come from? What was the first ever celebration? What prompted that celebration? Does celebrating serve some ecological purpose? Are we conditioned by society to celebrate, or is it rooted in our DNA? Or both? Is celebrating unique to our species?

Answers to those questions are for scientists, philosophers, and theologians to seek. Our task was to put together a radiant, compelling collection of photographs showing celebrations—large and small, formal and informal, past and present, personal and public—from around the world. Yet in looking at these pictures and considering countless others that were not selected for this book, common threads emerged that provide some insight into the act of celebration.

At root, all people seem to celebrate the same thing: the wonder of human life. Parents, family, and friends, as well as the attending doctors and nurses, celebrate when a healthy baby is born. That celebration is later reprised with music, laughter, and parties as the child goes through life. Through the cycle of life, achievements at school, in athletics, in the workplace are celebrated. We celebrate falling in love, getting married, and gathering with friends and family at the holidays.

All manner of events—religious events and commemorations, coronations, royal weddings, election results, civic rituals, horse races, harvests, and athletic contests—are celebrated. Some of these celebrations involve vast crowds gathered in public spaces; other people celebrate the same events at home.

Whether one is in a crowd or alone, all celebrations are personal, albeit some more so than others. Still, we experience them all from the subjective shell of ourselves. During the course of their life, most people also have myriad moments of private celebration, whether it is a quiet fist pump over a job well done or a shout of joy when receiving good news.

someone somewhere

Celebration, with apologies to Friedrich Nietzsche, is beyond good and evil. History tells many tales of kings, dictators, terrorists, and ordinary people committing and celebrating monstrous acts. Even death becomes cause for celebrating the life of the deceased. As Plutarch, the great biographer and author of ancient Greece, wrote, "Not by lamentations and mournful chants ought we to celebrate the funeral of a good man, but by hymns, for in ceasing to be numbered with mortals he enters upon the heritage of a diviner life."

It is not surprising that photography, the only artistic medium capable of capturing life at the speed of light, quickly became a part of almost every kind of celebration. Since William Henry Fox Talbot's discovery in 1839 of the negative to positive paper process, which was the basis of modern photography until the digital era, the medium has grown cheaper, more immediate, and more reliable. As cell phone cameras proliferate, it is safe to say that more celebrations are being photographed than ever before.

Photographs have a magic all their own, akin to, but quite different from, that of paintings, drawings, or prints. Generations of viewers have been captivated by the wonderful free-flowing, weightless quality of the dancers in Henri

in the world is

Matisse's masterpiece "Dance (I)," painted in 1909 and now in the collection of the Museum of Modern Art in New York. In Jodi Cobb's photograph of pink ballet costumes waiting on hangers during a rehearsal in the Salle Garnier of

celebrating

the Opéra de Monte-Carlo in Monaco, that same sense of rhythm and gravity-defying grace is achieved without the presence of human forms.

The pictures in this book were taken by some of the finest contemporary photographic artists, which testifies to the visual force of many celebrations. Whether it is the child's birthday photographed by Harry Gruyaert in an apartment in Paris, France; or the photo from National Geographic's archives of the hundreds of thousands of people celebrating at Kumbh Mela, India's largest religious festival; or the soapsuds party in a warehouse-size disco in Ibiza, Spain, shot by David Alan Harvey, the pageantry, excitement, action, and emotion of celebrations make irresistible and riveting subjects.

The artists' images enable us to connect with places, cultures, and peoples we might never actually see or encounter in the course of our life. This is possible because we have experienced similar celebrations. We've felt the joy, the delight, and the sorrow at celebrations marking the passage of loved ones. Through photographs we connect not just with the subject, the scene, and the shared humanity, but with the act of photographing, because at some time, most of us have taken pictures of a parade, a wedding, or a group of friends and family celebrating.

Some readers may not see celebration in every photograph in these pages. That is to be expected. In my years as a critic, I have yet to meet anyone who was moved by every picture in an exhibition or a museum. Nor will the reader see many images of people celebrating death and destruction. Those are all too easy to find—and rarely cause for the joy inherent in celebration.

This book is intended as a celebration of the human spirit, of the irrepressible, mysterious force that prompts women, men, and children the world over to celebrate the milestones, the miracles, and the mundane. In his great song "Boogie Chillen," recorded in 1948, John Lee Hooker, the legendary bluesman, speaks to that urge to celebrate, singing:

I heard papa tell mama, let that boy boogie-woogie,
It's in him, and it got to come out.
And I felt so good.

something.

Someday, science may reach the same conclusion: Celebrating is in us, it has got to come out, and it feels so good. And when it does, we'll take its picture. ■

CHAPTER ONE
cycles of life

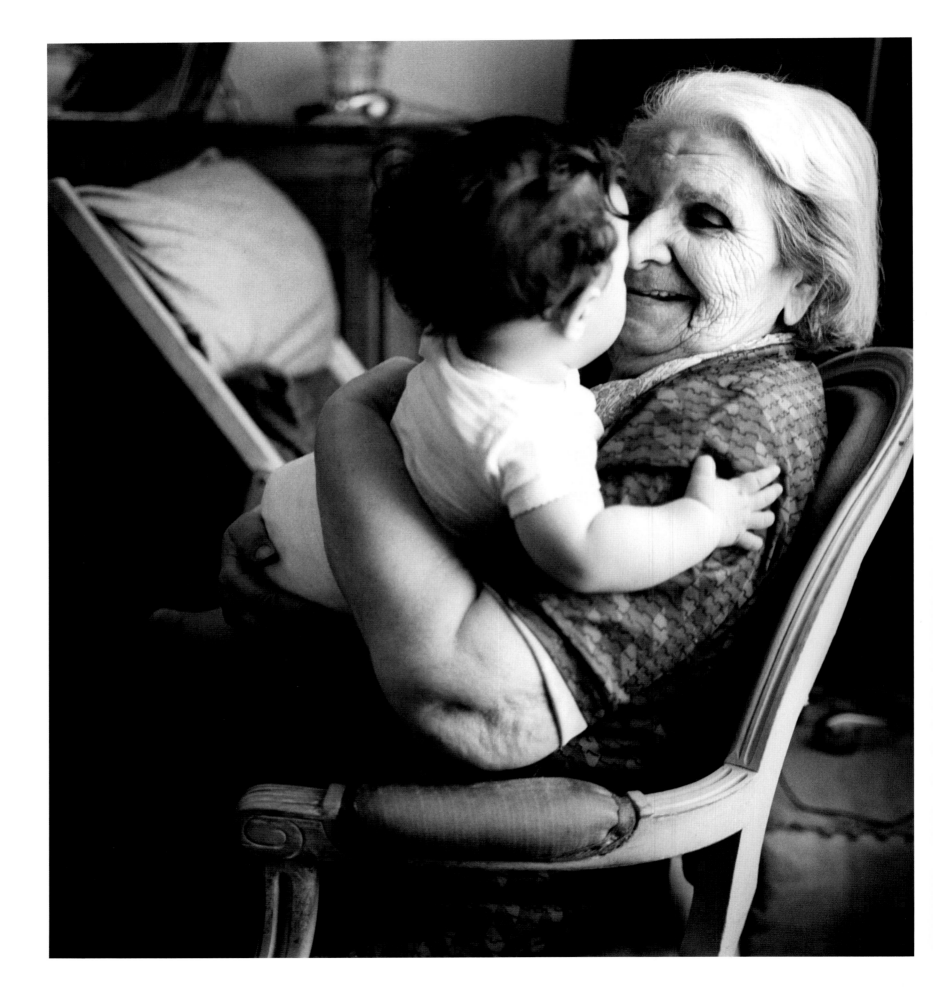

The elderly woman with the furrowed brow and crinkly smile cradles the little girl firmly in her arms.

They sit face-to-face, noses nearly touching, on a straight-backed chair in a cluttered living room somewhere in France. Both are bathed in the burnished silvery light and soft, subtle shadows that only black-and-white photography conveys. The medium and the natural backlight from a window heighten the contrast between the woman's white hair and the toddler's dark locks, while showcasing the similar shape and position of their arms. The picture's closeness and compact composition allow the viewer to share the moment's easy intimacy.

Julien Daniel's fetching, poetic image of his grandmother holding her great-granddaughter is warm, genuine, and spontaneous, a moment of quiet celebration that stretches across four generations of his family. Painted by some Renaissance master, a similar scene could be interpreted as an allegory for age and experience looking with love and, perhaps, a touch of longing into the eyes of innocent youth.

But the photograph's appeal is not allegorical or artificial. While it sparks the imagination as a painting would, its power derives from the universality of the scene and from the fact that the shot exemplifies one of the central tenets of photojournalism: Show real people doing real things. By taking an unposed picture in an everyday setting, Daniel turned a sweet, private moment in his family life into an image that captures the special bonds shared by children and their parents, grandparents, and great-grandparents. It is a quiet, fleeting celebration of life, love, and kinship, the same kind of celebration that families around the world have been holding for thousands of years.

Family life is the cradle of all celebrations, the place where the impulse to celebrate was born in the distant past as Homo sapiens ascended to the status of being Earth's dominant species. Through the centuries, most lives have begun and ended with private celebrations centered on the family, and often shared with relatives and friends. Filled with emotion, joy, and sorrow, these ceremonies, festivities, and rituals at such times serve as the bookends of a person's earthly existence. On each occasion, families usually gather to help, to pray, to wait, to welcome the newborn, or to mourn the departed.

In between those bookends, the ceremonies and festivities of various celebrations reveal our personal histories, marking the passage from infancy to youth to adulthood to senior status and beyond. In all cultures, the main things that people celebrate are birth, the coming-of-age of young women and men, marriage, and death. The way those things are celebrated varies greatly from culture to culture. And many other things, great and small, are celebrated. But if the photographs in this book have one central message, it is that celebration is one of the common denominators of humankind, transcending race, creed, religion, politics, economics, and gender. In short, everyone on the planet does it.

Why do we celebrate? How did celebrations as we know them today get started? Let us go to the beginning. Our own birth is the first thing most of us celebrate. The irony is that, while we are the undisputed star of that show, which usually includes family and friends, food, fun, and gifts, we will recall little or nothing about it. Frankly, I doubt anyone really recalls anything, although I have seen people on television describe in great detail their own birth and the subsequent celebration.

JULIEN DANIEL | Paris, France | 2008. A passing generation meets the new one: A grandmother cradles her great-granddaughter.

All I know about my arrival party was that there was blueberry pie. I know that because of photographs. Since it was the pre-Photoshop era I take their veracity at face value. No one faked those purple lips. Over time, I have also witnessed at numerous celebrations on both sides of the family a pronounced fondness for fruit pies.

While not every baby comes wrapped up in pink ribbons like the newborn in Larry Price's riveting, if rather eerie, photo at a maternity hospital in Lithuania, most are greeted as a great gift, which they are. Reduced to the most basic level, that gift is survival. After the long months of pregnancy, through the pain of childbirth, a new life enters the world, and the family is likely to continue to exist for at least another generation, possibly two.

In modern industrial societies with their low infant mortality rates, survival is pretty much taken for granted. But in prehistory, back when most hominid lives were—as Thomas Hobbes wrote in *Leviathan*, his magnum opus, published in 1651—"solitary, poor, nasty, brutish, and short," the birth of a healthy child must have seemed even more miraculous than it does in our era. Beyond the joy and relief the primeval parents felt at the birth, there may have been an awareness that the child, with another pair of hands to help, could contribute to the survival of the family, and by extension, of any clan or group of which it was a part.

It seems reasonable that births were the first collective celebrations, since the group would have a vested interest in its own survival. Any extended family would gather to help the father and mother through labor. News of the event most likely spread throughout the clan and possibly beyond. Since human beings are innately curious creatures, some probably gathered to find out what was happening or to help out. And if things went well, they made music and ate blueberry pies, or whatever treats they had hunted and gathered, to celebrate the newcomer and the continued survival of the family and the group.

Somewhere along the way, presumably after modern humans had developed calendars and recordkeeping, friends and family would gather to reprise that ritual at annual birthday celebrations. Traditions developed such as making music or using noisemakers, which some cultures believe scare away evil spirits. More recent rituals include birthday cakes bearing candles commemorating each year of the birthday girl's or boy's life. The child then makes a wish and extinguishes the flames with a single breath, before the cake is cut and served.

When photography became a mass phenomenon, birthday pictures (and later videos) quickly joined the list of traditions, as did phrases like "Look at the camera," and "Say cheese." The child celebrating its first birthday in Elliott Erwitt's photo shot in East Hampton, New York, in 1981, looks like it is wishing big sister would stop staring at the cake and let go of its head. Trying to get a one-year-old to focus on and blow out a birthday candle is another traditional, if routinely futile, exercise. Nonetheless, children's birthday parties often make for fun photos because little kids will do and say anything, as countless photos of demolished cakes and laughing, frosting-smeared faces attest.

Nearly all celebrations are event driven, but they are also events in and of themselves. Children may not know the reason for the celebration, but most of them like to have fun and be the center of attention. For kids fortunate enough to be born into safe, supportive circumstances, life can be one continuous celebration full of fresh faces, new things, and unexpected delights. They go through daily life seizing on any excuse to celebrate, whether it is a birthday party, a carnival, a day at the beach, or a raucous group bath such as the one photographed by Philippe Brault in southwestern France, in which a tub is filled with screaming, splashing children.

Those family celebrations are a mix of the past, present, and future; of traditions and rituals; of hopes and dreams. Some are celebrated in private, with only family members present. Others, such as coming-of-age graduation ceremonies marking a young person's transition from adolescence to adulthood, are often celebrated in public settings.

Cultures and religions celebrate this transition in a wide variety of ways, and at different points in the lives of the young men and women involved.

Under Jewish law and tradition, a boy becomes known as a bar mitzvah upon turning 13 and is obligated to fulfill Jewish commandments. Although it is not actually a rite of passage, since the status is conferred automatically and the boy remains legally a minor, the transition is usually celebrated by a religious service in which the young person takes active part, often by chanting a haftarah, or biblical selection. When Jewish girls reach the age of 12, they are known as bat mitzvahs and participate in a service much as boys do.

The services are frequently followed by a party, like the one Leonard Freed photographed in Amsterdam in 1958. Unlike some bar mitzvahs, who still look and sound like youngsters, the Dutch boy standing between his proud parents actually resembles a male on the cusp of adulthood.

Motherhood, specifically a girl's readiness to become a mother, is believed to have been the original purpose for the *quinceañera* ritual, which is celebrated in some Hispanic cultures. The ritual is thought to date back to around 500 B.C. in Aztec culture, when a girl at the age of 15 was considered ready to bear children. This transition was celebrated with a ceremony, followed by dancing and the bestowing of sage advice from the girl's mother. After the Spanish conquest, the tradition was adapted to the Roman Catholic faith. Over the years, it acquired some European flourishes, with the original dance becoming a waltz, and the girl being squired by a well-groomed date known as a *chambelan*, or chamberlain.

Gerd Ludwig's photograph shows a Mexican-American girl in Brawley, California, being congratulated by friends and family at her quinceañera celebration. These days, the ceremony is more popular in the United States than in Latin America. Instead of celebrating a girl's readiness for motherhood, it involves a Catholic service and a carefully choreographed and sometimes extravagant ceremony celebrating the family's standing in the community and its cultural roots.

In many such celebrations, considerable time, effort, and money is spent on clothing for the participants, as well as on food, drink, decorations, and entertainment for the guests. But those expenditures pale in comparison with what goes on in cultures around the globe to prepare for weddings.

Whether the wedding is big or small, lavish or frugal, traditional or free-form, it is a ceremony celebrated around the world. Although traditions and customs vary, the union of two people usually involves certain things. The couple exchange wedding vows. In Western culture, they usually exchange wedding rings. Their union is sanctioned by a religious or civic authority figure. Special garments are worn by the couple, and their wedding may involve a religious service or a civil procedure. Some weddings have music, prayers, readings, blessings, and recitations.

Since this is a book of photographs, I would be remiss if I did not mention the great tradition of wedding photography. In one of the few weddings I have attended at which no wedding photographer was present, I was the groom. My fiancée and I had very much disliked nearly all the photos we had seen of friends' weddings. Since so many family members and friends would be taking pictures at the ceremony and the reception, we felt we did not need to hire a professional. As a result, we have only a handful of decent photographs of our wedding celebration. This experience greatly deepened our appreciation of professional photographers.

What separates outstanding photographic artists from the rest of us is their ability to see things that most people miss—like the pink sneakers Jodi Cobb spotted on a bride in Las Vegas—and turn them into remarkable pictures. Some of that is, of course, a matter of being in the right place at the right time. The photographs that conclude this chapter were taken in Vietnam, Germany, Britain, the United States, Taiwan, Sweden, India, Kenya, South Africa, and France, by some of the world's top photographers.

The pictures by Cobb, Ami Vitale, Per-Anders Pettersson, Chien-Chi Chang, Ian Berry, Abbie Trayler-Smith, David Alan Harvey, Albert Moldvay, and Julien Daniel form a vibrant mosaic of people around the globe celebrating the same thing—their love and commitment—each couple in their own way, like their parents, grandparents, and great-grandparents before them. ∎

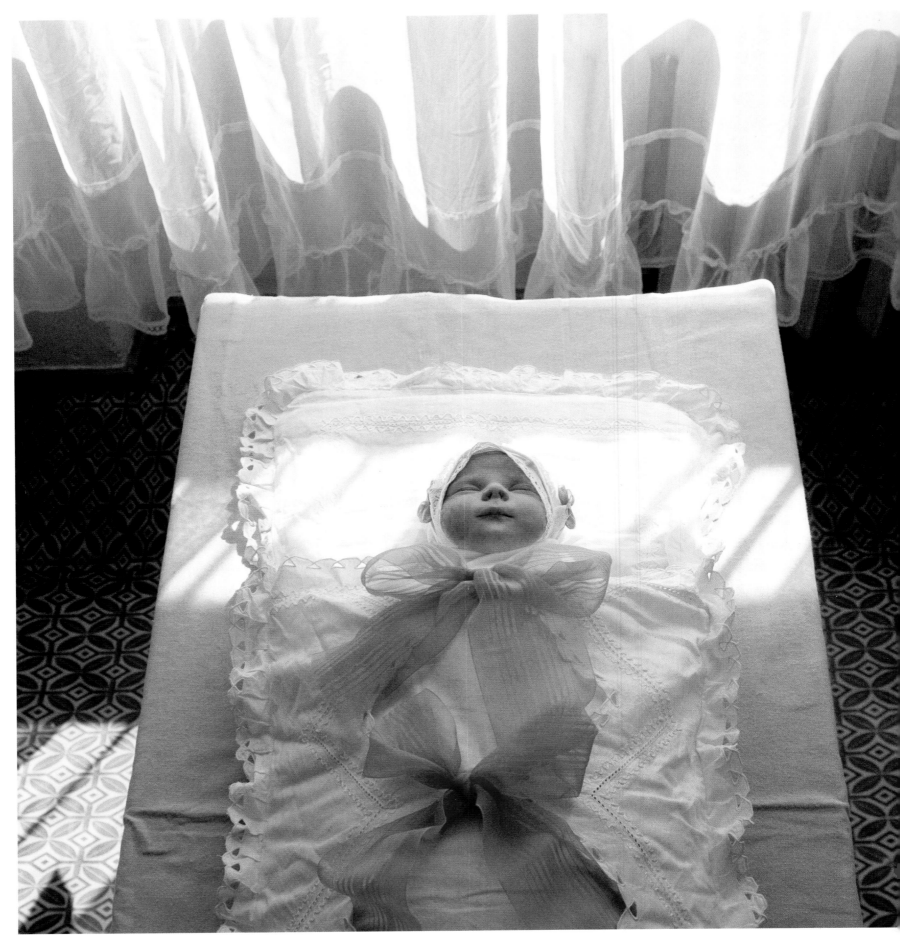

As nine months go to the
shaping an infant ripe for his birth,
So many a million of ages have
gone to the making of man.

—HERBERT SPENCER

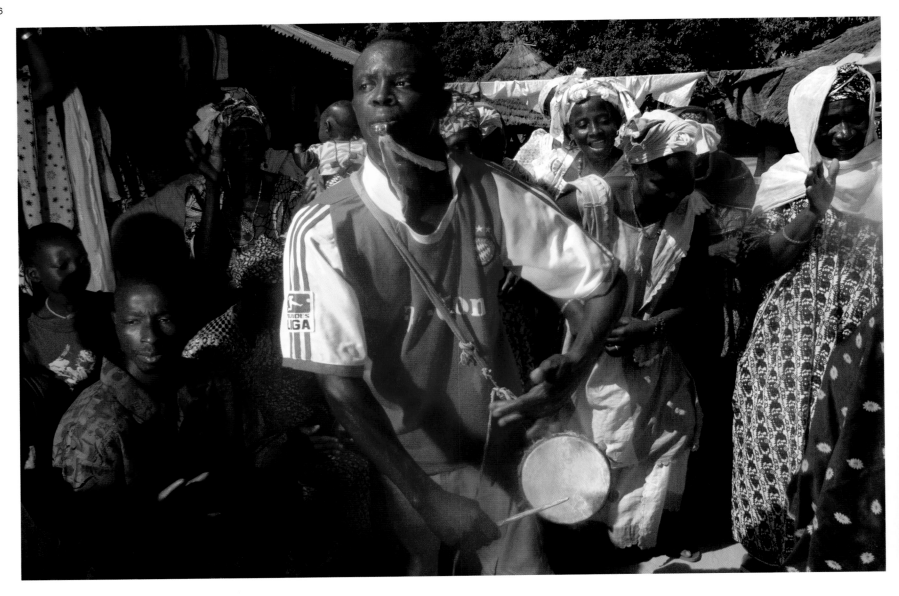

PREVIOUS PAGES: LARRY PRICE | Vilnius, Lithuania | 1990.
A gift-wrapped newborn awaits her parents at a maternity hospital.

DAVID ALAN HARVEY | Casamance region, Senegal | 2007.
Drumming provides the pulse for a newborn's welcoming ceremony.

OPPOSITE: AMI VITALE | Barentu, Eritrea | 2006. A newborn baby girl is held
by the woman who helped her mother give birth to her a few days before.

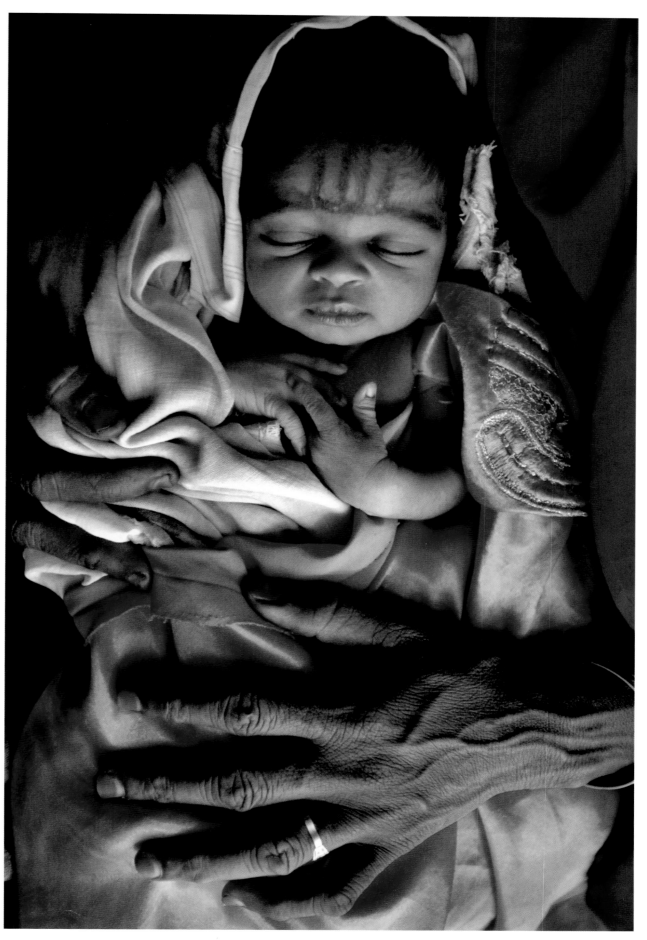

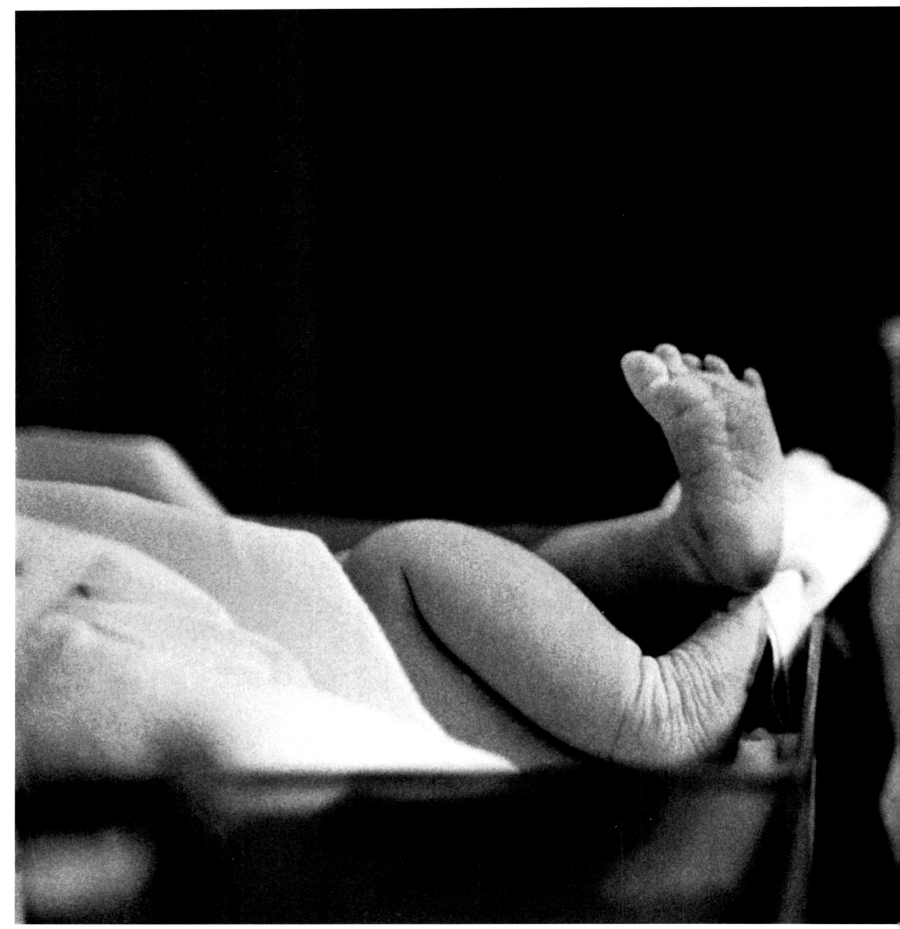

PREVIOUS PAGES: EVE ARNOLD I **Long Island, New York I 1959.** A five-minute-old infant makes its first kicks outside the womb as its mother looks on.

SERGEY MAXIMISHIN I **El'Tyubyu, Russia I 2008.** A mother and her baby at home against the backdrop of an exotic mural

FOLLOWING PAGES: AMI VITALE I **Barentu, Eritrea I 2006.** Children pray at a Sunday church service for Coptic Christians in the village of Fithi.

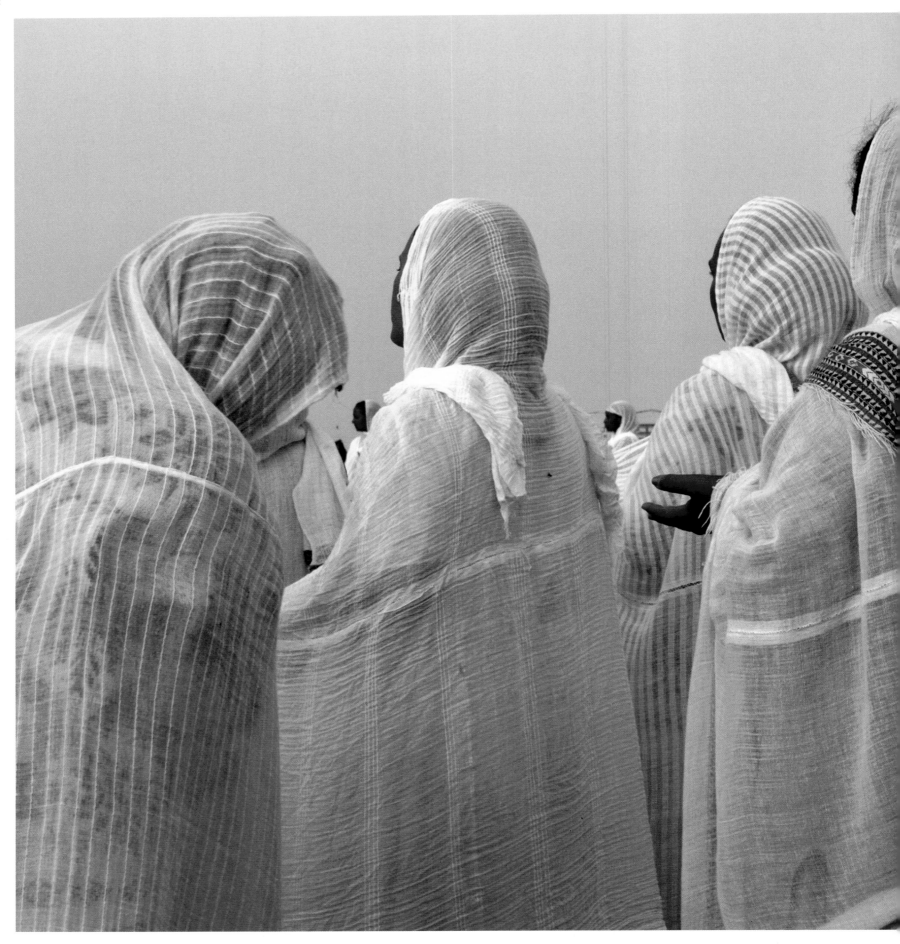

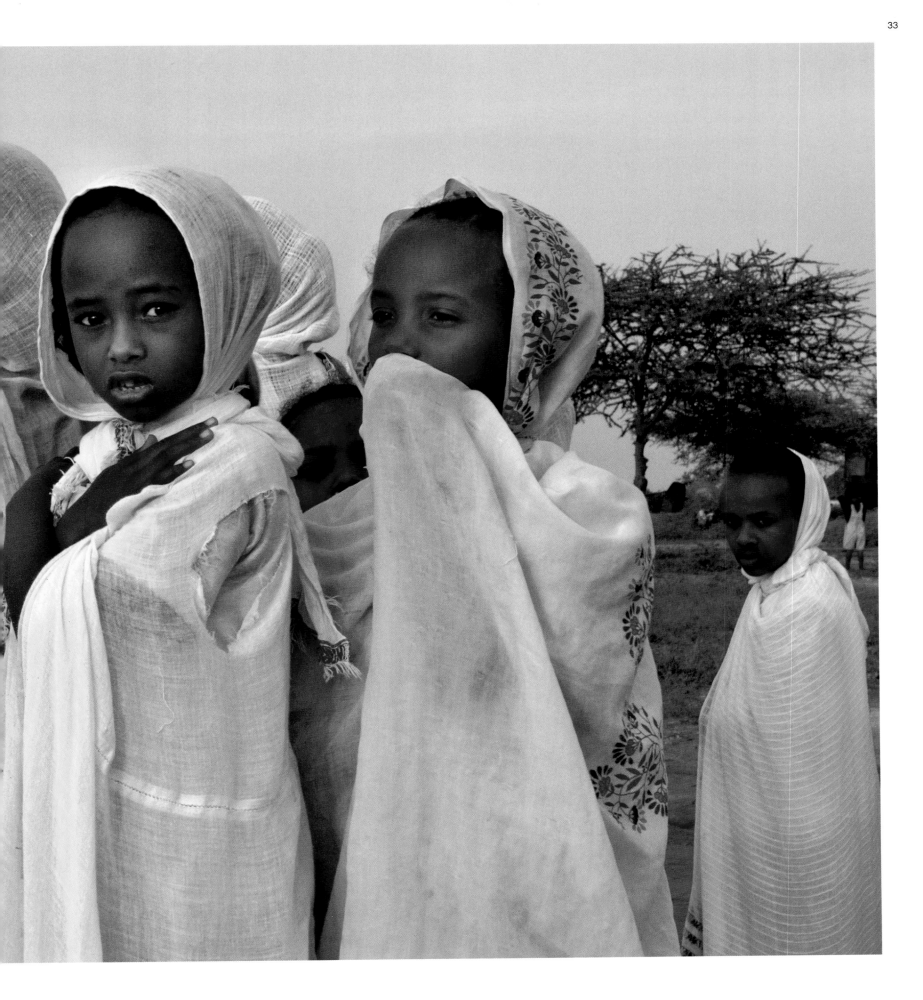

RANDY OLSON I Democratic Republic of the Congo I 2005.
Boys in ceremonial skirts follow their elders to a hunting camp.

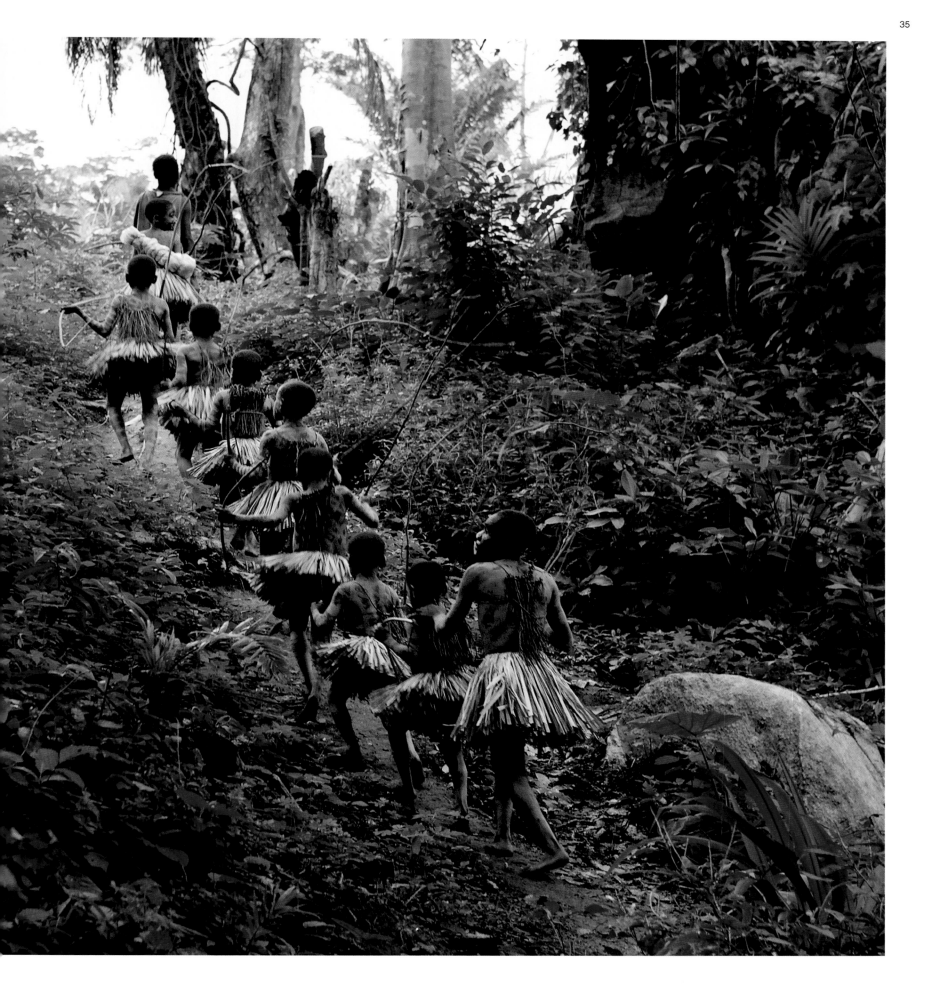

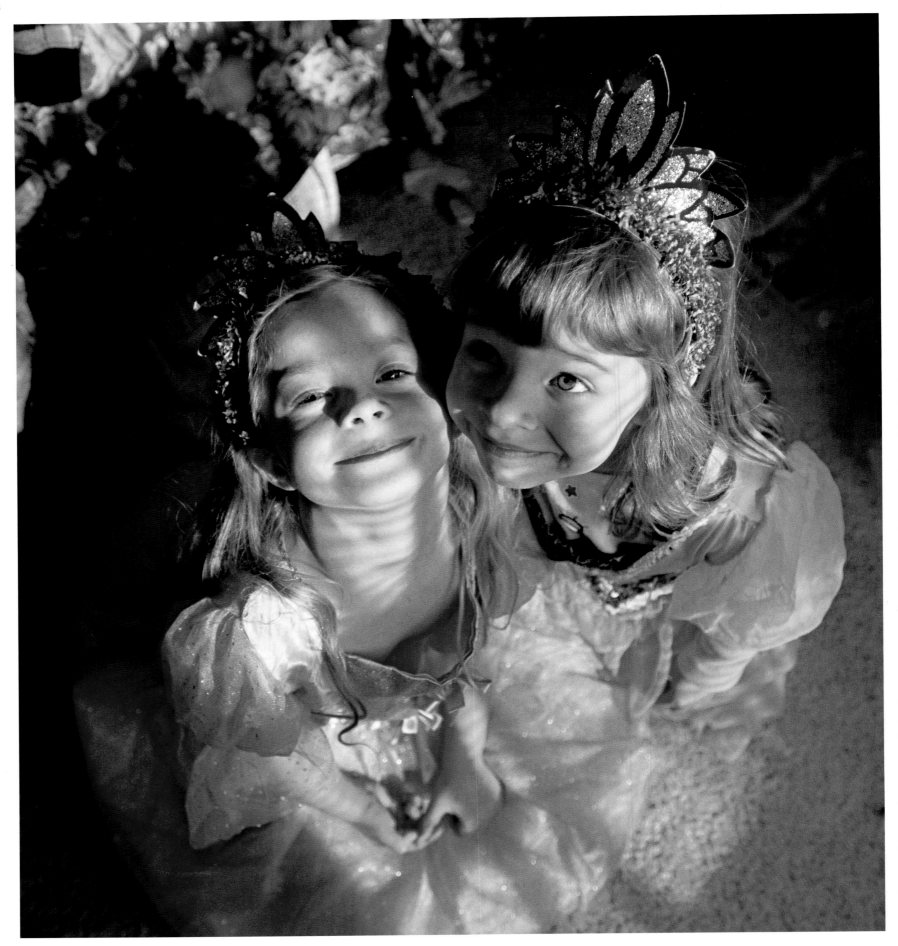

How dear to this heart
are the scenes of my childhood,
When fond recollection
presents them to view.

—SAMUEL WORDSWORTH

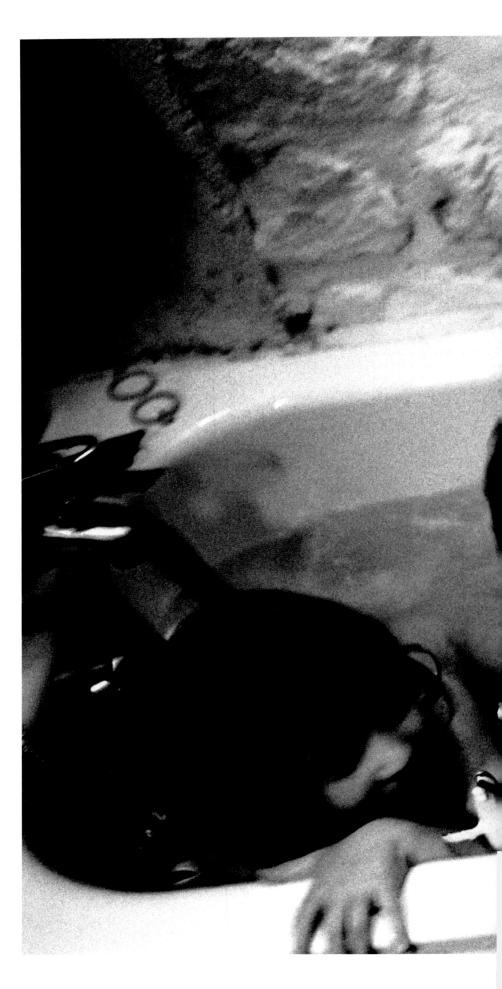

PREVIOUS PAGES: JOEL SARTORE I Lincoln, Nebraska I 1997.
Two young girls in a game of dress up

PHILIPPE BRAULT I Saint-Siffret, Gard, Languedoc-Roussillon, France I 2009.
Children delight in the ageless joy of water during a bath.

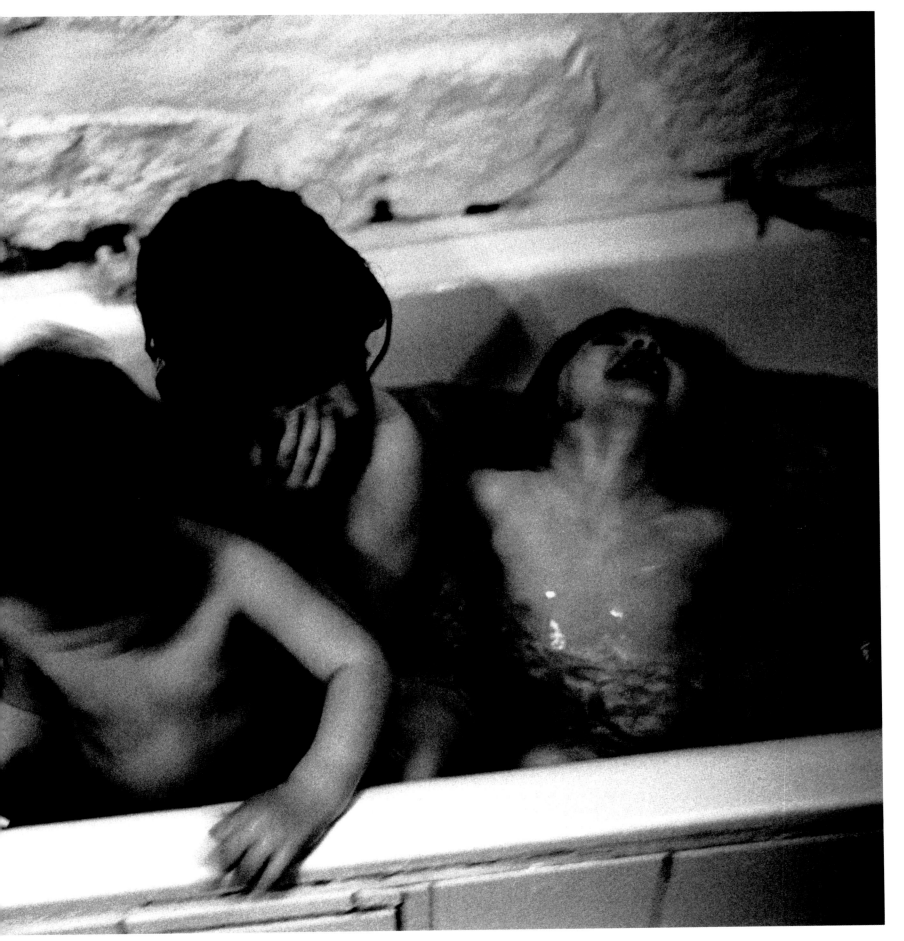

JOEL SARTORE | Lincoln, Nebraska | 2001.
The photographer's son bears a newly toothless grin.

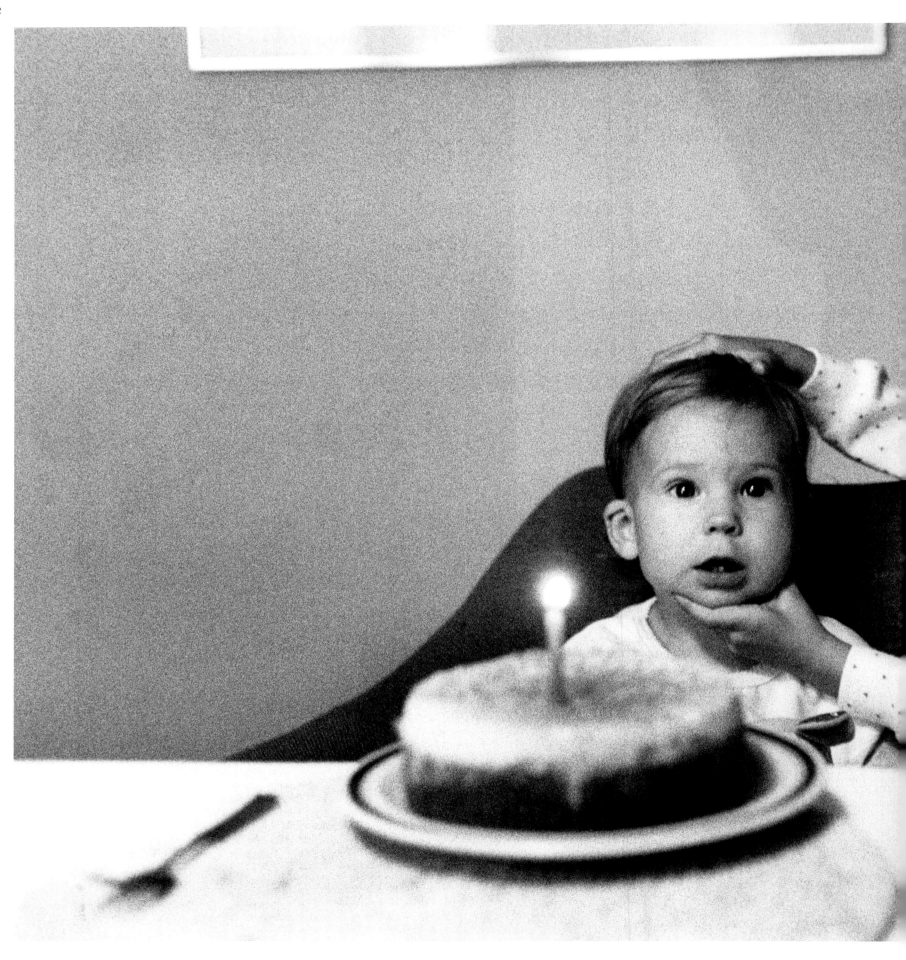

ELLIOTT ERWITT | East Hampton, New York | 1981.
A single candle commemorates a child's first birthday.

FOLLOWING PAGES: JODI COBB | Monte Carlo, Monaco | 1995.
Ballet costumes hang backstage during a dress rehearsal in Salle Garnier.

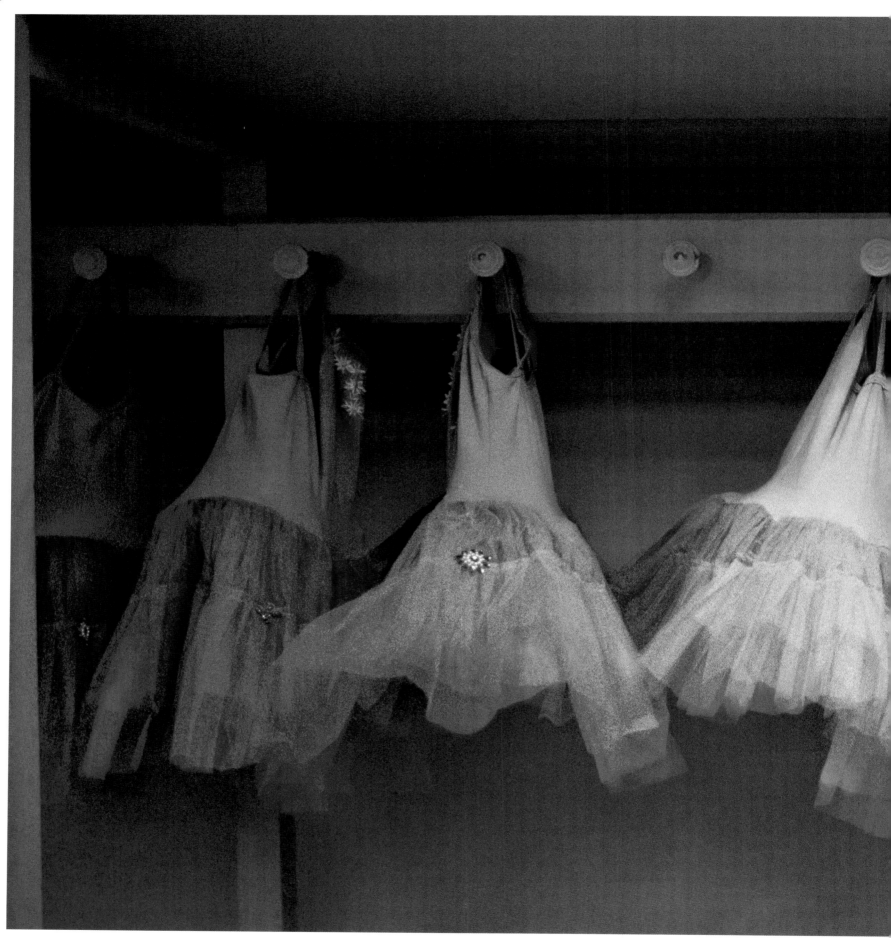

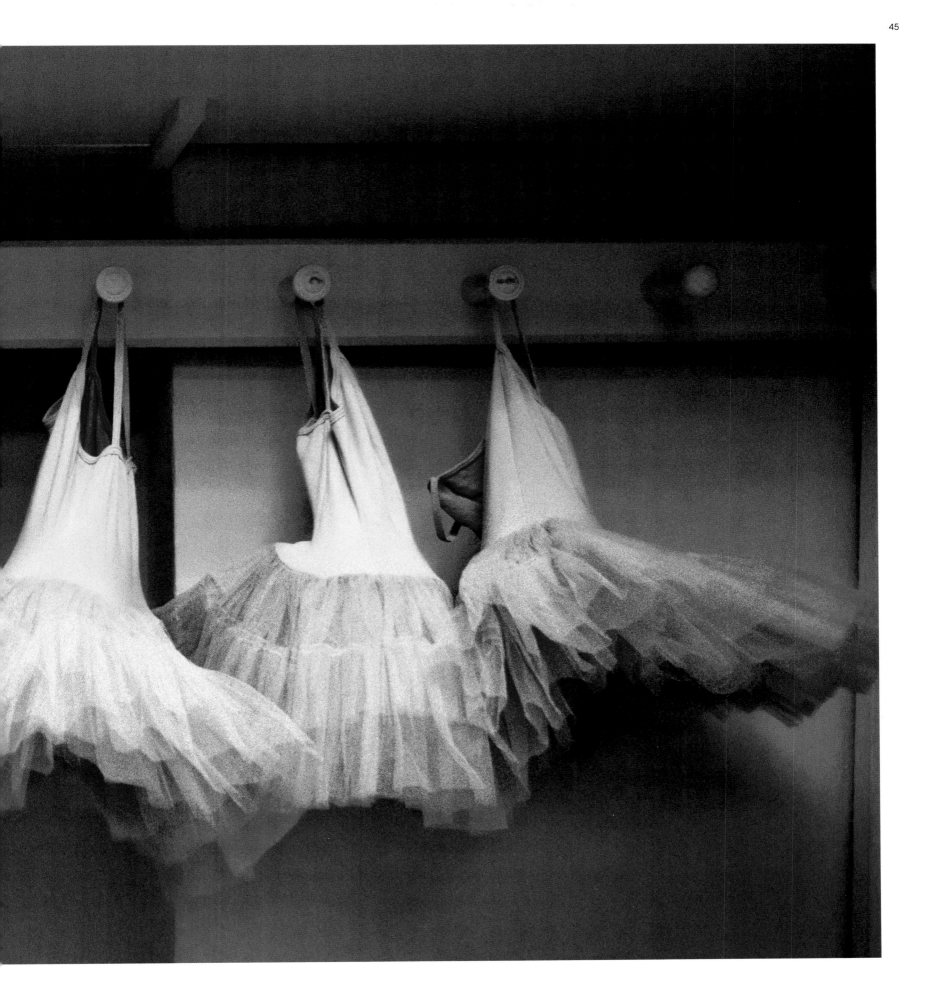

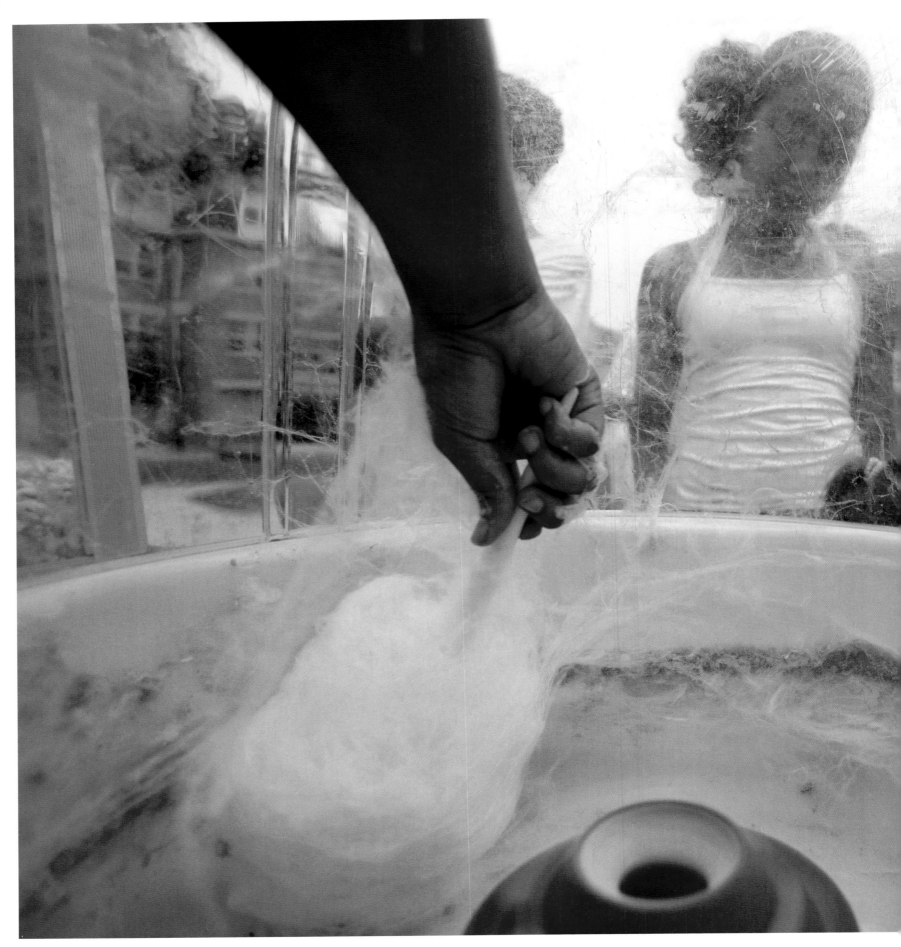

MIA SONG I New Brunswick, New Jersey I 2007.
Children wait for cotton candy during a community celebration.

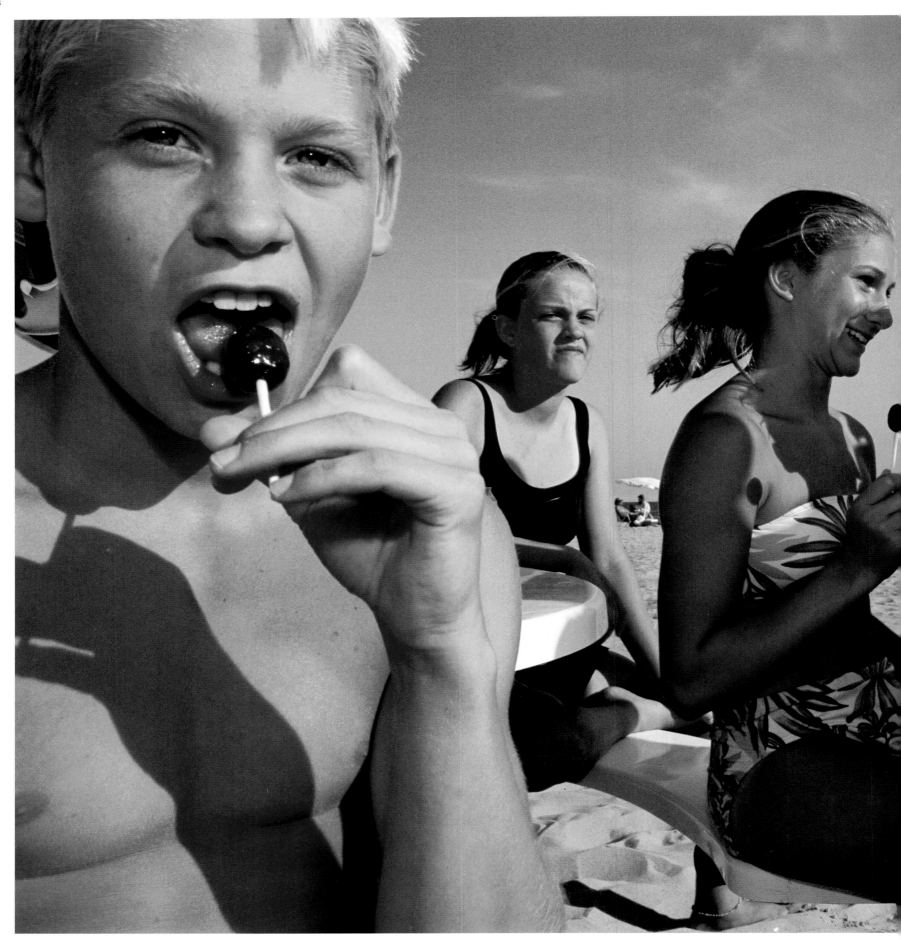

AMY TOENSING | Ocean Grove, New Jersey | 2000.
An all-American summer afternoon on the Jersey shore

50

DAVID ALAN HARVEY I San Juan, Puerto Rico I 1995.
A boy tosses a ball inside the famous Hiram Bithorn Stadium.

What greater thing is there
for two human souls
than to feel that they are joined for life . . .
to be one with each other in
silent unspeakable memories.

—GEORGE ELIOT

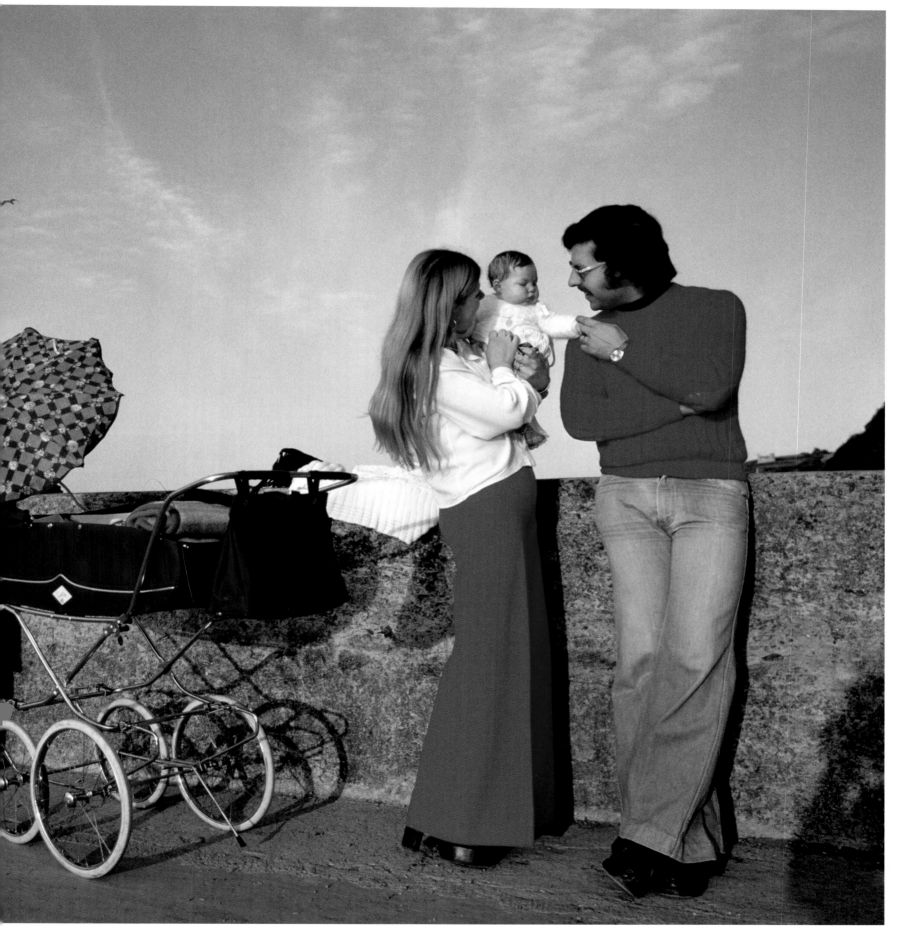

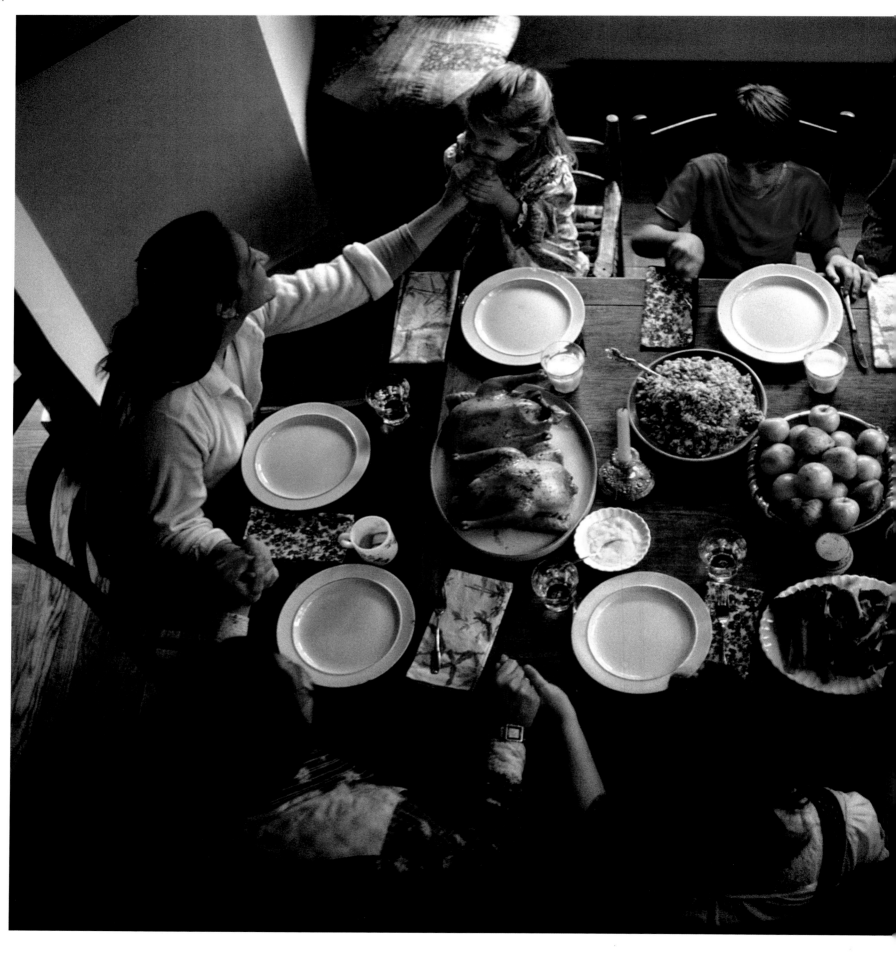

PREVIOUS PAGES: DAVID ALAN HARVEY I **Bermeo, Spain I 1977.**
Basques clad in black share a dock with a young family.

EVE ARNOLD I **Whitesburg, Kentucky I 1984.**
A family joins hands for a blessing over dinner.

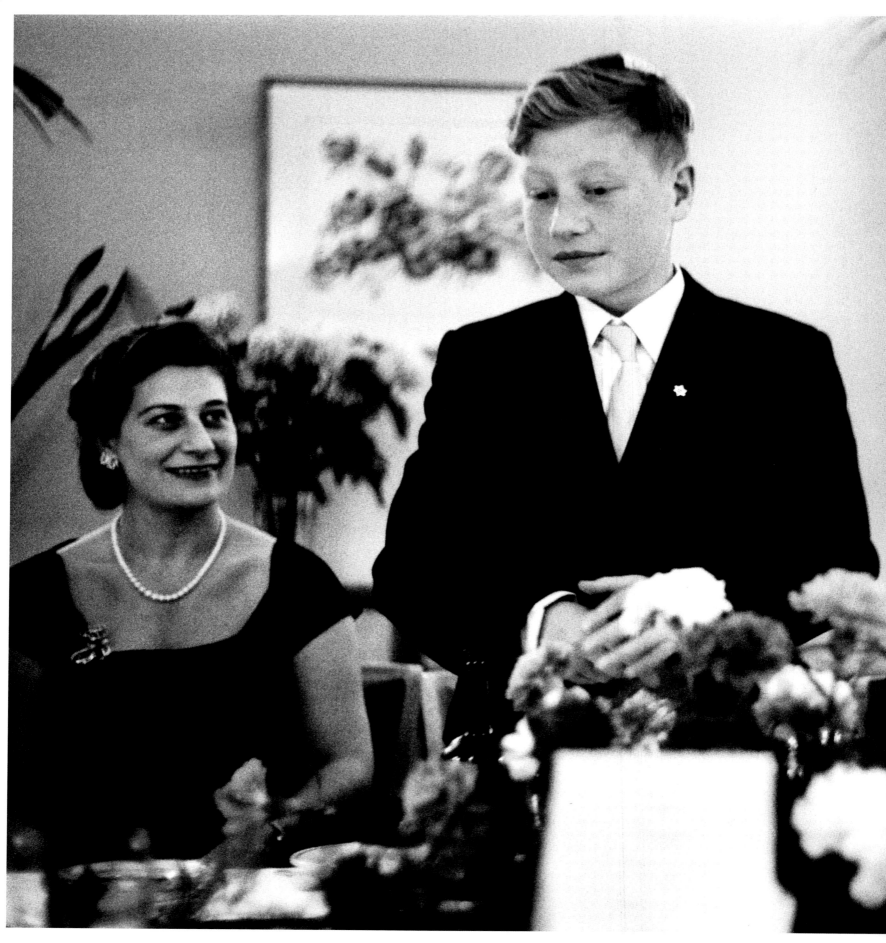

LEONARD FREED I Amsterdam, Netherlands I 1958.
A boy and his parents at his bar mitzvah

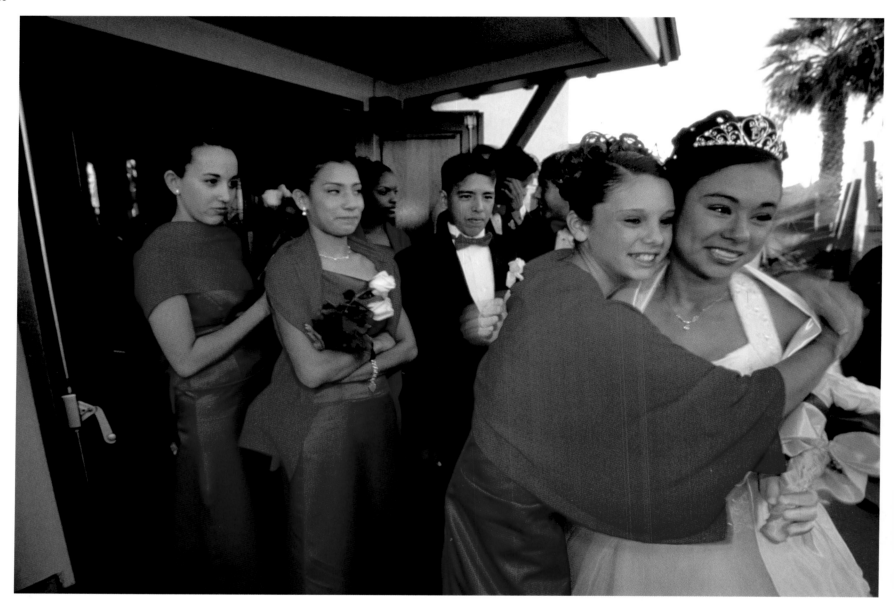

GERD LUDWIG | Brawley, California | 2003.
A Mexican-American girl celebrates her *quinceañera*.

OPPOSITE: AMI VITALE | North Sikkim, India | 2003.
Two girls traverse the Rongyong River on a dizzying footbridge.

FOLLOWING PAGES: LYNN JOHNSON | Mfuwe, Zambia | 2005.
Friends share a laugh at the Cinderella beauty shop.

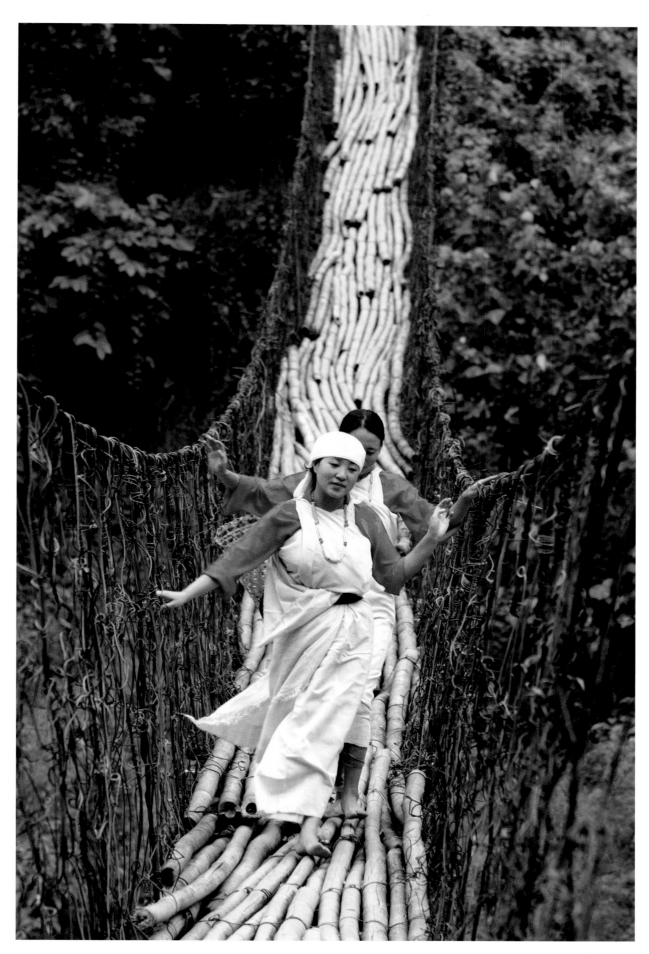

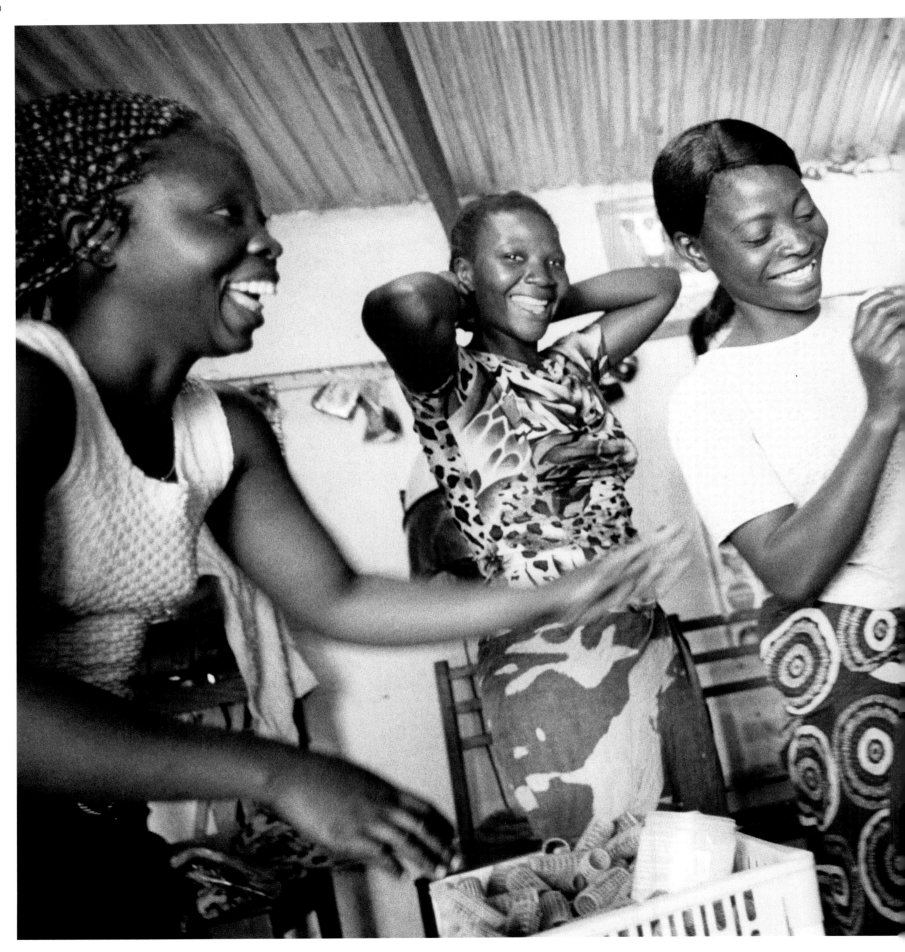

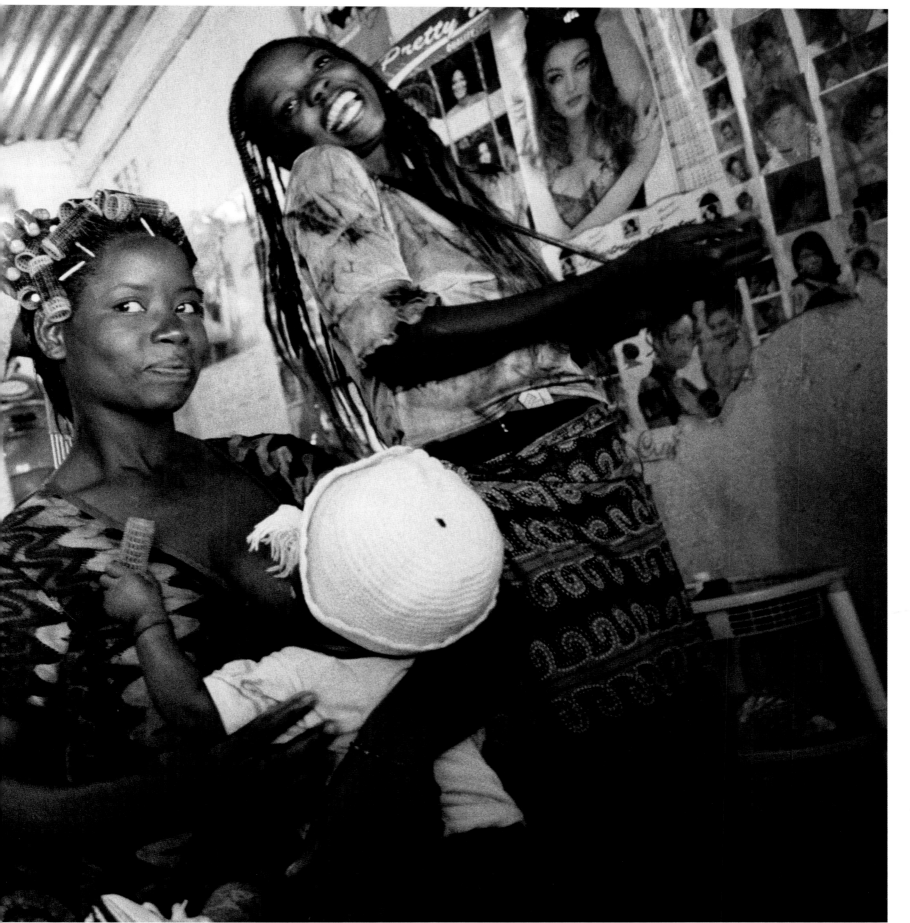

RANDY OLSON | Harappa, Pakistan | 2007.
Families gather at a Camel Festival.

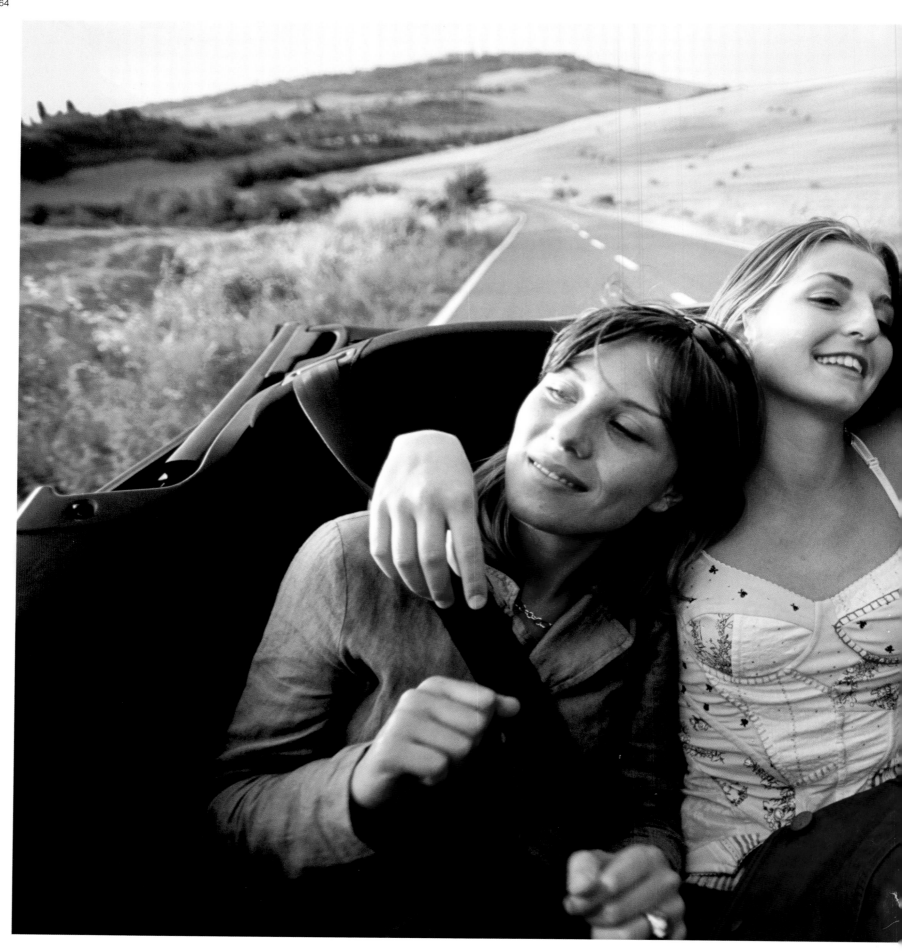

The young are permanently in a state
resembling intoxication.

—ARISTOTLE

66

PREVIOUS PAGES: JODI COBB I San Quirico, Italy I 2004.
Friends ride through the Tuscan countryside with the top down.

JOEL SARTORE I Salt Lake City, Utah I 1995. Teens make a scenic stop
overlooking Salt Lake City on the way to a high school prom.

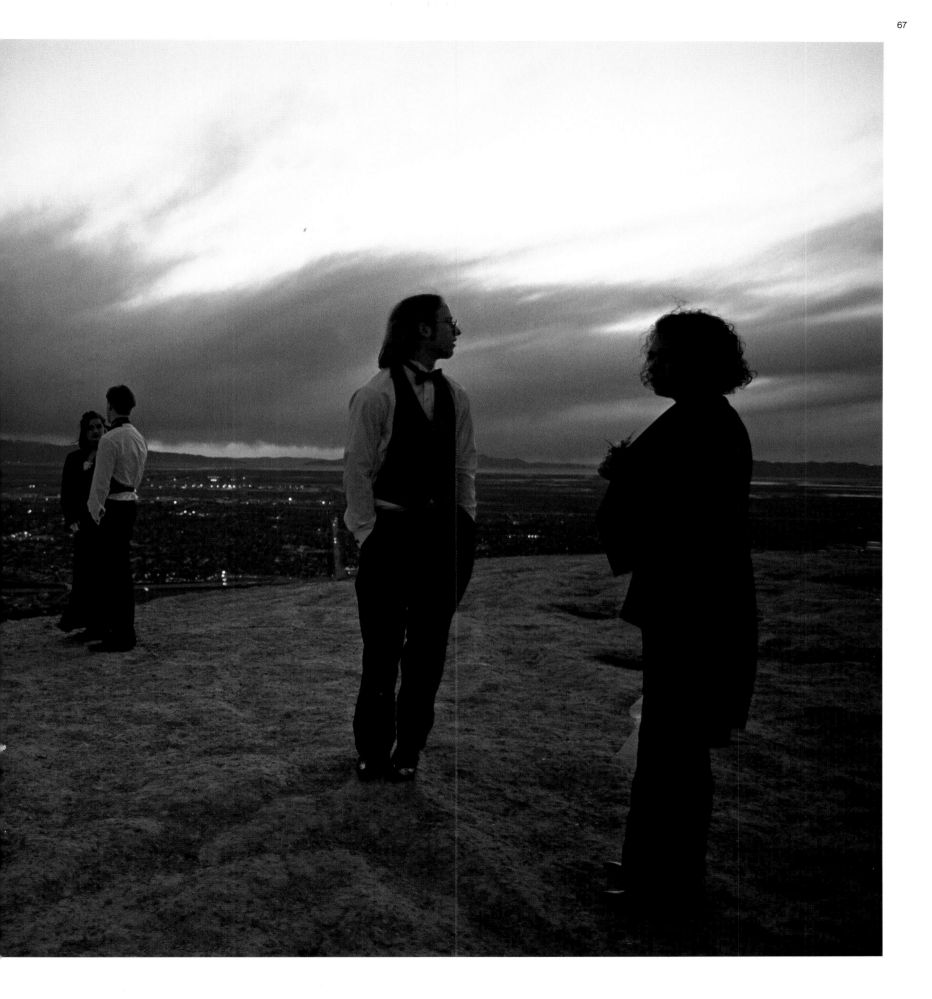

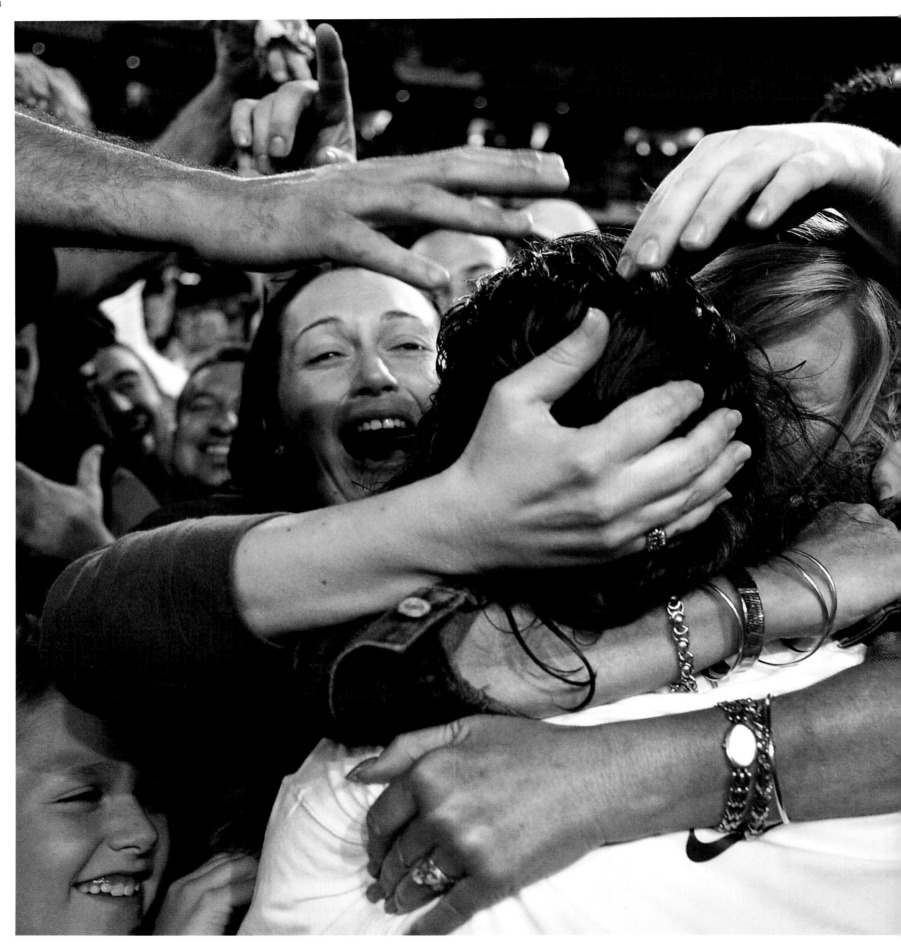

ADAM PRETTY | **Sydney, Australia | 2005.** Harry Kewell of Australia celebrates with fans after a victorious football (soccer) match against Uruguay in the 2006 FIFA World Cup.

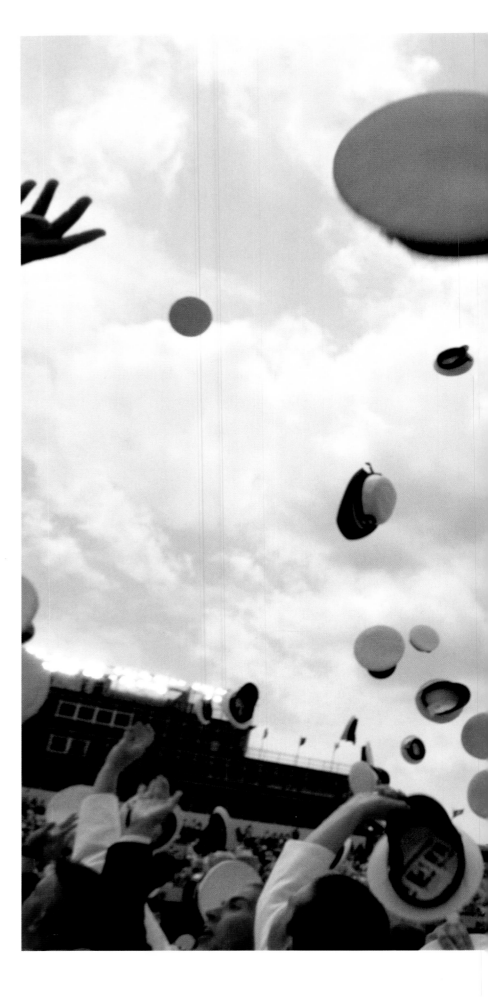

ANNIE GRIFFITHS BELT I **Annapolis, Maryland I 2007.**
U.S. Naval Academy graduates toss their caps in jubilation.

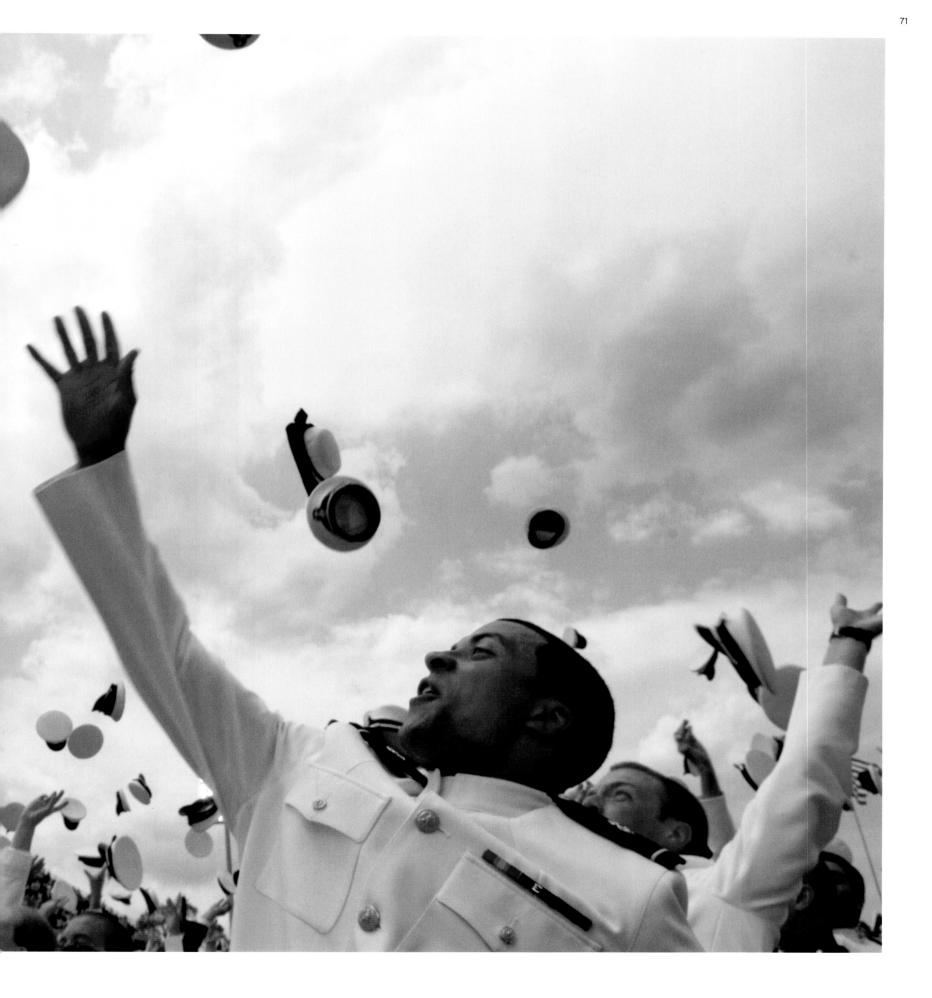

72

ELI REED | Edison, New Jersey | 2000. Former classmates relive their teens at their 45th high school class reunion.

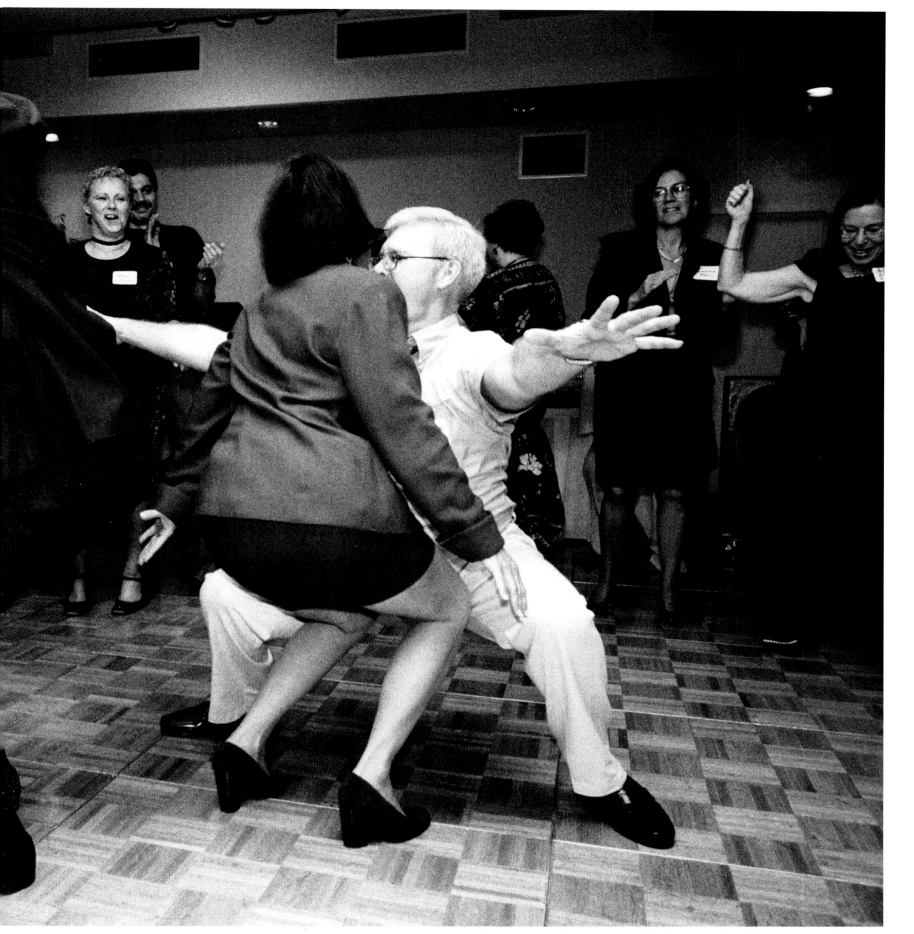

Oh, fill me flagons full and fair,
Of red wine and of white,
And, maidens mine, my bower prepare,
It is my wedding night!

—EDITH NESBIT BLAND

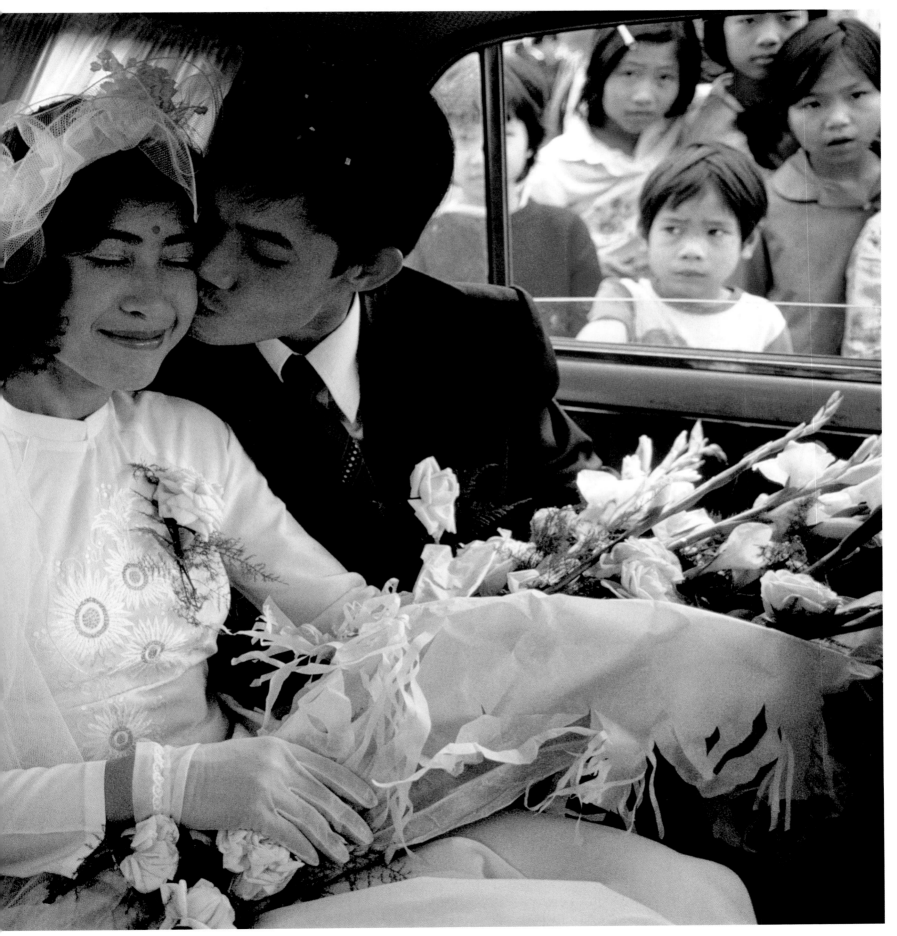

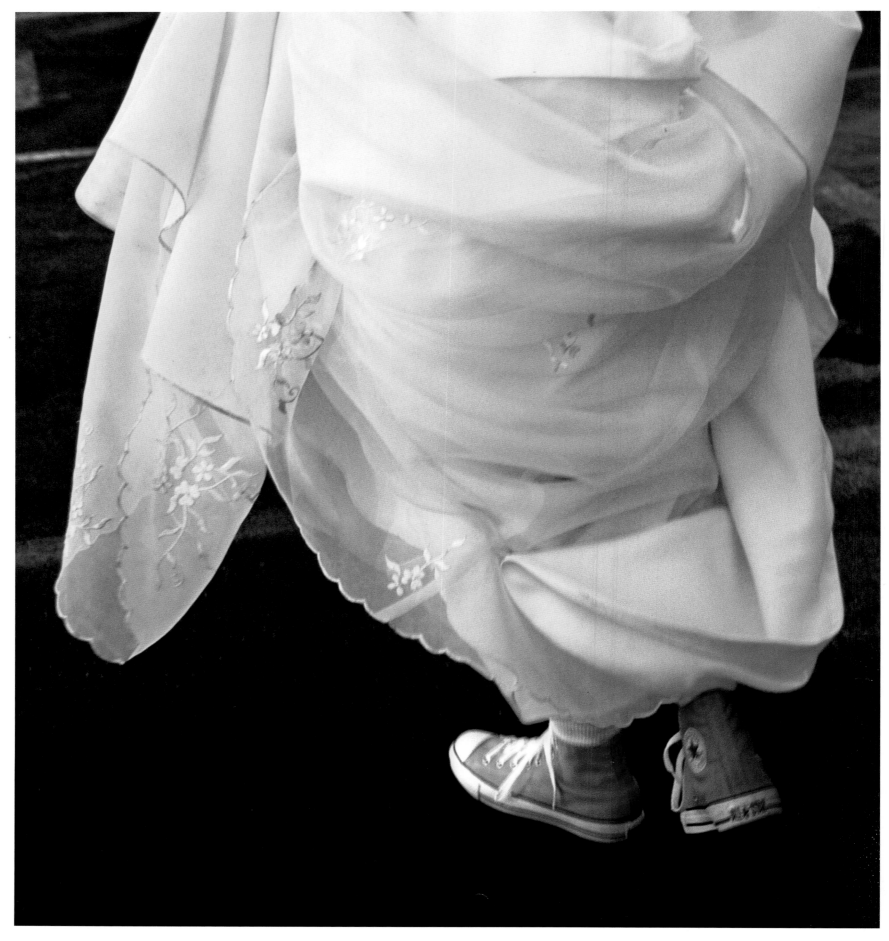

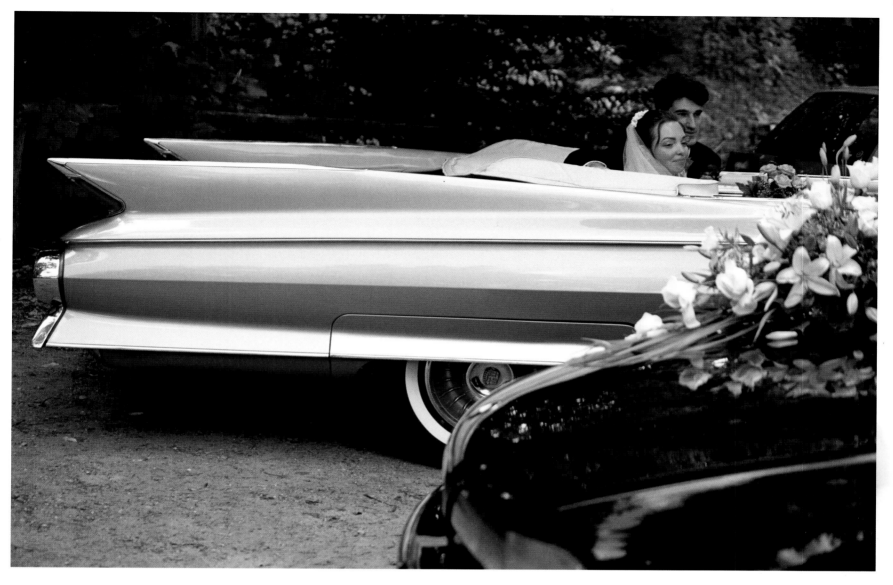

PREVIOUS PAGES: DAVID ALAN HARVEY I Hanoi, Vietnam I 1989.
A groom kisses his bride following their wedding.

OPPOSITE: JODI COBB I Las Vegas, Nevada I 2004.
A modern bride prizes comfort over tradition.

IAN BERRY I Berlin, Germany I 2000.
A couple departs their wedding in a pink Cadillac.

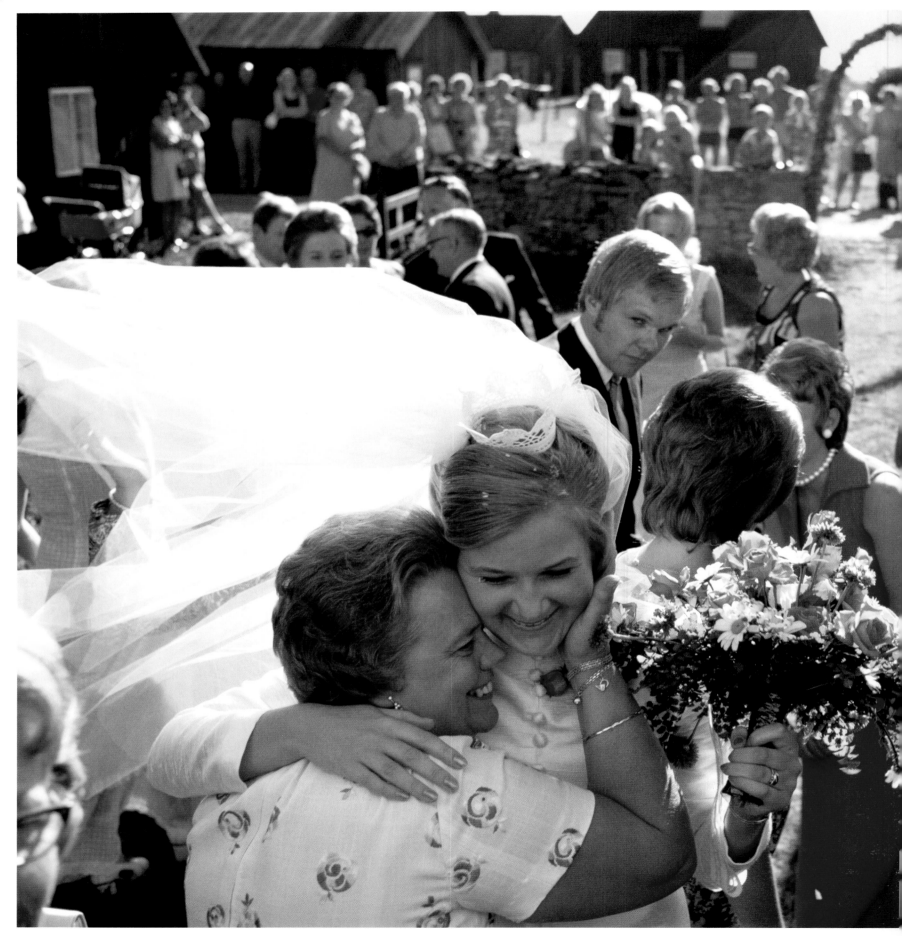

ALBERT MOLDVAY I Gnisvärd, Gotland Island, Sweden I 1972.
A bride receives good wishes after her wedding.

ABBIE TRAYLER-SMITH | Tooting, England | 1991. A bride makes finishing touches to her appearance before her wedding.

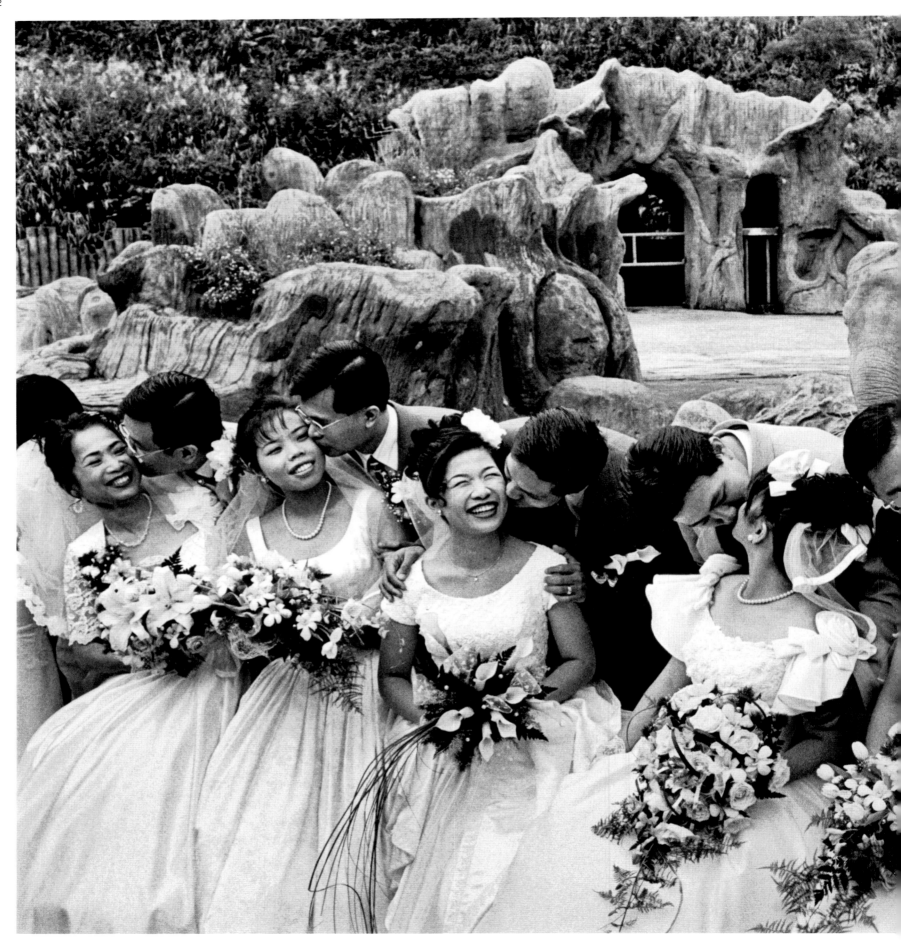

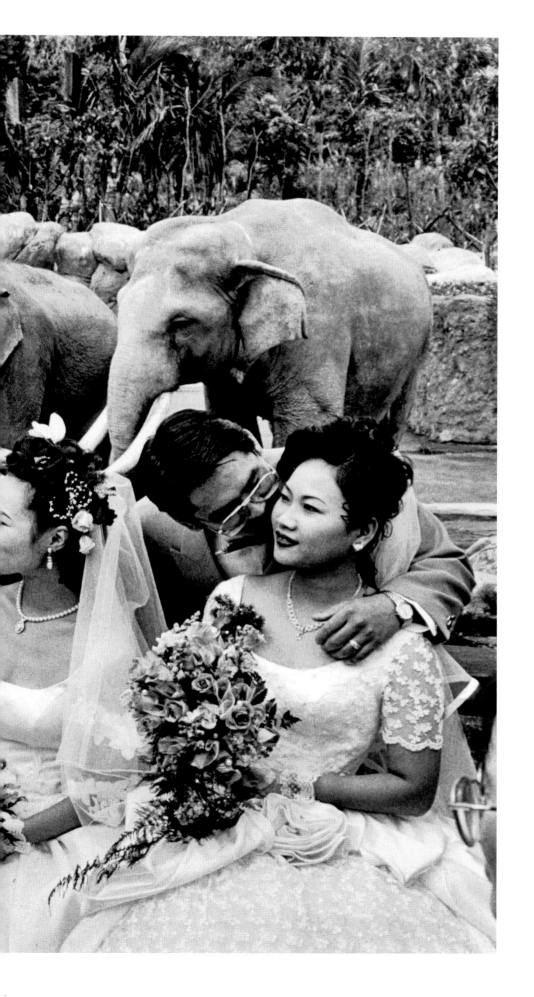

CHIEN-CHI CHANG | Taipei, Taiwan | 1997.
A group wedding in the zoo celebrates an elephant's 80th birthday.

FOLLOWING PAGES: MIKE HETTWER | Ingal, Niger | 2008.
Wodaabe men preen for the ladies.

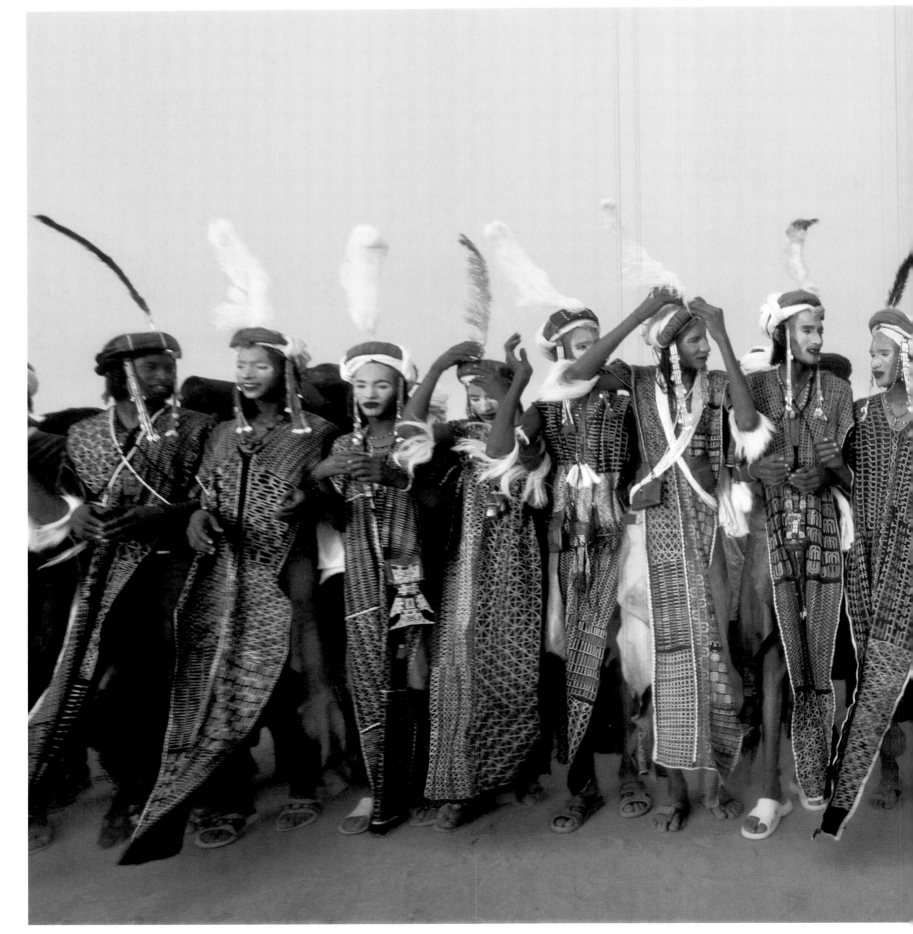

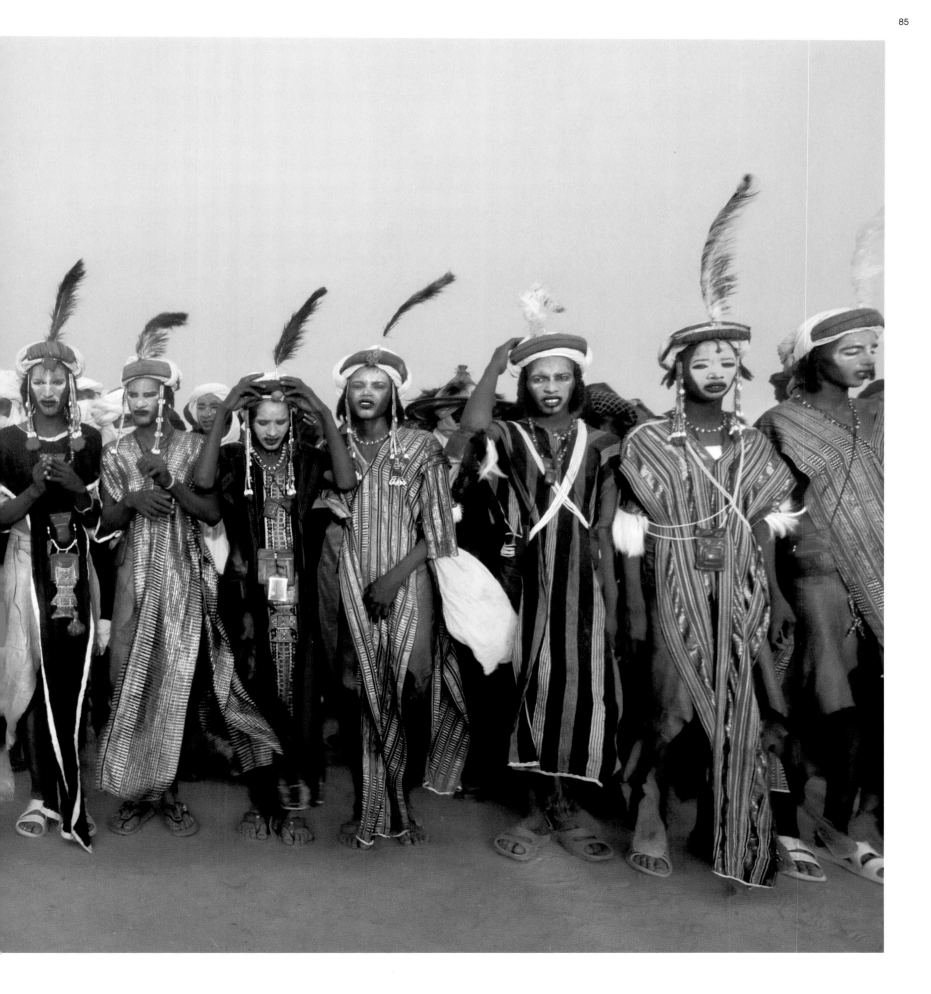

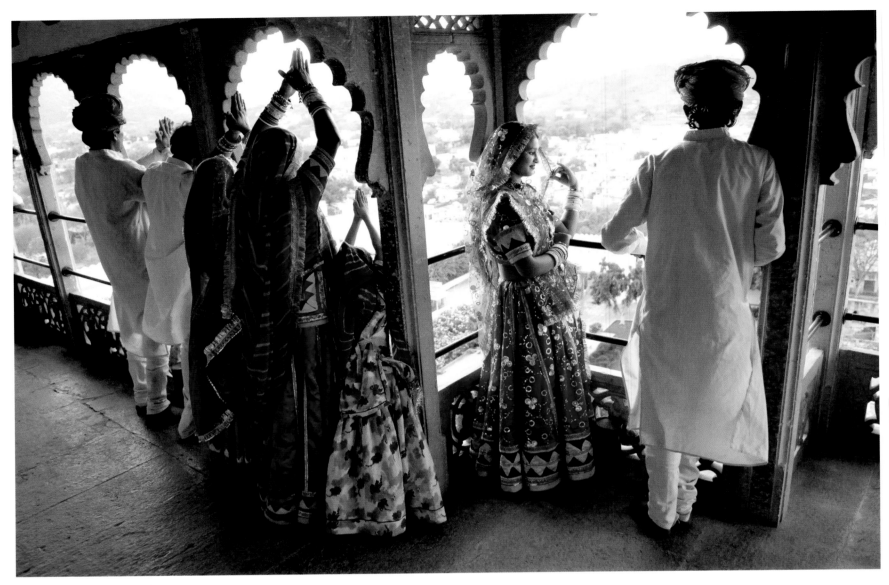

AMI VITALE I Udaipur, Rajasthan, India I 2009.
Dancers greet a relative who is arriving at the Devi Garh fort.

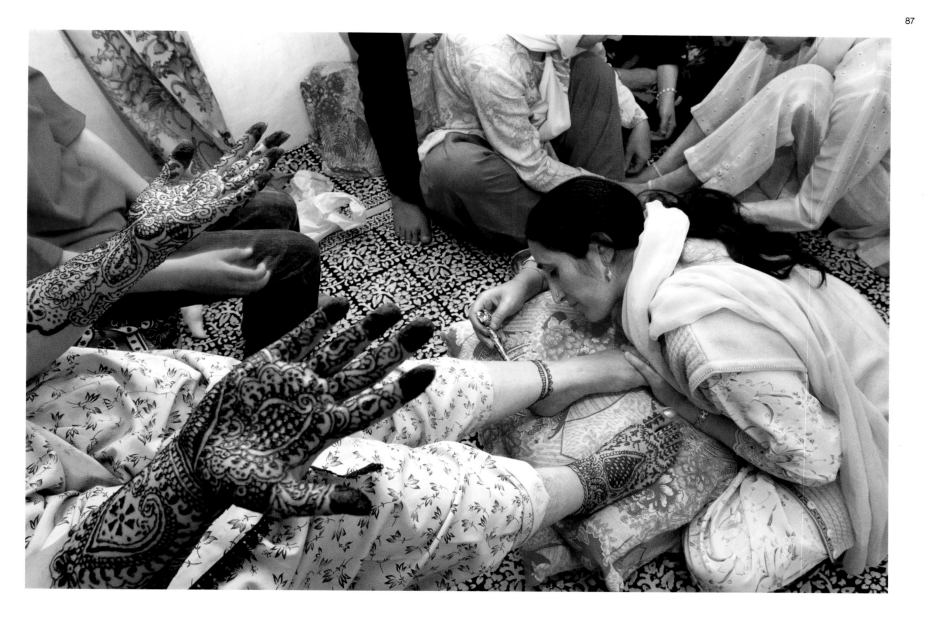

AMI VITALE I Srinagar, Kashmir, India I 2003.
A bride-to-be is decorated with henna at her engagement ceremony.

SISSE BRIMBERG AND COTTON COULSON I Mill Valley, California I 2007.
A young couple celebrate an intimate moment.

FOLLOWING PAGES: MICHAEL NICHOLS I Maralal, Kenya I 2008.
Dancers perform during a three-day Samburu wedding.

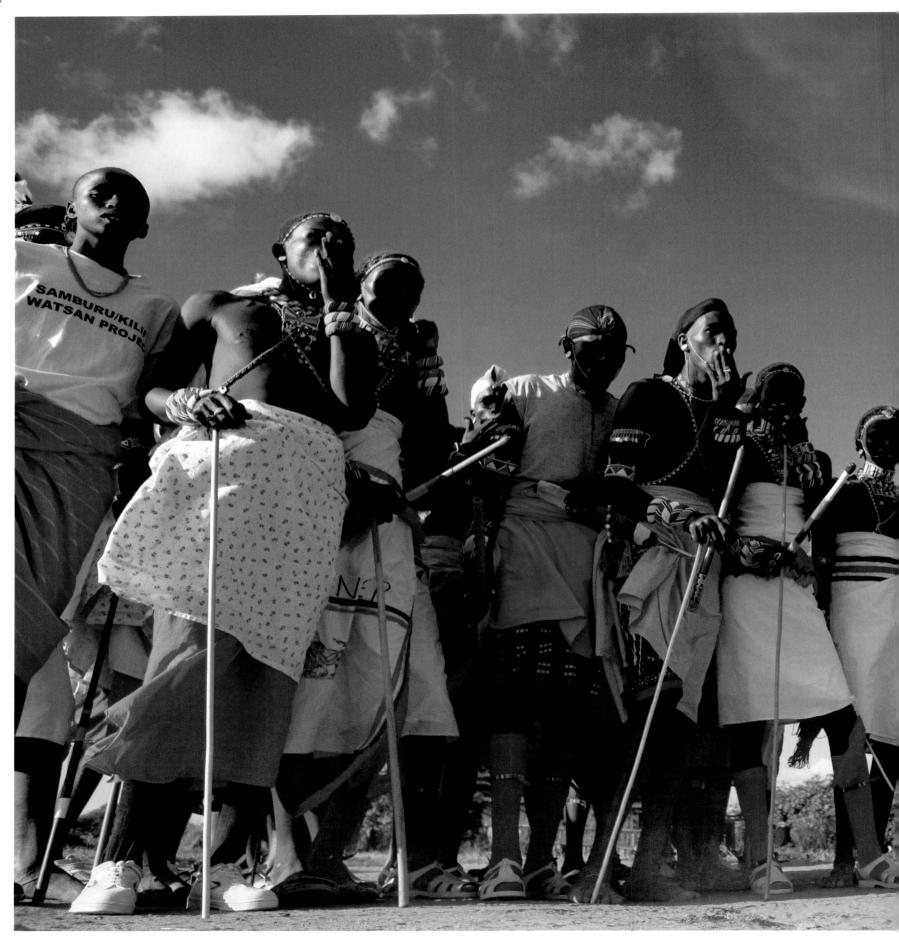

PER-ANDERS PETTERSSON I Johannesburg, South Africa I 2005.
Children take part in a wedding ceremony.

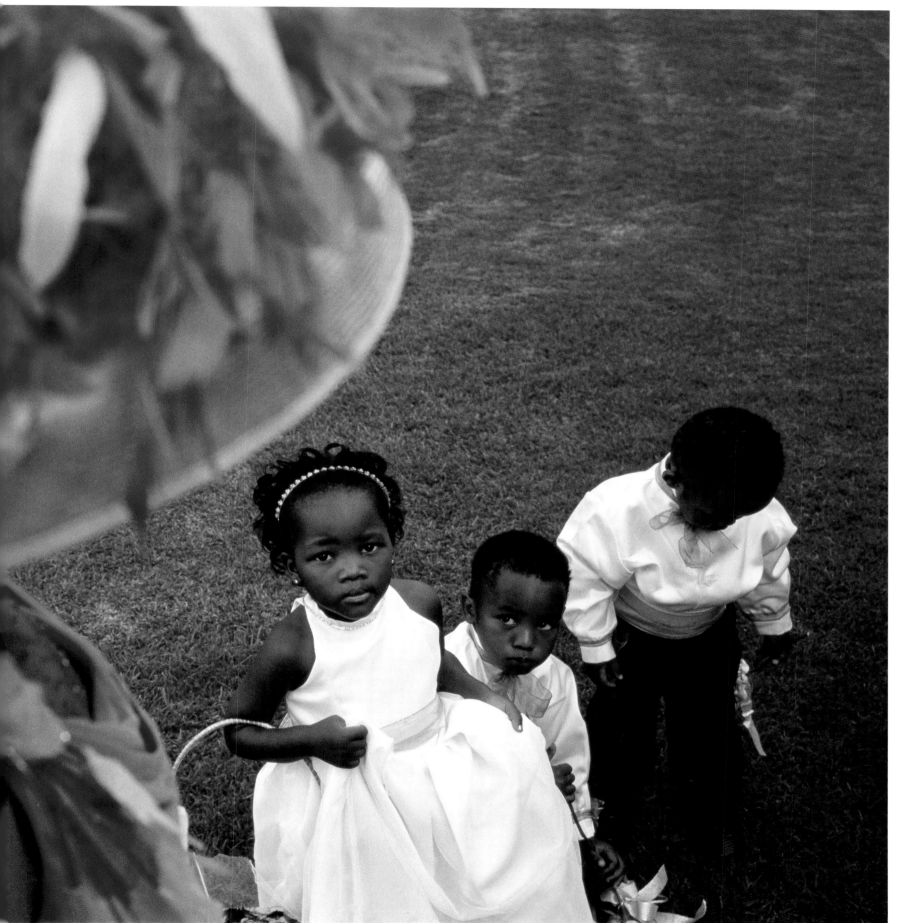

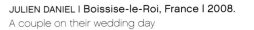

JULIEN DANIEL | Boissise-le-Roi, France | 2008.
A couple on their wedding day

CHAPTER TWO

around the world

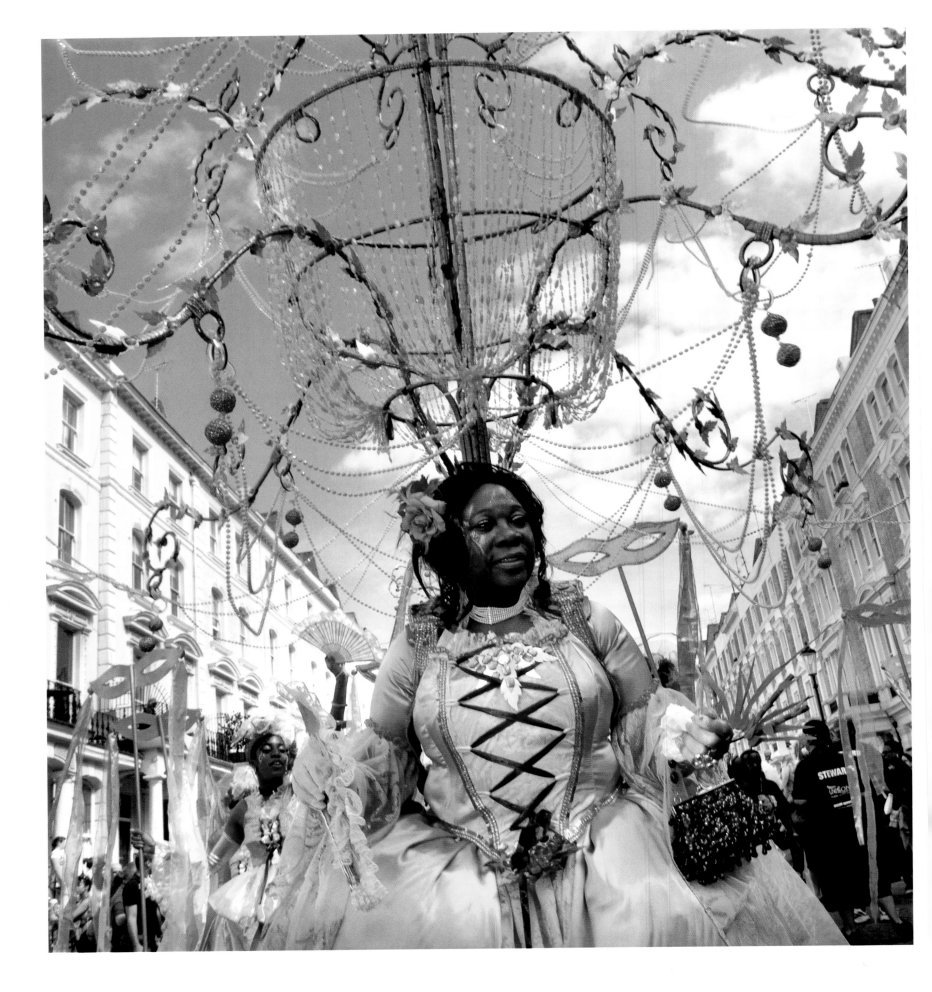

Celebrations,

Looking at the photographs in this chapter one can only conclude that people around the world take celebrating seriously, and many of them are willing to go to extraordinary lengths to plan and participate in public celebrations.

Parades, for example, usually require permits from local authorities. At a minimum, a route must be planned, streets have to be closed, security provided, and marching order established. Then someone has to start the parade and keep it moving. Afterward, there is cleanup. Whether the parade is long or short, religious or secular, held in a big city or a small town, it requires effort and expenditure.

The same applies to those who are in the parade. The woman in Steve Forrest's photograph of the procession at London's Notting Hill Carnival has obviously put some work into her gown. Decked out in a fancy pink-and-gold dress, she looks as if she would have been right at home in the sartorially splendid court of France's "Sun King," Louis XIV. Yet her gown is modest and slightly dowdy compared with the feathery, rhinestone-bedecked outfit worn by the dancer perched atop a giant hummingbird in the Rio de Janeiro Carnaval parade competition in Brazil. The fantastic colors, intricate detail, and mix of real and imaginary elements on the float, combined with Jorge Saenz's brilliant framing of the scene, make his photograph look like a cross between a Hieronymus Bosch painting and a psychedelic-era album cover. How many months of work went into conceiving, constructing, and operating that amazing float?

Exactly when and where human beings began congregating in public to celebrate as a group is unknown and unknowable. Logic suggests that the first public celebrations were existential and probably spiritual in nature and did not involve giant hummingbirds. In hunter-gatherer societies, success in the never ending search for food, clothing, and shelter must have triggered some collective, celebratory impulse.

A hunt producing abundant meat and skins; a bountiful harvest supplying a winter's worth of nuts, berries, or grains; or the discovery of an easily defended dwelling place were all events that ensured a group's survival and well-being. The earliest parades may have been of hunters laden with game returning to a joyful welcome by their thankful families.

As civilizations developed, with agriculture, permanent settlements, trade, sociopolitical structures, organized religions, calendars, and recordkeeping, such celebrations became more regular and formal and served broader social purposes.

There are records of religious parades and processions dating back to 3000 B.C. Parades were also used, as they still are today, to demonstrate military might and celebrate military victories; to lure paying customers to events such as the circus, by giving the public a sampling of the entertainment; and to celebrate ethnic affiliation and religious and secular holidays.

An editorial in the *New York Times* published on October 28, 1917, summarized the status of parades by saying, "If you take the parades out of history you have precious little history left. The instinct to form processions and to partake

> to paraphrase inventor Thomas Alva Edison's famed comment on genius, often appear to be 1% inspiration and 99% preparation.

STEVE FORREST | London, England | 2007. A procession during the Notting Hill Carnival

of ceremonies is the most persistent characteristic of human beings, of whatever century or degree of civilization."

Parades and other public celebrations have also become important economic events in many places around the world. At the Kansas State Fair in Hutchinson, where Joel Sartore's photograph makes the carnival rides spin like neon dervishes, or at the monthlong Kumbh Mela festival in India, money is being made.

In some places, the commercial aspect has eclipsed the original reason for the celebration. Carnival celebrations in Venice, Italy, date back to the late 13th century, when the Senate of the Venetian Republic declared the day before Lent a public holiday. The official celebrations, which were held in large, public spaces such as the Piazza San Marco, and the unofficial celebrations, which went on all over the city and often involved masked revelers drinking, dancing, and engaging in licentious behavior, grew and flourished for the next five centuries. Shortly after the republic fell to Austria in 1797, however, Carnival ceased. The city's occupiers banned it for much of the 19th century. Although it returned in various iterations over the ensuing decades, the celebration was a tepid reprise of its former glory.

In the current version of Carnival, hundreds of thousands of visitors flock to Venice. Most of the city's inhabitants avoid the official celebrations, as well as the unofficial festivities in the campos, canals, sidewalks, and bridges, all choked by hordes of tourists whose purchases of meals, lodgings, and Carnival masks pump great sums of money into the economy of the city and the region.

One cannot blame the tourists. They are drawn by Venice's unique and undeniable magic. Sam Abell's photograph captures the yin and yang of commercialism and tradition that powers many public celebrations. In it, two costumed and masked Carnival participants float like exquisite, white specters in front of the Doge's Palace, just ahead of a woman in a pink winter jacket, wearing a camera around her neck, who appears thoroughly unimpressed by the Carnival couple.

For commercialization of celebration, it is hard to beat the United States. As Calvin Coolidge, the 30th President of the United States, once said, "The business of America is business." Celebrating in American can be big business.

Christmas is the classic example. The Christian world has been celebrating Christ's birth in Bethlehem for more than 2,000 years, albeit at varying dates depending on the denomination. Countless books have been written about Christmas traditions around the world, and how the holiday's religious significance has become mixed over the centuries with what were originally pagan symbols, such as the brilliantly lit Christmas tree in New York's Rockefeller Center.

The Christmas season is also a shopping orgy. For millions of Americans, that season begins on Thanksgiving Day and is kicked off by the Macy's Thanksgiving Day Parade in New York City. The parade began in 1927 and was organized by and filled with employees from Macy's, the huge New York department store. Many of the employees were from Europe and wanted to re-create the kind of procession that was held on religious holidays in their countries of origin.

The parade's popularity exploded with the advent and subsequent spread of television after World War II. Thanks to TV, the Macy's parade is now arguably the most famous in America. One of my earliest Thanksgiving memories is sitting in front of a black-and-white set with my older sister, watching the parade's marching bands, floats, and giant balloons; we were hardly able to contain ourselves as we waited for a glimpse of Santa Claus, who traditionally rides at the very end of the procession.

Burt Glinn had a different take on the parade. Glinn, who passed away in 2008, was a stalwart of the Magnum photo agency and possessed the ability to move easily between photojournalism and commercial photography. He had an exceptional eye for detail and a dry, insidious sense of humor that appears in some of his pictures. Glinn described his approach to photography by saying, "I think that what you've got to do is discover the essential truth about the situation, and have a point of view about it."

That approach can be seen in his photograph of kids on a balcony of a building on Central Park West, looking down on the Macy's parade of 1992. Glinn's vertigo-inducing shot has remarkable depth of field, thanks to a phalanx of buildings across the park and the street running from the foreground to a vanishing point near the top of the picture plane. The elevated viewpoint also makes the massive parade and the giant dog seem smaller than they

do on television. The picture catches the excitement the parade generates in kids, but also makes it seem slightly out of step with reality.

Billions of dollars are spent on gifts, food, beverages, and travel between Christmas and Thanksgiving, but both holidays still retain their spiritual resonance. They also are prime examples of mass celebrations that take place largely in the private realm, with families, friends, and neighbors gathering to share the holiday and to celebrate according to their own beliefs and traditions.

Religious services are celebrated year-round in mosques, synagogues, temples, cathedrals, churches, and homes all over the world. Pilgrimages take place annually in Asia, Europe, the Middle East and South America. The hajj, the pilgrimage to Mecca made by Muslims, is the world's largest annual pilgrimage, made by three million people each year. Reza's photograph of thousands of worshippers filling Mecca's Al-Haram mosque, built around the Kaabah, the building that sets the Muslim direction of prayer, gives a powerful sense of the sheer size and the constant motion of the hajj.

Other collective celebrations are secular in nature. People around the world greet the New Year with champagne, fireworks, music, and noisemakers, just as they are doing in Mark Power's picture of a crowd in Warsaw, Poland, in 1989.

In the Internet era, cell phoning, texting, tweeting, emailing, and other forms of quick communication make it possible for people to organize celebrations almost instantly. Gerd Ludwig caught one such event in Moscow in 2007. While the city was holding the Moscow Zorya, a series of international military band performances on Red Square, young people used the Internet to organize a "flash mob" kissing event on the adjacent Manezhnaya Square. An announcement was posted and hundreds of young people gathered, either as kissing couples, or as individuals holding signs saying they were seeking a kissing partner.

Such spontaneous celebrations were rare in the past. When they did occur, they were often set off by news reports about the end of a war, or some team's sports triumph. But celebration is a much more fluid thing now than it was in the past. Where survival was once the prime motivation for celebration, as was the case with harvest festivals, people gather now to celebrate their shared pursuits, pastimes, and passions. I don't share the willingness of members of the Coney Island Polar Bear Club to dash into the icy waters of the Atlantic Ocean in the middle of winter, but I admire their passion.

Szilard Koszticsak's photograph of cyclists holding their bikes aloft during a demonstration called Critical Mass, which was held in a park in Budapest, Hungary, on European Car Free Day in 2007, is remarkable on many levels. As documentation, the photo testifies to the commitment and passion of the celebration's organizers and participants. On an aesthetic level, it is a work of art that calls to mind Canadian photographer Edward Burtynsky's large-scale photographs of junkyards, and, looking at the upper third of the picture plane, Jackson Pollack's drip paintings. You cannot ask for much more from a photograph or a photographer.

The level of civic engagement Koszticsak caught with his camera is a reminder of the time and effort people around the world devote to celebrating, whether it is with family and friends at home or with tens of thousands of people jammed into a square or stadium for a rally.

That effort is not so apparent in one of the photographs I keep returning to in this chapter. It is B. Anthony Stewart's color shot of the Mayflower II, an exact copy of the 17th-century ship that brought the Pilgrims to America, entering New York Harbor on its maiden voyage in 1957. The vessel was built in England as a symbol of friendship and wartime cooperation between the United States and Britain. Its construction was financed by private donations in Britain and funding provided by Plimouth Plantation, an American museum that still owns it. When it arrived in New York, the captain and crew were welcomed with a ticker tape parade.

What intrigues me is the almost surreal, time-shifted quality of the photograph. In our era, getting the Pilgrims, the Mayflower, powerboats, a Navy blimp, and the New York skyline and harbor in one image can be done with a computer. To do that in the 1950s, Stewart had to be in the right place at the right time, know what he was doing, and have some luck. He was and he did. The picture is a tribute to the time, money, and effort it took to create, sail, and celebrate the ship. It is also a tribute to the magic of photography. ∎

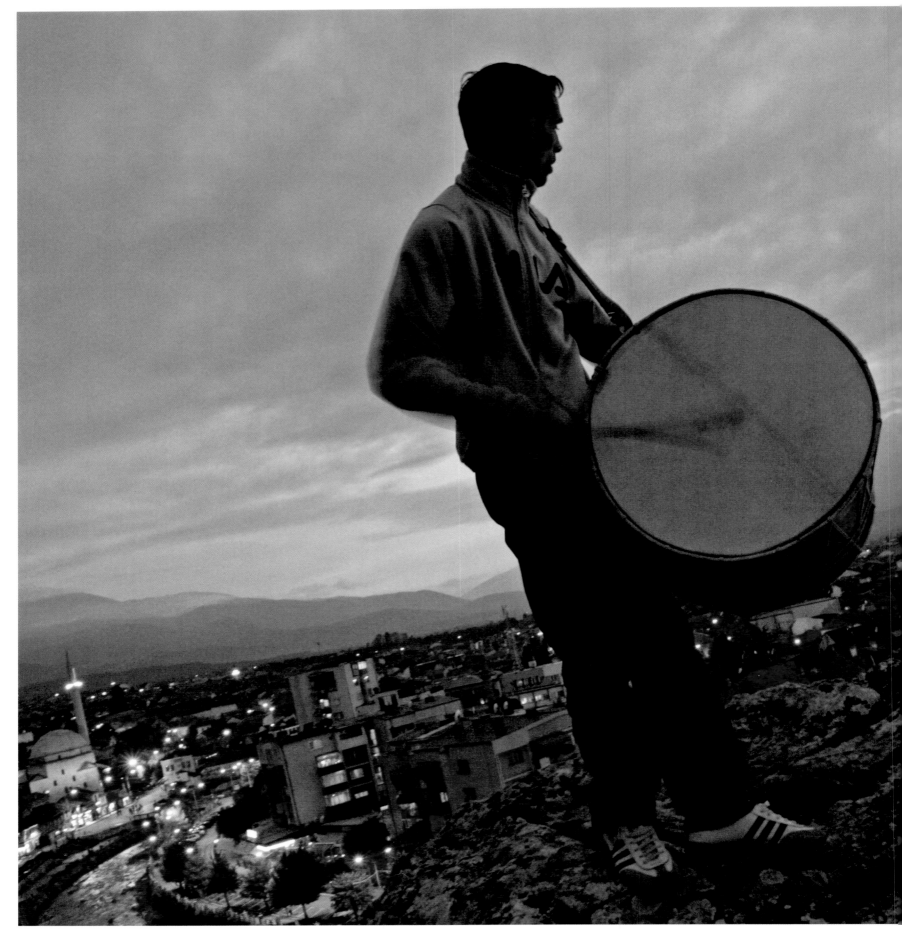

That is solemn we have ended,—
Be it but a play,
Or a glee among the garrets,
Or a holiday.

—EMILY DICKINSON

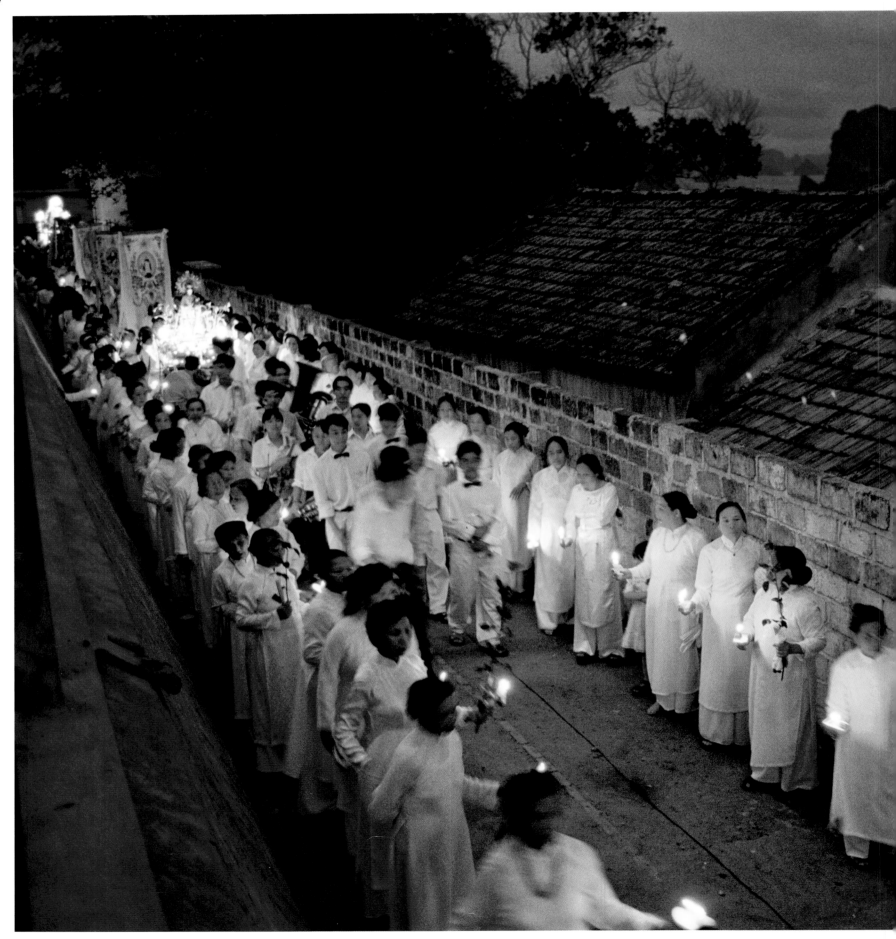

PREVIOUS PAGES: RHODRI JONES I Prizren, Kosovo I 2006.
A Roma signals the end of fasting during Ramadan.

JOHN VINK I Hong Gai, Vietnam I 2000.
An Easter procession makes its way to the Catholic Church.

ABOVE AND OPPOSITE: STEPHANE REMAEL | Loches, France | 2003.
Children hunt for eggs during the Easter season.

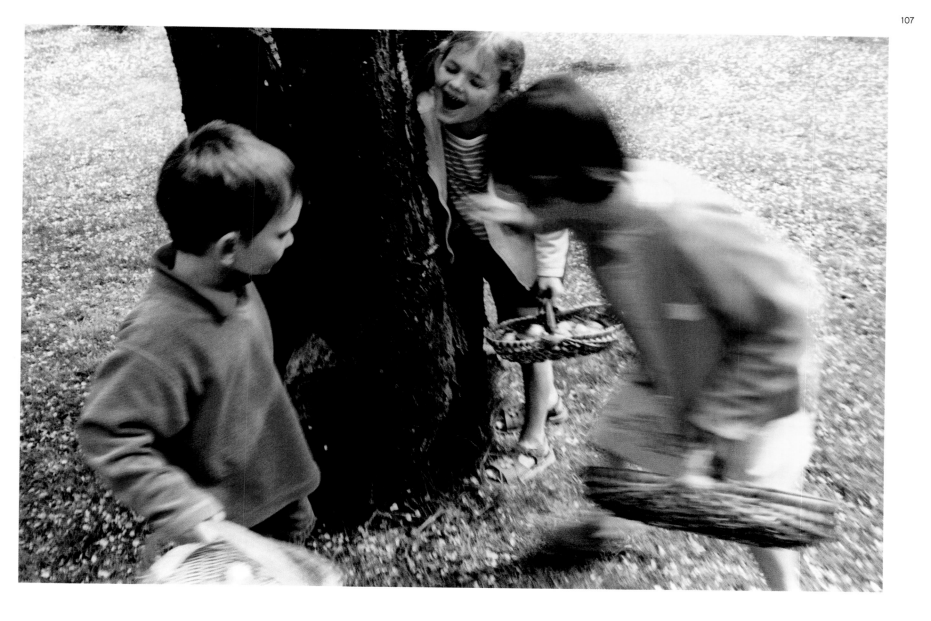

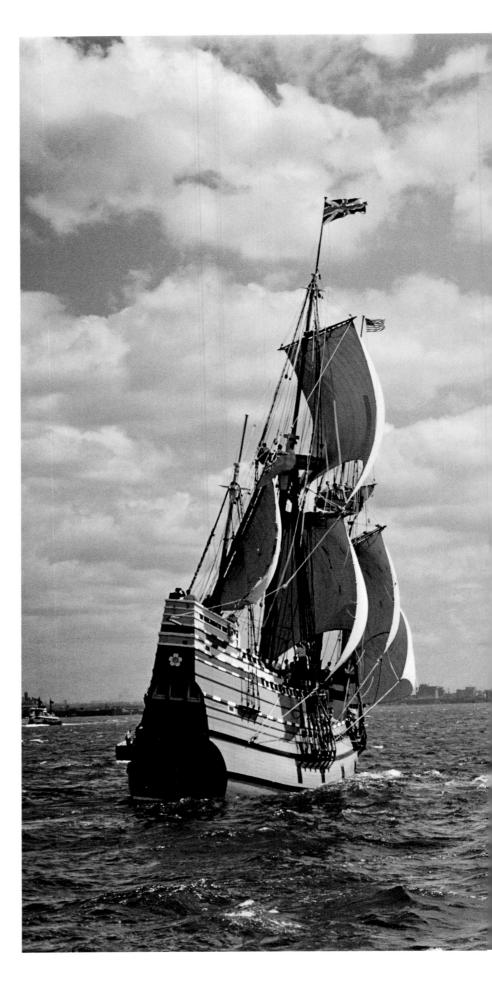

B. ANTHONY STEWART | New York Harbor, New York | 1957.
The *Mayflower II* enters the harbor escorted by yachts and a blimp.

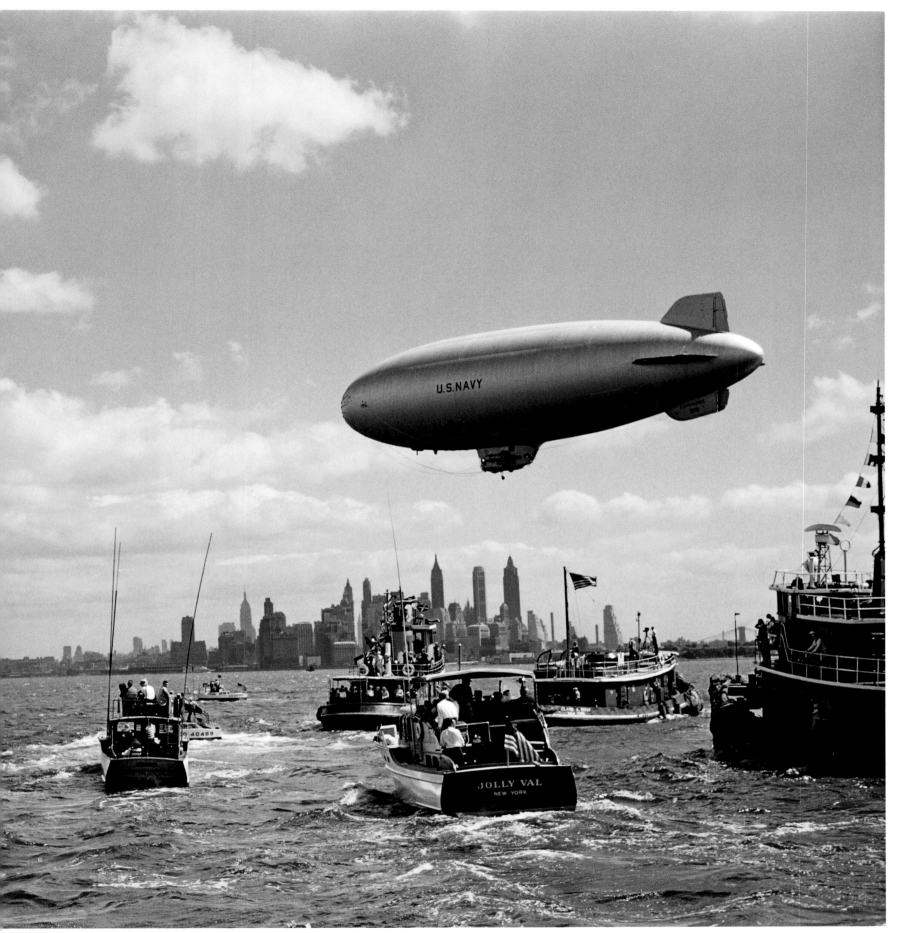

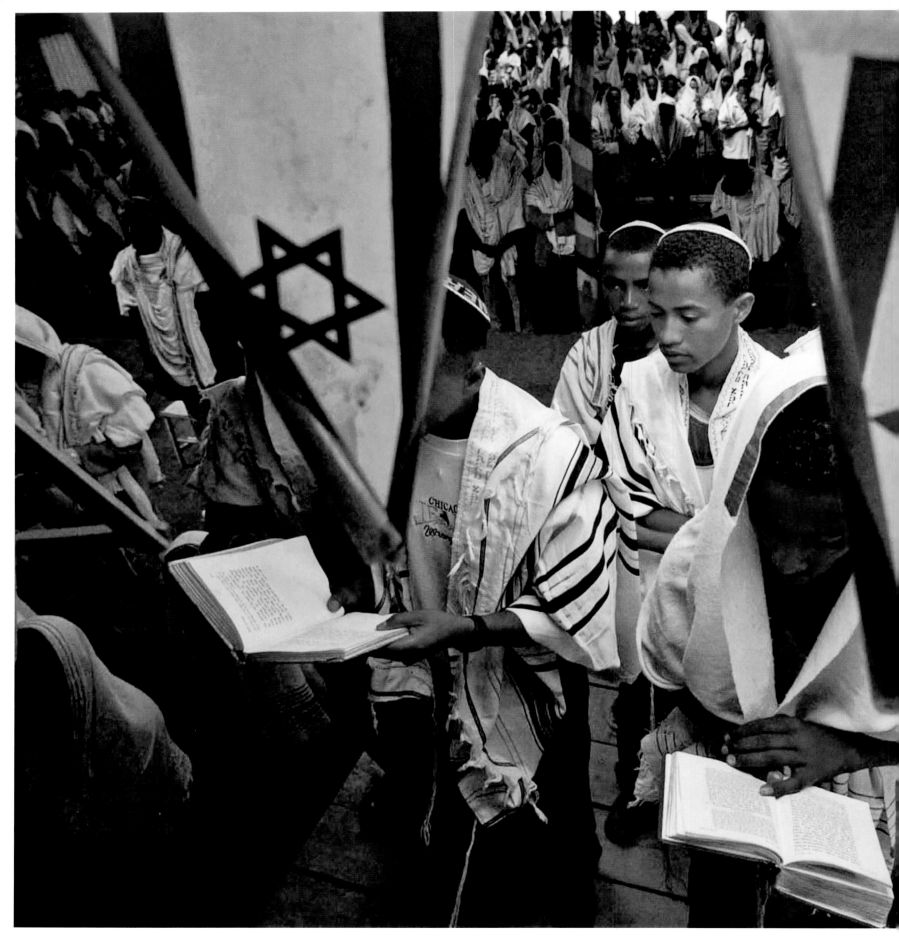

VANESSA VICK | Addis Ababa, Ethiopia | 2005.
Ethiopian Jews observe the holiday of Shabuoth.

FOLLOWING PAGES: STEPHANIE DIANI | Santa Monica, California | 2004.
Labor Day crowds play in the low waves.

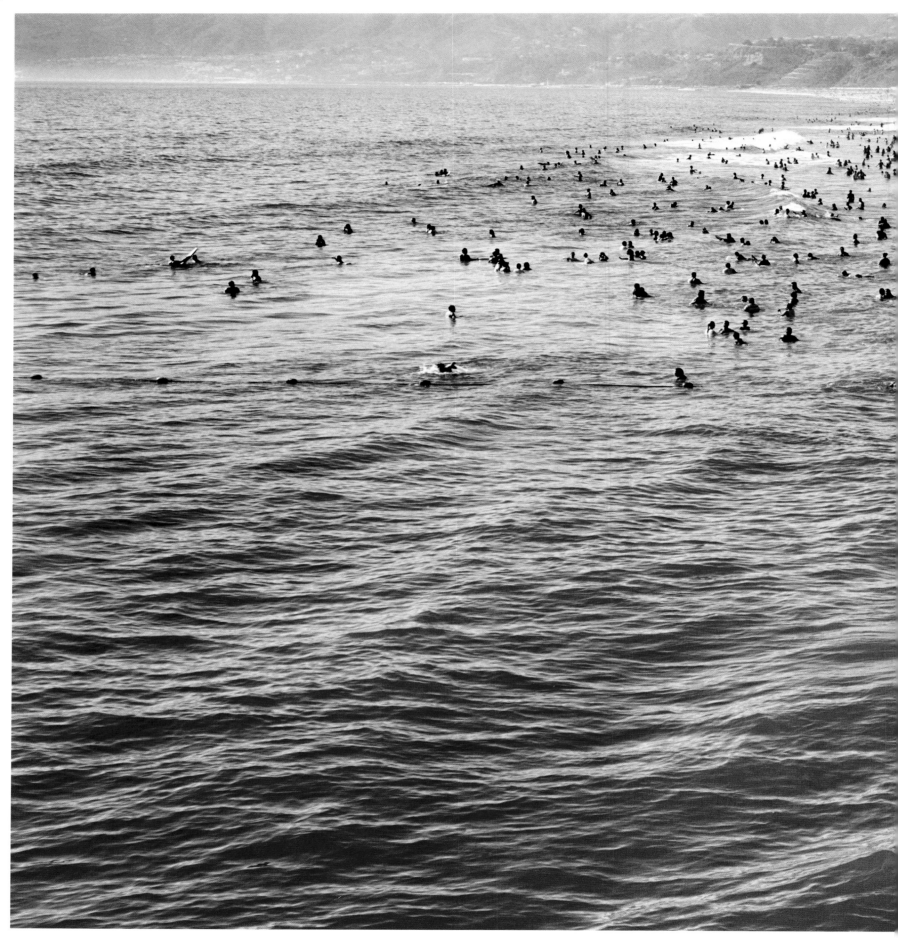

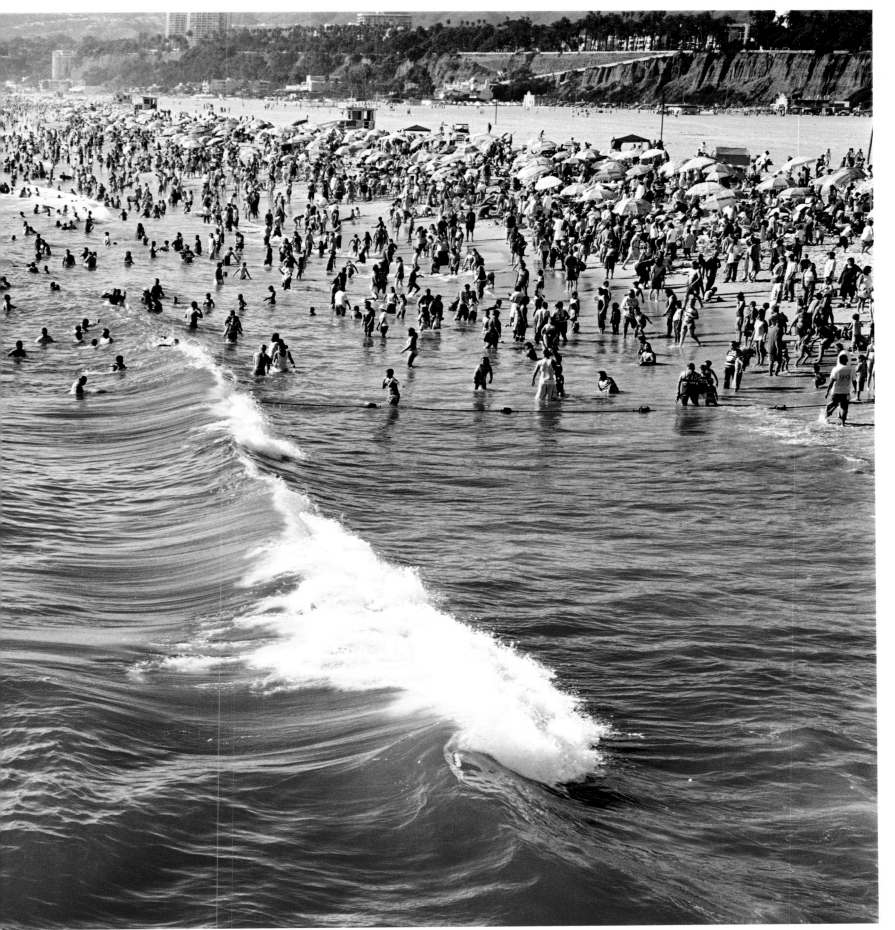

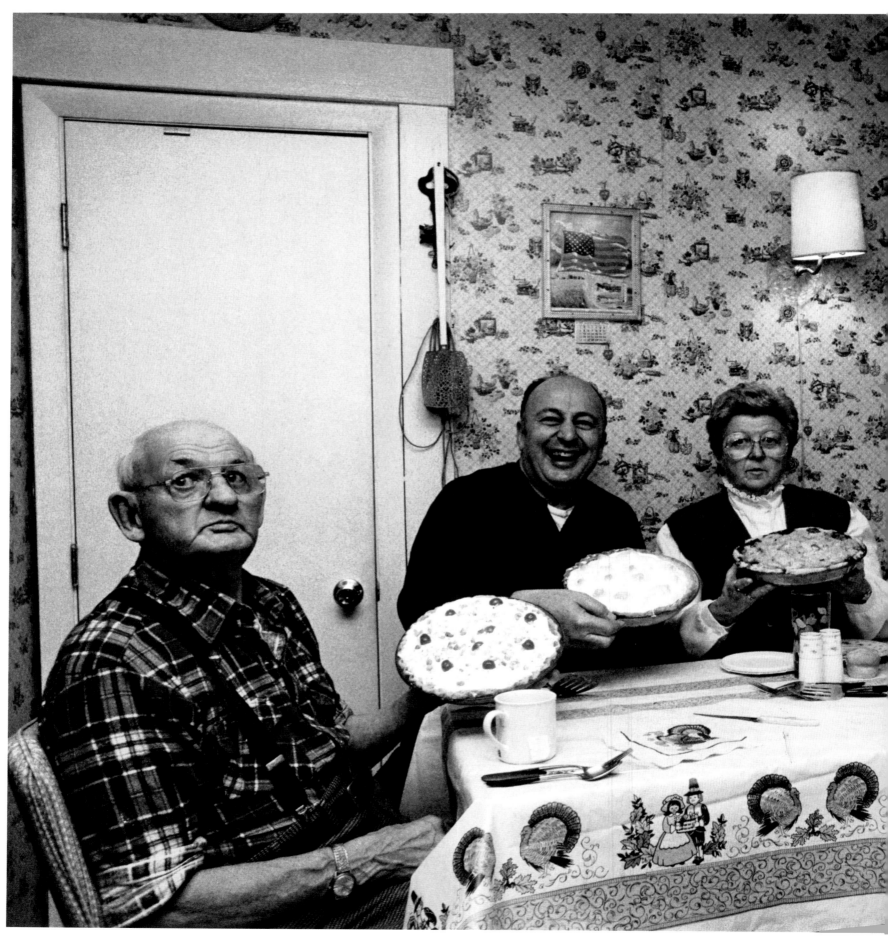

DAVID GOODMAN | Lebanon, New Hampshire | 1985.
A photographer's family shows off their Thanksgiving Day pies.

HOLLY WILMETH | Woodstock, New York | 2004.
Kids in costume gather for the local Halloween parade.

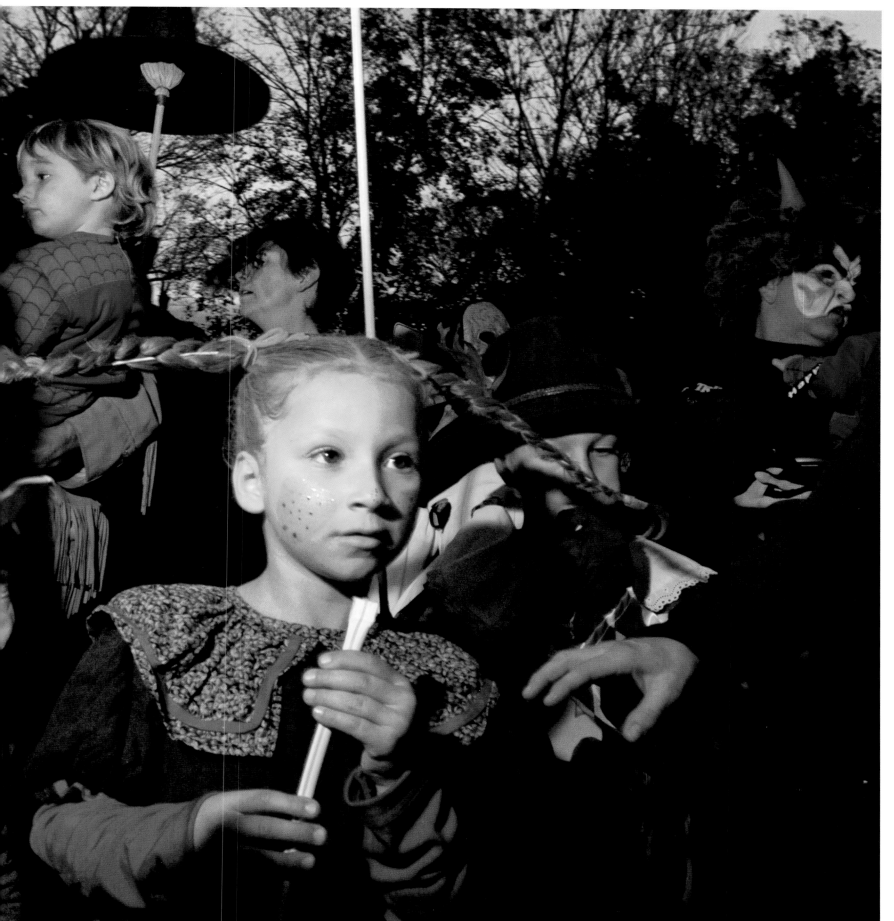

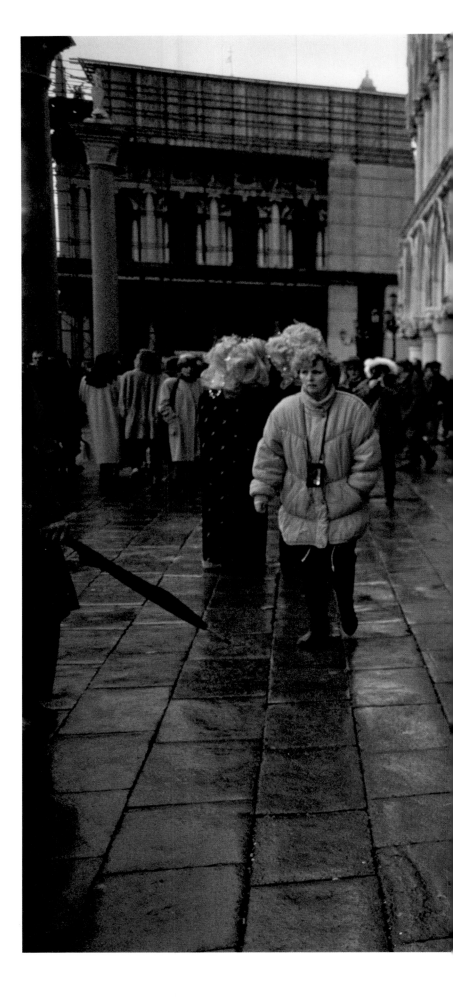

SAM ABELL I Venice, Italy I 1995.
Easter Carnival participants in lavish costume

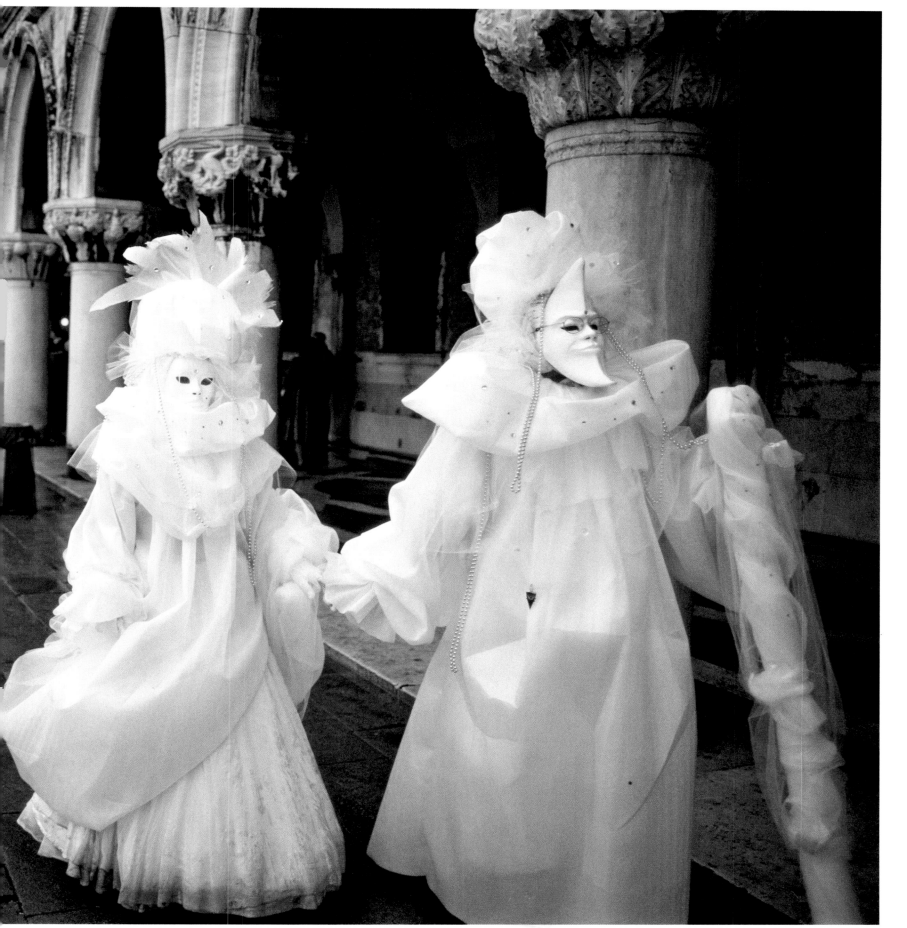

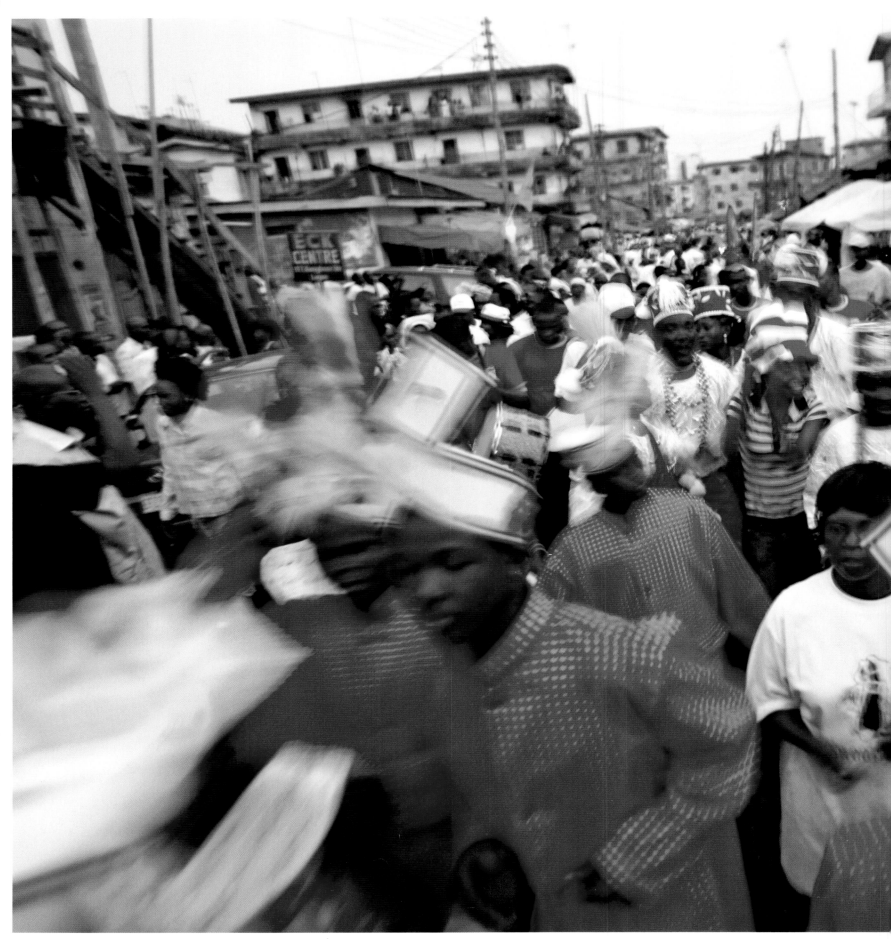

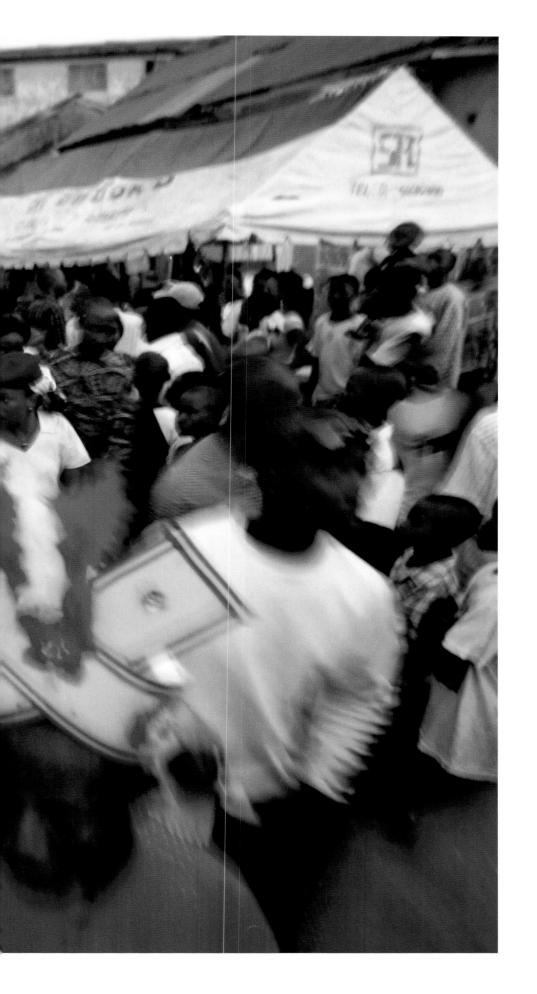

GEORGE OSODI I Lagos, Nigeria I 2008.
People congregate for Kwanzaa celebrations.

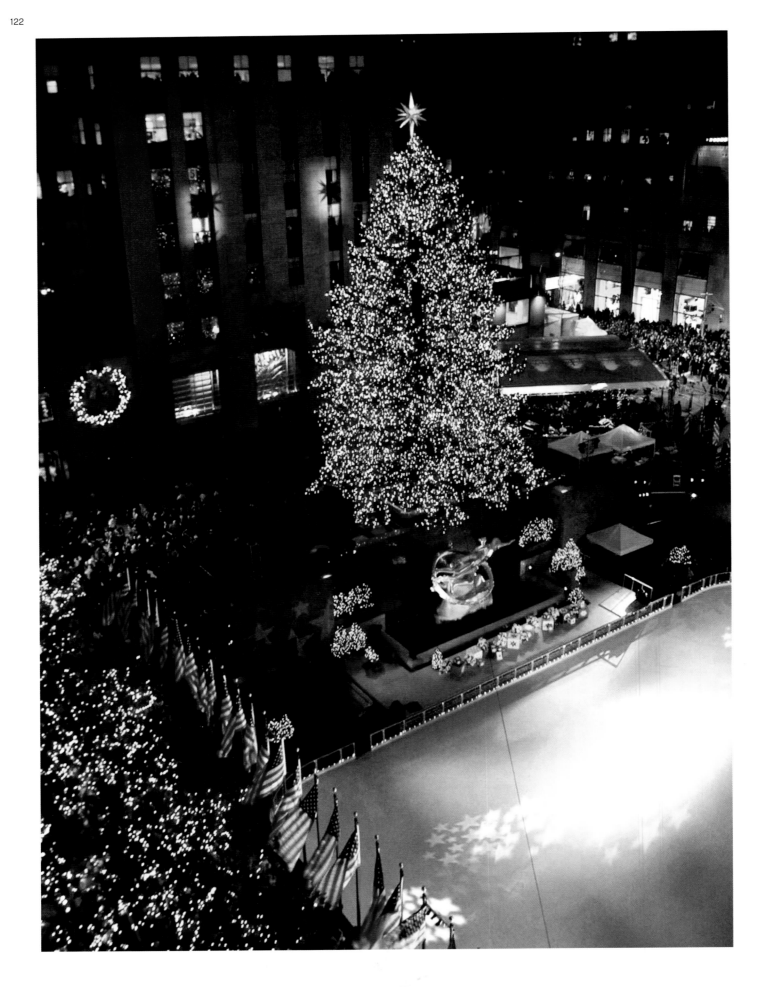

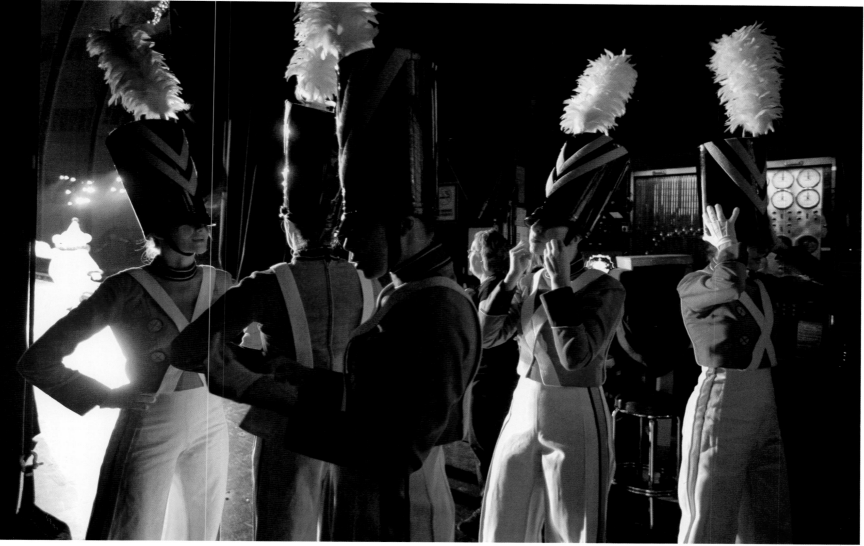

OPPOSITE: JAMES ESTRIN | New York City, New York | 2001.
An 81-foot Norway spruce is lit in Rockefeller Center during the annual tree lighting.

DAMON WINTER | New York City, New York | 2007.
The Rockettes prepare for a *Nutcracker* rehearsal at Radio City Music Hall.

FOLLOWING PAGES: JOEL SARTORE | Lincoln, Nebraska | 2006.
Children play amid discarded Christmas wrapping paper.

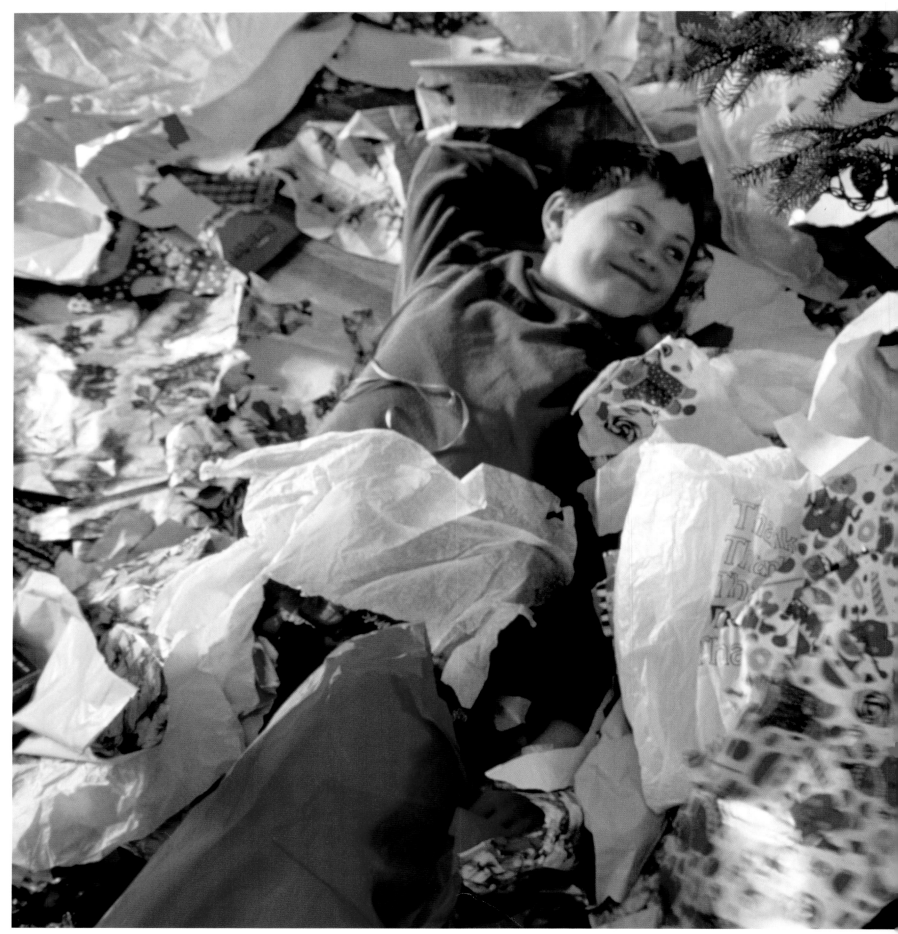

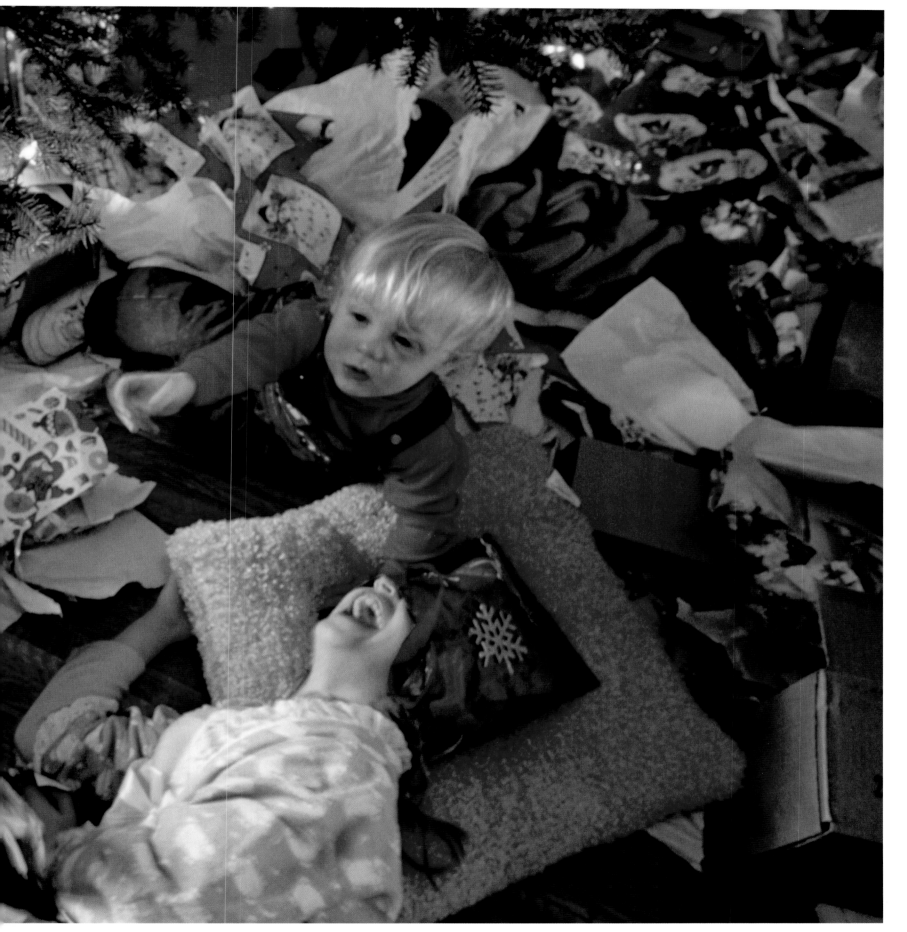

MARIA STENZEL I Lhasa, Tibet I 1999.
Pilgrims celebrate Losar, the Tibetan New Year, with prayer flags and paper.

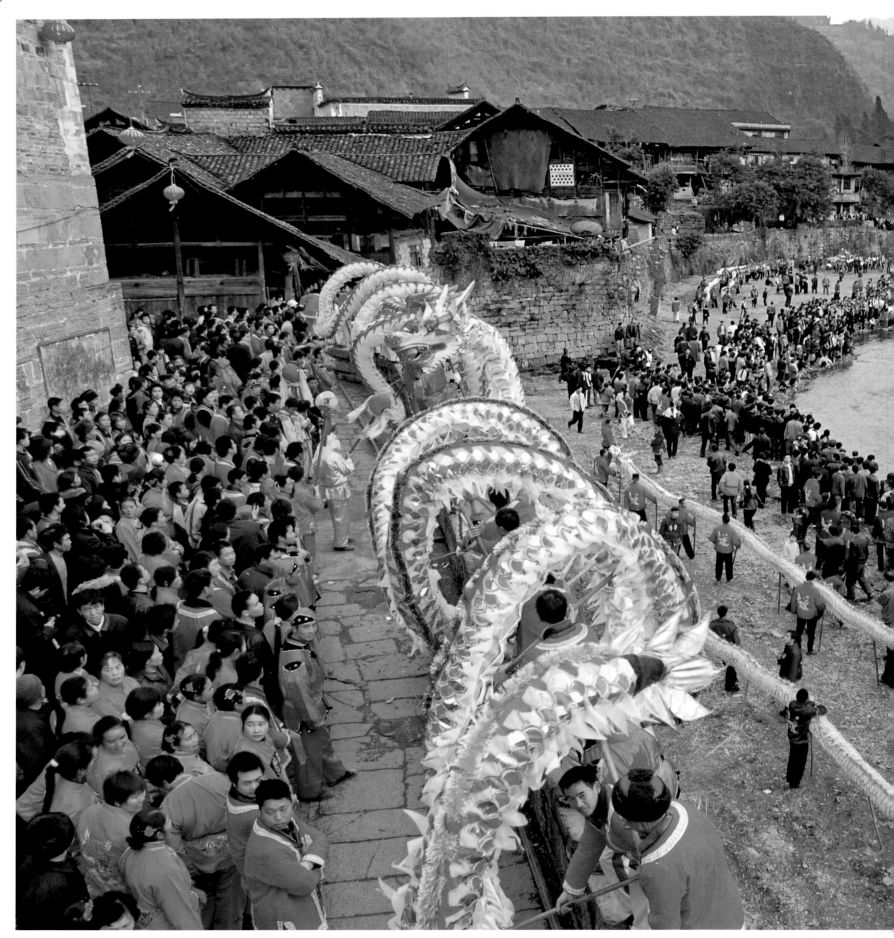

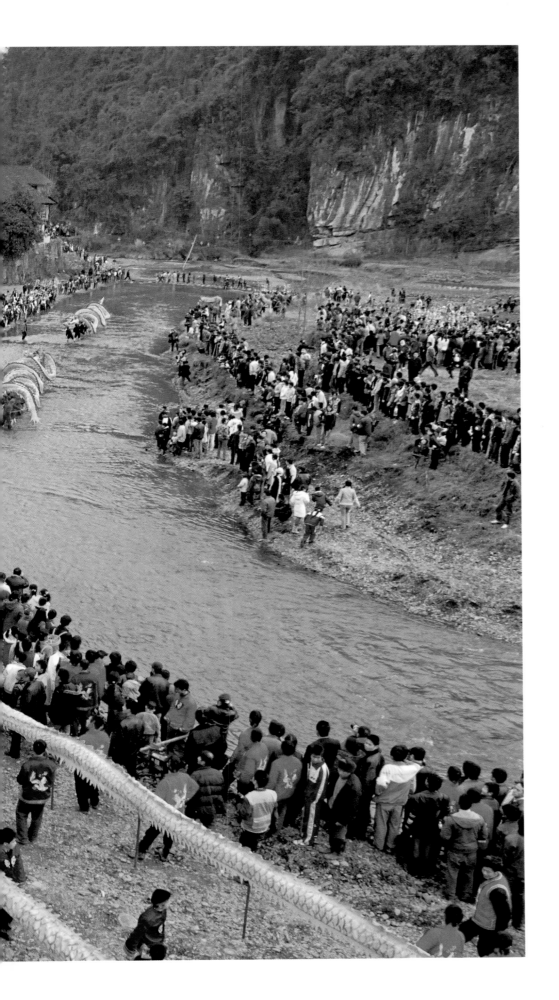

ZHANG TIANLIN | Guizhou, China | 2006.
Villagers perform a Dragon Dance in the ancient
Zhaiying Town to celebrate Spring Festival.

130

MARK POWER I Warsaw, Poland I 1989.
Crowds welcome the New Year with champagne and confetti.

FOLLOWING PAGES: ATES TUMER I Ankara, Turkey I 2008.
Girls perform in activities to mark National Sovereignty Day.

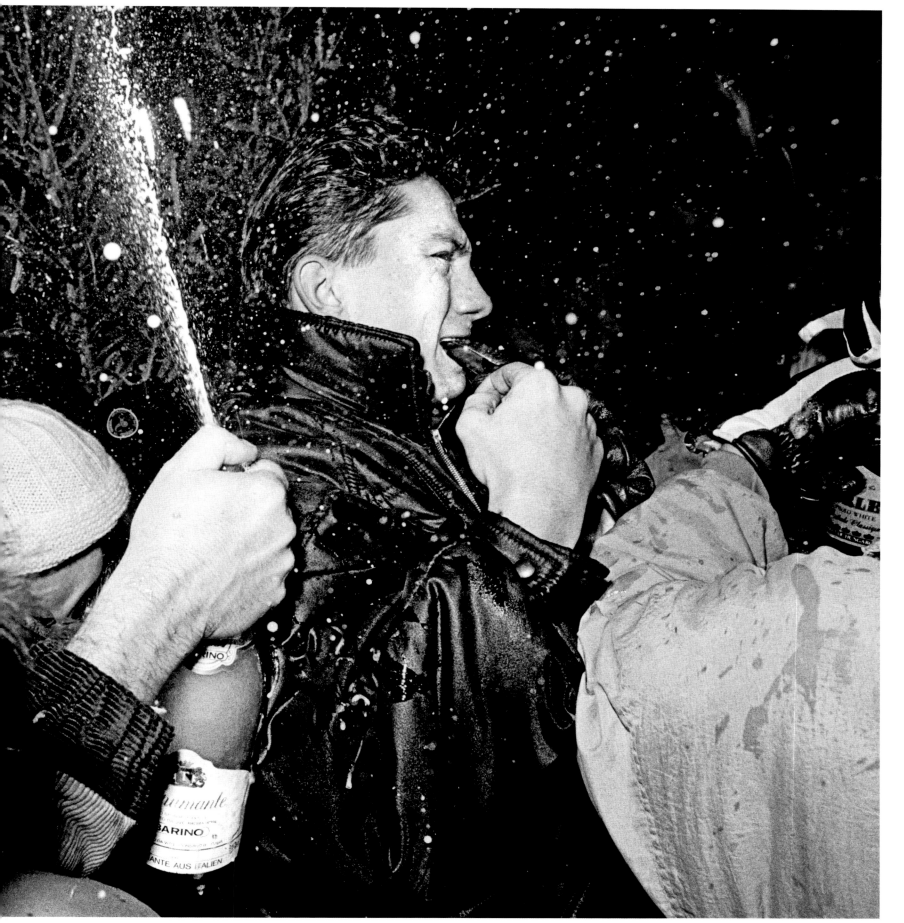

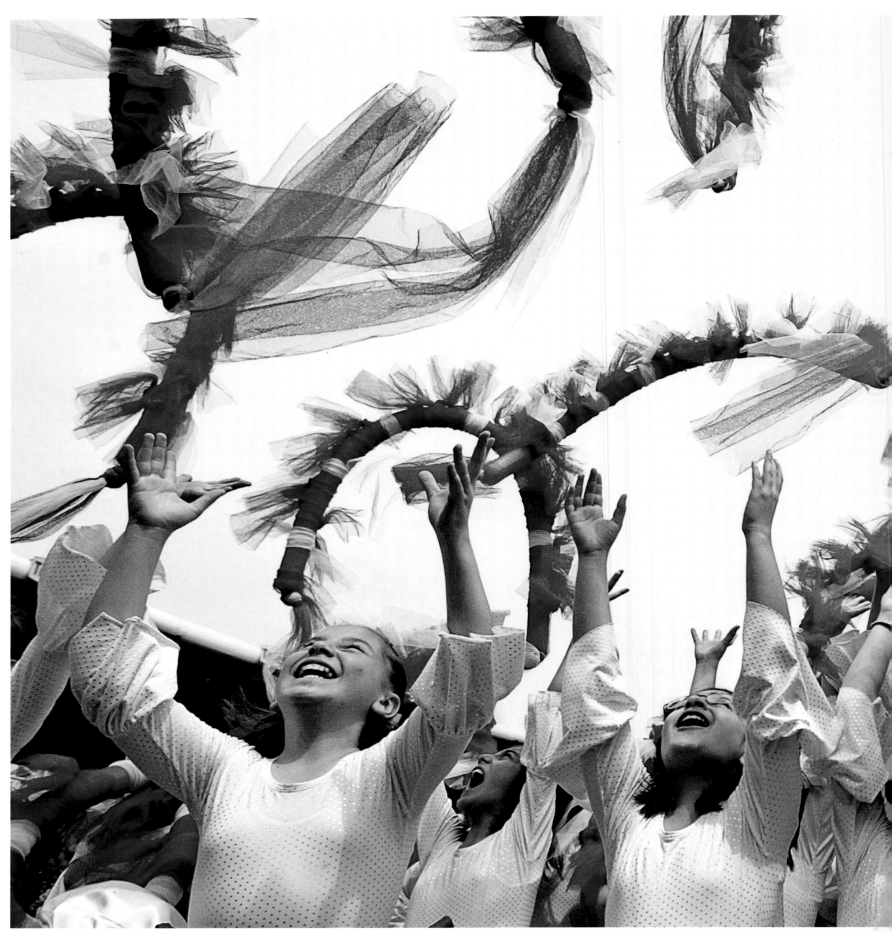

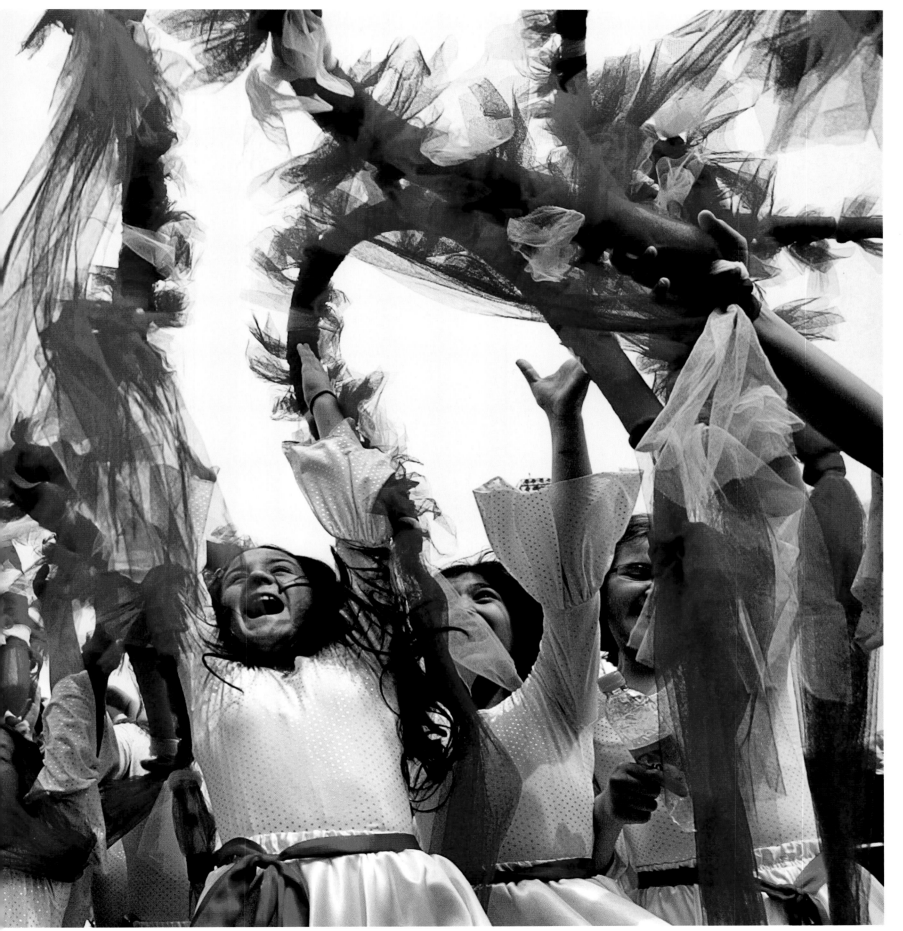

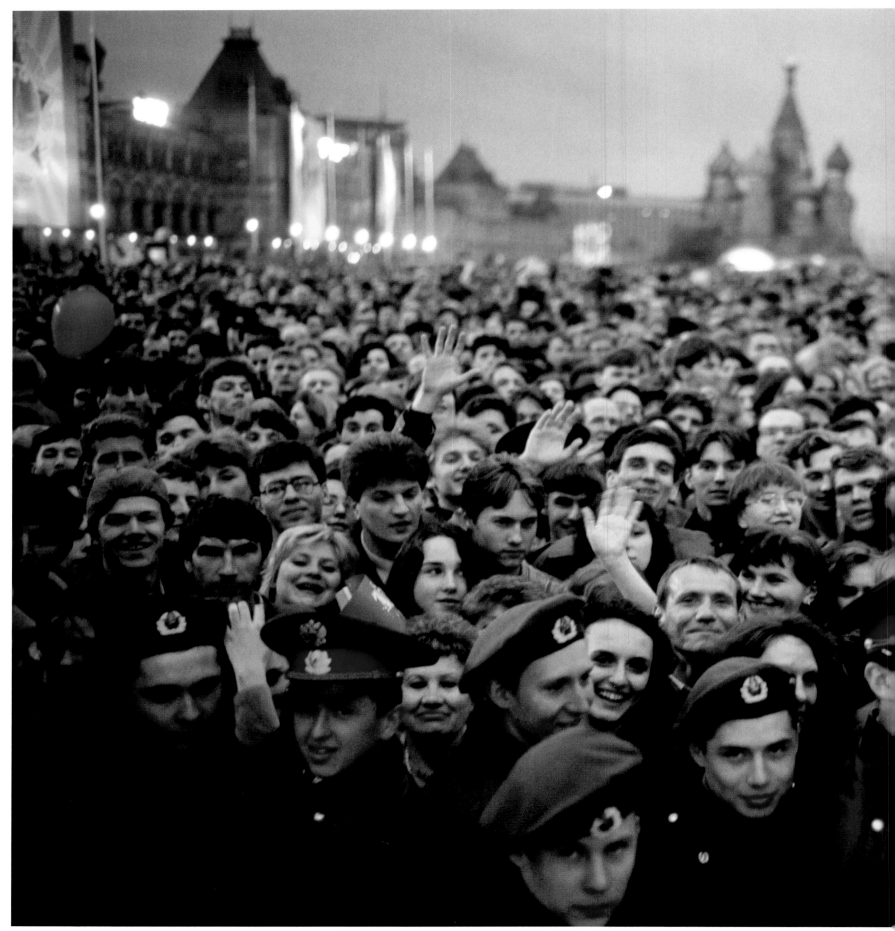

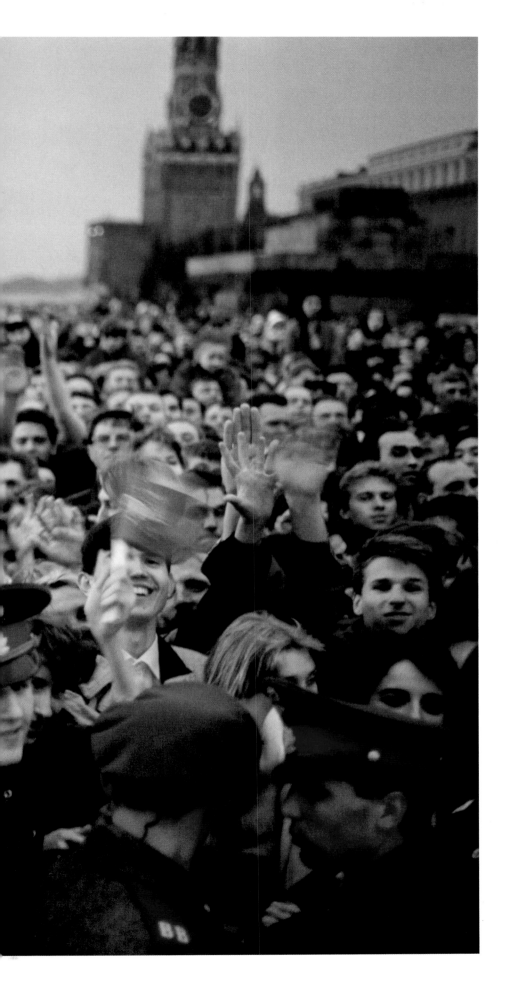

STUART FRANKLIN | Moscow, Russia | 1995. Red Square teems with people on the eve of the 50th anniversary of Victory in Europe Day.

I see, O year, in you, the vast terraqueous globe,
given, and giving all,
Europe to Asia, Africa join'd,
and they to the New World;
The lands, geographies, dancing before you,
holding a festival garland,
As brides and bridegrooms hand in hand.

—WALT WHITMAN

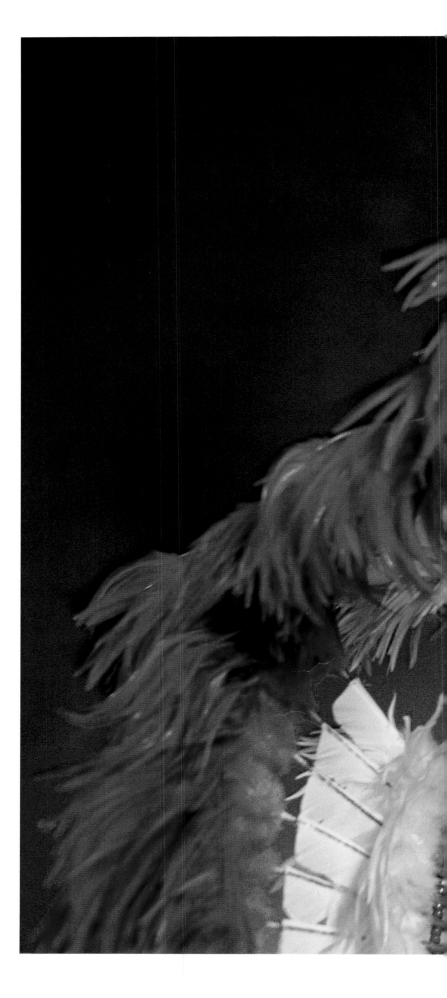

PREVIOUS PAGES: STUART FRANKLIN I Jaipur, India I 2000.
The sky explodes with kites during the annual Kite Festival.

DAN WESTERGREN I Annandale, Virginia I 1992.
A Lakota Sioux boy performs in a powwow.

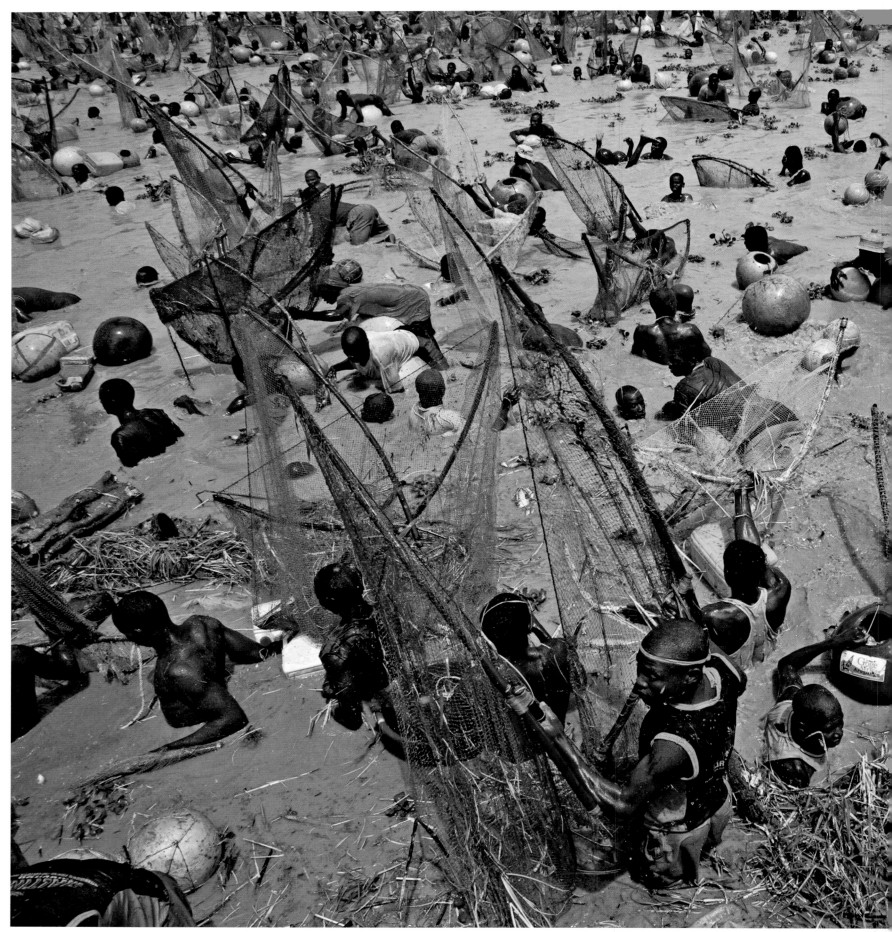

GEORGE OSODI I Argungu, Kebbi, Nigeria I 2008.
Fishermen comb the Matan Fada River during the Argungu Fishing Festival.

ROBB KENDRICK I Choguita, Chihuahua, Mexico I 2008.
Tarahumara Indians prepare for a pre-Easter ritual.

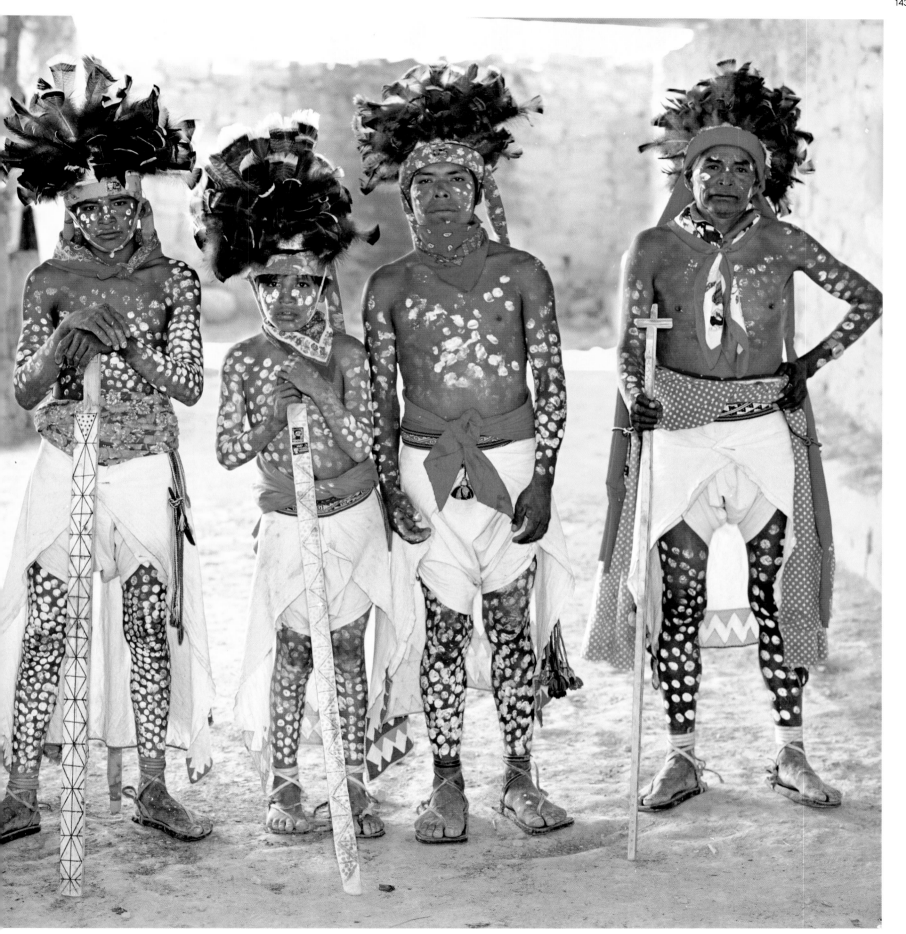

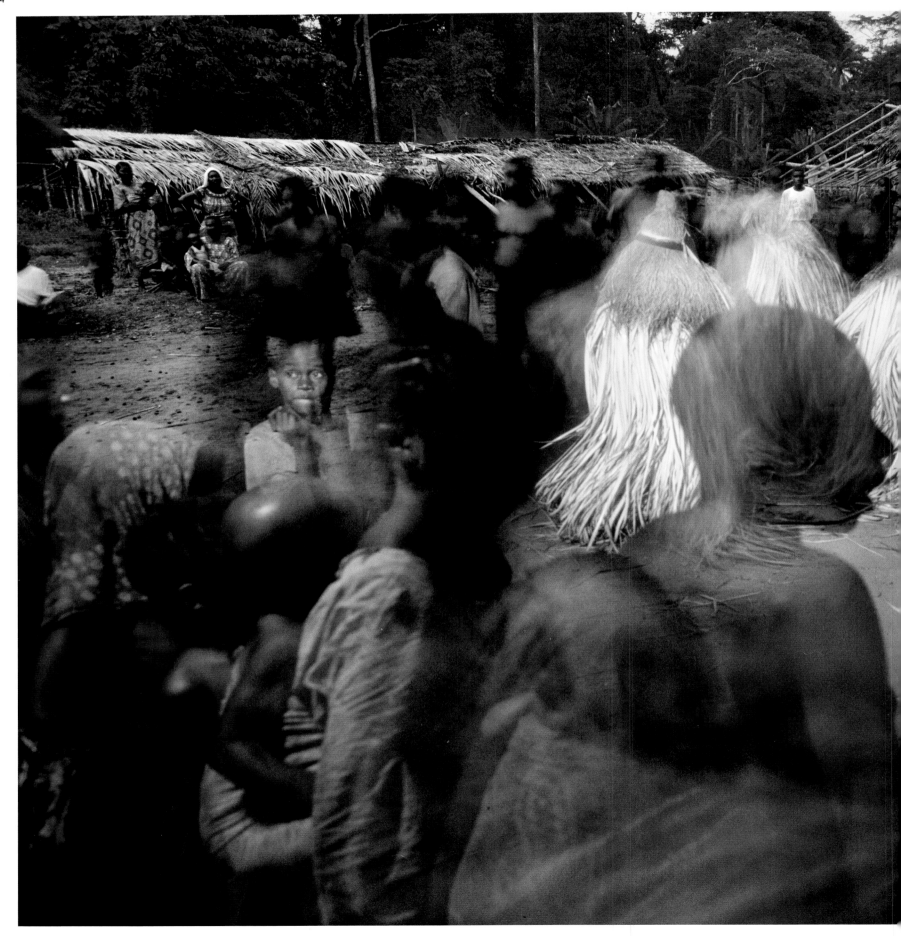

MICHAEL NICHOLS I Makao, Republic of the Congo I 1999.
Spectators watch a Bambendjelle tribal dance.
FOLLOWING PAGES: REZA I Mecca, Saudi Arabia I 2000.
Hundreds of worshippers gather around Masjid Al-Haram.

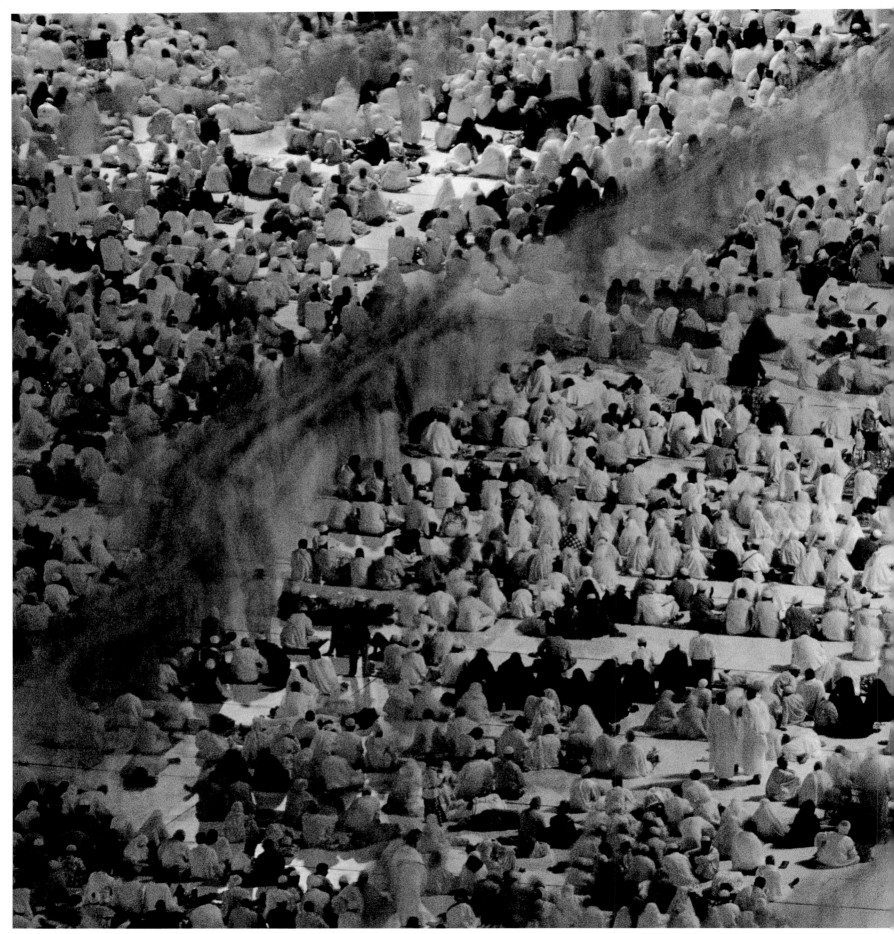

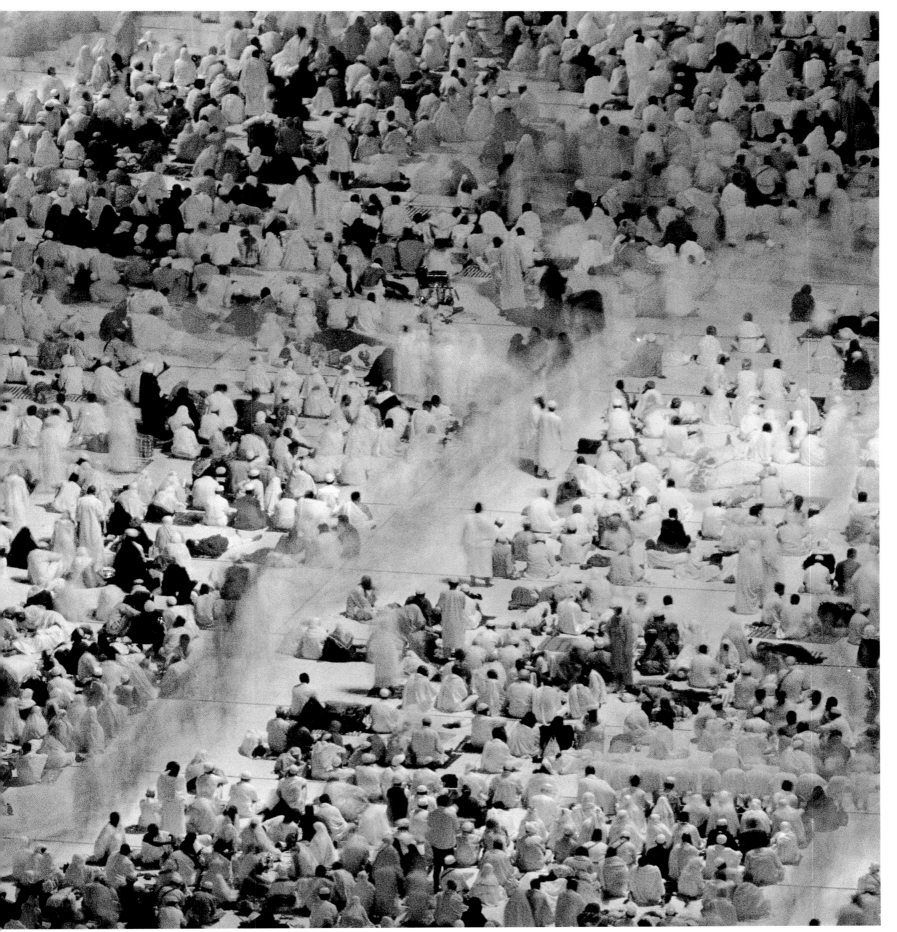

AMI VITALE | Trimbakeshwar, India | 2003.
A Hindu pilgrim at a shrine during Kumbh Mela festival

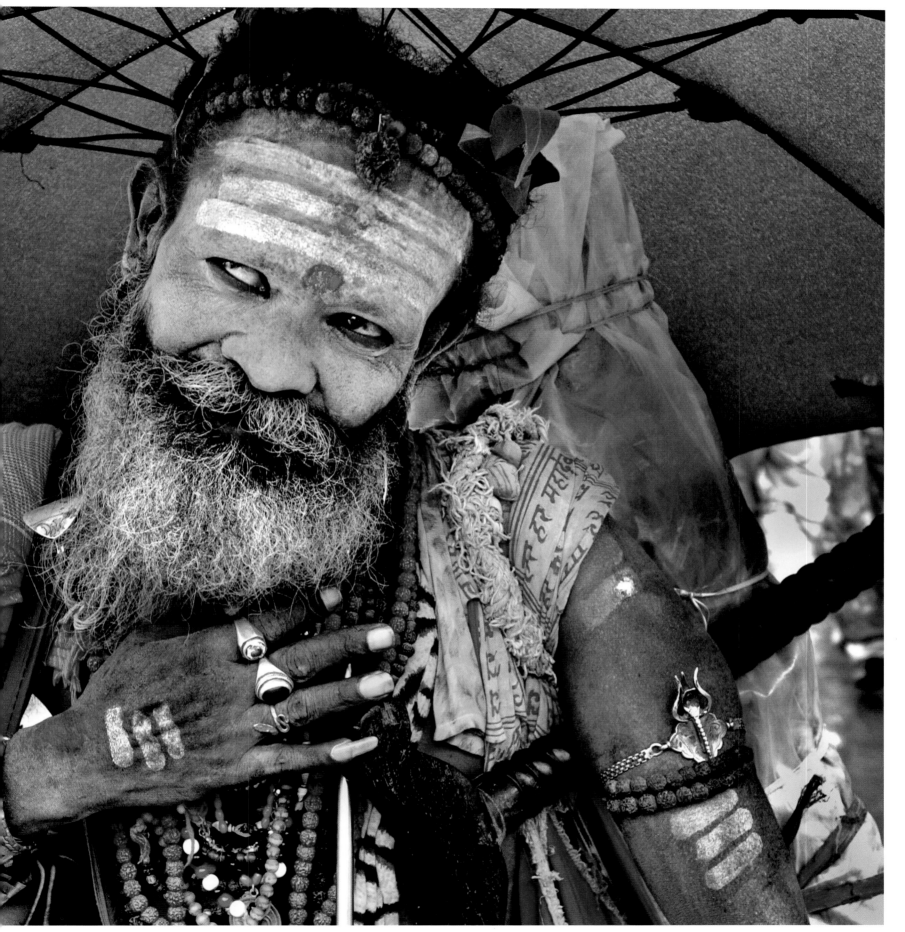

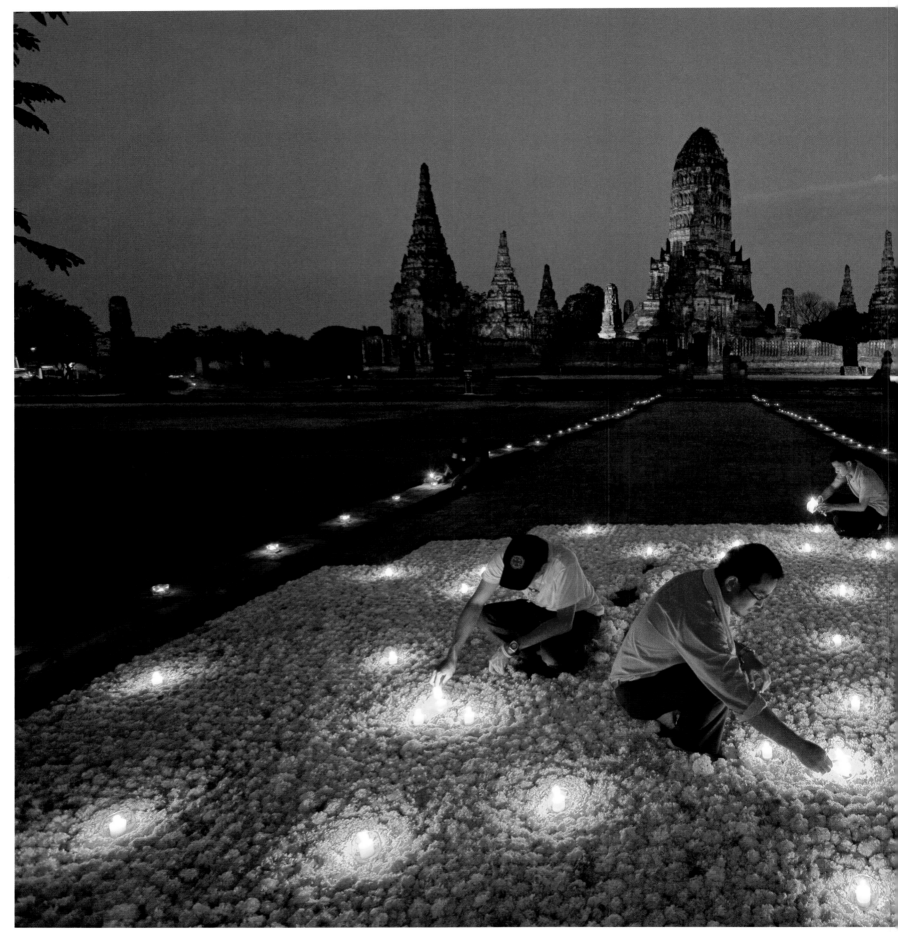

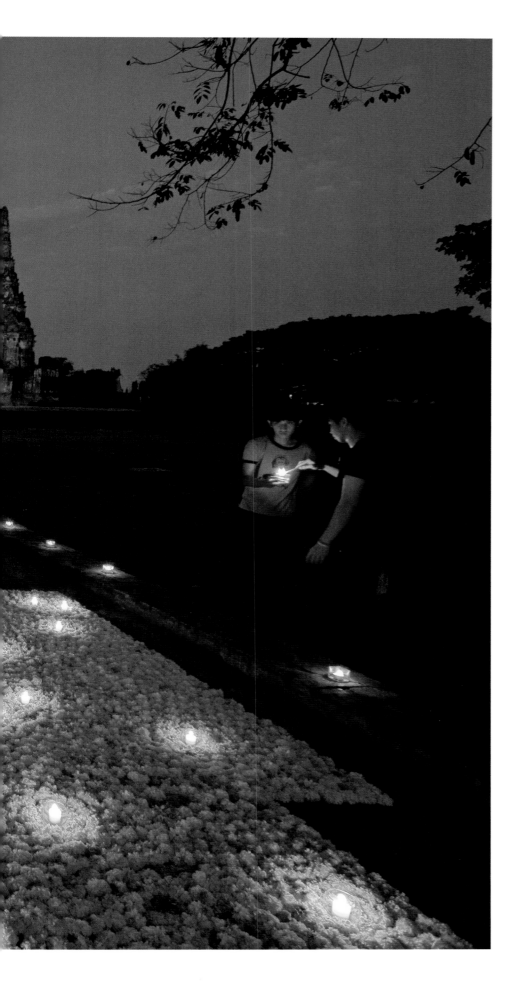

CATHERINE KARNOW | Bangkok, Thailand | 2007.
At Ayutthaya temple, a Thai flower designer creates an installation
that pays homage to one of Thailand's most treasured temples.

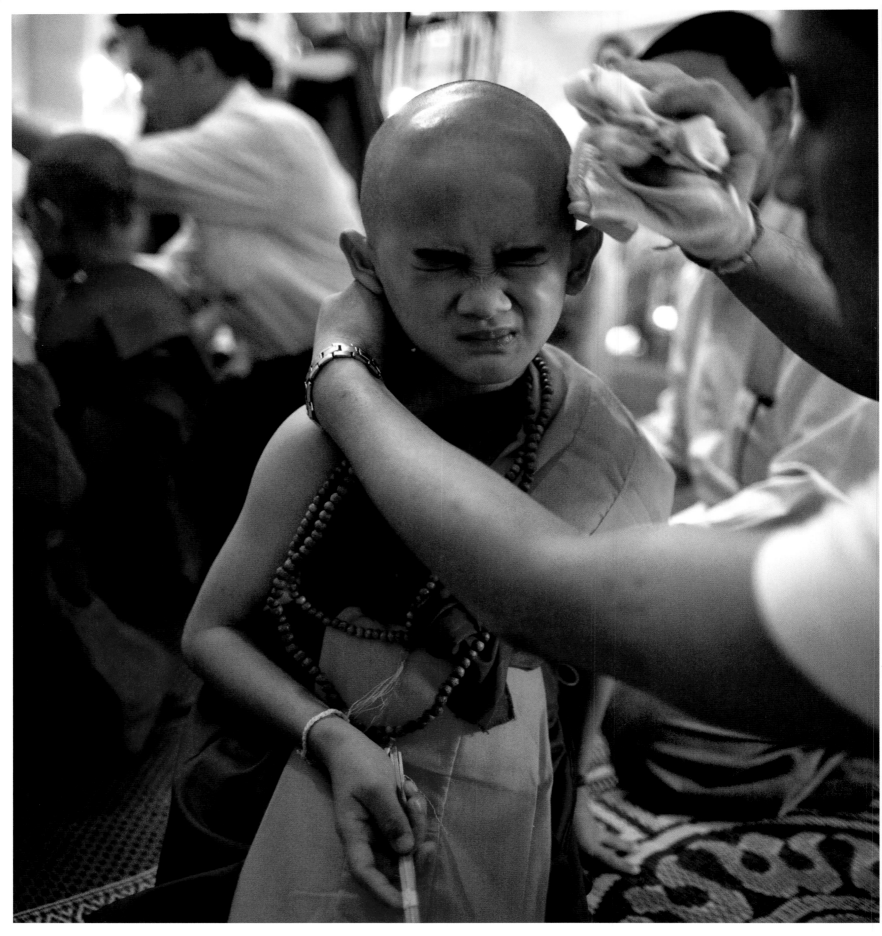

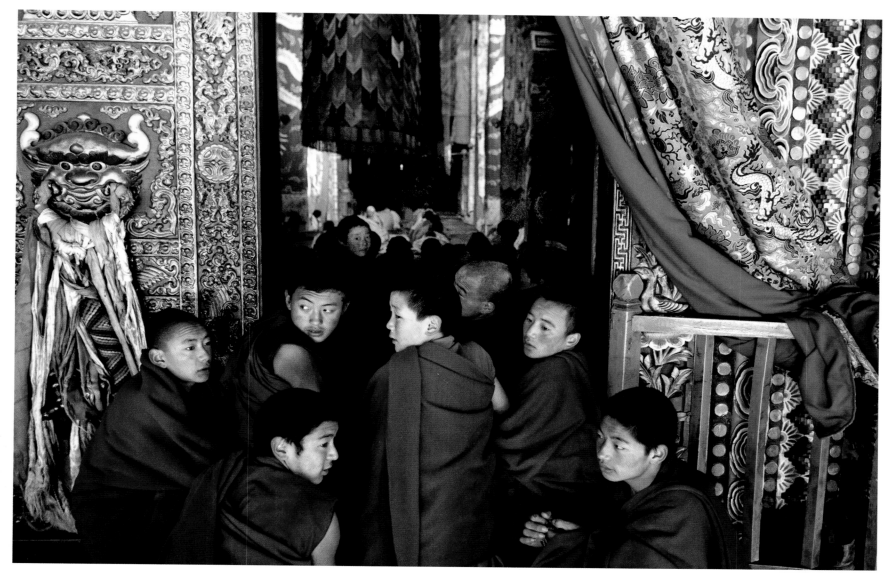

OPPOSITE: PAULA BRONSTEIN | Tachilek, Myanmar (Burma) | 2009.
A boy's makeup is removed after a Buddhist novice ordination ceremony.

GILLES SABRIÉ | Sichuan, China | 2008.
Young monks gather to celebrate Sojong festival at Kirti monastery.

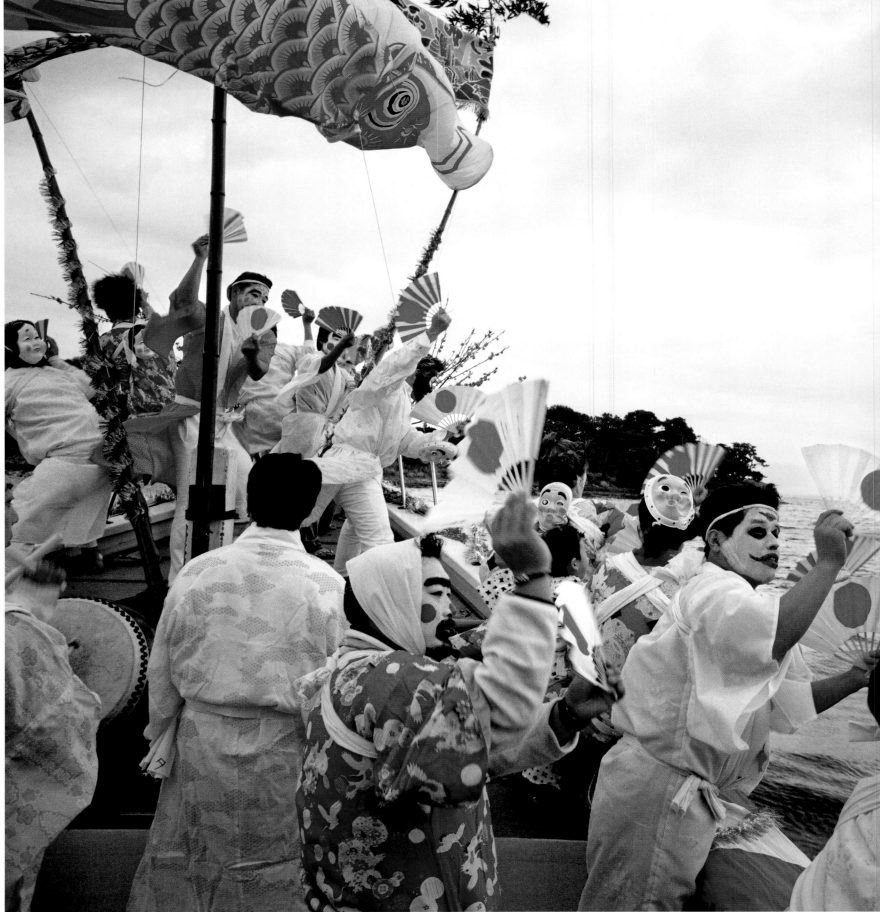

CHRIS STEELE-PERKINS | Izu Peninsula, Japan | 1999.
Men dressed in women's clothing placate the goddess of the sea at a fishermen's festival.

FOLLOWING PAGES: BRUNO BARBEY | Rio de Janeiro, Brazil | 1973.
Municipal ball during Carnaval

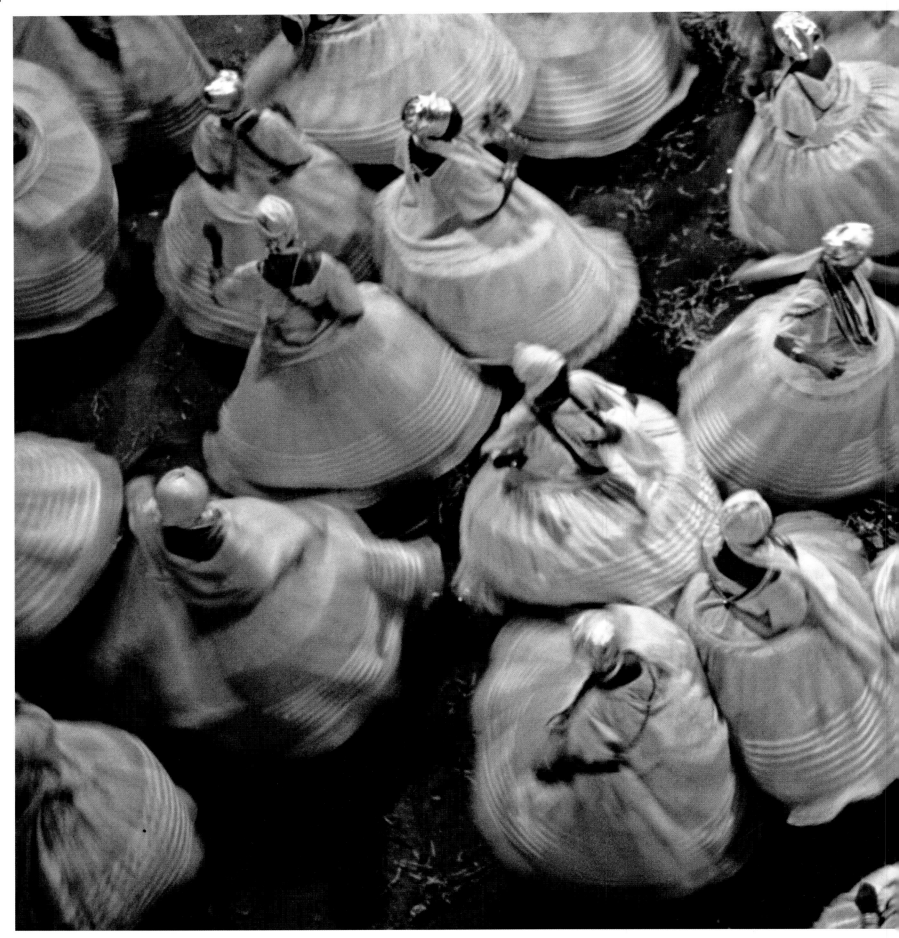

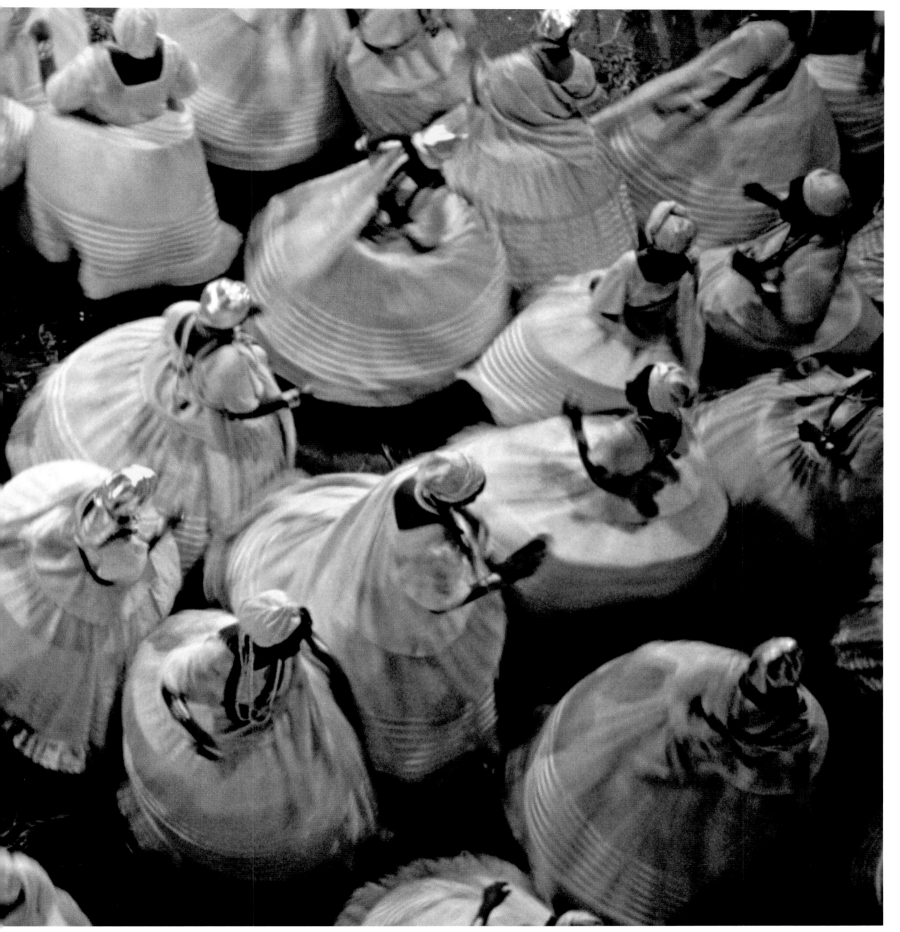

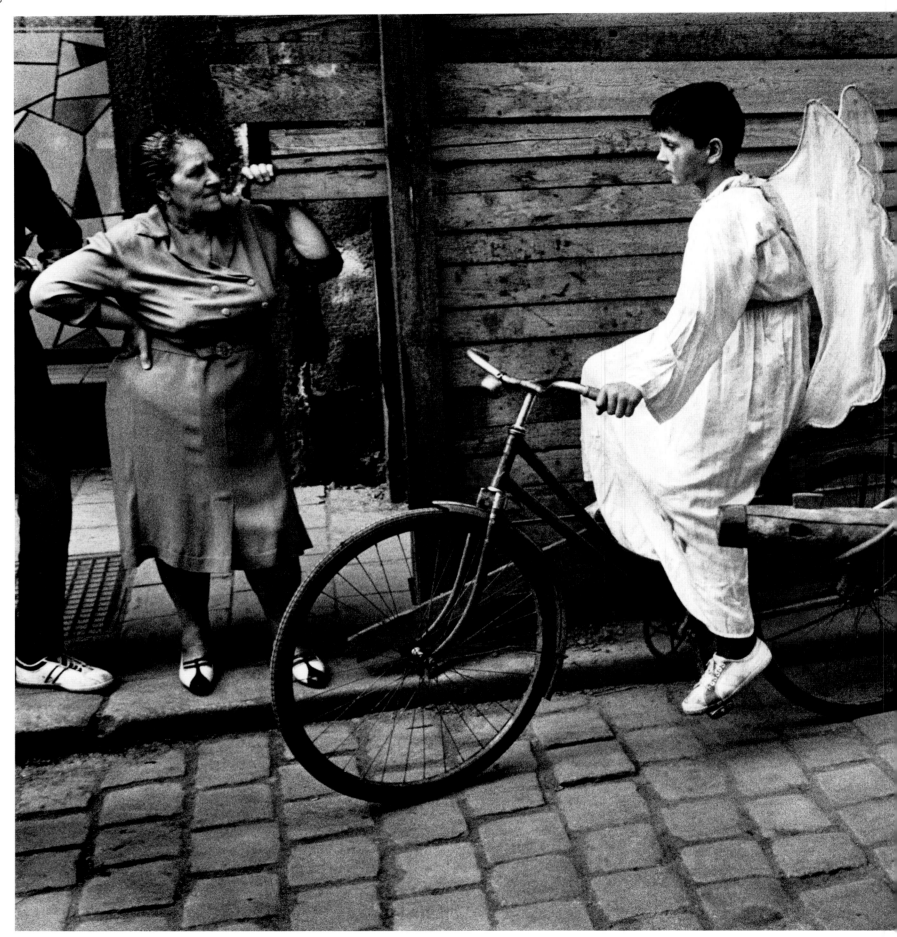

JOSEF KOUDELKA | Moravia, Olomouc, Czechoslovakia | 1968.
During *masopust*, a season of merrymaking and masquerading,
a boy takes part in an Easter carnival procession.

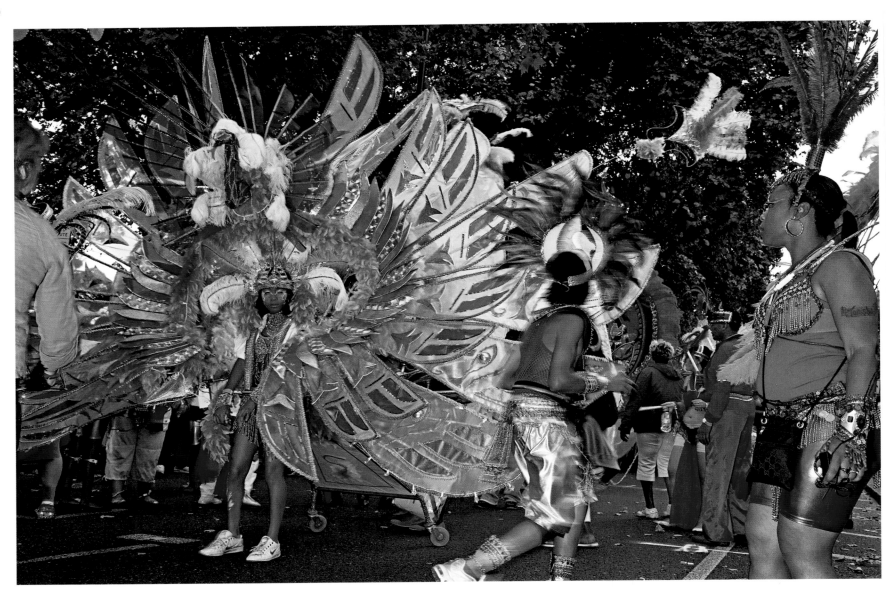

CHRIS STEELE-PERKINS I London, England I 2007.
Extravagantly costumed people take part in the Thames Festival.

OPPOSITE: GEORGE STEINMETZ I Oruro, Bolivia I 2008.
Some 30,000 participants prepare for the Carnival parade.

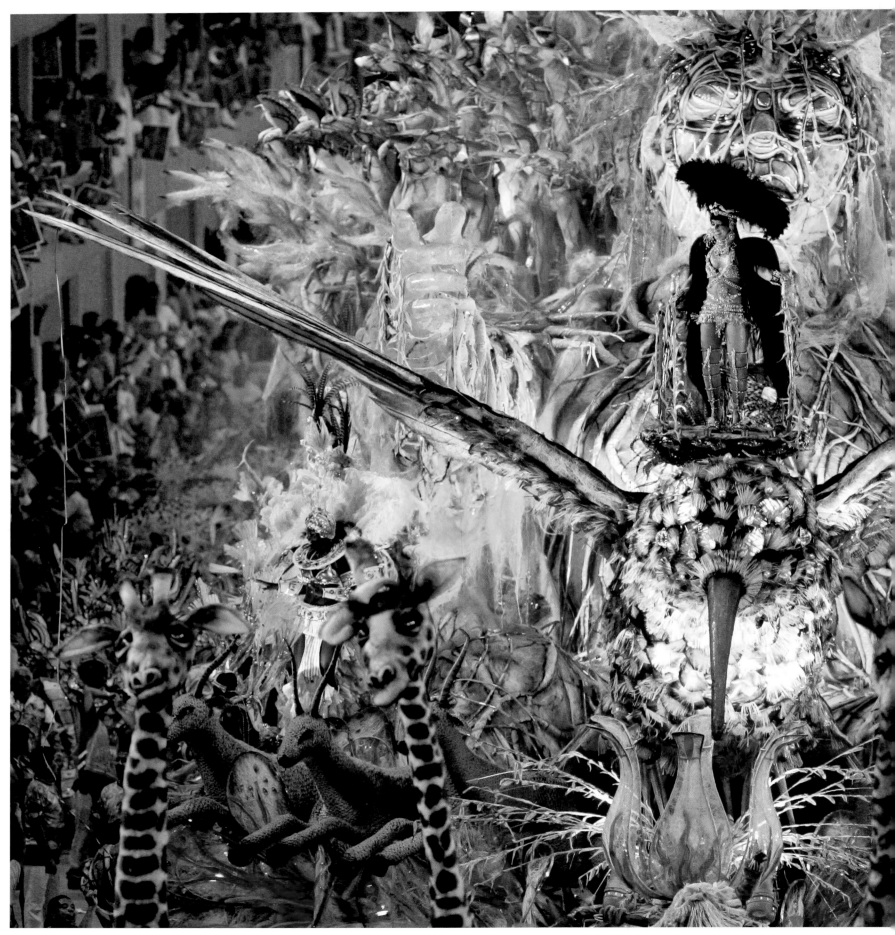

JORGE SAENZ I Rio de Janeiro, Brazil I 2007. A glittering dancer rides atop a giant hummingbird in Rio's Carnaval parade competition.

FERNANDO MOLERES I Black Rock, Nevada I 2005.
On the way to Dream Temple for a wedding during the Burning Man Festival

FOLLOWING PAGES: TINO SORIANO I Lake Banyoles, Catalonia, Spain I 2005.
Masked people cross a mustard field on the way to a summer festival.

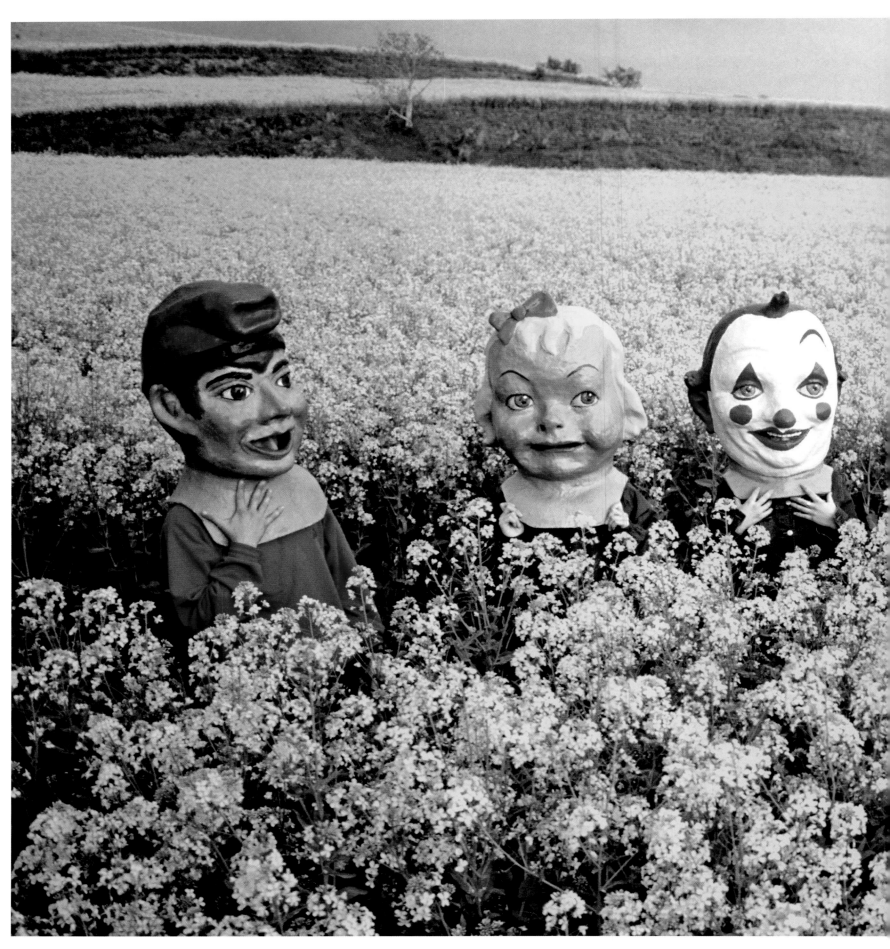

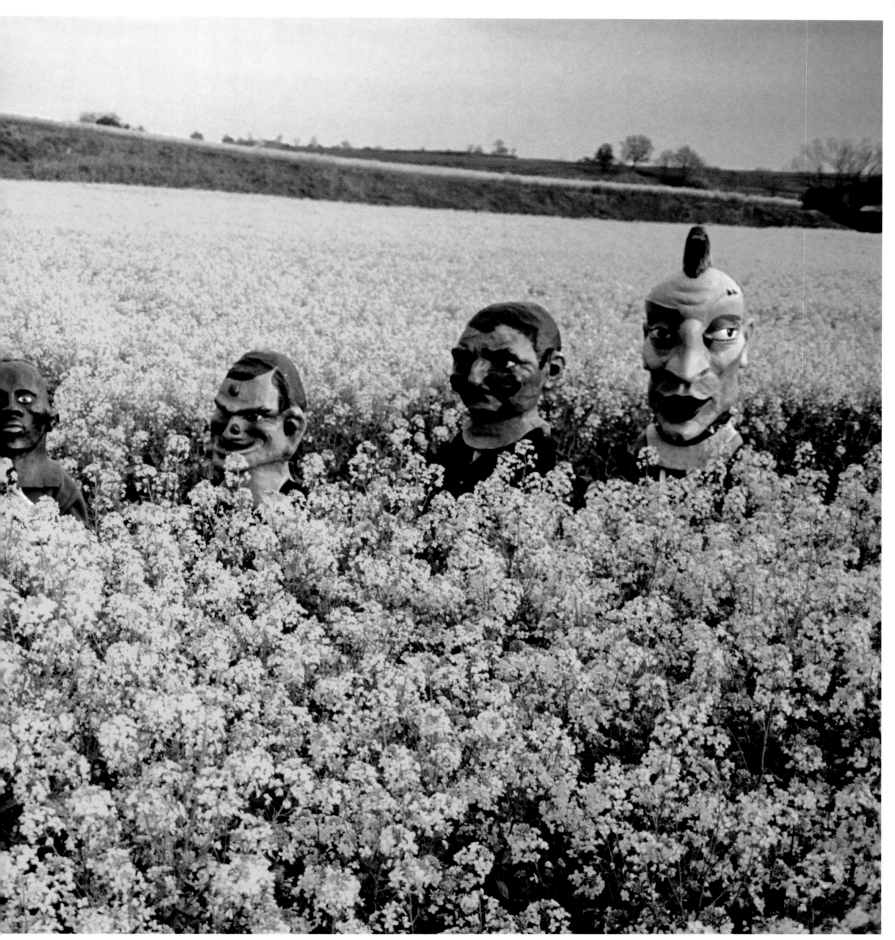

168

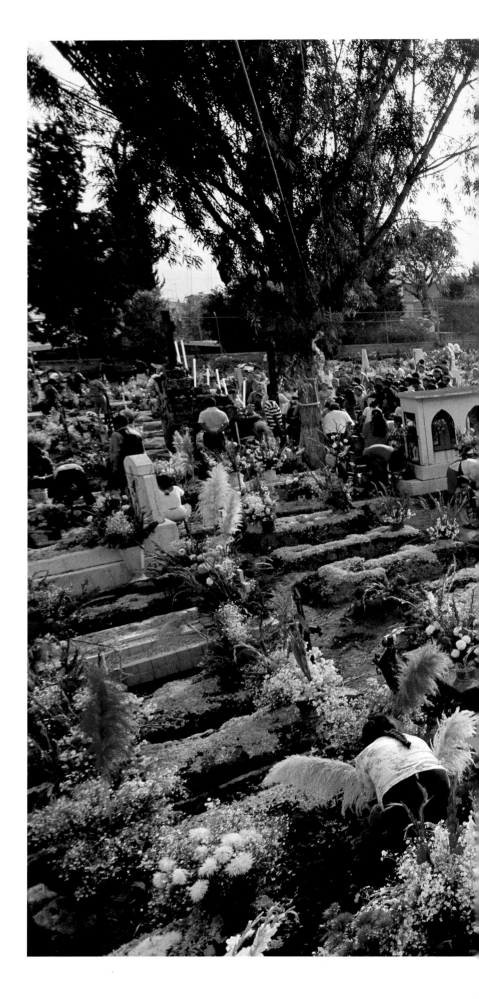

SISSE BRIMBERG | San Paulito, Puebla, Mexico | 1994. Mexicans hold vigil
in cemeteries during El Día de los Muertos (Day of the Dead).

FOLLOWING PAGES: GERD LUDWIG | Moscow, Russia | 2007.
A "flash mob" kissing event breaks out in Manezhnaya Square.

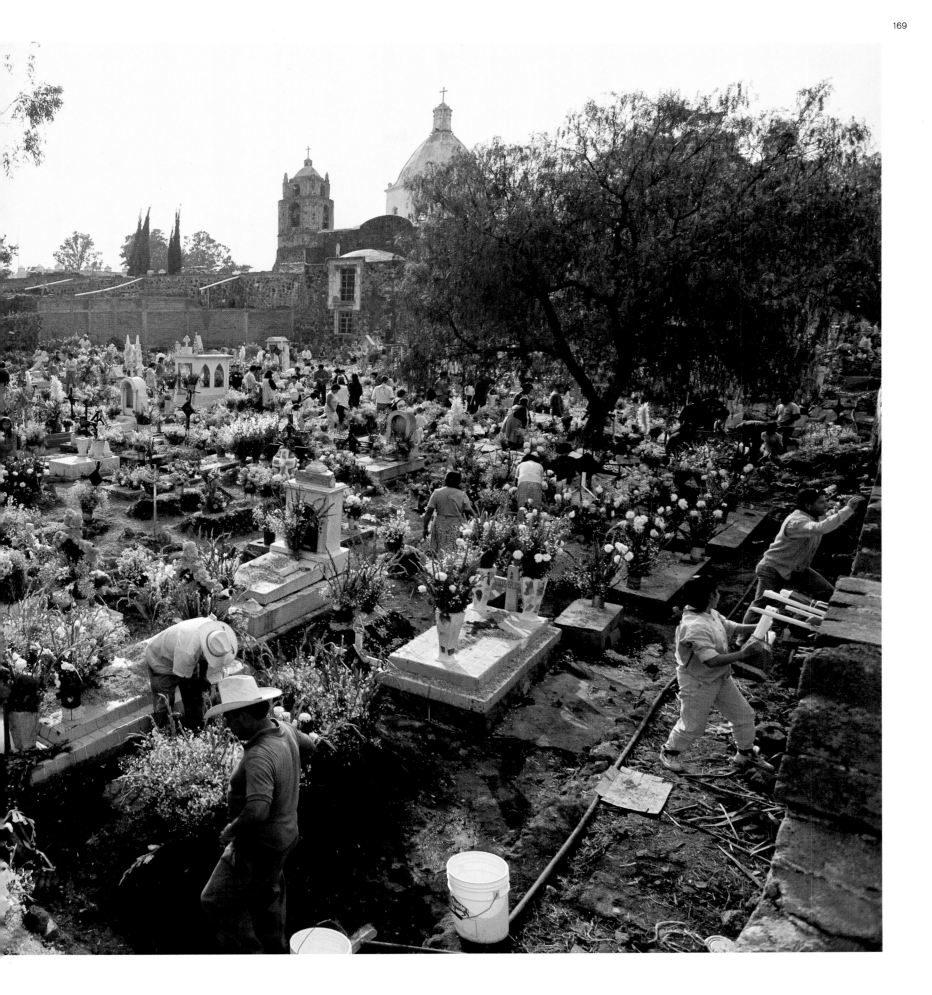

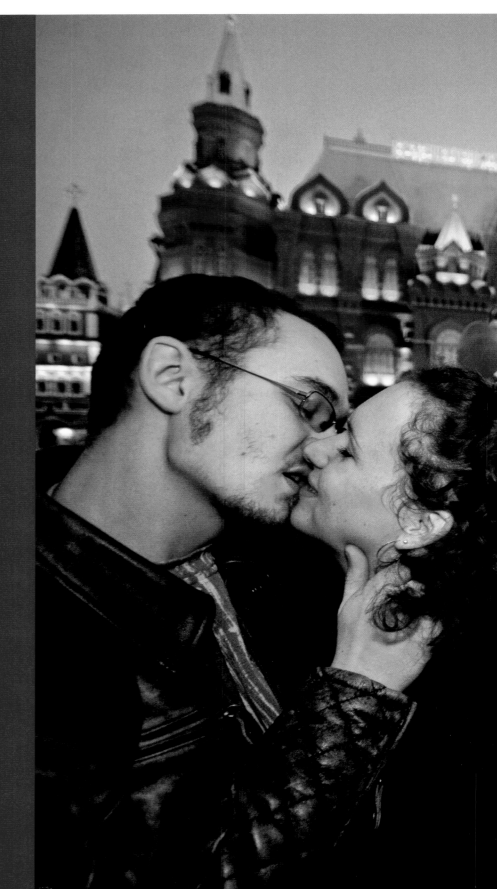

Ye blessed Creatures, I have heard the call
Ye to each other make; I see
The heavens laugh with you in your jubilee;
My heart is at your festival,
My head hath its coronal,
The fulness of your bliss, I feel—I feel it all.

—WILLIAM WORDSWORTH

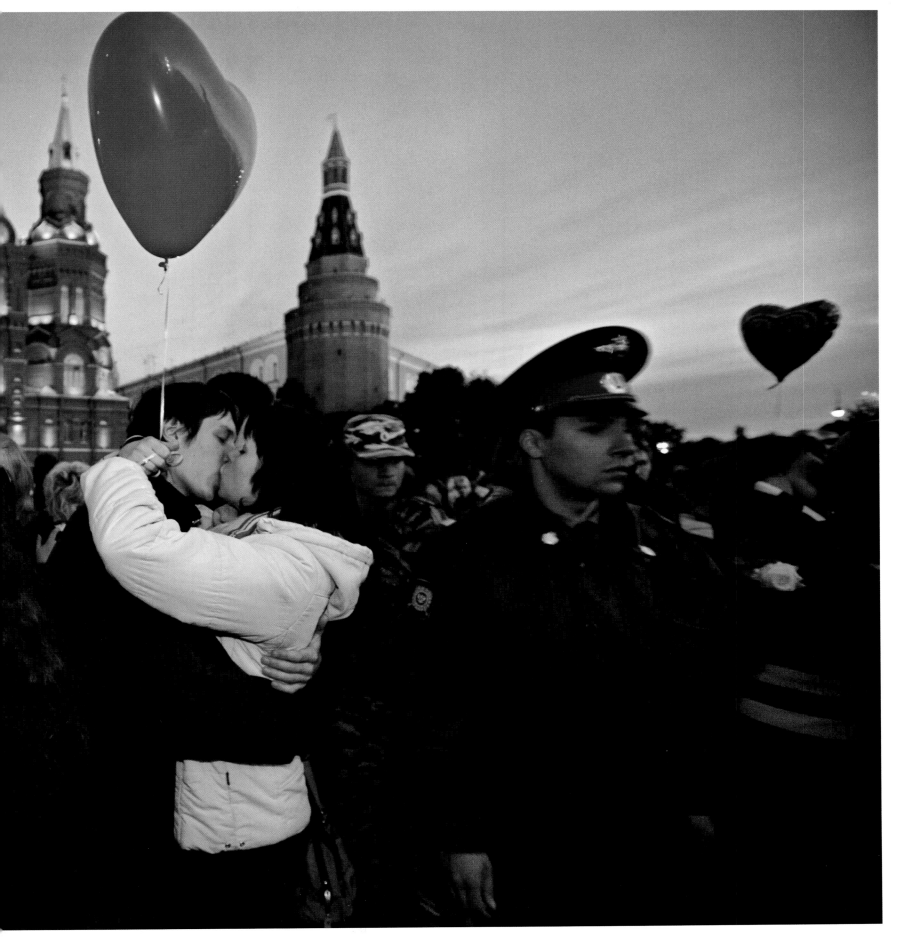

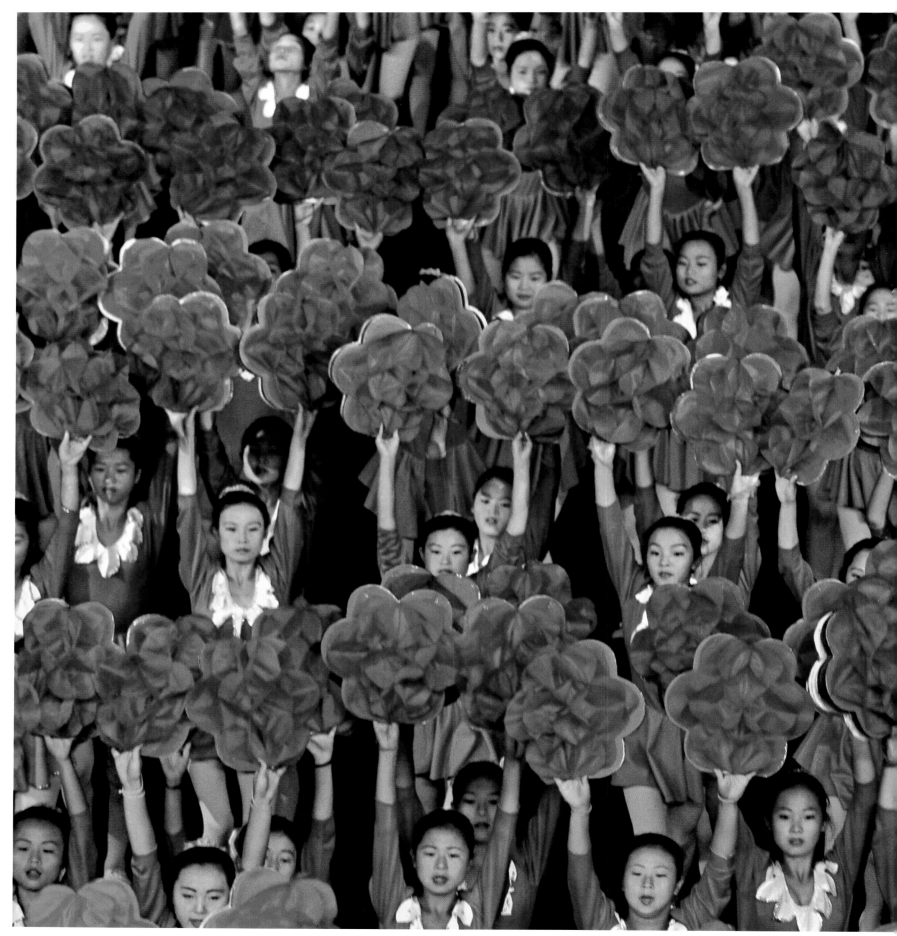

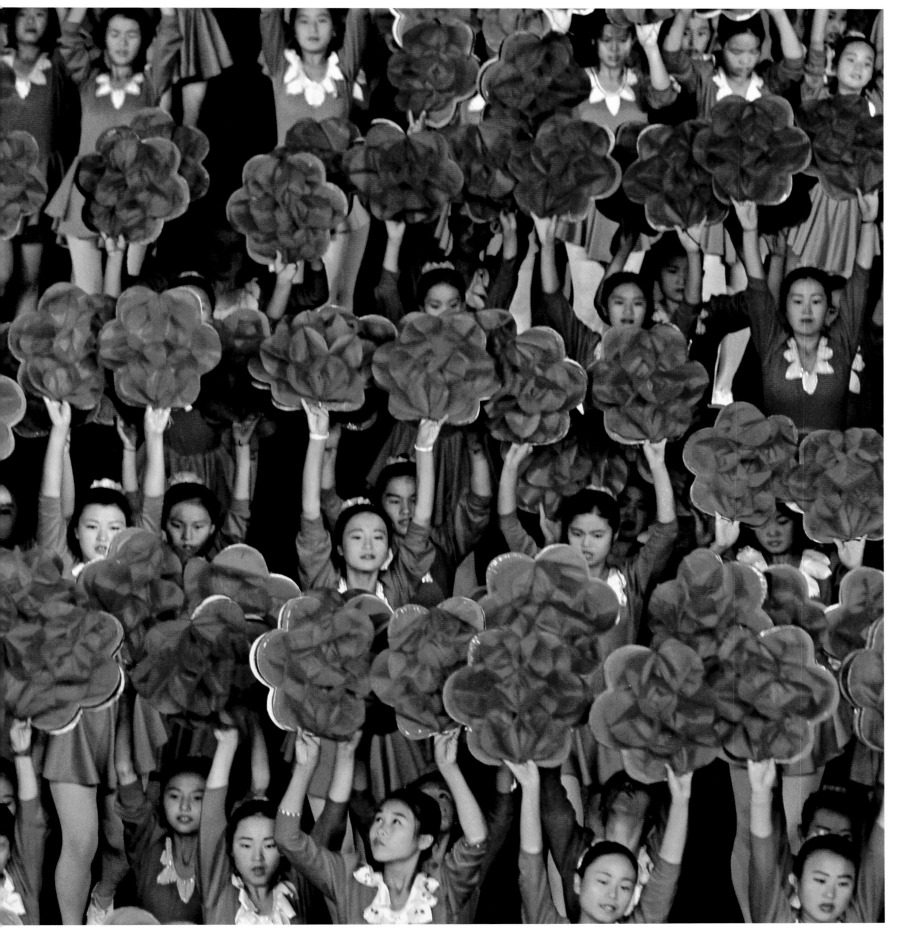

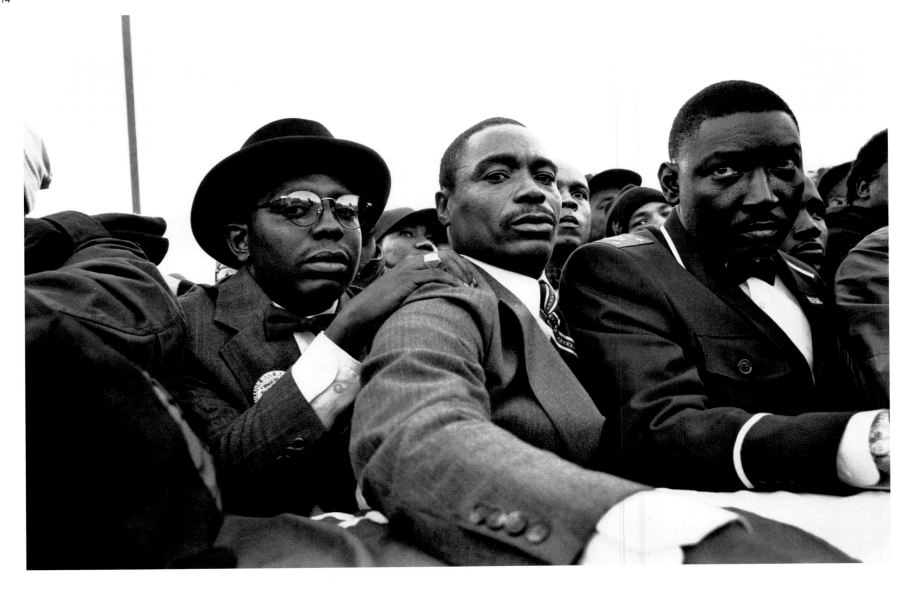

PREVIOUS PAGES: ALAIN NOGUES I Pyongyang, North Korea I 2008.
A mass gymnastics performance marks the 60th anniversary of the nation's founding.

ELI REED I Washington, D.C. I 1995. Men attend the Million Man March on the National Mall.

OPPOSITE: ELI REED I Washington, D.C. I 1995. The Washington Monument rises above
thousands congregated on the National Mall for the Million Man March.

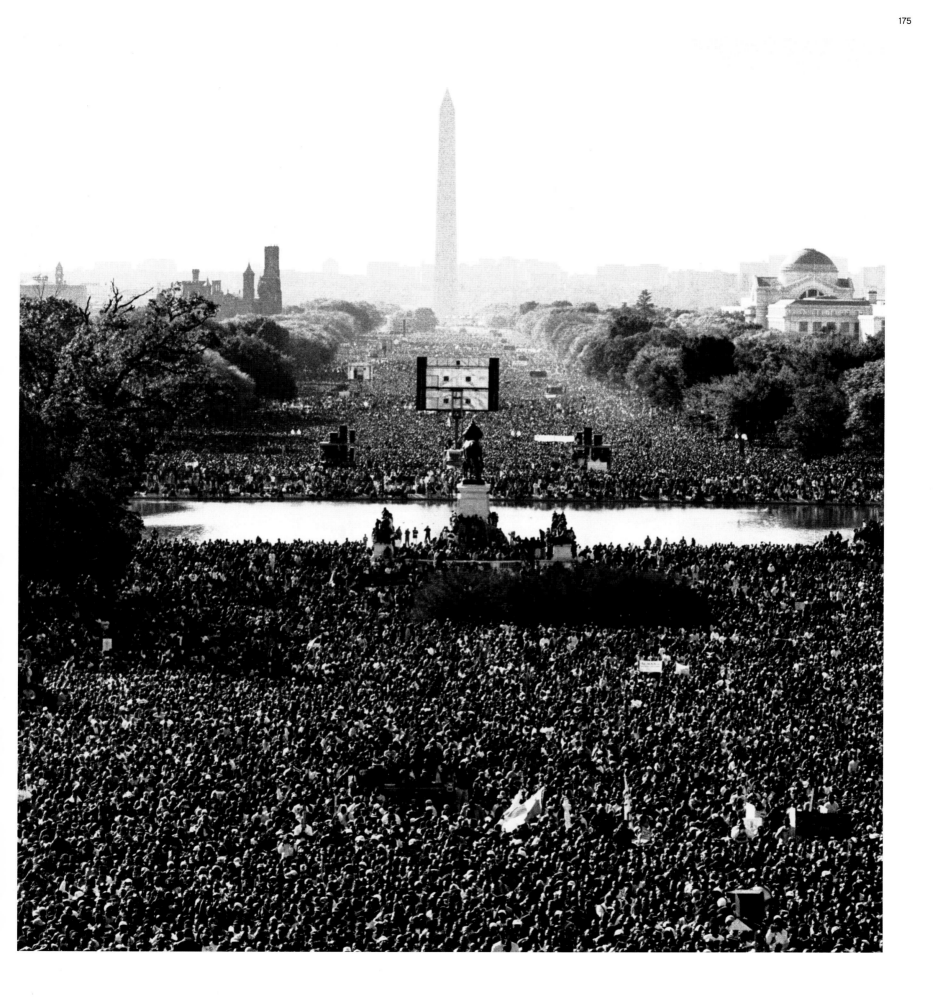

GUEORGUI PINKHASSOV | New York City, New York | 2005.
Kids play amid Christo and Jeanne-Claude's
installation "The Gates," in Central Park.

BRIAN LIU | **Washington, D.C. | 1991.** A happy, energetic crowd braves the rain at a Grateful Dead Concert at RFK Stadium.

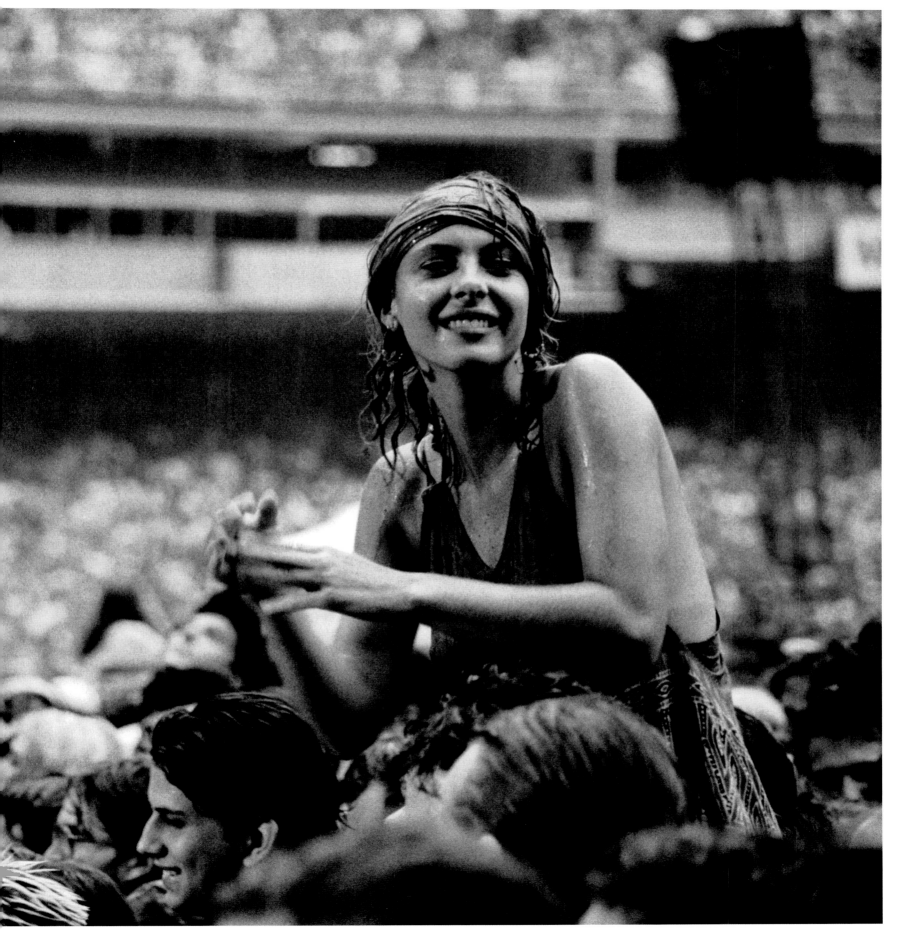

J CARRIER | Kisumu, Kenya | 2008.
Kenyans celebrate Barack Obama's election.

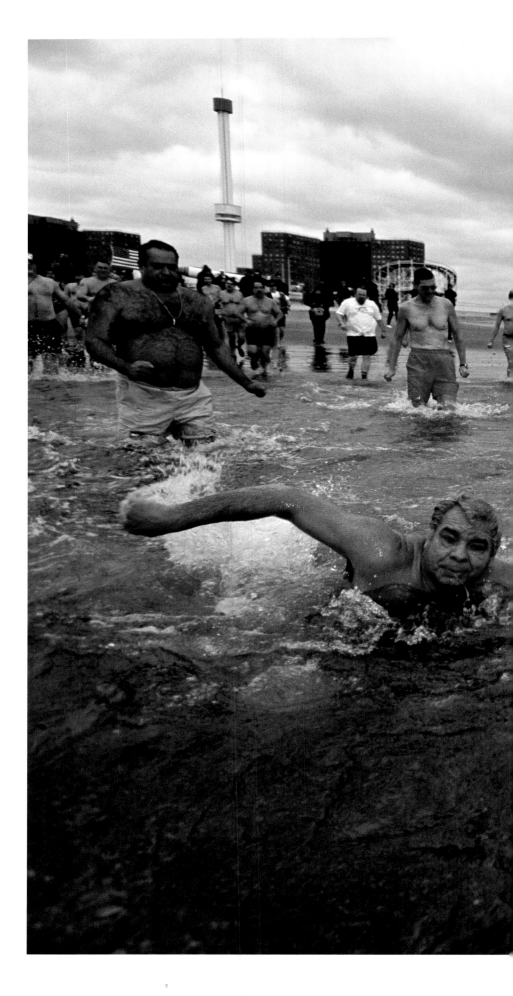

JAY DICKMAN I Coney Island, New York I 2003.
The Coney Island Polar Bear Club celebrates its hundredth anniversary.

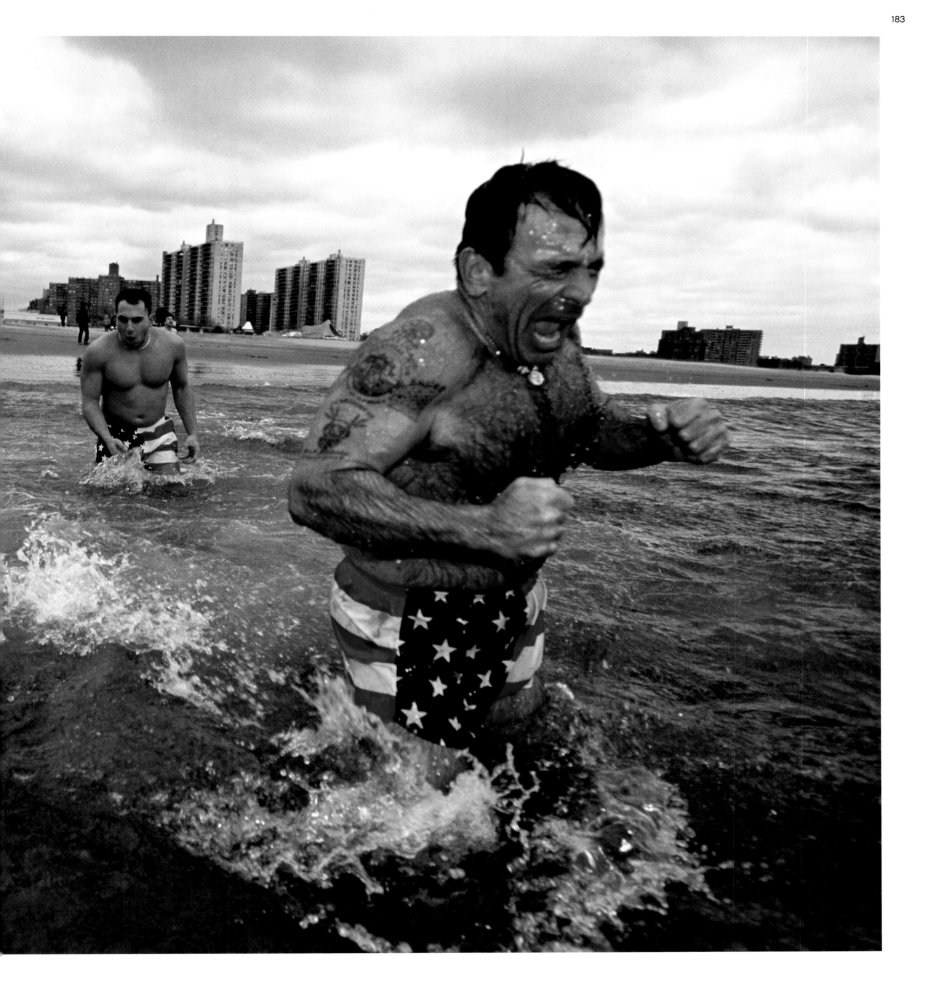

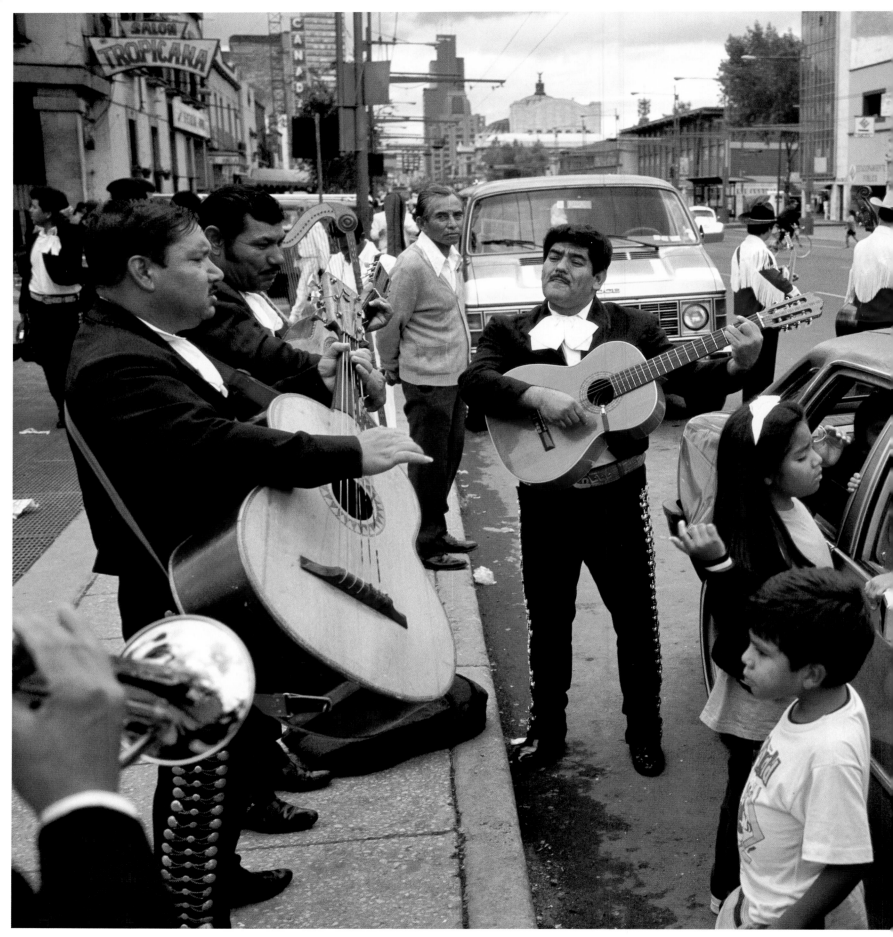

STUART FRANKLIN | Mexico City, Mexico | 1996.
Mariachis serenade a family in the Plaza Garibaldi.

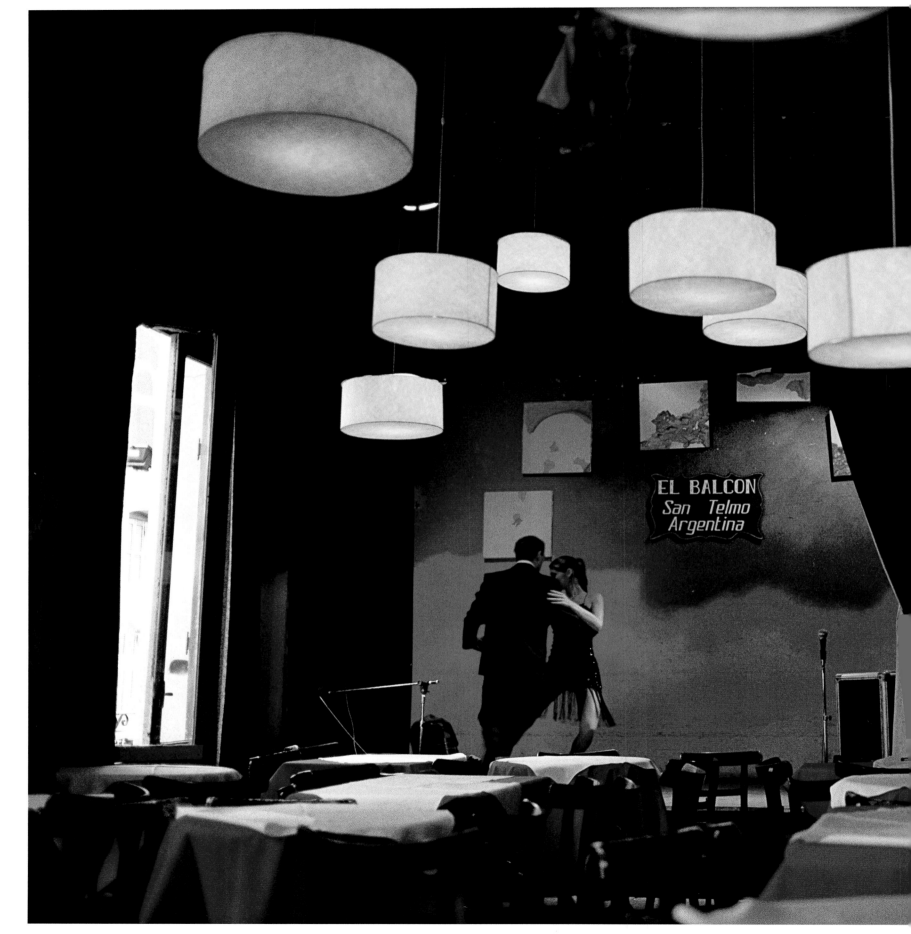

What an enormous magnifier
is tradition! How a thing grows in
the human memory and in the
human imagination, when love,
worship, and all that lies in the
human heart, is there to encourage it.

—THOMAS CARLYLE

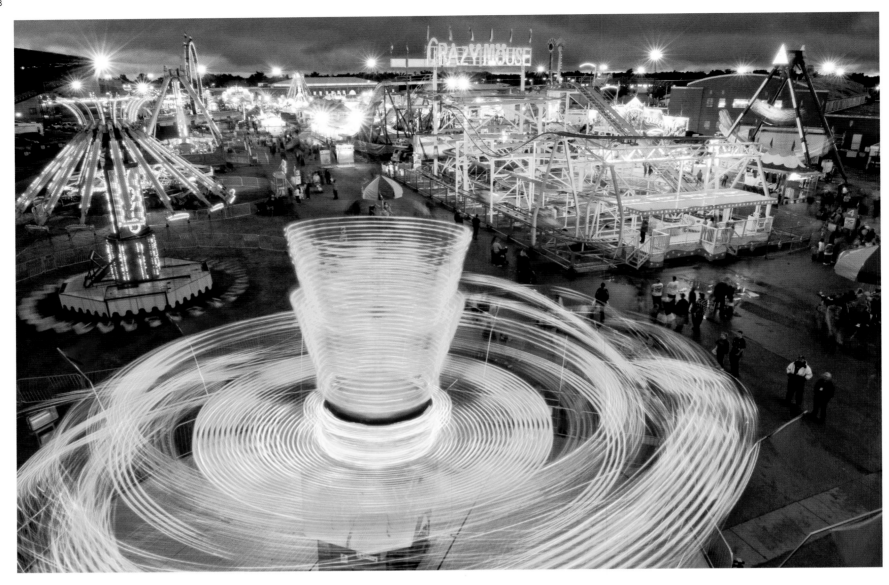

PREVIOUS PAGES: PABLO CORRAL VEGA I Buenos Aires, Argentina I 2002.
A couple dance the tango at a club in the San Telmo district.

JOEL SARTORE I Hutchinson, Kansas I 2008.
The blur of a spinning ride at the Kansas State Fair

JOEL SARTORE I Dallas, Texas I 2008.
Thrill seekers on the Extreme Ride at the Texas State Fair

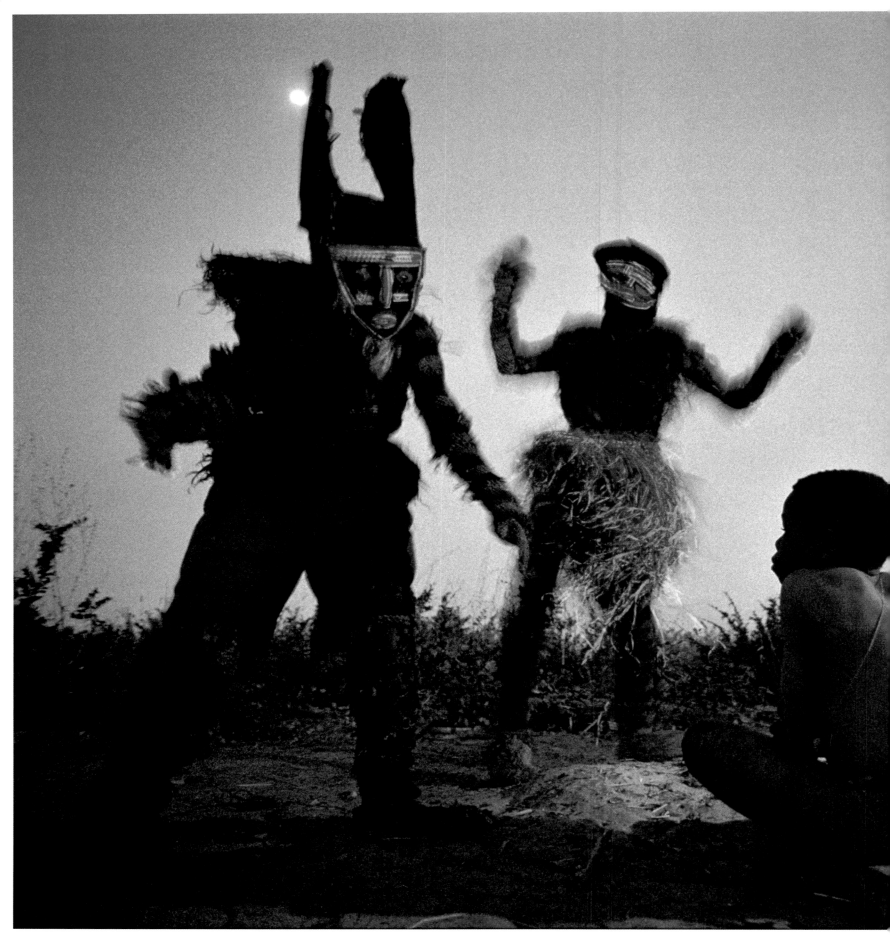

CHRIS JOHNS I **Zambezi River, Zambia I 1996.** Luvale tribe members perform for boys who have undergone a ritual circumcision.

FOLLOWING PAGES: STEVE MCCURRY I **Angkor, Cambodia I 2000.** A member of a Khmer dance troupe prepares for her performance.

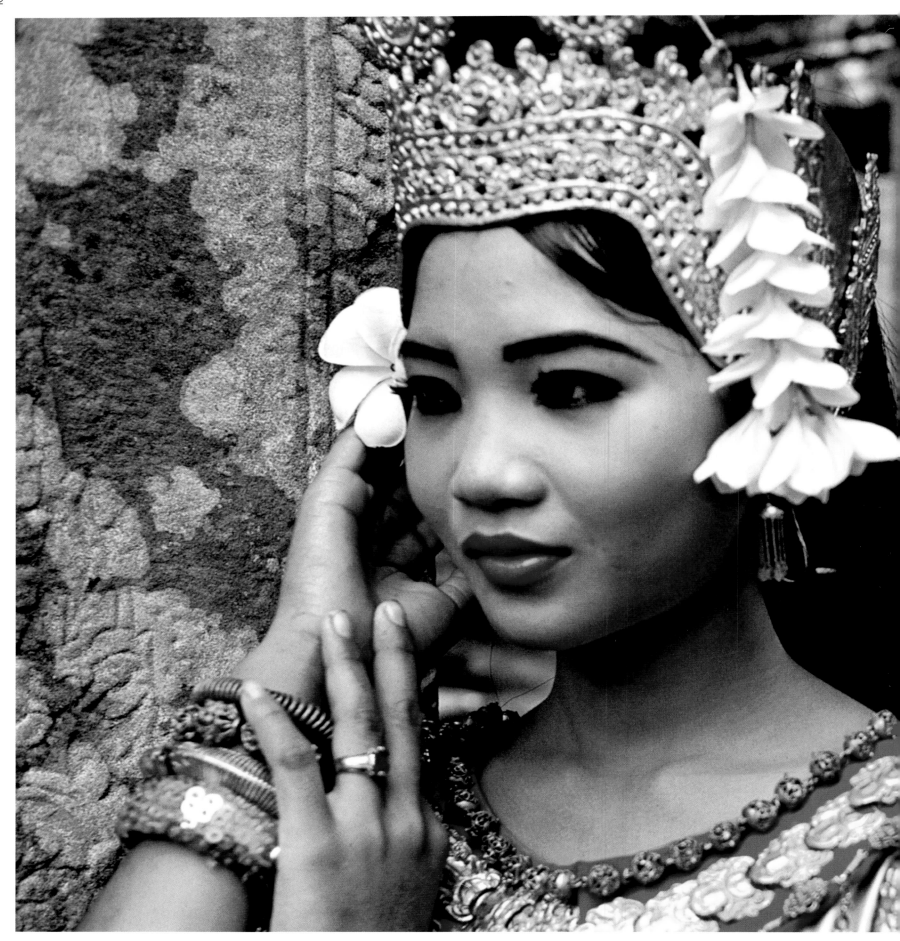

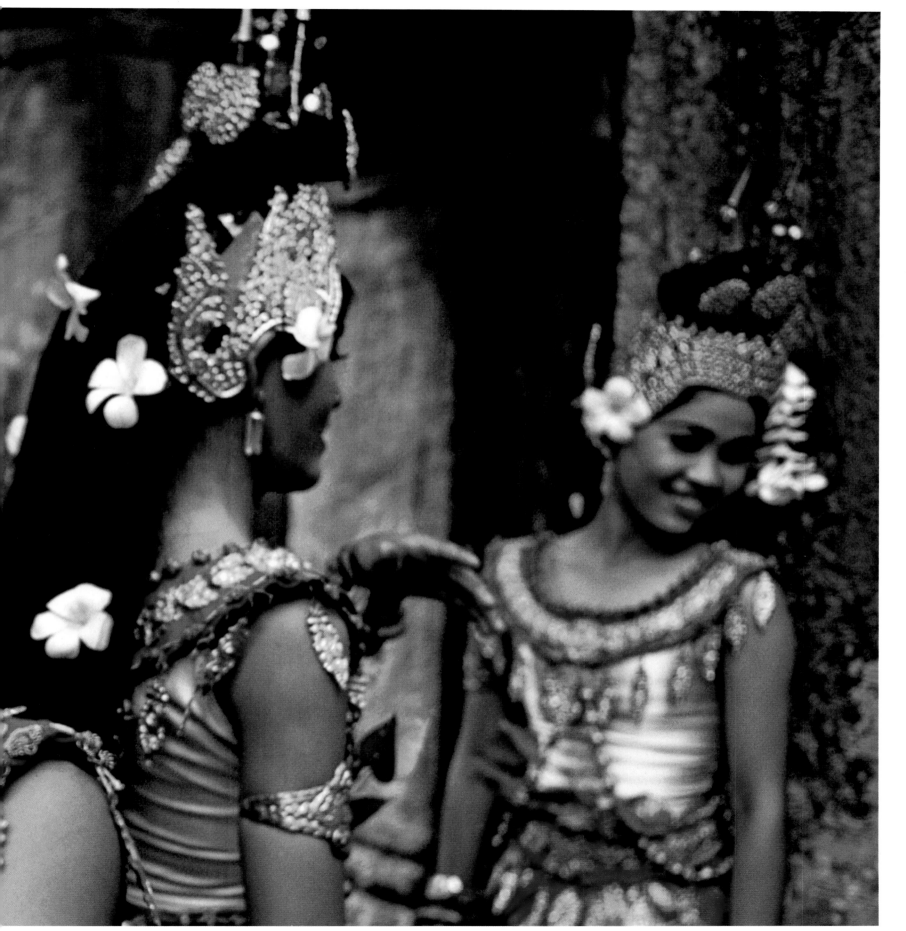

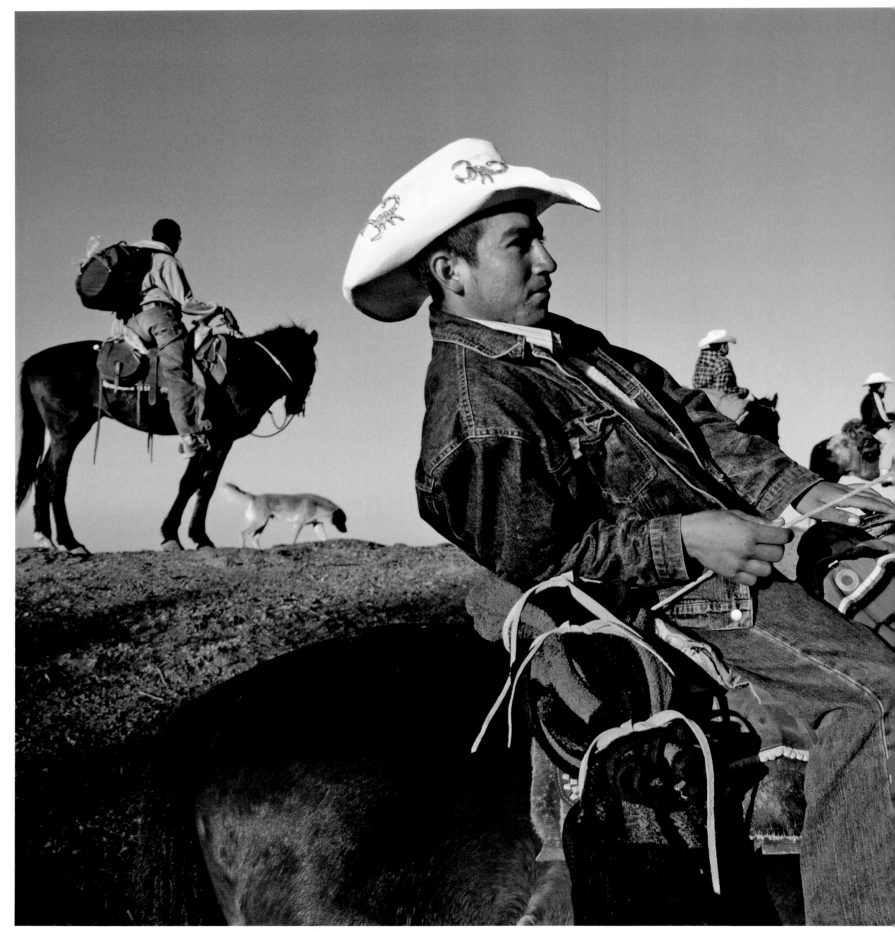

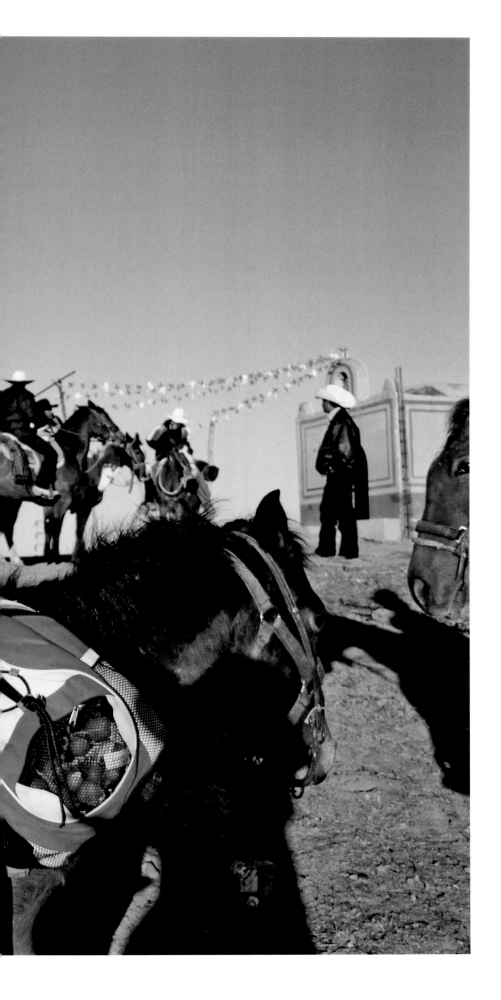

DAVID ALAN HARVEY | Guanajuato, Mexico | 2007.
The day before Epiphany, thousands of cowboys ride to the
top of a plateau to pray to a statue of Cristo Rey (Christ the King).

196

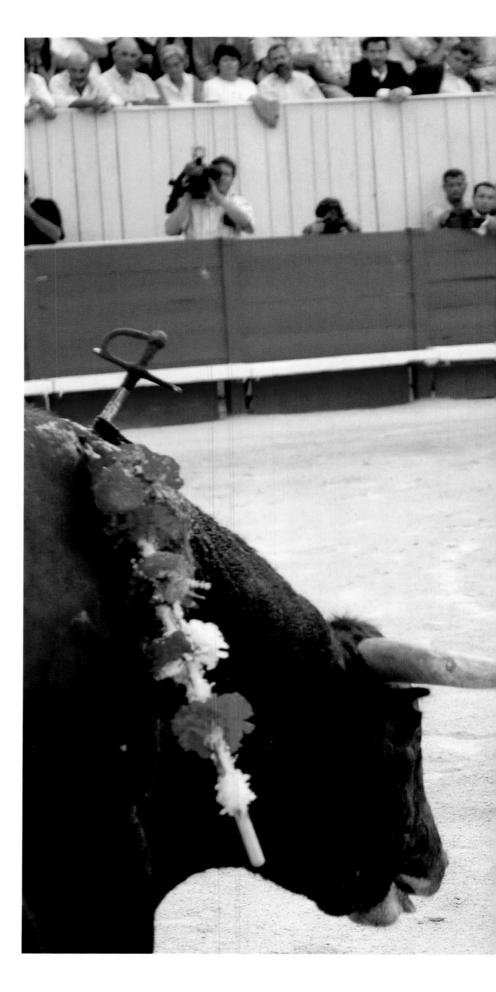

STEPHANE REMAEL I **Arles, France I 2008.** In an Arles arena,
a promising 20-year-old French bullfighter "takes the alternative,"
the christening rite of becoming a torero in bullfighting.

FOLLOWING PAGES: HIROJI KUBOTA I **Shan, Myanmar (Burma) I 1986.**
Participants of the Phaung Daw U Pagoda Festival use their legs to row boats.

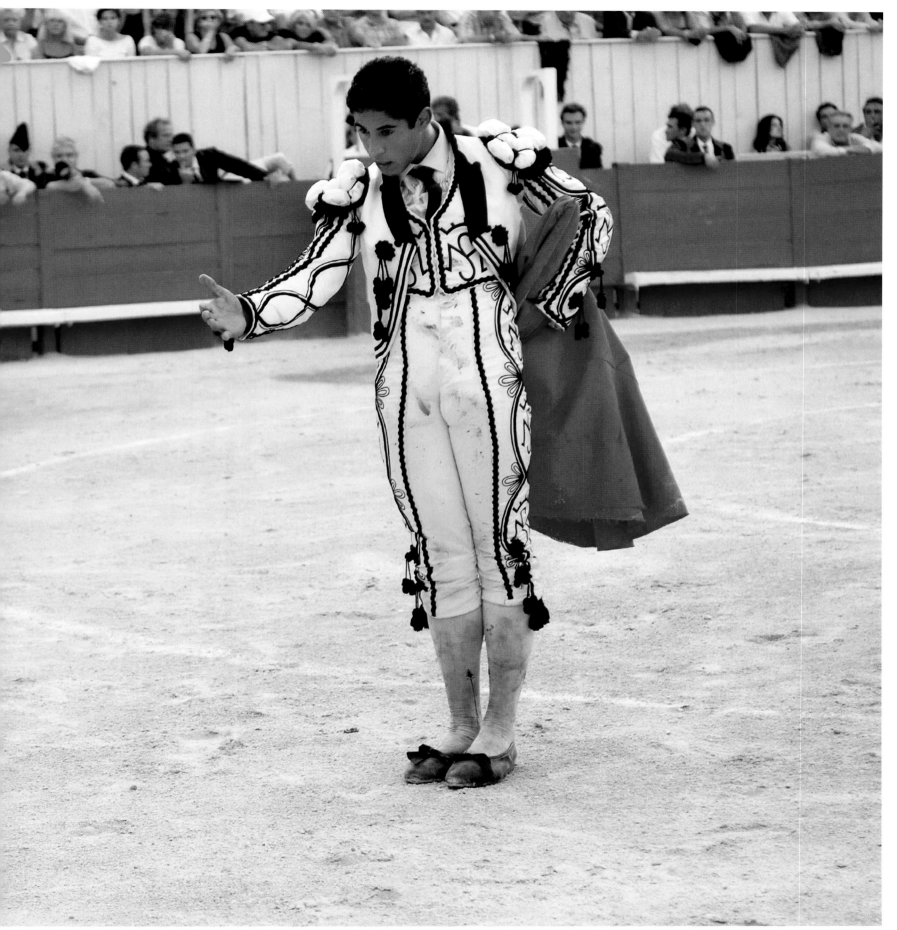

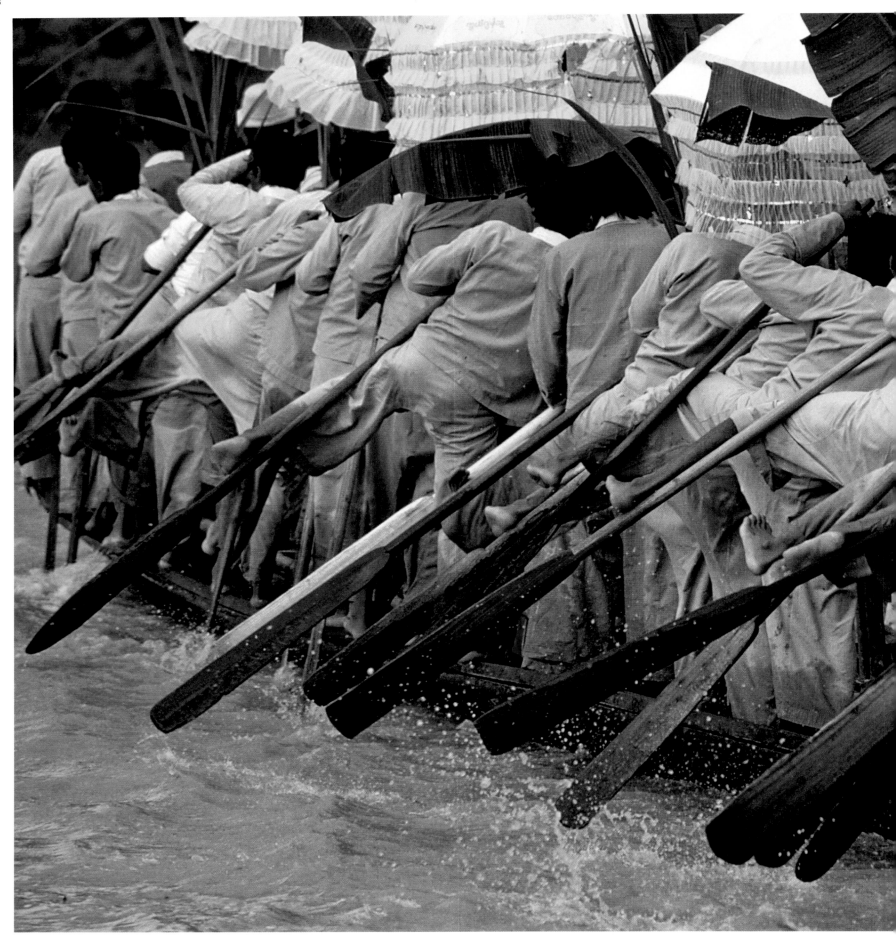

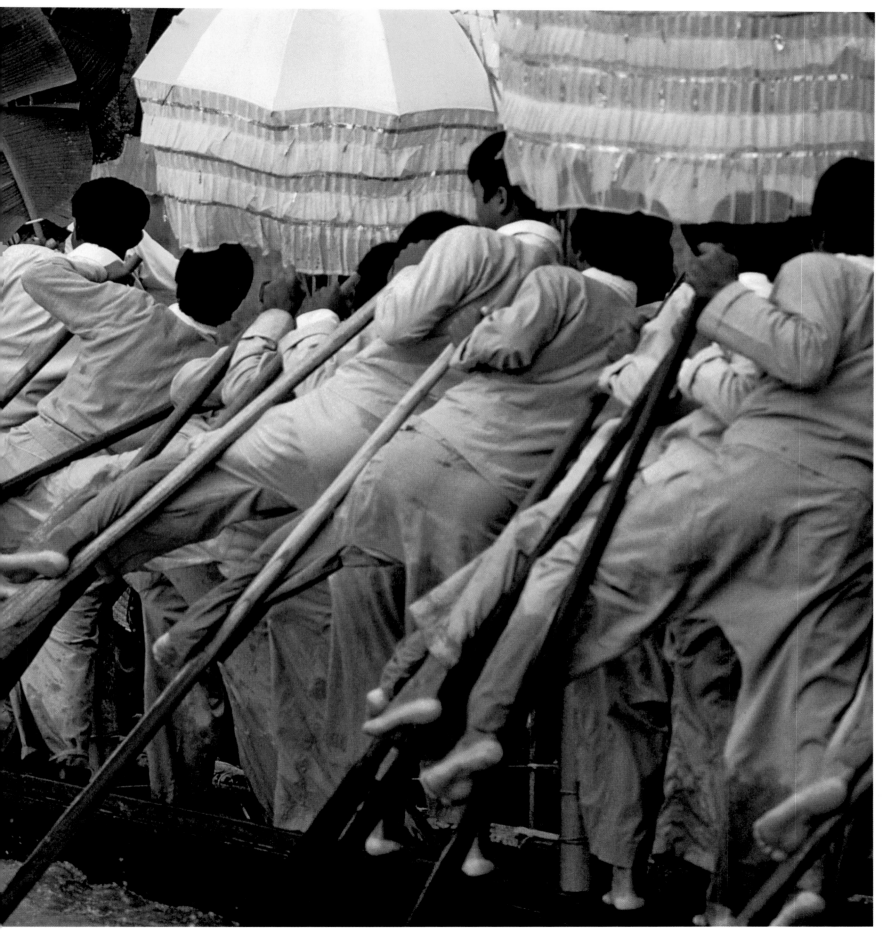

JODI COBB | Miyagawacho Geisha District, Kyoto, Japan | 1986.
A young geisha completes her wardrobe.

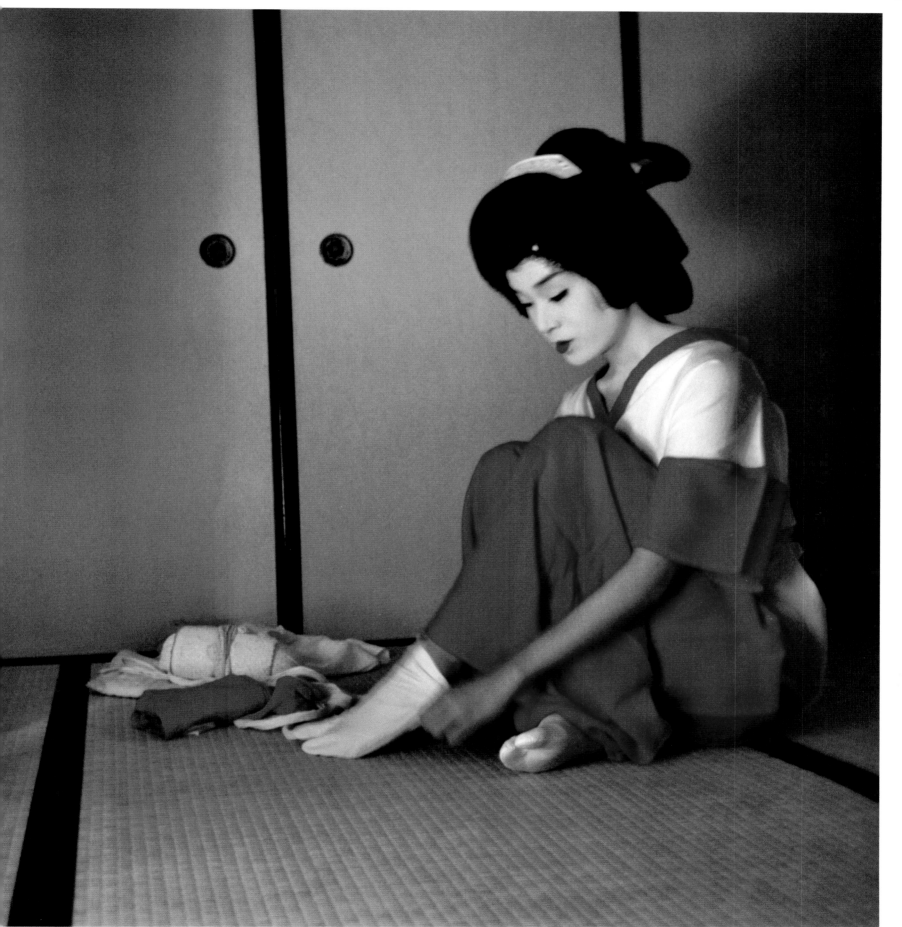

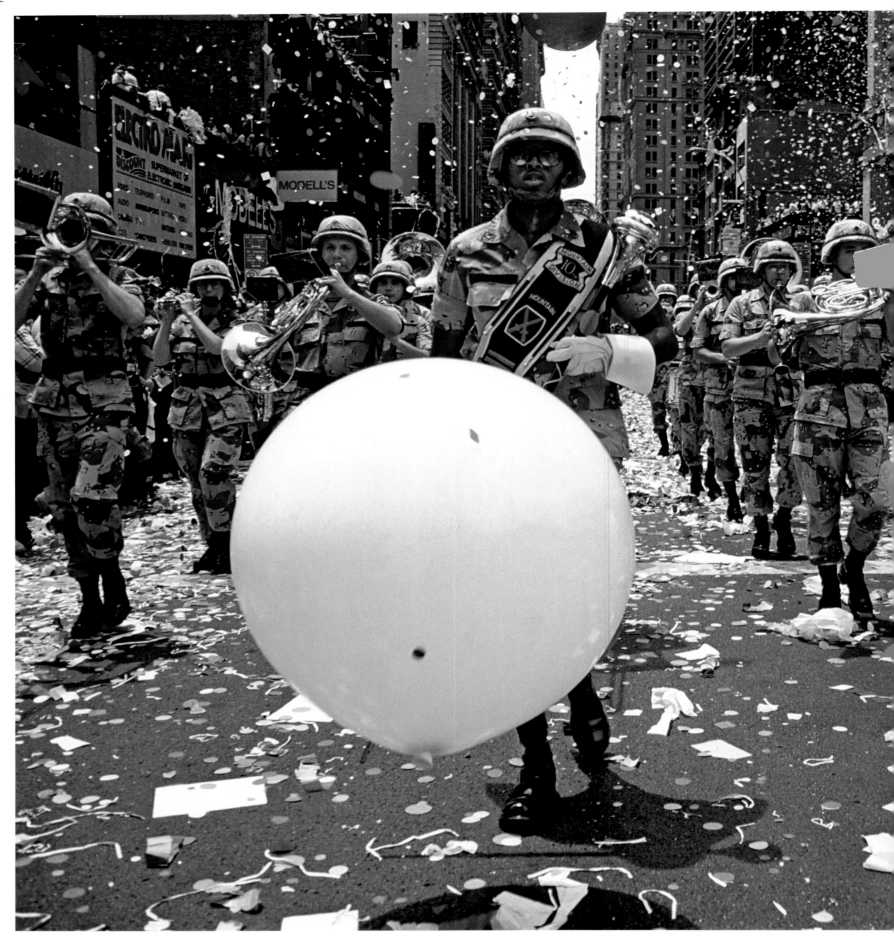

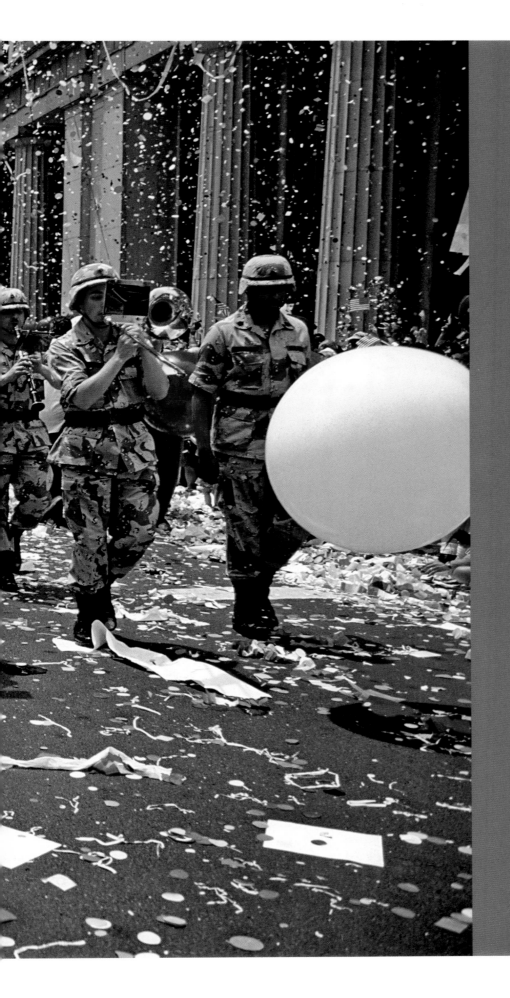

Man is a military animal,
glories in gunpowder,
and loves parade.

—PHILIP JAMES BAILEY

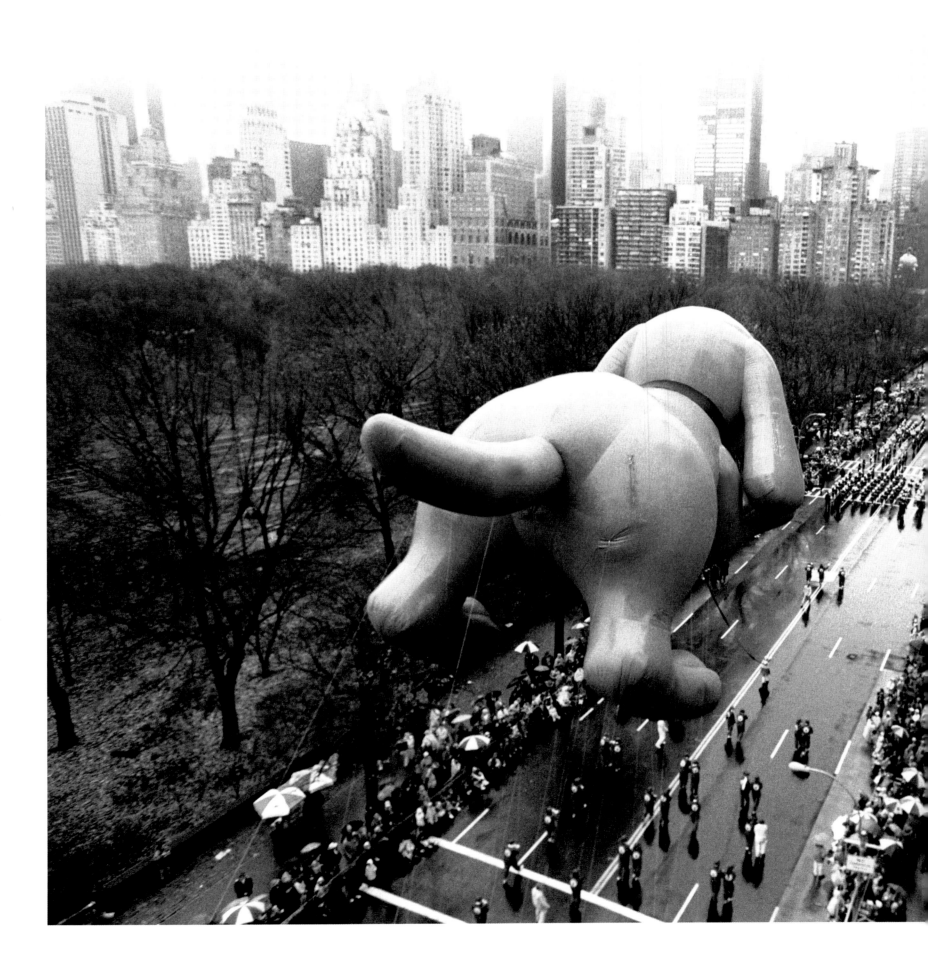

PREVIOUS PAGES: SUSAN MEISELAS | New York City, New York | 1991. Soldiers march through a cloud of ticker tape during a parade.

BURT GLINN | New York City, New York | 1992. A stunning vantage point for Macy's Thanksgiving Day Parade on Central Park West

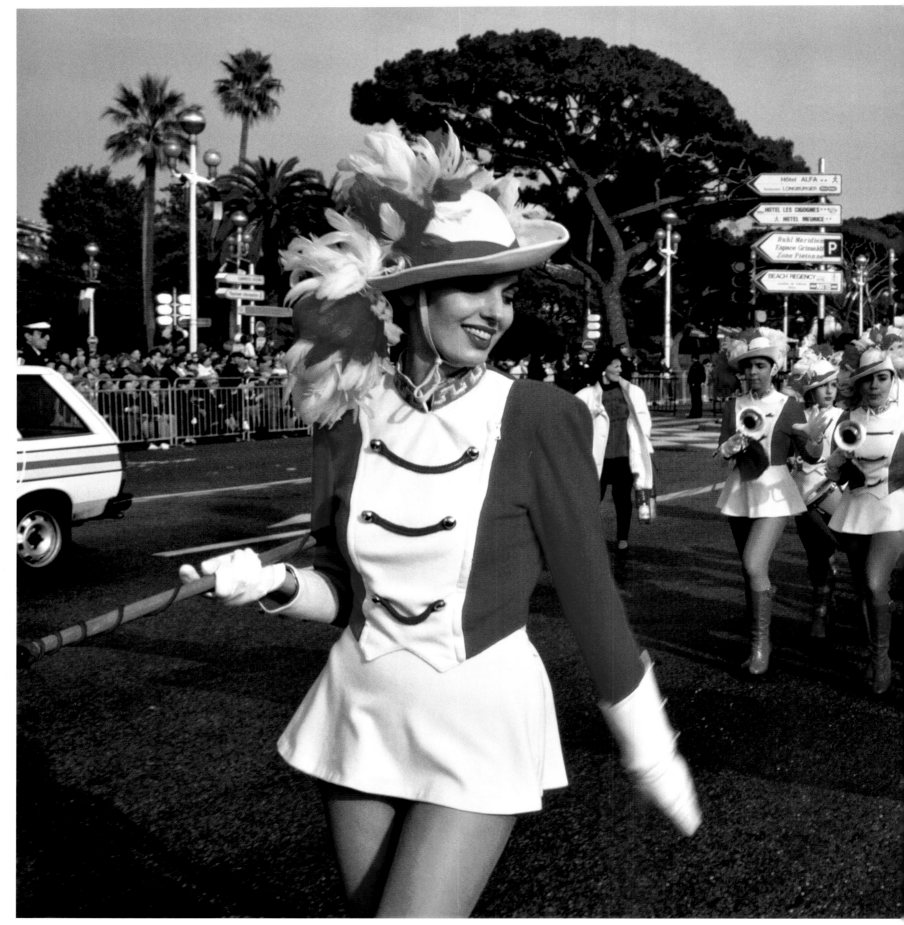

BRUNO BARBEY I Nice, France I 1988.
Saucily dressed musicians march in a parade during a carnival.

FOLLOWING PAGES: PAUL CHESLEY I Beijing, China I 2004.
Female soldiers march in Tiananmen Square during the National Day parade.

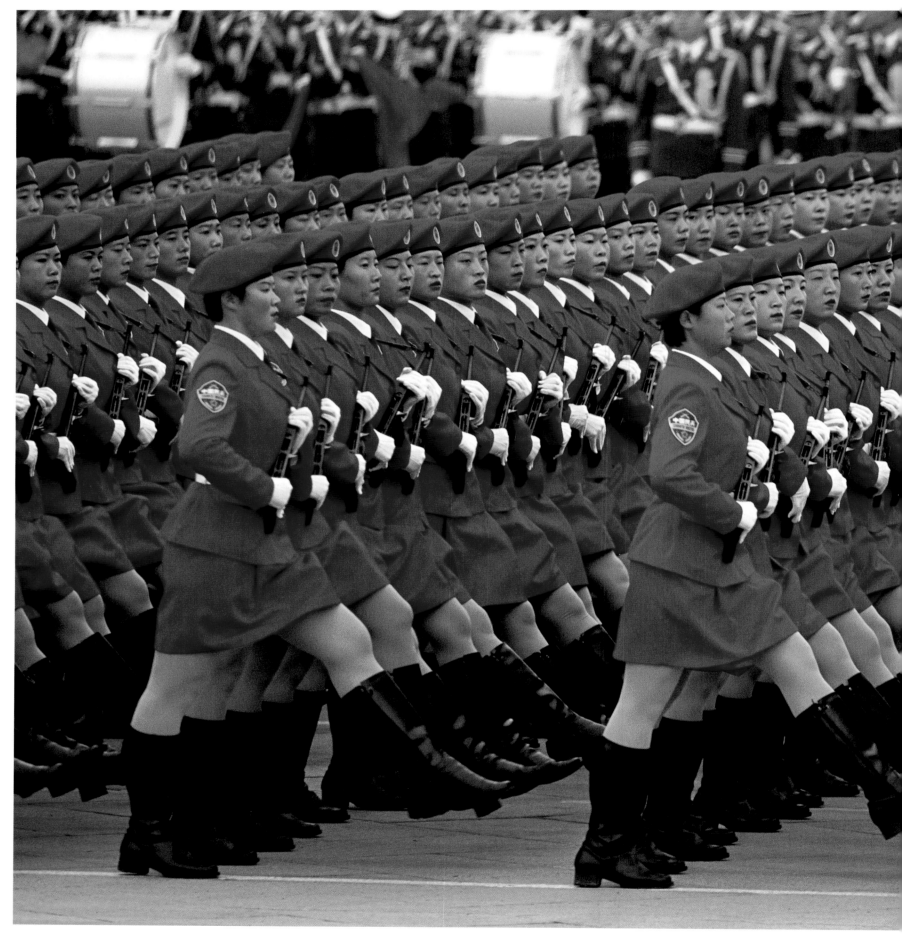

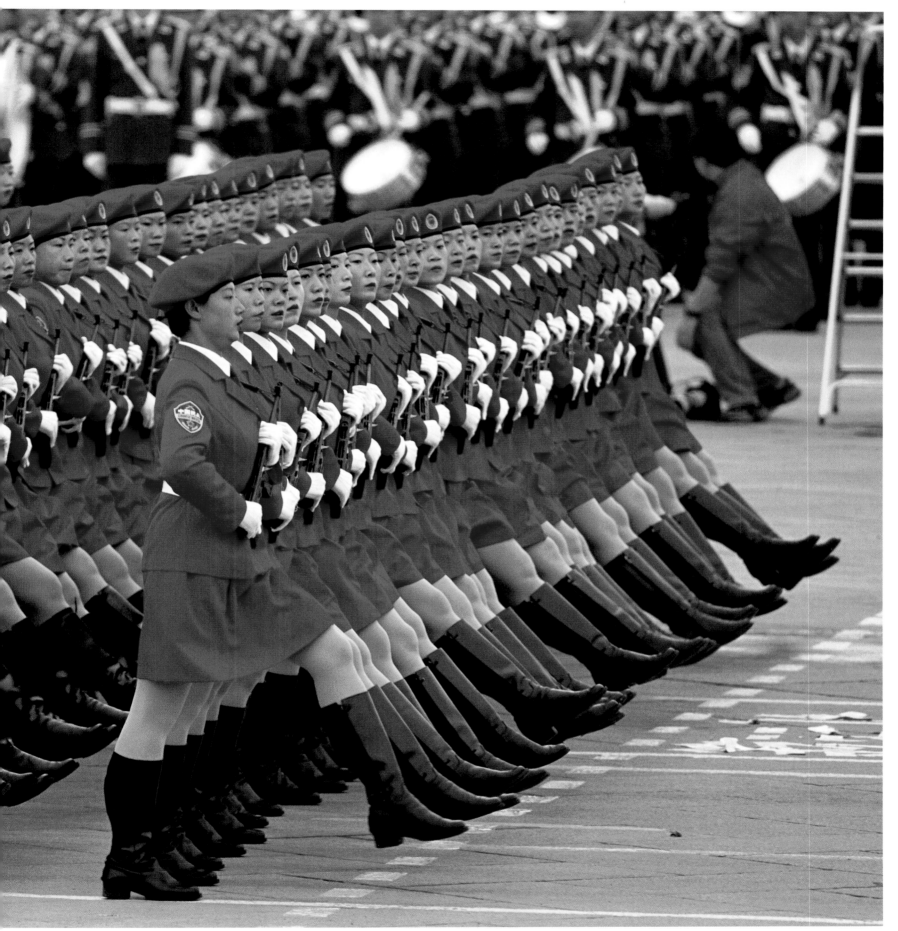

PAUL FUSCO I New York City, New York I 1994.
Friends attend the Wigstock Festival in Greenwich Village.

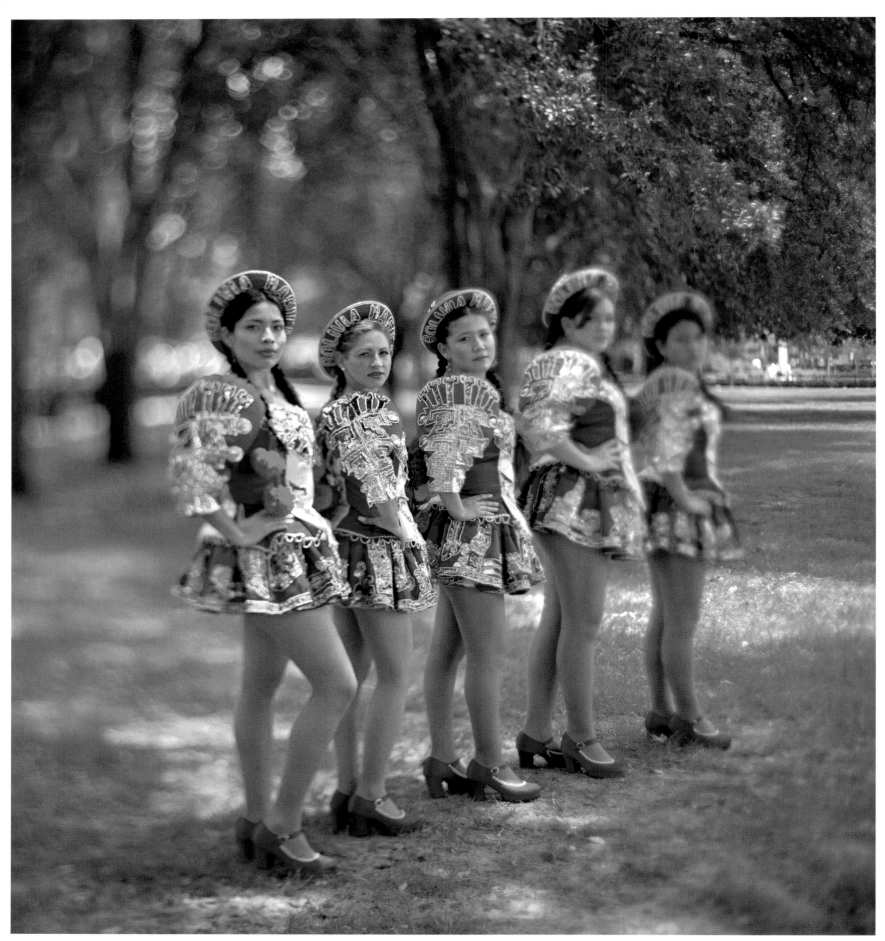

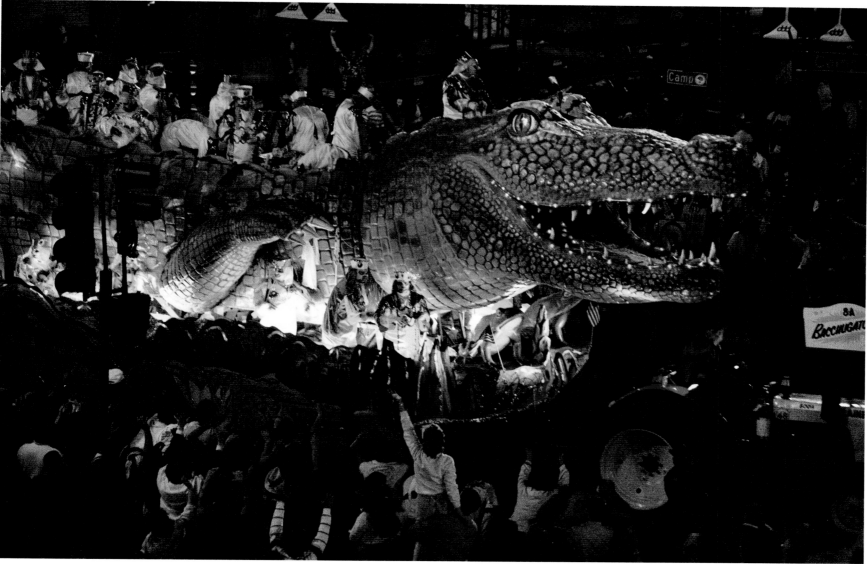

OPPOSITE: DAVID BURNETT | Orlando, Florida | 2006.
Dancers pose after marching in the Puerto Rican Day parade.

JOEL SARTORE | New Orleans, Louisiana | 2004.
Crowds cheer for a giant alligator float in the Mardi Gras parade.

TYRONE TURNER I **New Orleans, Louisiana I 2007.**
The Big Nine Social Aid and Pleasure Club parades
past empty houses on Forstall Street in the Lower Ninth Ward.

FOLLOWING PAGES: CHIEN-CHI CHANG I **central Taiwan I 1996.** Masked
followers of the Taoist saint Matsu embark on a pilgrimage in her honor.

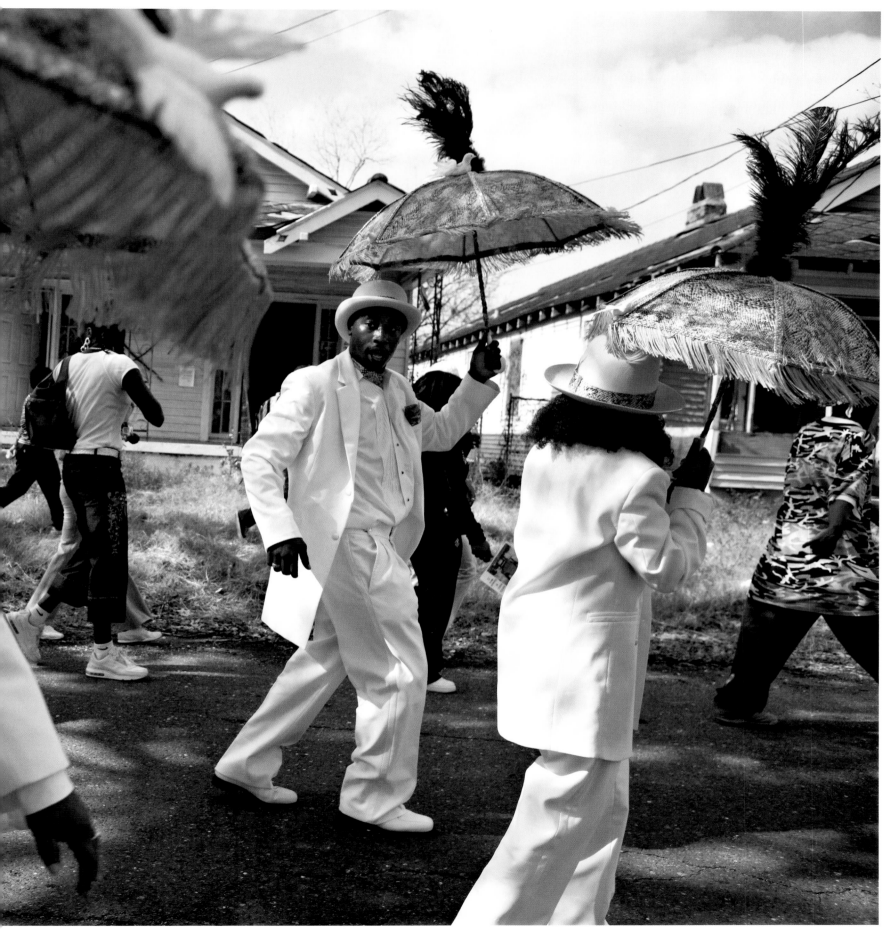

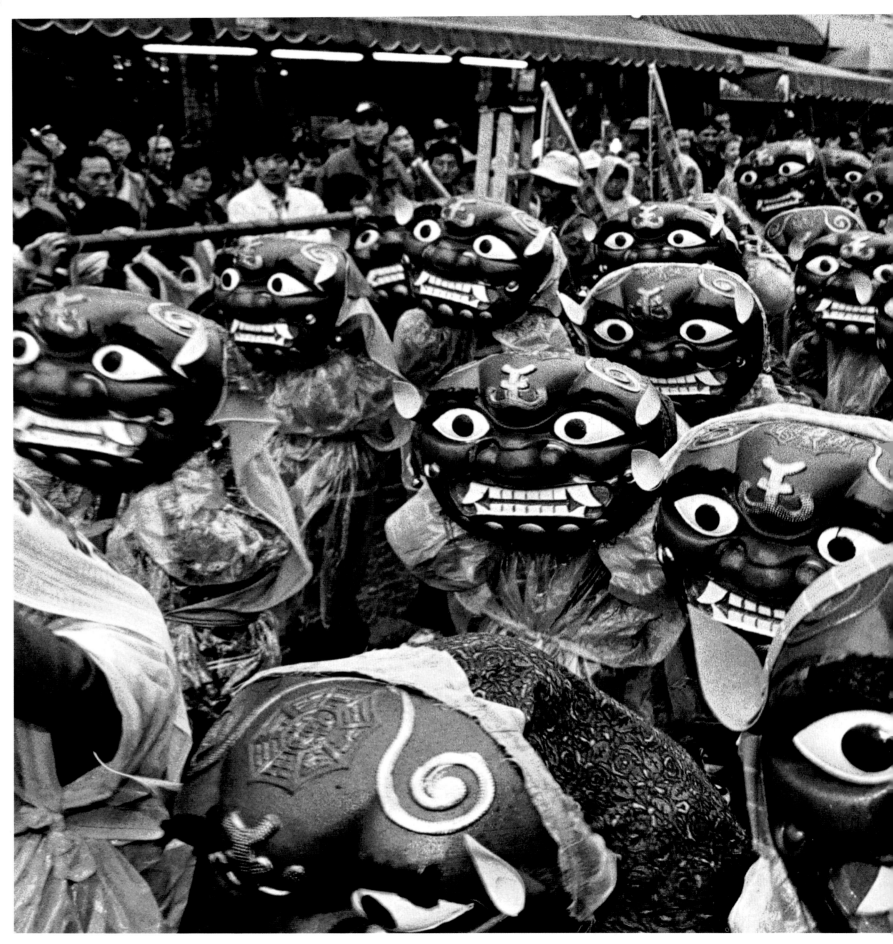

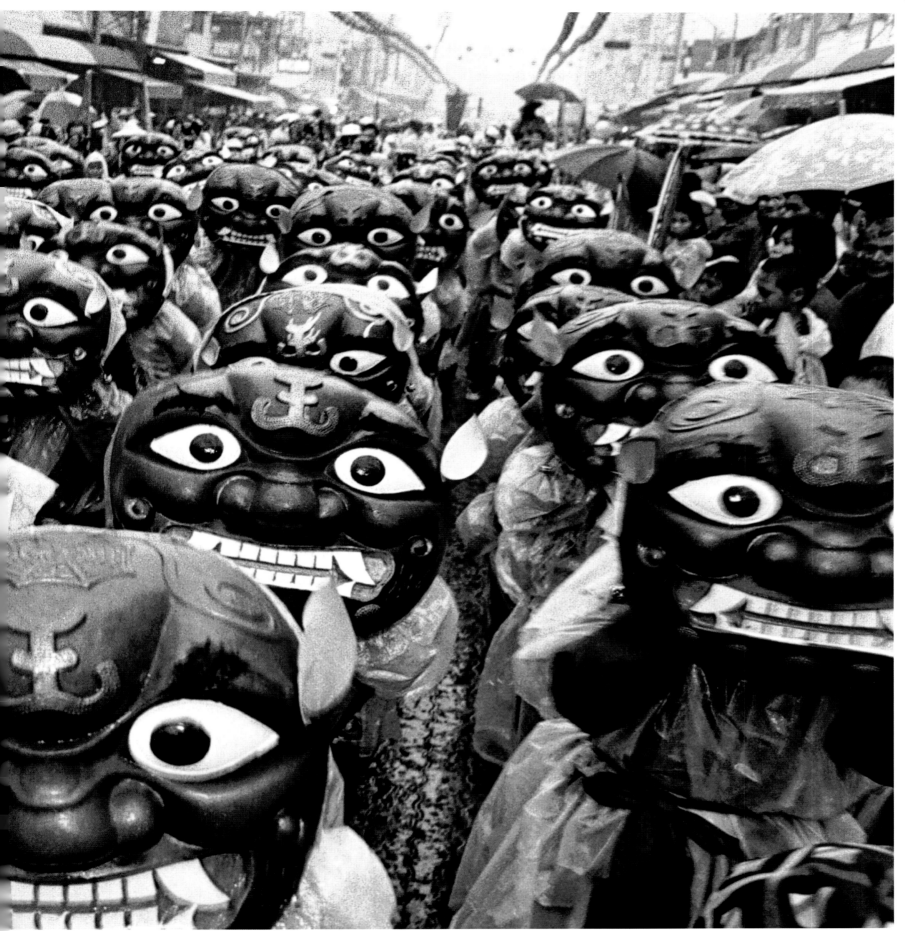

STUART FRANKLIN | Córdoba, Spain | 1998.
A Holy Week parade participant walks through the Juderia (Jewish Quarter).

CHAPTER THREE

life of the party

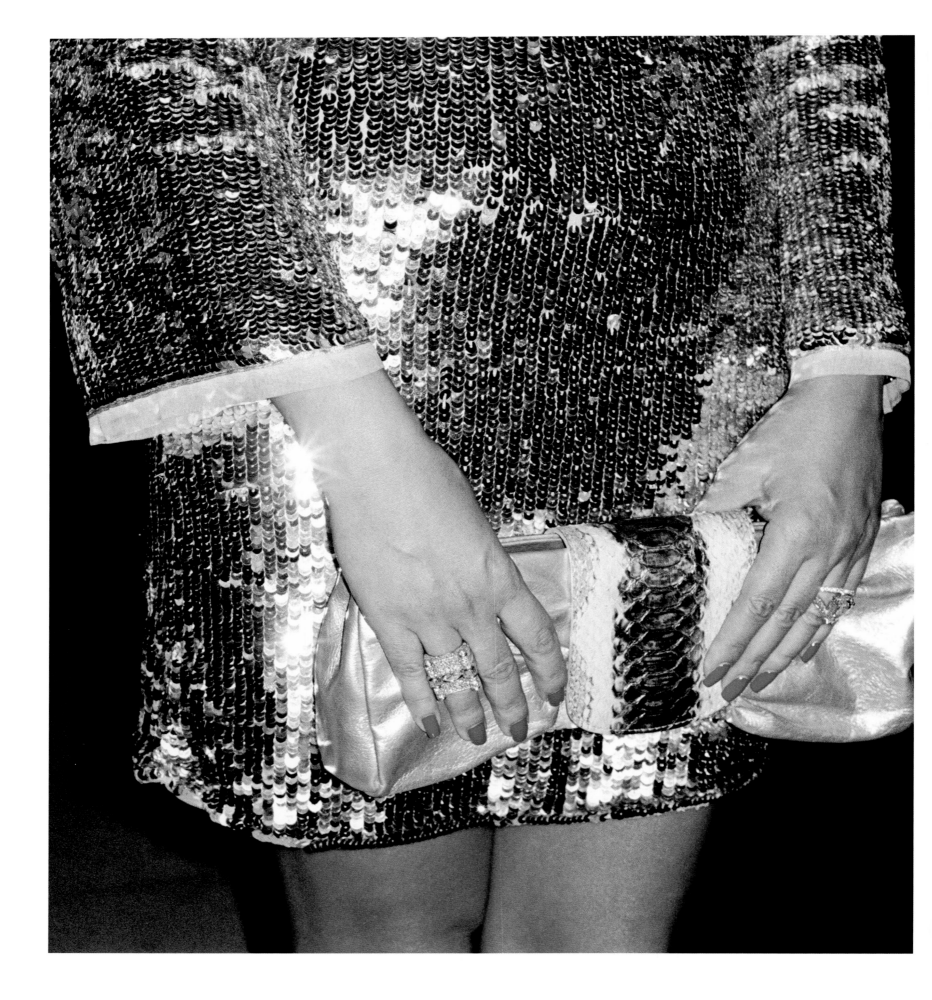

A couple of years after graduation, a group of my college friends got together one gray saturday morning in chicago to party.

The reason for the gathering was that some pals and their significant others who were going to graduate school in Iowa City were on fall break and had come to the Windy City for some urban action and a mini-reunion.

The celebration began with brunch. After that, we headed to Lincoln Park, which fronts Lake Michigan, and wandered around for a while, eventually getting in a spirited touch football game with some local folks. Following postgame drinks at a tavern, our group went to the Lincoln Park Zoo and spent a couple hours watching animals watching us.

When night fell, we were back in the apartment, looking down on the lake, listening to music, making and consuming a pasta feast, and getting somewhat inebriated. Sometime after supper, someone with a camera and a tripod herded everyone into a corner of the living room, set the timer, and took a group portrait.

The colors in that picture are muted because the light was low, and the scene is slightly out of focus. But so were we. The photo shows a bunch of young people with abundant hair, sporting jeans, flannel shirts, and sweaters, looking bleary, full, and happy to be partying together again one carefree autumn day on their journey into adult life.

That image of college friends circa 1977 is meaningful only to those of us who faced the camera that day. As an aesthetic object, our picture does not rise to the level of fine art or photojournalism. It is a vernacular photo, a snapshot not unlike billions of other snapshots taken by family and friends at similar gatherings around the world. Like those pictures, however, it says a great deal about the relationship between photography and celebrations, especially parties.

A party, by definition, is a social gathering for conversation, refreshments, or entertainment. Used as a verb, party means to go to parties, especially a series of parties, or, more informally, to enjoy oneself thoroughly and without restraint. As the photographs in this chapter show, parties and partying lend themselves to picture taking.

That has been the case since photographic technology became more portable and affordable in the late 19th century. Parties are attractive photographic subjects for a number of reasons. Oftentimes, the celebrators, like my college crowd, want to commemorate the occasion, whether it is a mini-reunion, a fancy-dress ball, an evening in a nightclub, a tea party, or a rock concert.

Parties also offer action. Contrary to my group portrait example, party scenes are seldom static. At parties, people talk, gesture, mingle, eat, drink, laugh, listen to music, and dance. At discos, clubs, dance halls, and juke joints, most of the crowd is there to drink, to dance, and maybe to find someone interested in romance. David Alan Harvey's photo of a vast crowd of young people boogying in an ocean of suds at a disco in Ibiza, Spain, is the quintessential party picture.

It also raises the point that when people are partying, their inhibitions may fade. The tales of the quiet co-worker dancing around with a lampshade on his head at the office Christmas party or doing "the worm" to his favorite song do have some basis in real life. After a few drinks, even staid, senior executives have been known to take to the dance floor to do the "electric slide," or

MARTIN PARR I Dubayy, United Arab Emirates I 2007.
A guest attending a party at the Grosvenor House Hotel

to imitate the late Michael Jackson's moonwalk. Such occurrences are, of course, best photographed with extreme discretion.

Even at parties where inebriation is not a major factor, women and men behave in ways that are beyond everyday norms. People dress up for many festive occasions, whether it is the posh bash in Dubayy for which the woman in Martin Parr's photo at the beginning of this chapter donned a glittering, sequined dress, or the dance floor at Queen Charlotte's Ball in London in 1959, across which Henri Cartier-Bresson saw swirling tuxedos and gowns.

Spectacle also enlivens many party photographs. This is evident in Cartier-Bresson's aforementioned picture, and in Johann Rousselot's shot of dancers at a Dior-sponsored event in Paris, cavorting pink flamingos mirrored in the polished stage at the Lido nightclub on the Champs-Élysées. While the photo shows an eating establishment rather than a party, Gerd Ludwig's picture of the Turandot Restaurant in Moscow, dripping in baroque gilt and featuring a quartet dressed in historical costumes providing background music to the wealthy patrons, is completely off the chart in terms of spectacle.

Besides the eye-catching settings of some public venues, parties also provide endless scenes of human interaction. These scenes can be dramatic, comedic, or even tragic. Thanks to photography, we have the luxury of looking at these interactions frozen in chemicals and time, or on our cell phones and computers, in a way that would be impossible amid the noise and motion of the actual event.

Looking at Erich Hartmann's photograph of a dressy crowd at a cocktail party in Charlotte, North Carolina, in 1979, I cannot help but try to parse the body language, and what Nobel laureate Elias Canetti described as "the game of the eyes," of the four women in the foreground. Unlike at a real party, we can stare at their picture as long as we like without causing anyone discomfort.

The woman in the center, mouth agape and eyes almost shut, appears to be laughing loudly. To her right (our left) stands a young woman sporting a string of pearls. She seems to be enjoying the conversation. The blond lady in the right foreground holds her drink and cigarette in her left hand, as she looks directly at the pearl wearer. Something about the set of the smoker's jaw suggests she is telling the tale. Judging from the woman in the floral dress occupying the left foreground, glass forever poised at her lips, eyes aimed into the room, the story is neither amusing nor interesting.

What was actually being said, I have no idea. But that would most likely be the case had I actually been in the room with the women. Whether George Plimpton, the late writer and actor who stares straight at us in Larry Fink's black-and-white image taken in a popular Upper East Side restaurant, is angry at Fink or at being photographed or at the fact that a fellow across the table is kissing the neck of the young blond woman is anyone's guess. Plimpton may not have been perturbed at all. But his expression, combined with the setting, the people, the action, and the medium, give Fink a picture that could have come from Italian film director Federico Fellini's La Dolce Vita.

Thomas Hoepker photographed a different kind of mini-drama at an opening party for an art exhibition at a SoHo gallery party. For some people, especially film stars, artists, and politicians, as well as those aspiring to those vocations, the primary reason for going to a party is to see and be seen. There are also party-goers who function like worker bees, buzzing about any celebrities who happen to be present and conveying food and drink to the queens and kings of the ball. For others, such as journalists, attending parties can simply be part of their job.

As a critic, I've been to more gallery and museum openings than I can count. Some were fun, some not. I quickly learned that it is almost impossible to actually look at the art during the opening party. There is too much noise, too many people, and too much tension and pretense. Attendees are there because they are friends of the artist, or the gallery owner, or they are a collector or curator, or they're simply interested in the artist's work.

Hoepker's photo nails the Soho atmosphere circa 1983. I doubt he posed the man and woman. They dressed to get noticed and they posed

themselves. Their appearance and outfits contrast and complement each other so perfectly, and their gestures and body language are so theatrical, that the scene borders on staged. The woman's clawlike fingernails add a touch of feline menace to the picture. Given the amount of cattiness I've encountered at various openings, I think that telling detail must have drawn the photographer's eye.

The eyes of many of the photographers featured in this chapter, as well as the eyes of professional and amateur photographers in general, have been enchanted through the years by dancing. There is no precise record of when dancing became a part of human life, although it clearly predates civilization. Archaeological evidence, such as cave and tomb paintings in India and Egypt, shows human beings dancing in prehistoric times.

Experts say that dancing may have been used to convey myths or express feelings for the opposite gender in mating rituals. Before the invention of written language, dances were probably a way to pass history and social norms from one generation to the next.

As civilizations developed, dancing was soon included in written records. The rhythmic movement of human bodies fascinated thinkers and artists. In his *Poetics*, written around 350 B.C., Artistotle, the great Greek intellectual, wrote, "In dancing, rhythm alone is used without 'harmony'; for even dancing imitates character, emotion, and action, by rhythmical movement."

His observation speaks to the importance of dance in ancient Greek culture. Dancing has continued to be an important part of Western culture and cultures around the world. Dance and dancers have inspired numerous sculptures, paintings, drawings, and photographs over the centuries. Henri Matisse's "The Dance" springs to mind.

Whether watching a person dance tells us something about what he or she does or feels, or offers insight into the man's or woman's character, is debatable. Martha Graham, the legendary choreographer, once said, "Dancing is the hidden language of the soul."

Watching people dance at parties, as opposed to onstage with the Martha Graham Dancers, one can only conclude that some souls are in anguish. Then again, as Dave Barry, the American humorist, once wrote, "Nobody cares if you can't dance well. Just get up and dance."

At parties and celebrations around the world, men, women, and children do just that. They dance alone. They dance at home with parents and siblings. They dance in discos full of suds, on the bare dirt of African or Indian villages. They dance in elegant ballrooms and nightclubs or city squares, gymnasiums and church basements. They dance holding each other close or at arm's length. They dance wearing tuxedos and gowns, or wearing a cowboy hat, gun belt, and shiny jeans like the woman William Albert Allard photographed whirling an imaginary lasso over her head at an Old West party in Houston, Texas. And some do not dance, period. What that says about a nondancer's soul, I'm not sure. It may simply be a statement about arthritic knees and pain.

I don't recall any dancing at the mini-reunion of my college classmates in Chicago. Maybe our legs were worn out from walking and football. Or maybe the food and drink were weighing us down after a long day of partying. Celebrations ebb and flow. There are high points and low points in the action. It makes no difference if it involves thousands of people, like the New Year's celebration in Times Square in New York City, or two people, like the glum, young couple David Butow photographed in a club. After all the preparation, anticipation, and activity, every celebration ends.

A picture at the end of this chapter was taken by Johann Rousselot. It shows two young dancers resting backstage at a cabaret in Fatehpur Sikri, Rajasthan, India. One girl has her arms around the other. They stare straight into the camera, looking calm, relaxed, and glad to be together, much as my friends and I looked at the end of our party years ago. In a world where strife is in ample supply, such pictures remind us that whenever we get the chance, life and friendship are worth celebrating. ∎

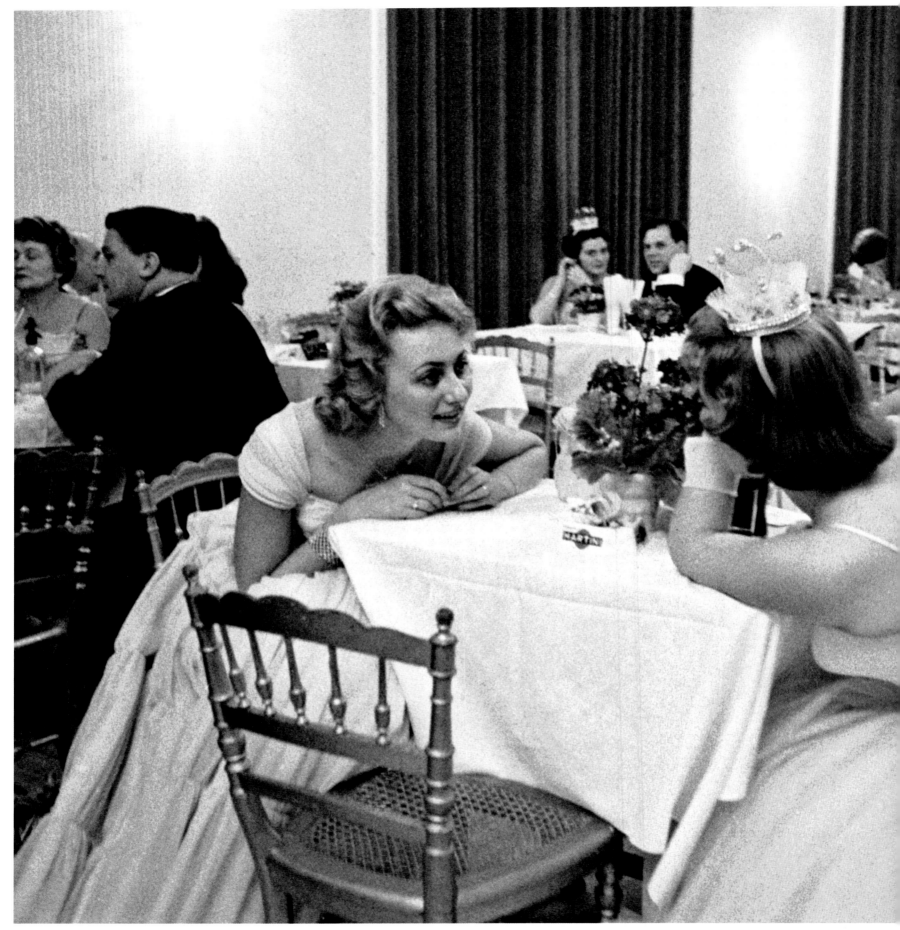

Let us drink and be merry,
dance, joke, and rejoice,
With claret and sherry, theorbo and voice!
The changeable world to our joy is unjust,
All treasure's uncertain,
Then down with your dust!
In frolics dispose your pounds,
shillings, and pence,
For we shall be nothing
a hundred years hence.

—THOMAS JORDAN

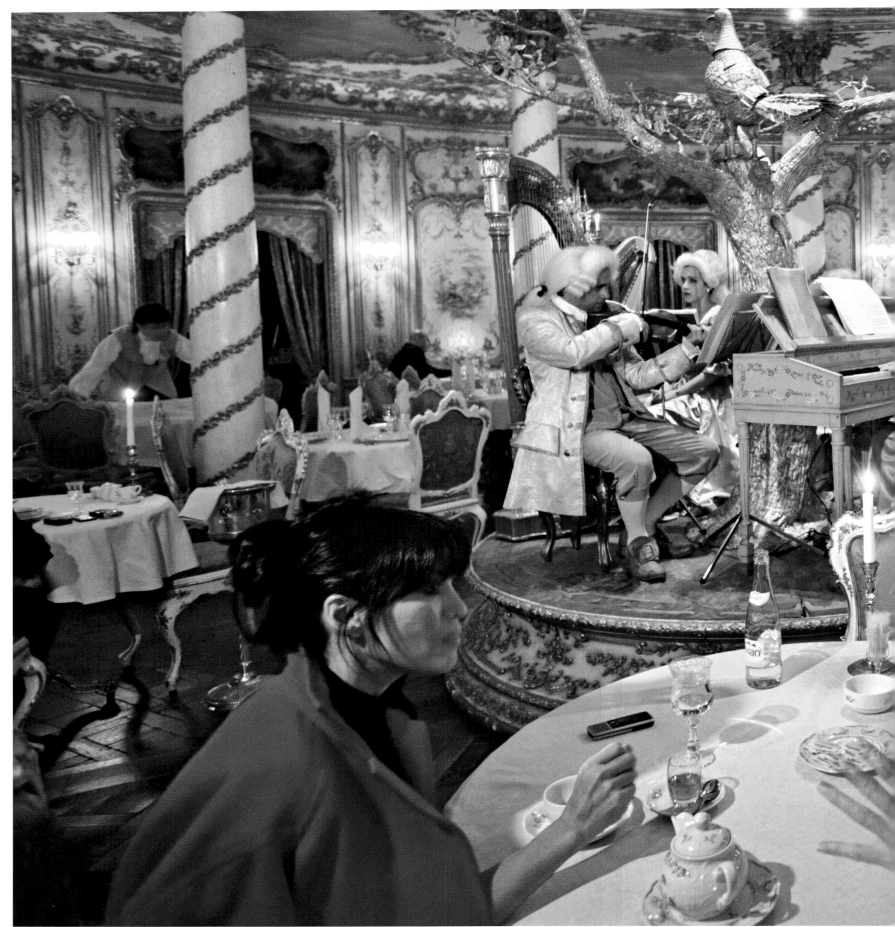

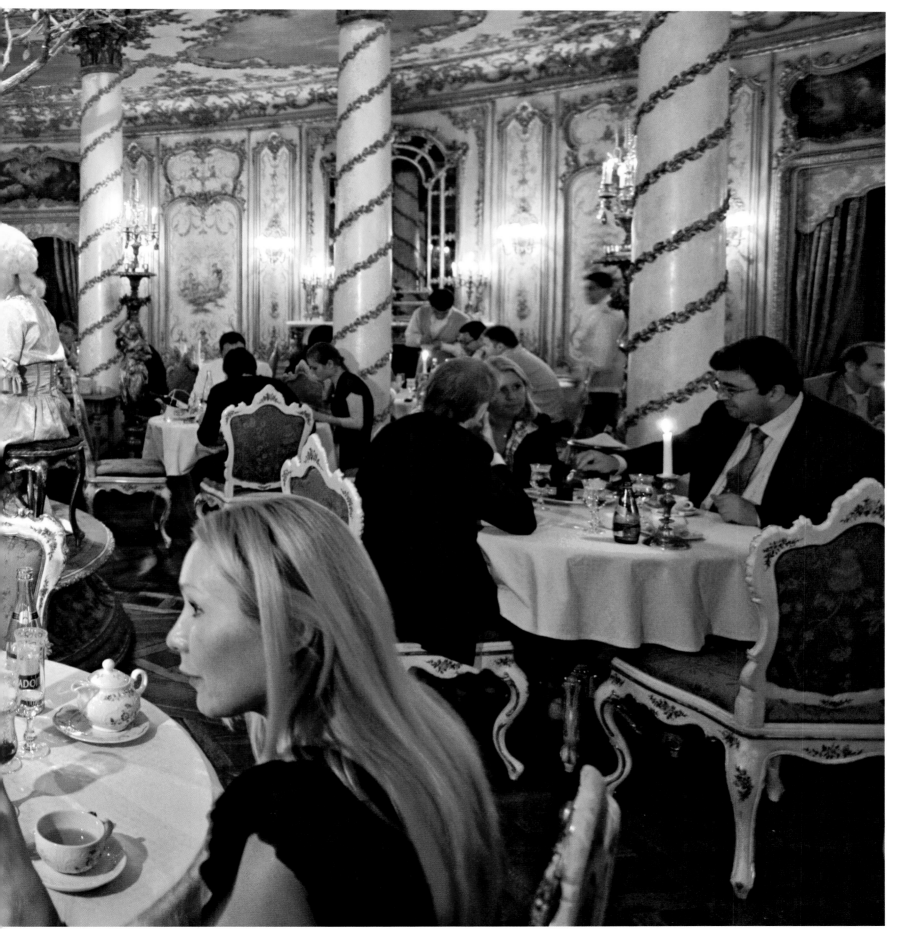

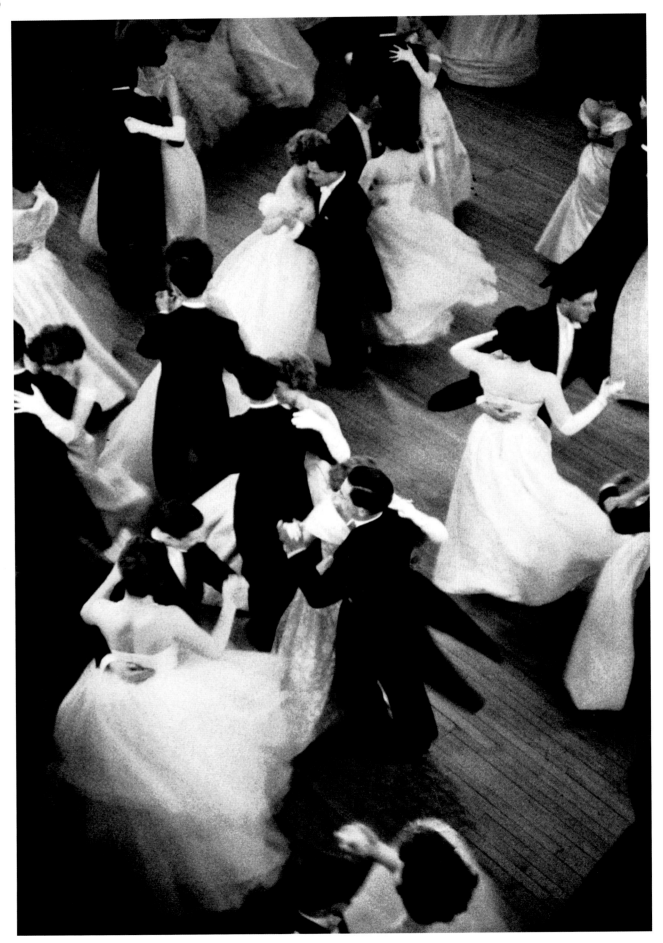

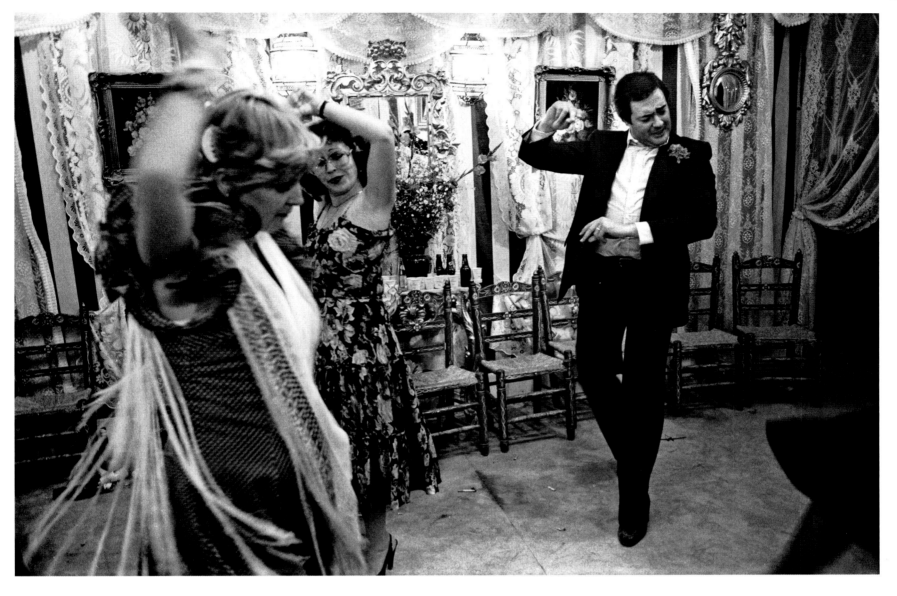

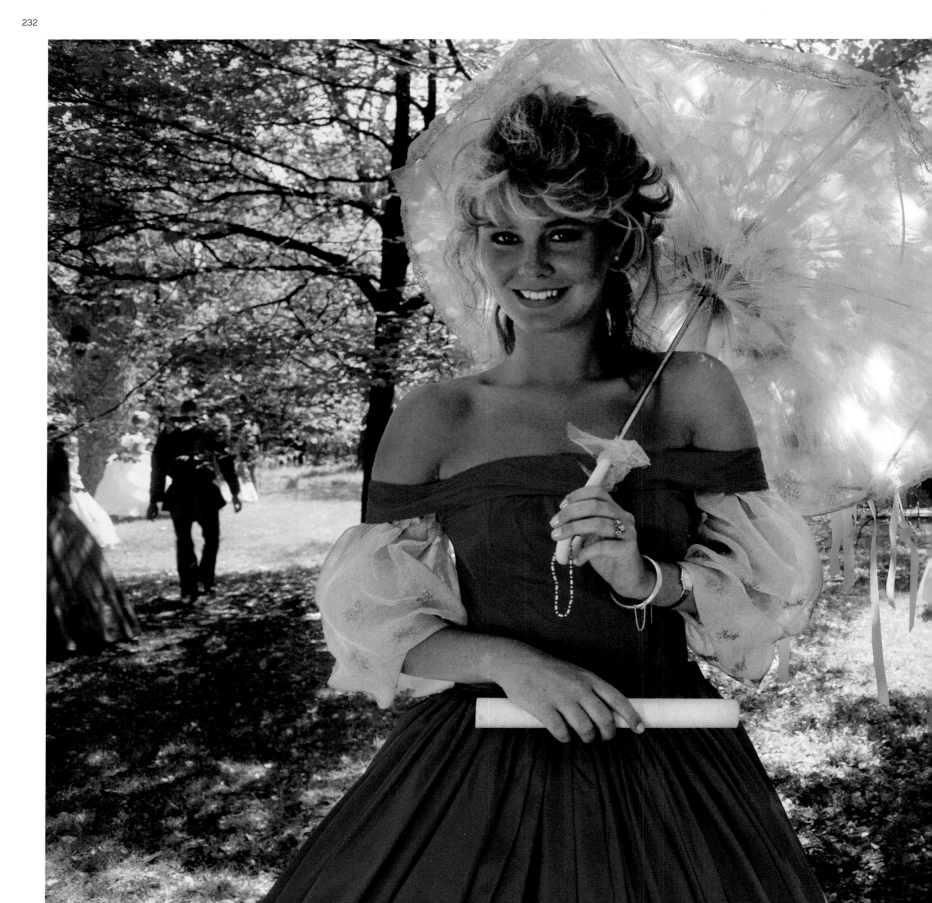

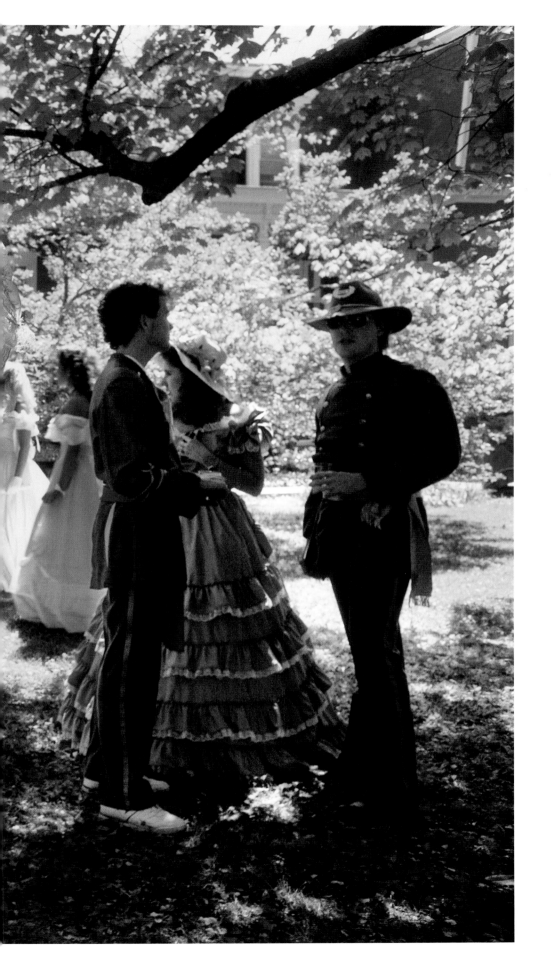

WILLIAM ALBERT ALLARD I Oxford, Mississippi I 1987. Students at Ole Miss dress up for a fraternity's Old South lawn party.

FOLLOWING PAGES: SAM ABELL I Tokyo, Japan I 2000. Musicians play for guests at the Emperor's Garden Party at the Imperial Palace.

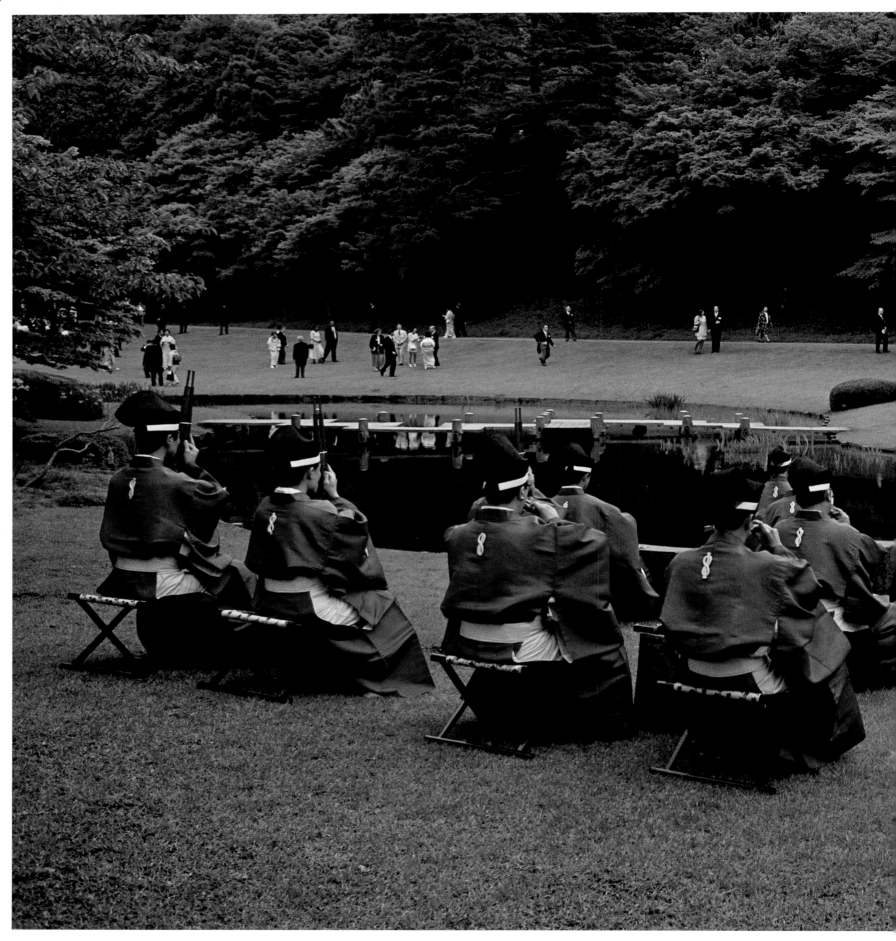

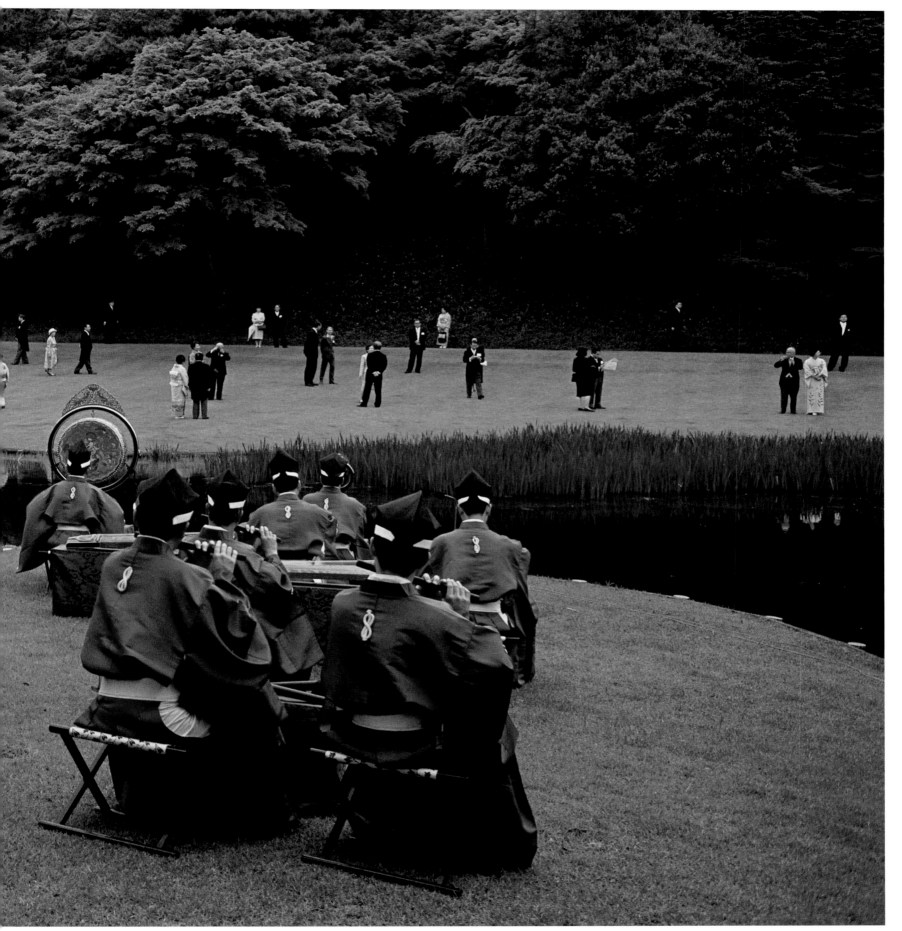

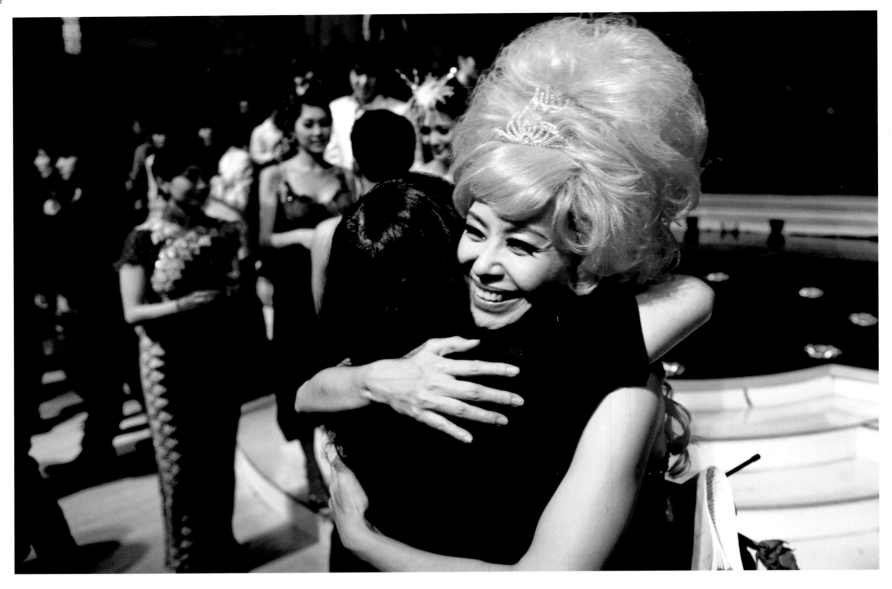

ESPEN RASMUSSEN I Changsha, Hunan, China I 2008.
Winning participants congratulate each other after advancing to the next round of the
most popular television show in China, *Strictly Come Dancing*.

OPPOSITE: JOHANN ROUSSELOT I Paris, France I 1992.
A cabaret show at the Lido on the Champs-Élysées launches a new Dior fragrance.

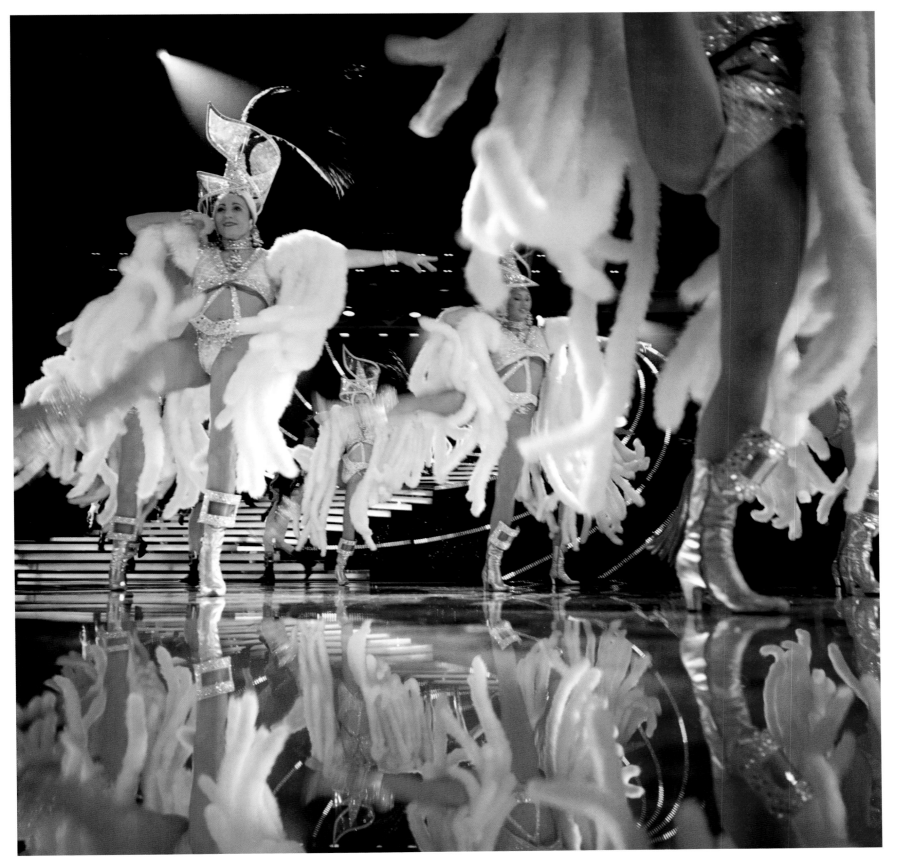

ERICH HARTMANN I Charlotte, North Carolina I 1979.
A debutante ball at Hibernian Hall

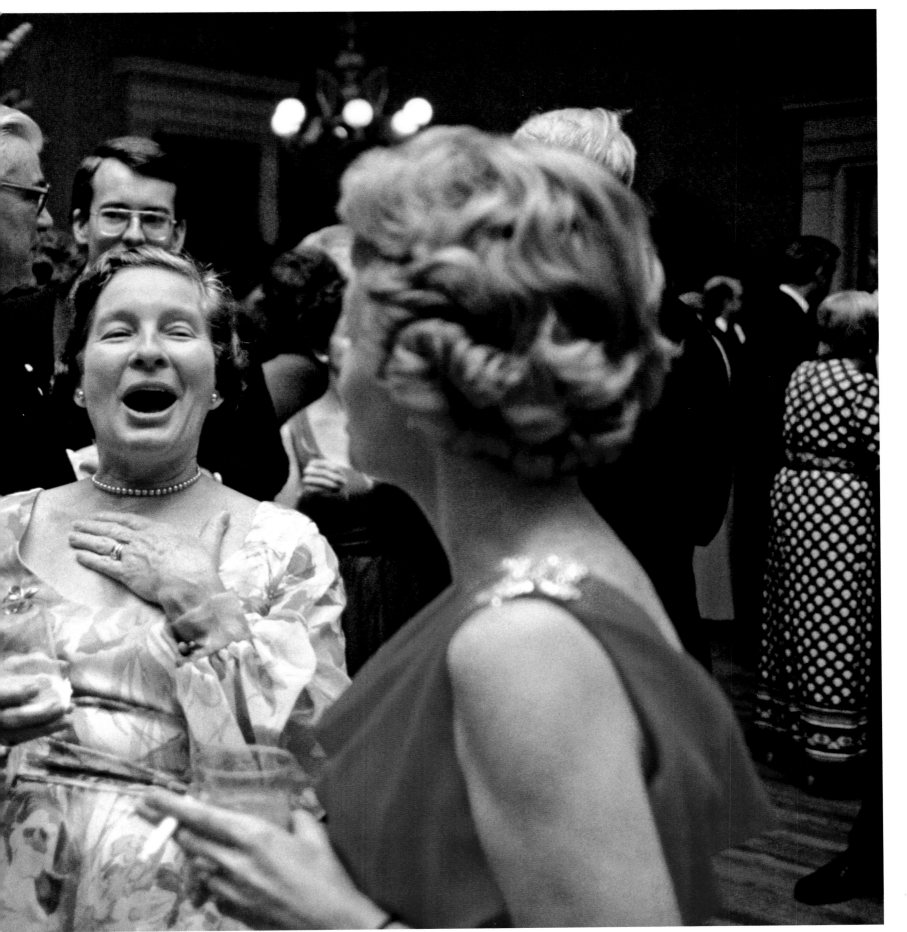

LARRY FINK I New York City, New York I 1999. George Plimpton (center) and models pose at Elaine's Restaurant for a *Detour* magazine fashion shoot.

FOLLOWING PAGES: MARTIN PARR I Chew Stoke, Somerset, England I 1992. The hostess does the honors at a garden tea party.

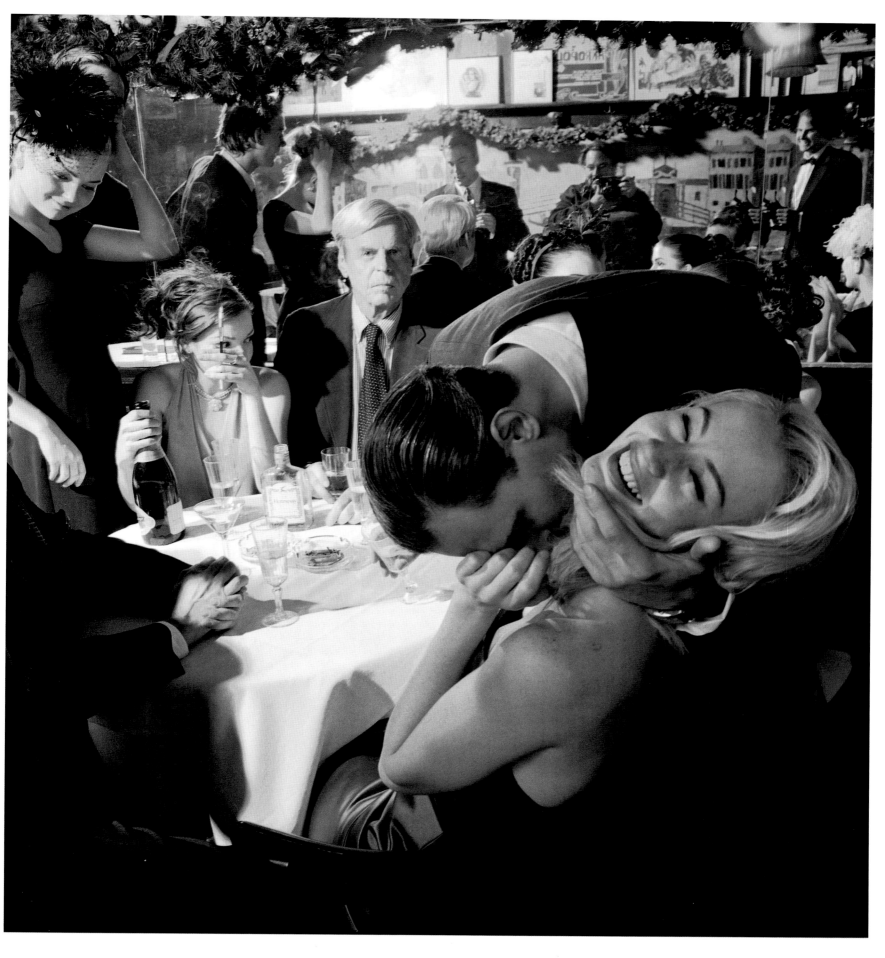

At a dinner party one should eat wisely
but not too well,
and talk well but not too wisely.

—W. SOMERSET MAUGHAM

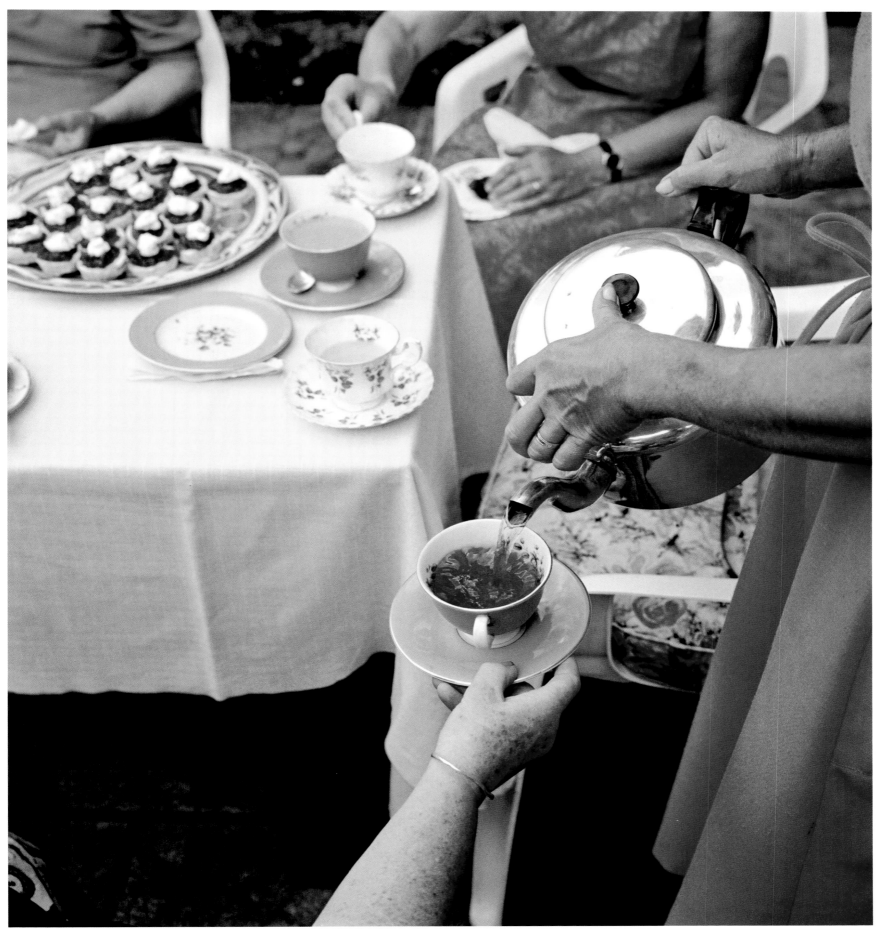

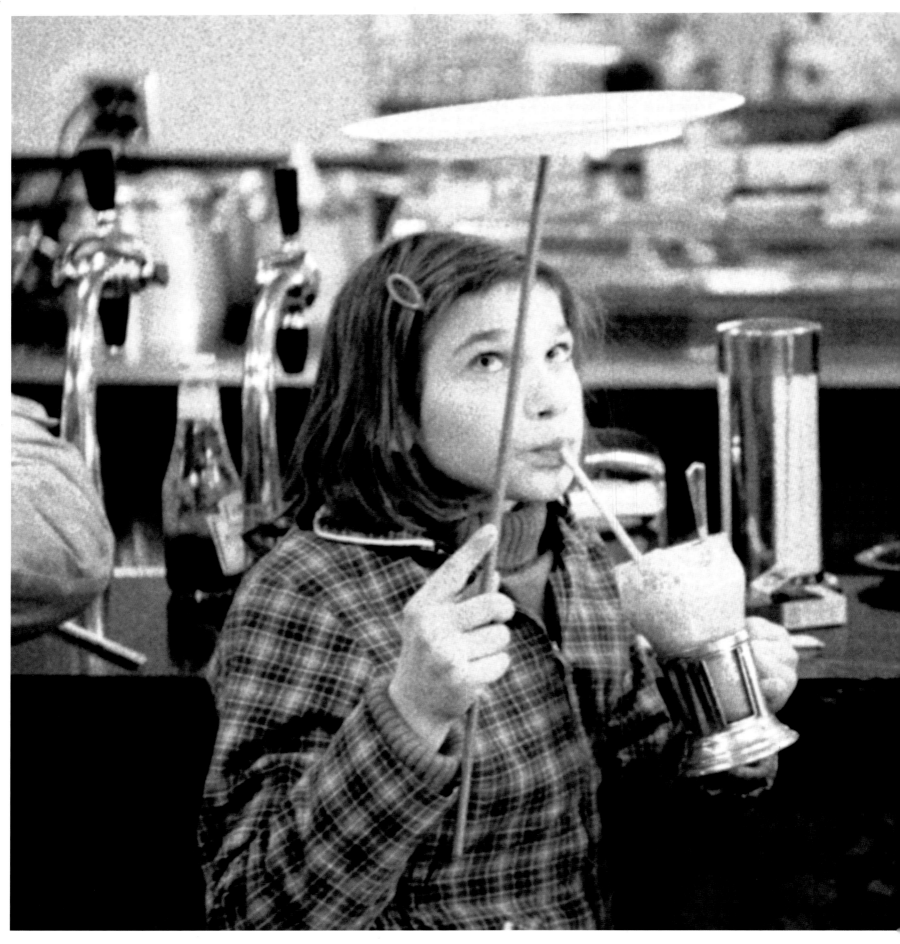

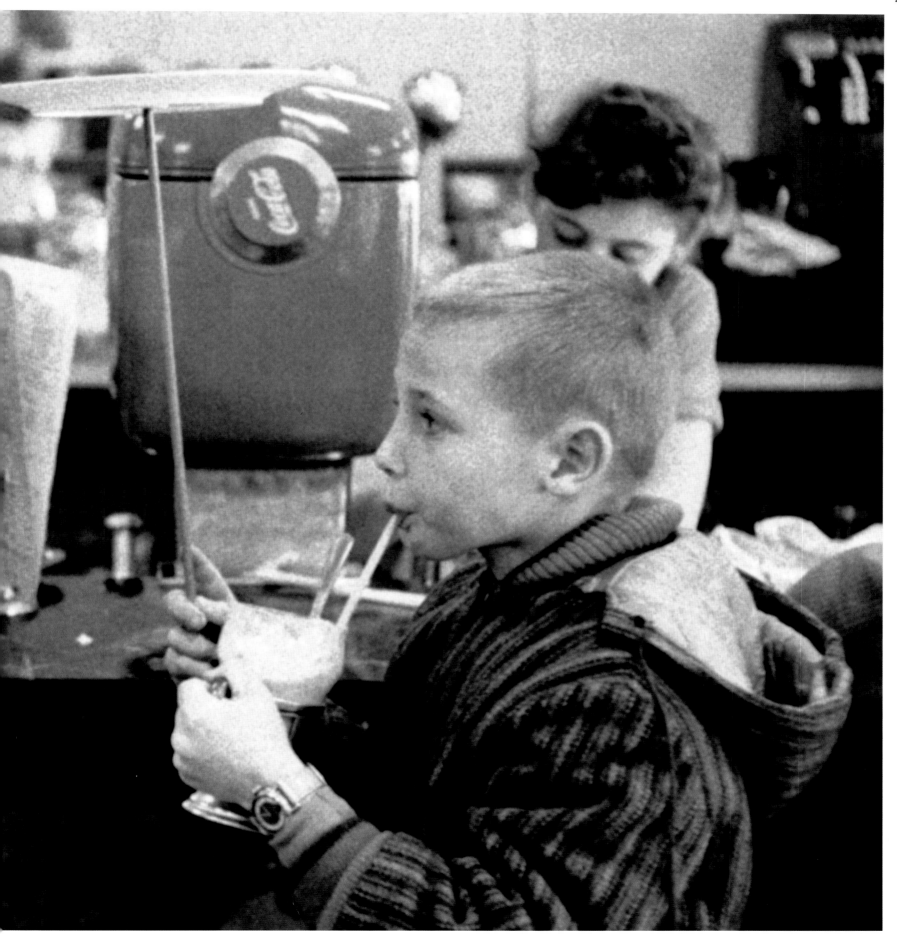

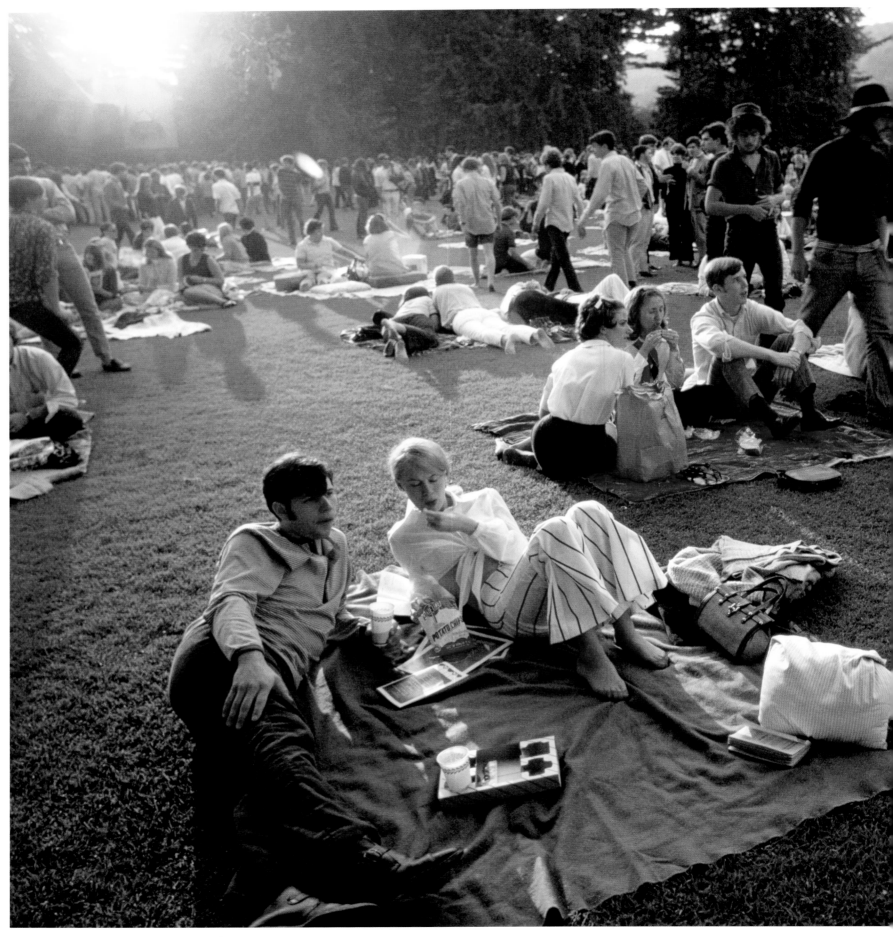

247

PREVIOUS PAGES: BURT GLINN I New York City, New York I 1959.
Spinning plates at the soda fountain

JONATHAN BLAIR I Tanglewood, Massachusetts I 1969.
Music lovers gather on the lawn for the Berkshire Festival.

CHIEN-CHI CHANG I Taegu, South Korea I 2007.
A lavish party for a child's first birthday

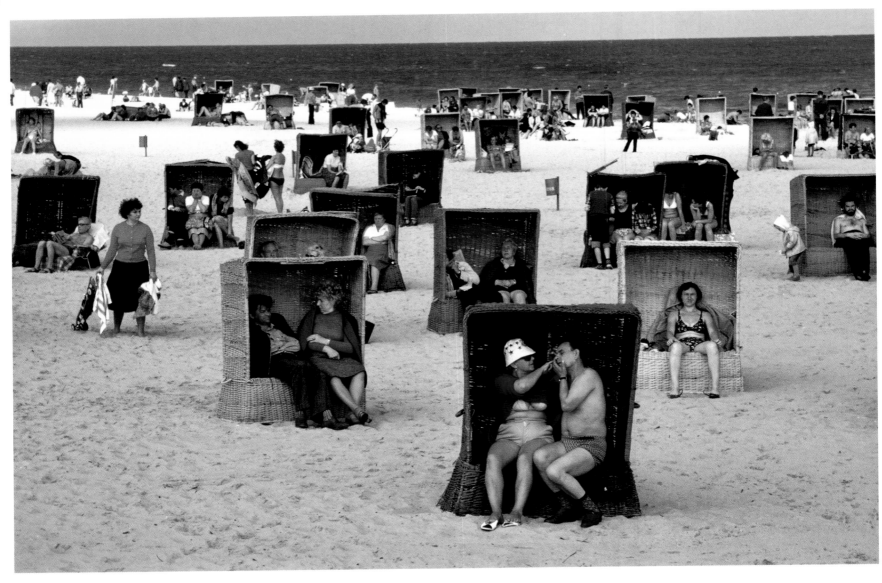

BRUNO BARBEY I Sopot, Poland I 1981.
Vacationers on a beach in the Pomerania region

OPPOSITE: WILLIAM ALBERT ALLARD I Grand Teton National Park, Wyoming I 1965.
College students dance at a party in the park's lodge.

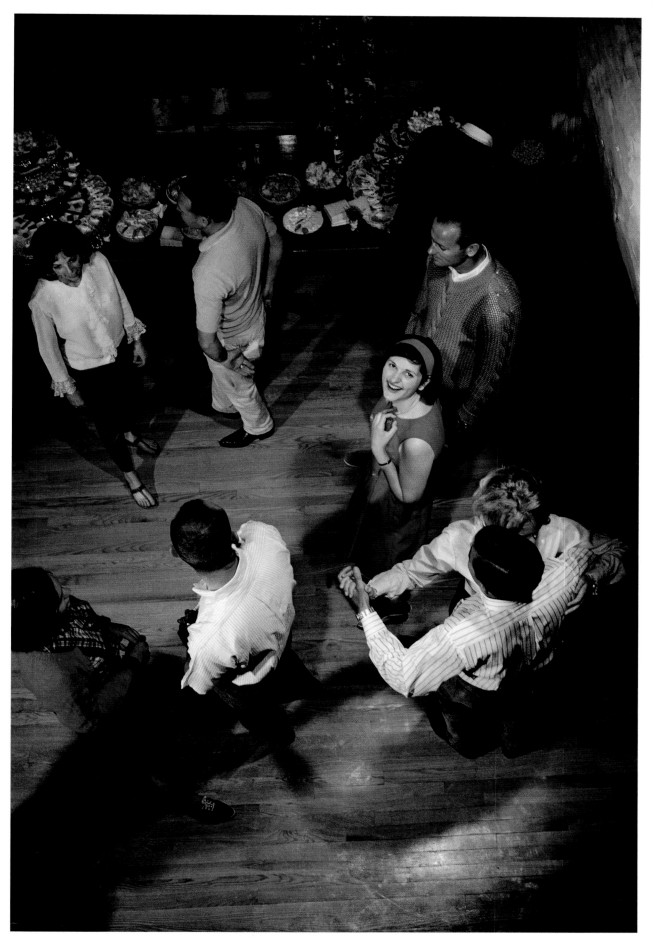

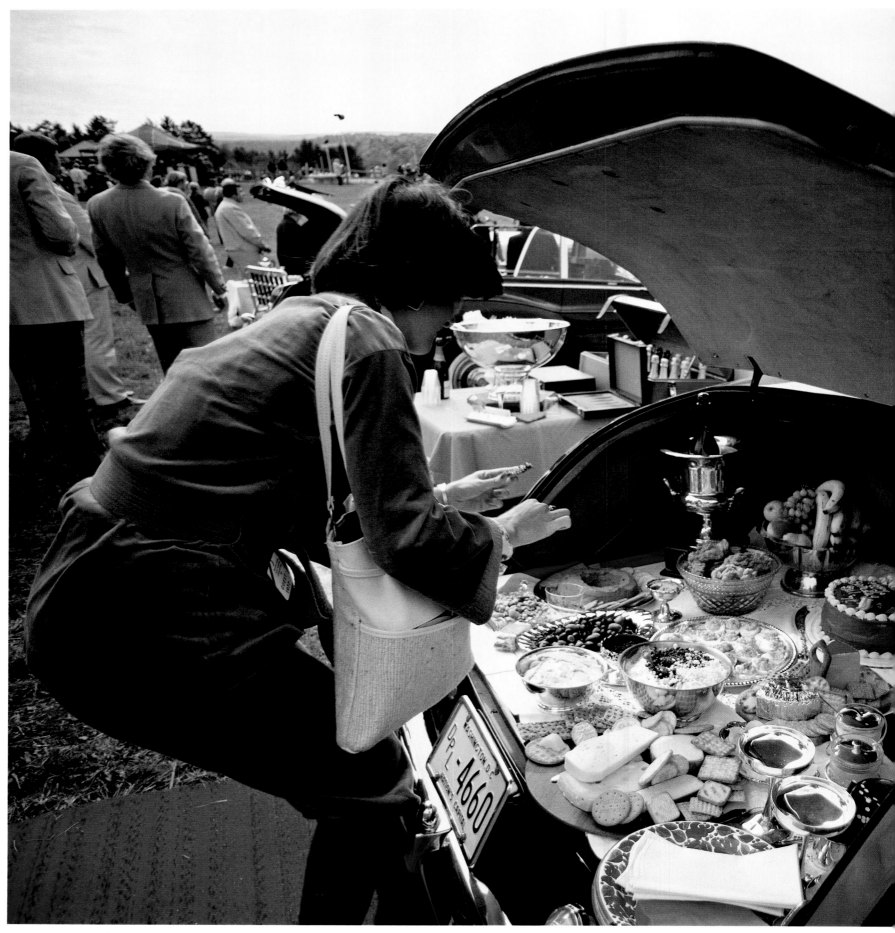

PREVIOUS PAGES: DAVID ALAN HARVEY I Nairobi, Kenya I 2005.
Friends enjoy an afternoon at the Ngong Racecourse.

CARY WOLINSKY I Pittsburgh, Pennsylvania I 1978.
An elaborate tailgate buffet in the trunk of a Rolls-Royce

At every party there are two kinds of people—
those who want to go home and those who don't.
The trouble is, they are usually married to each other.

—ANN LANDERS

PREVIOUS PAGES: JOHANN ROUSSELOT I Marbella, Spain I 2009.
A couple luxuriate with drinks on the beach.

CHRIS JOHNS I Ely, Nevada I 1991.
A legal bordello and bar along Highway 93

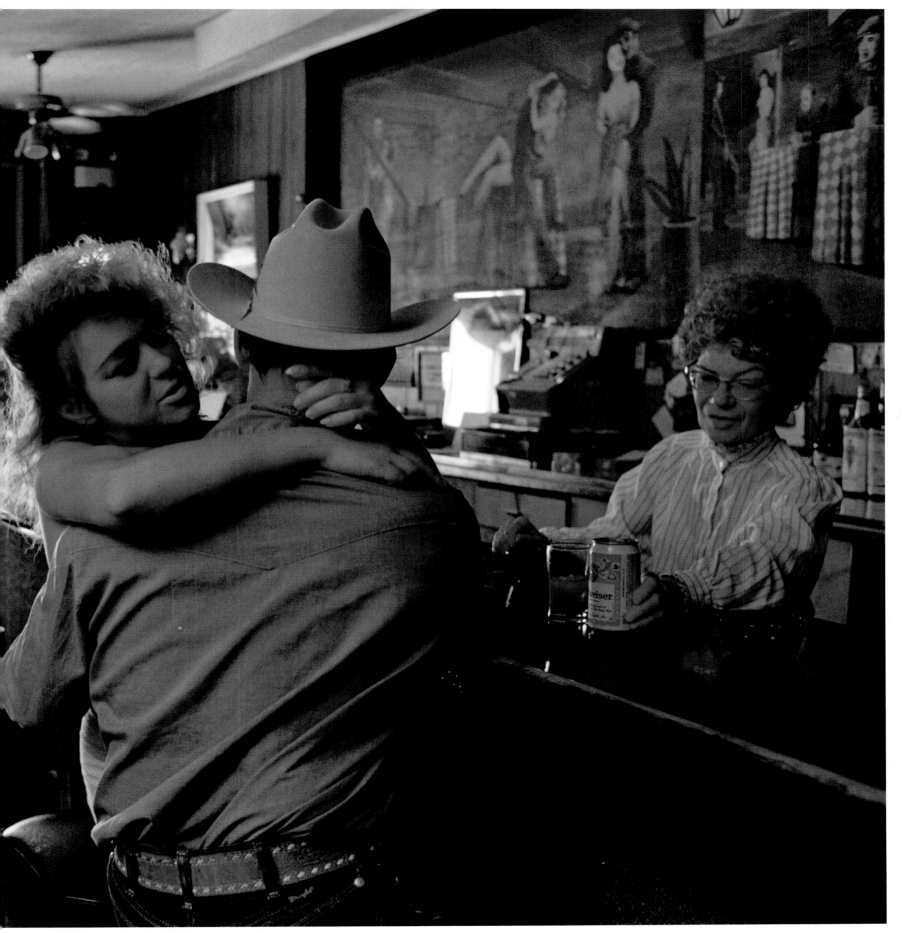

ELLIOTT ERWITT I New York City, New York I 1977.
Well-heeled children get a dance lesson in a Park Avenue lobby.

CATHERINE KARNOW I St. Petersburg, Russia I 2004.
Twins Valentin and Alexander Gudkov—who make their living playing Lenin
in films and commercials—toast the good life from Alexander's apartment.

THOMAS HOEPKER I New York City, New York I 1983.
An opening party at a SoHo gallery

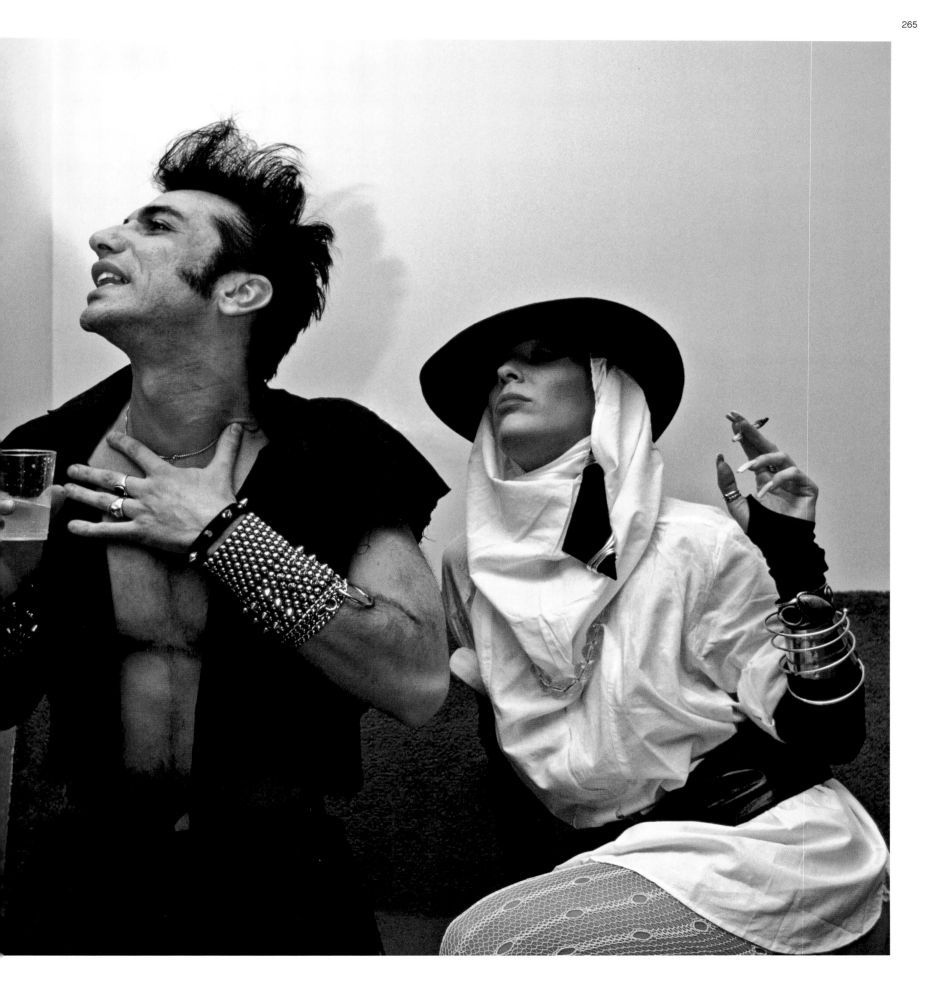

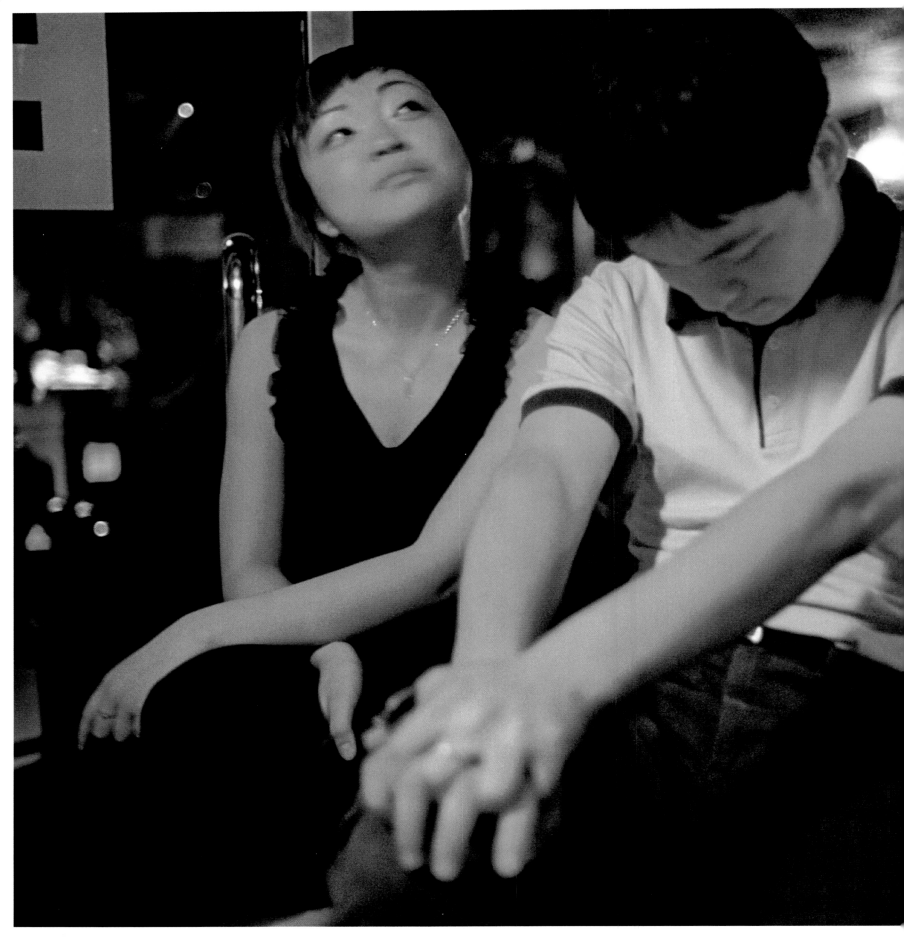

DAVID BUTOW I Guangzhou, China I 2002.
A young couple spend an evening at a nightclub.

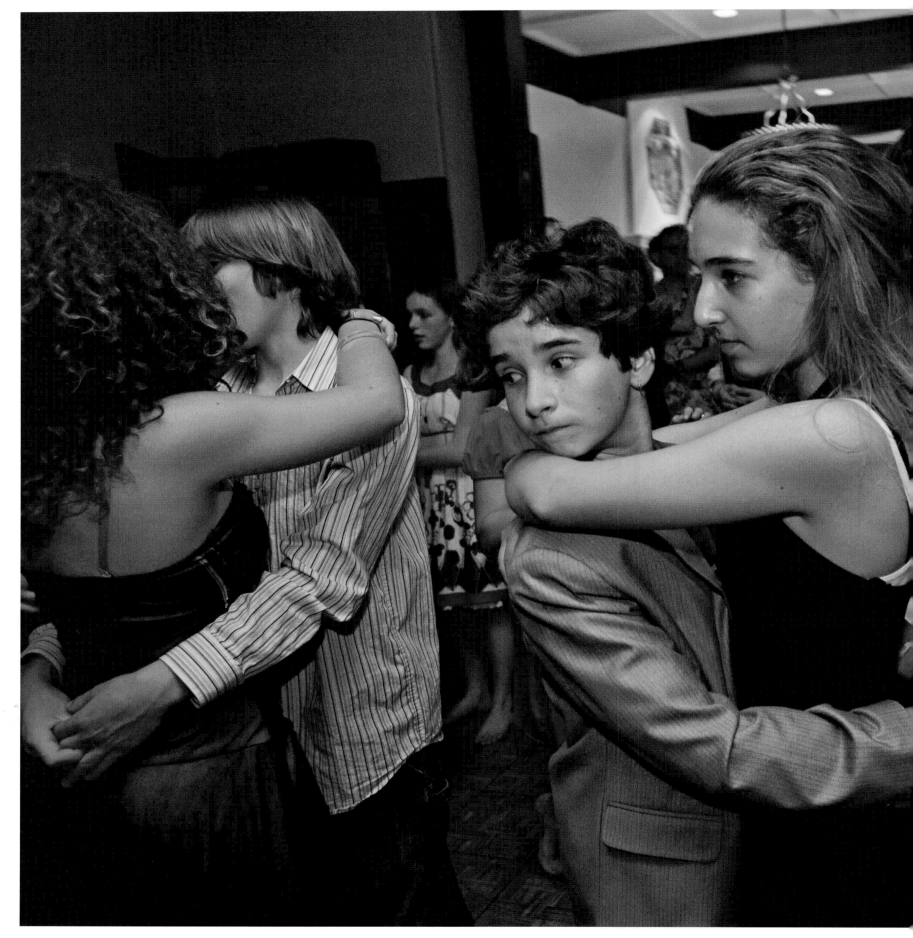

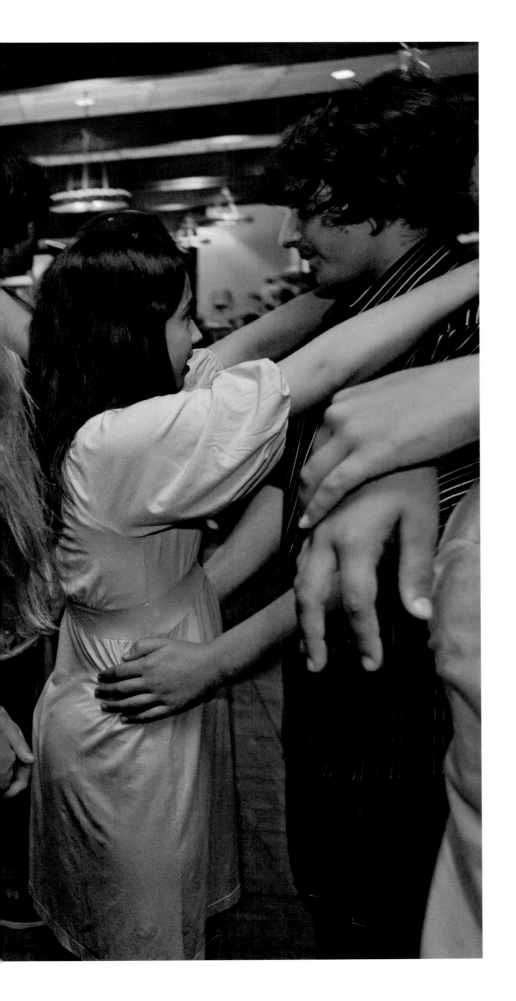

CATHERINE KARNOW I Berkeley, California I 2008.
Thirteen-year-old Liam Klaidman-Rinat dances
with a classmate at his bar mitzvah.

On with the dance! let joy be unconfined;
No sleep till morn, when Youth and Pleasure meet
To chase the glowing hours with flying feet.

—LORD BYRON

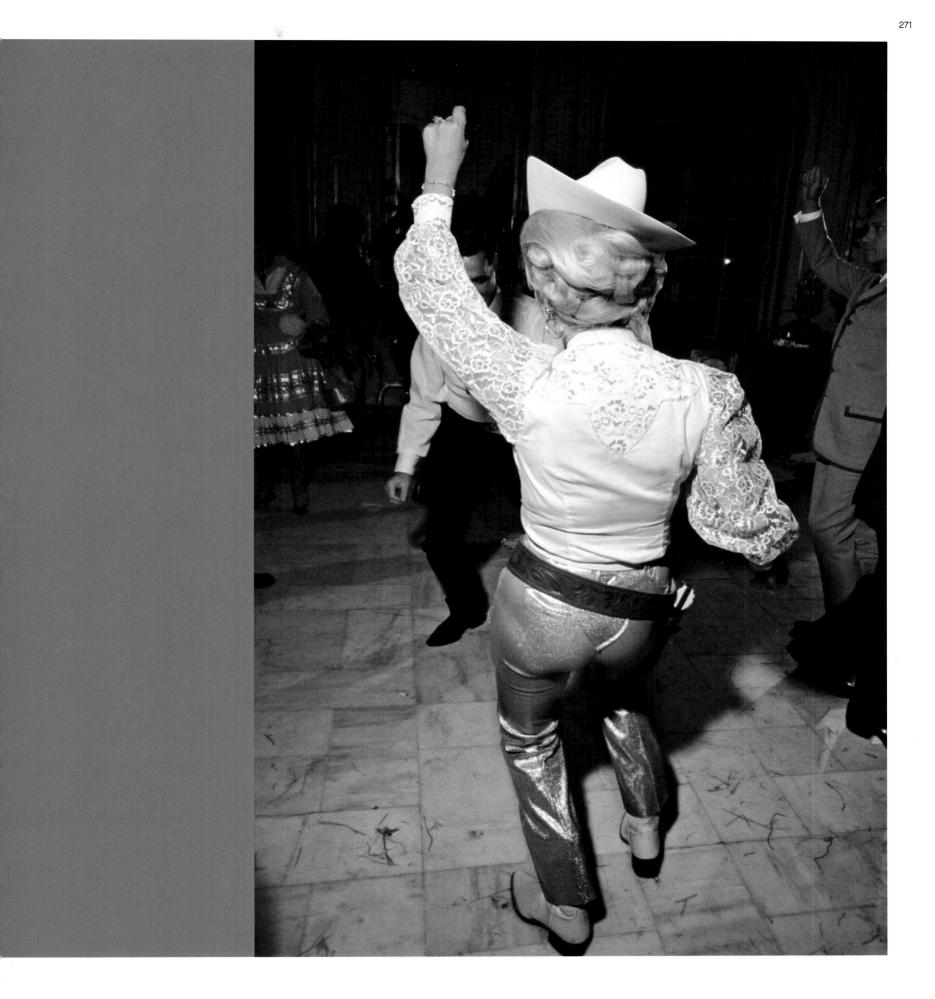

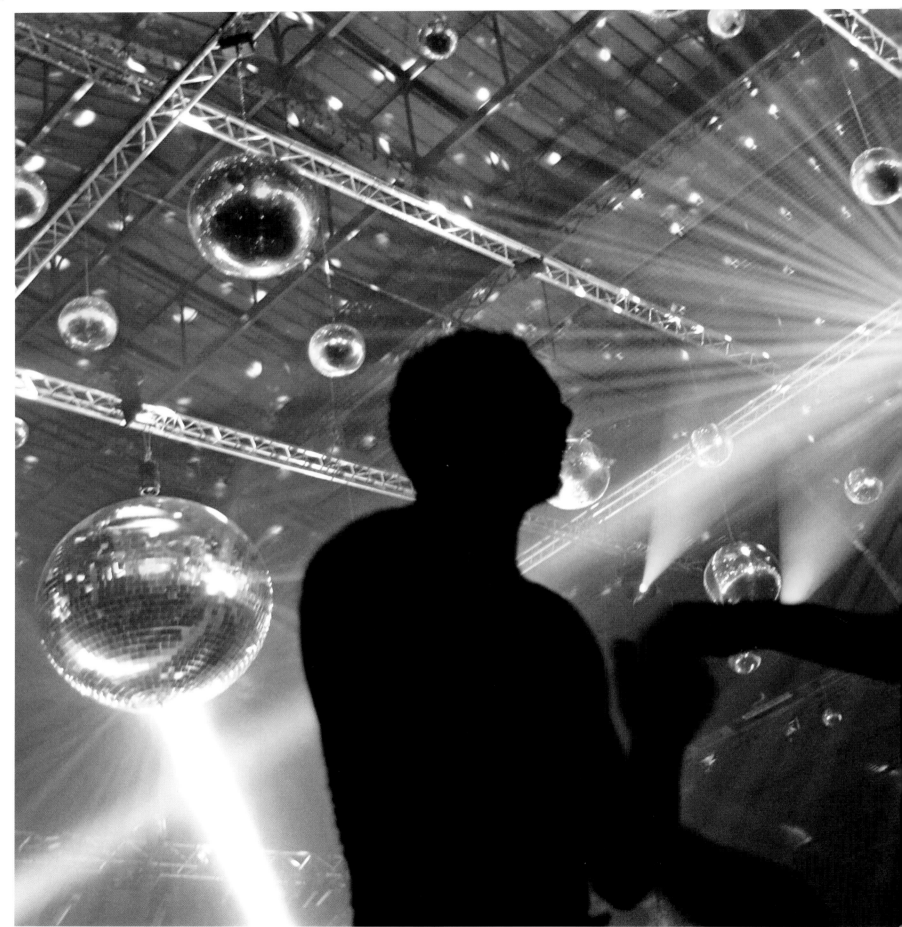

PREVIOUS PAGES: WILLIAM ALBERT ALLARD I Houston, Texas I 1966.
A flamboyant local dances at an Old West party.

JOHANN ROUSSELOT I Paris, France I 2009.
A private corporate party in La Villette's Great Hall

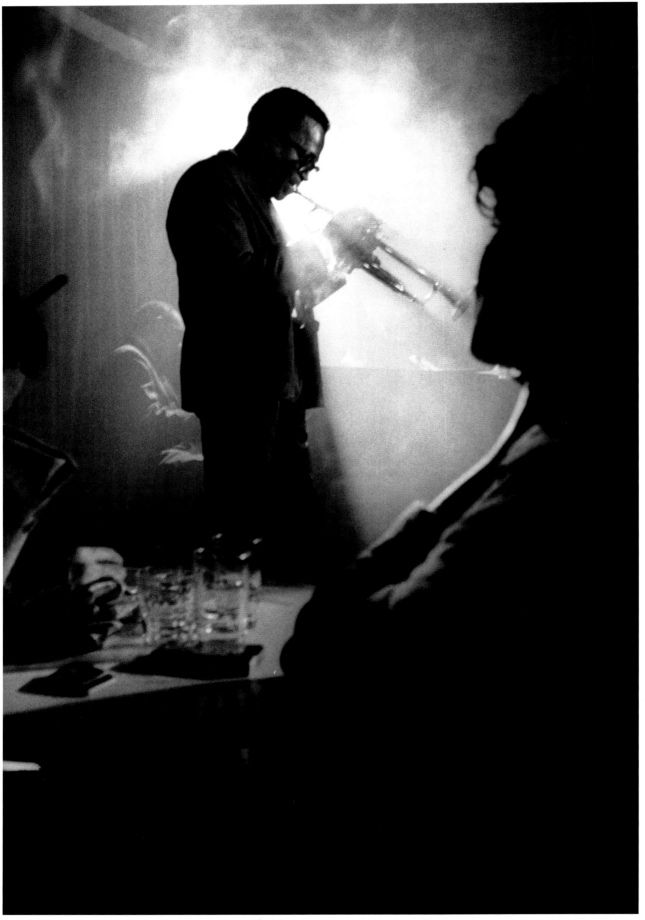

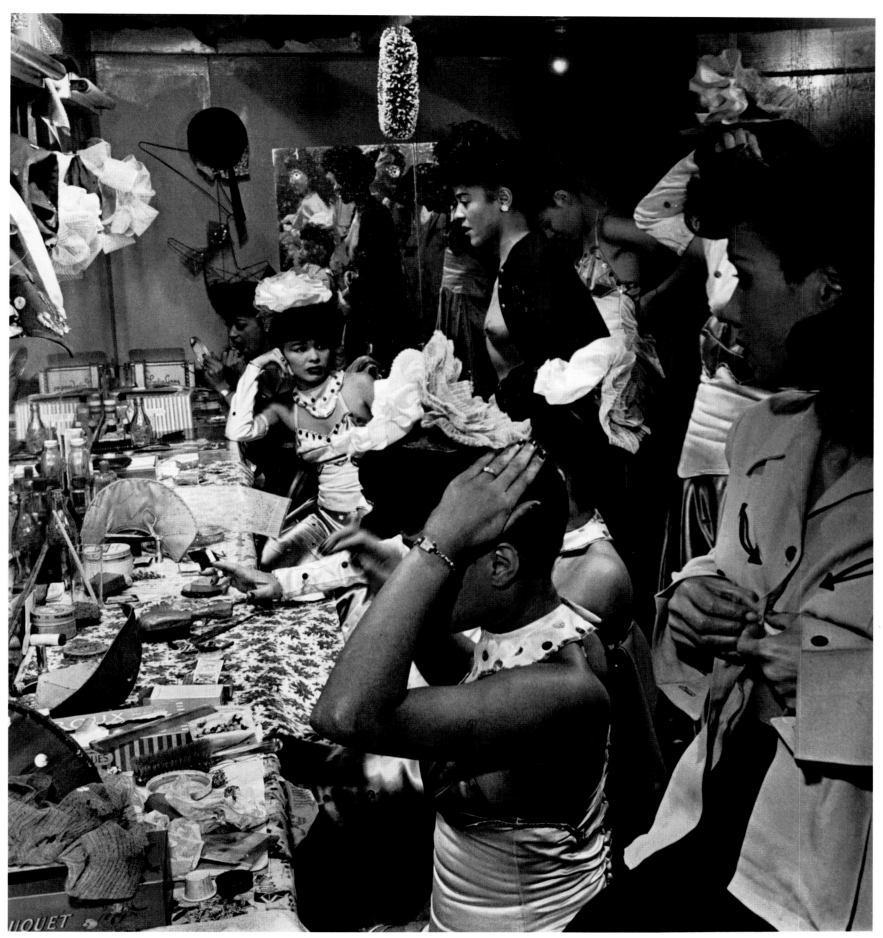

PREVIOUS PAGES, LEFT: DENNIS STOCK | New York City, New York | 1958.
The legendary Miles Davis performs at Birdland.

PREVIOUS PAGES, RIGHT: WAYNE MILLER | Chicago, Illinois | 1946.
Chorus girls backstage at the Rum Boogie Club

PIOTR MALECKI | Warsaw, Poland | 2007.
Guests linger at the bar during a party at the Vistula-Wólczanka store.

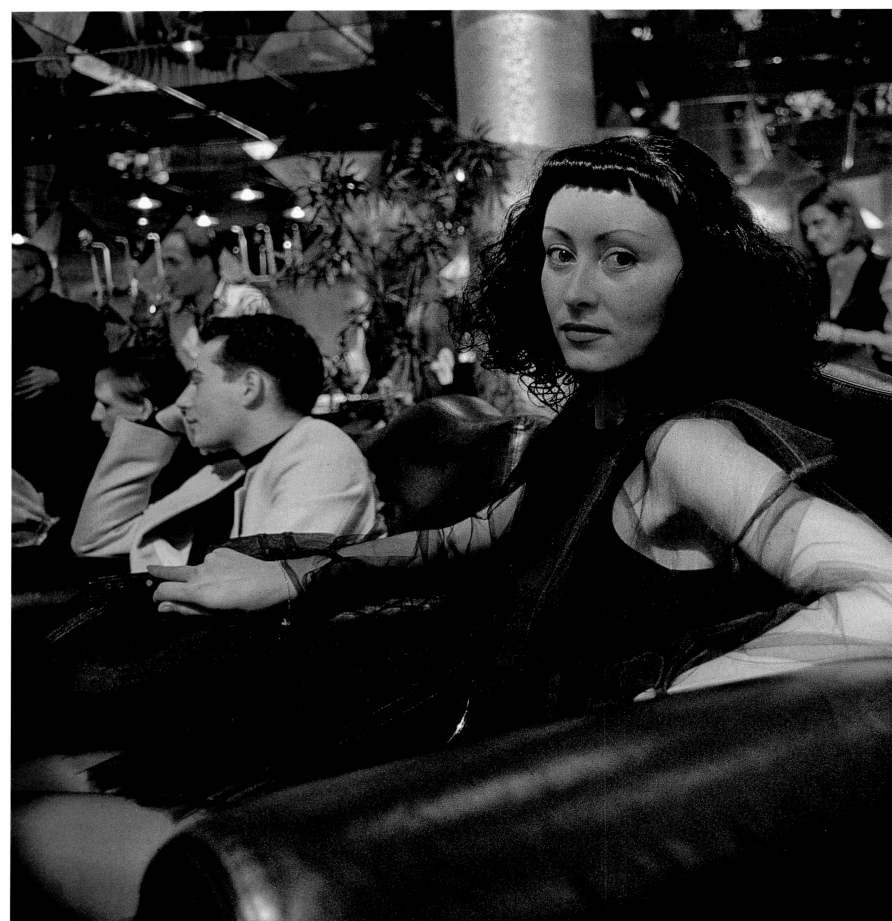

LISE SARFATI I Moscow, Russia I 1996.
An evening at the nightclub Mieltelnitza

JULIEN DANIEL I Paris, France I 2003.
Music and light fill the inner courtyard at the Hôtel de Ville.

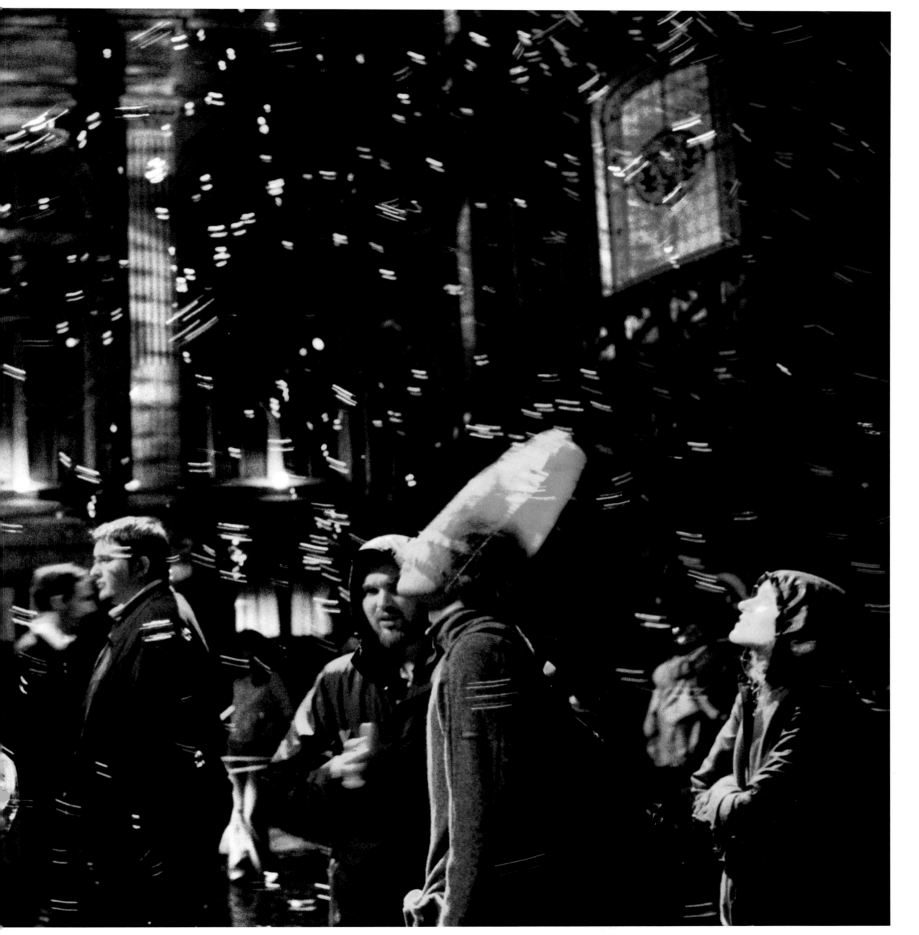

ED KASHI I Durban, South Africa I 1998.
A Zulu dance group performs at an *Iscatamiya* competition.

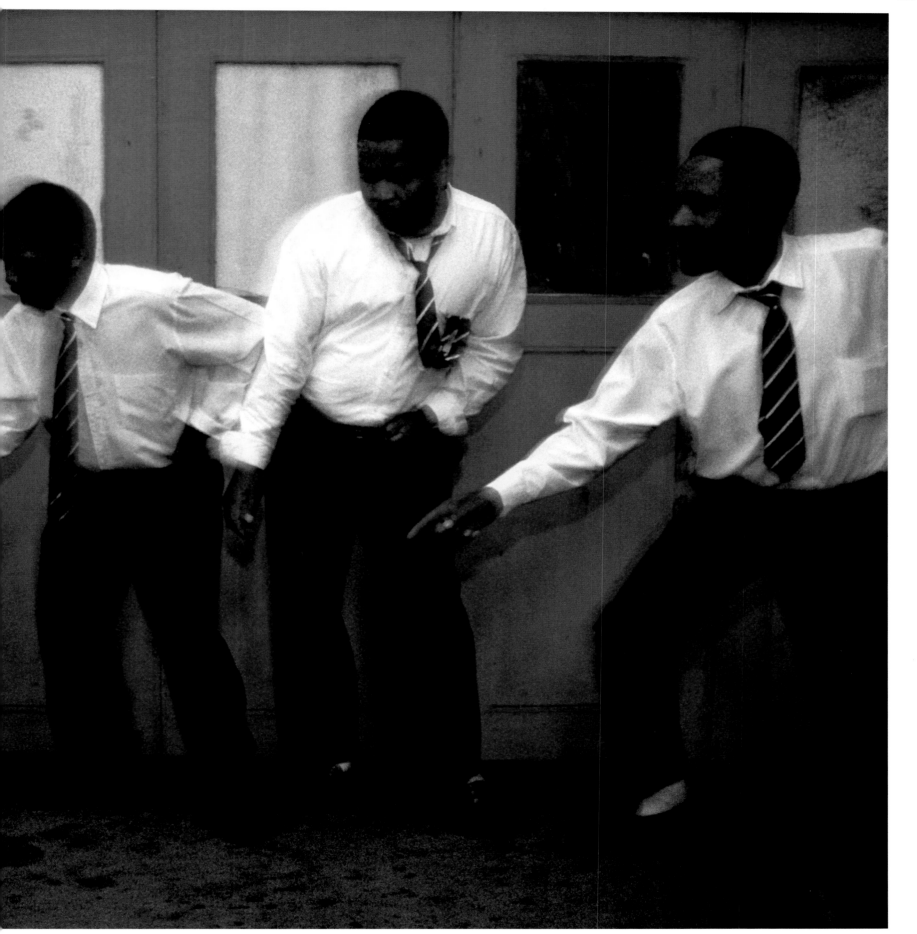

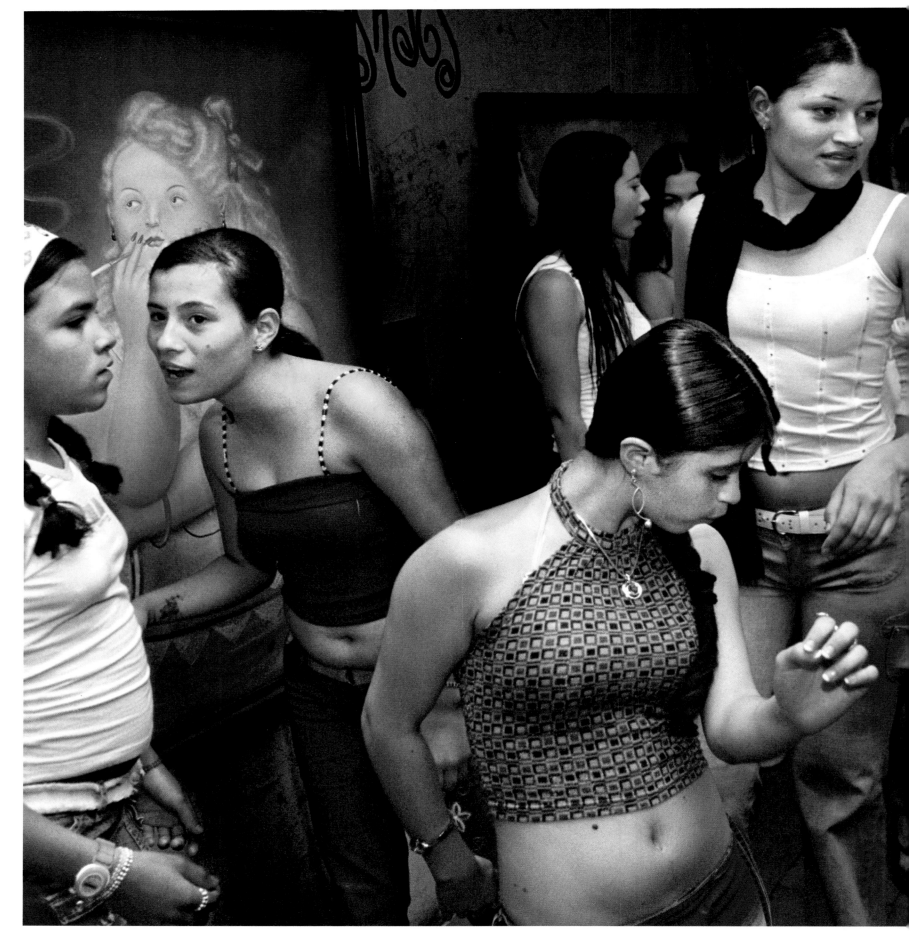

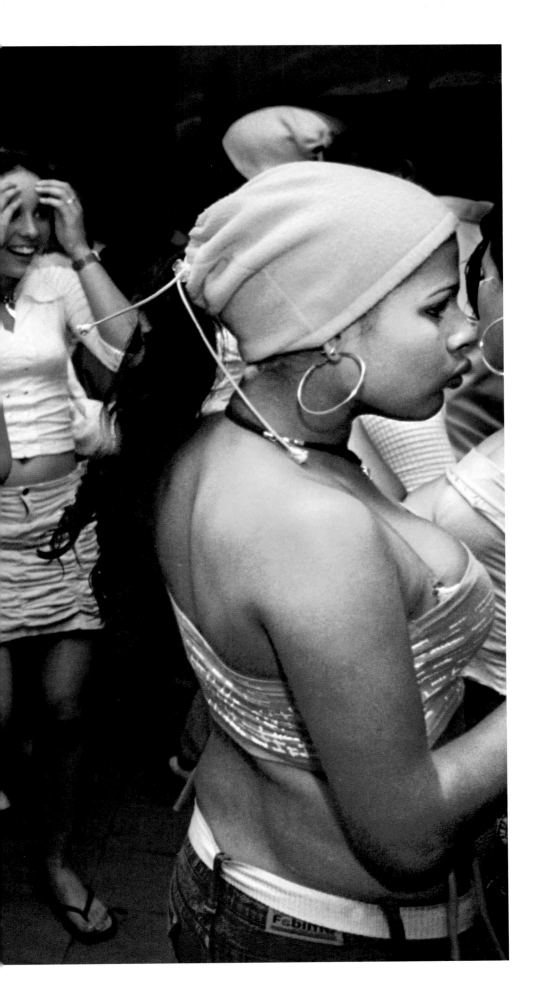

PAUL SMITH I Medellín, Antioquia, Colombia I 2007.
Women socialize at a reggaeton party in El Jardín neighborhood.

JOHANN ROUSSELOT I Rajasthan, India I 2006.
Dancers backstage at an itinerant "Bollywoodian" cabaret

FOLLOWING PAGES: DAVID ALAN HARVEY I Ibiza Island, Spain I 1991.
A foam party at Amnesia, a popular disco

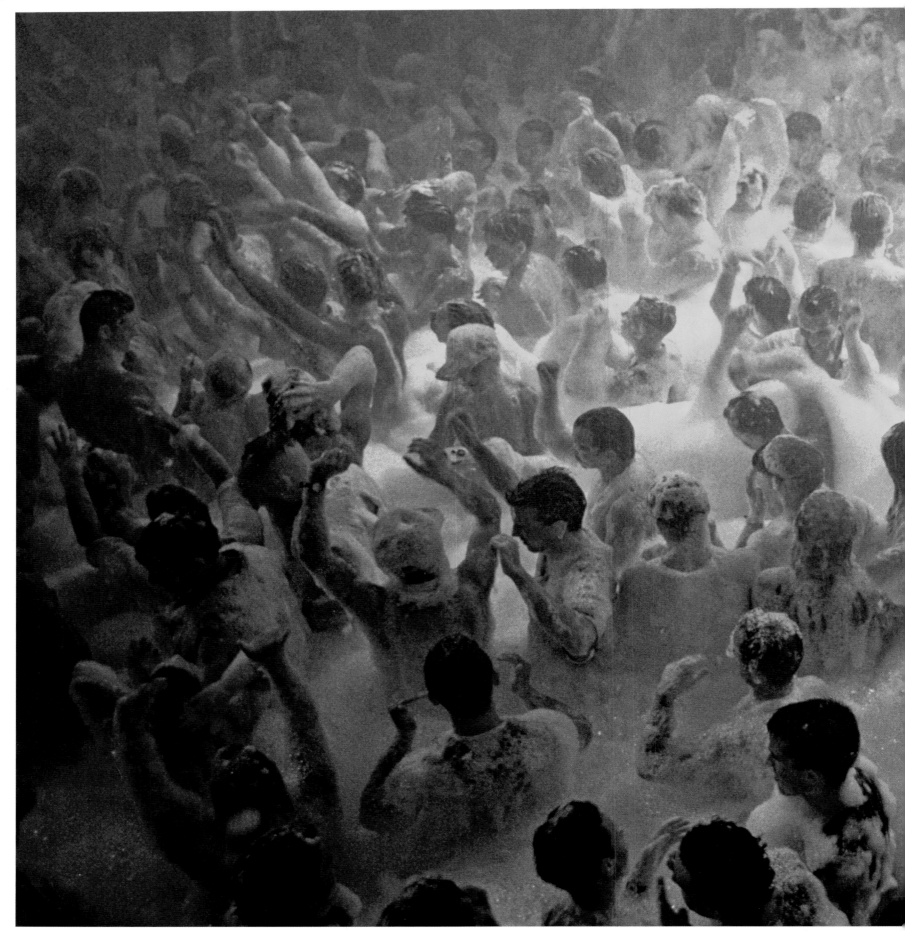

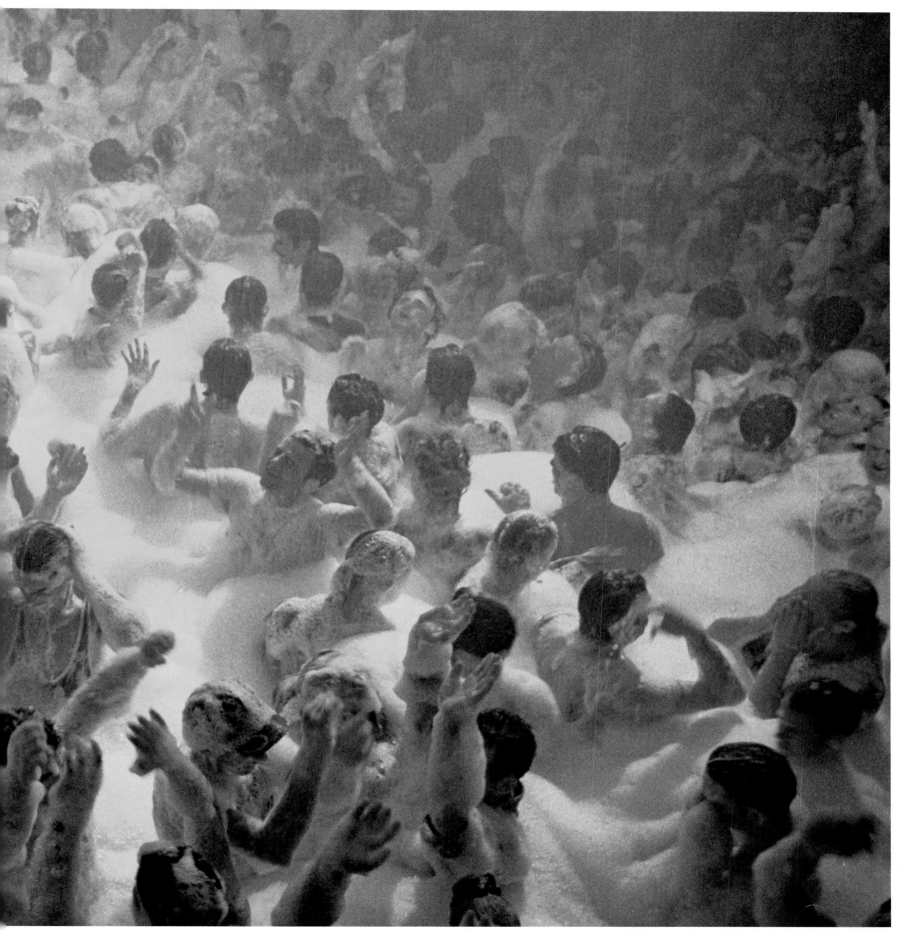

The Photographers

SAM ABELL has photographed more than 20 stories for *National Geographic* magazine, some documenting wilderness, others different cultures. His many books include *Australia: Journey Through a Timeless Land, Seeing Gardens,* and *The Life of a Photograph.* In 1998, the Ohio-born Abell, who learned photography from his father, joined historian Stephen Ambrose in retracing Lewis and Clark's journey through North America's West. The result, *Lewis & Clark: Voyage of Discovery,* was so successful that in 2002 they reunited for *The Mississippi: River of History.*

WILLIAM ALBERT ALLARD was born in Minneapolis in 1937. His milestone 1982 book about the West and the cowboy, *Vanishing Breed,* won awards, including the distinguished Leica Medal of Excellence for Outstanding Achievement. Allard has shot for the *National Geographic* magazine for more than 35 years. A self-described "people photographer," he uses existing light, shoots only color, and doesn't enter competitions. Other books include *Portraits of America* and *Time at the Lake.*

EVE ARNOLD was born in Philadelphia to Russian immigrant parents. Arnold, a full Magnum member since 1957, is a fellow of the Royal Photographic Society, and in 1995 was also elected Master Photographer—the world's most prestigious photographic honor—by New York's International Center of Photography. Arnold portrayed stars such as Marilyn Monroe with candid charm, as well as various cultures: the Soviet Union on five trips (from 1965 on); Afghanistan and Egypt (1967 to 1971), where she made the film *Behind the Veil,* 1973; China for her 1980 book *In China;* the United States for *In America,* 1983; and Britain for the 1991 exhibition *Eve Arnold in Britain.*

BRUNO BARBEY was born in Morocco and studied photography and graphic arts at the École des Arts et Métiers in Vevey, Switzerland. Over four decades Barbey has journeyed across five continents and into numerous military conflicts. Although he rejects the label of "war photographer," he has covered civil wars in Nigeria, Vietnam, the Middle East, Bangladesh, Cambodia, Northern Ireland, Iraq, and Kuwait. Barbey has been a Magnum member since 1968 and has received many awards for his work, including

the French National Order of Merit. His photographs have been exhibited internationally and are in numerous museum collections.

ANNIE GRIFFITHS BELT has photographed many stories for *National Geographic* magazine and for the Society's Book Division. A Fellow with the International League of Conservation Photographers who is best known for nature, documentary, and travel photography, Griffiths and author Barbara Kingsolver created *Last Stand: America's Virgin Lands,* which has raised more than $250,000 for conservation grants. She has won awards from the National Press Photographers Association (NPPA), the Associated Press (AP), the White House News Photographers Association, and the National Organization for Women.

IAN BERRY was born in Lancashire, England. He made his reputation in South Africa, where he worked for the *Daily Mail* and later for *Drum* magazine. He was the only photographer to document the massacre at Sharpeville in 1960, and his photographs were used in the trial to prove the victims' innocence. The major body of his work produced in South Africa is represented in two books: *Black and Whites: L'Afrique du Sud* (1988) and *Living Apart* (1996). In 1964 Berry moved to London and became the first contract photographer for *Observer Magazine.*

JAMES BLAIR became a *National Geographic* staff photographer in 1962. Over the next 32 years, he contributed 47 stories to the magazine. Interested in the environment and social change, Blair contributed to *Our Threatened Inheritance,* a high-impact National Geographic book about federal land. A man of many honors, including awards from the White House News Photographers Association, Pictures of the Year International (POYi), and the Overseas Press Club, Blair has had a solo exhibit at Pittsburgh's Carnegie Mellon Museum.

JONATHAN BLAIR began his photography career taking pictures of stars at Northwestern University's Dearborn Observatory. While on a trip to help set up an observing station near White Sands, New Mexico, he discovered a passion for landscape photography. Soon after, Blair transferred to New York's Rochester Institute of Technology to pursue a degree in illustrative photography. During the 1970s, Blair established himself

as a contract photographer with the National Geographic Society and began specializing in adventure stories that took him from the Berkshires to the Mediterranean.

SISSE BRIMBERG has done more than 25 stories for *National Geographic,* many on history and culture. Her work, which has been exhibited at the Newseum in Washington, D.C., won the NPPA Picture Story of the Year and a POYi Award of Excellence. Hoping to "make a cultural difference in the world," Brimberg and her husband, photographer Cotton Coulson, founded Keenpress Publishing in her native Denmark. Among their books are *1621: A New Look at Thanksgiving* and *Mayflower 1620.*

DAVID BURNETT does it all—news, features, landscapes, and portraits. Co-founder of Manhattan's Contact Press Images, Burnett was named one of the 100 Most Important People in Photography by *American Photo* magazine. Other honors include Magazine Photographer of the Year from POYi, a Robert Capa Gold Medal, and World Press Photo of the Year. His post-Katrina pictures were exhibited at the George Eastman House in Rochester, New York, and New Orleans's Cabildo Museum.

DAVID BUTOW, a photojournalist interested in public policy and social issues, has made documenting China's Uighur ethnic group a personal and photographic mission. His work has been exhibited in New York and featured in a National Geographic book, *Inside China.* He has been honored with WPP awards, an NPPA Best of Photojournalism award, and inclusion in the *American Photography* Annual. Pictures taken by Butow in Kurdistan and Iraq in 2000 were exhibited at the Visa Pour L'Image festival in Perpignan, France.

J CARRIER'S first post-college career was as a drummer in a punk-blues band. It wasn't until 2001, when he was a Peace Corps volunteer in Ecuador, that he realized his calling. As a freelance photographer, Carrier has concentrated on chronicling the lives of the poor in Africa, shooting for major publications, and documenting Save the Children's efforts in Darfur, Sudan, and Ethiopia, as well as Indonesia one week after it had been devastated by a tsunami.

HENRI CARTIER-BRESSON Born in France in 1908, a young Cartier-Bresson developed visual language through painting. His concept of the "decisive moment," aided by his Leica camera, launched Cartier-Bresson's photographic career in 1932. He would later co-found Magnum Photos with Robert Capa and others in 1947. Cartier-Bresson received an extraordinary number of prizes, awards, and honorary doctorates.

PAUL CHESLEY is best known for the work that is his passion: photographs that show the people, culture, and splendor of Asia and the South Pacific. A National Geographic regular, Chesley has published a number of books; they include *The Circle of Life, Thailand: Seven Days in the Kingdom, A Voyage Through the Archipelago,* and *Malaysia: Heart of Southeast Asia.* His work has been exhibited at museums in London, Tokyo, New York, and Washington, D.C.

CHIEN-CHI CHANG Alienation and connection are the subjects of much of Chang's work. His investigation of the ties that bind one person to another—and to society— draws on his own immigrant experience. Chang joined Magnum Photos in 1995. He lives and works in Taipei and New York City.

JODI COBB is a former staff photographer for *National Geographic* and has worked in more than 50 countries, primarily in the Middle East and Asia. Cobb was one of the first photographers to cross China when it reopened to the West, traveling 7,000 miles in two months for the book *Journey Into China.* She was the first photographer to enter the hidden lives of women of Saudi Arabia for a landmark article in 1987, and for her book *Geisha: The Life, the Voices, the Art,* Cobb entered another world closed to outsiders, that of the geisha of Japan. She was the first woman to be named White House Photographer of the Year.

PABLO CORRAL VEGA Born in 1966, Ecuadorian photojournalist Pablo Corral Vega has published his work in *National Geographic* magazine, *Smithsonian, New York Times Magazine,* and a number of international publications. In 1994 he directed the Discovering Ecuador project, a gathering of 38 top international photojournalists from 11 countries. Corral is the author of several photographic books, including *Bare Earth: A Pictorial Book on Ecuador, Andes of Ecuador: Silent Landscapes,* and *Ecuador: From Magic to Horror.* He is also the founder of the Harmonia Terra Foundation, a nonprofit organization that publishes books on Latin American geography and the conservation of nature and culture.

JULIEN DANIEL, born in France in 1970, became a member of the Oeil Public photographers' association in 1997. Daniel's freelance work has regularly been published throughout the French press, in publications such as *Libération, Le Monde, L'Express,* and *Télérama.*

STEPHANIE DIANI is a freelance photographer who works for national *(New York Times, Time, Forbes, Kiplinger's)* and international *(Stern, Der Spiegel, Ventiquattro)* publications. Her work has been exhibited in solo and group shows around the country and her images have been featured in *American Photography, Graphis,* APA/NY, and the New York Photo Awards. She is currently based in Los Angeles, where she uses her degree in classical archaeology almost every day. She is inspired and encouraged by her husband, Tim, their dog, Cosmo, and their cat, Weegee.

JAY DICKMAN is a Pulitzer Prize winner and National Geographic photographer. His work has won several awards, including WPP's Golden Eye Award, the Sigma Delta Chi Award for Distinguished Service in Journalism, and others. Dickman has completed more than 25 assignments for the National Geographic Society, and he has contributed to 15 *A Day in the Life Of* books.

ELLIOTT ERWITT was born to Russian parents in Paris in 1928 and lived in Italy before immigrating to California. As a teenager living in Hollywood, he developed an interest in photography and worked in a commercial darkroom. In 1948 he moved to New York and exchanged janitorial work for film classes at the New School for Social Research. In 1953 Erwitt joined Magnum Photos and worked as a freelance photographer for *Collier's, Look, Life, Holiday,* and other magazines. Erwitt became known for benevolent irony and for a humanistic sensibility.

LARRY FINK began photographing at the age of 13. He has had one-man shows at the Museum of Modern Art, the Whitney Museum, and the San Francisco Museum of Modern Art, and his work is in the permanent collection of countless museums and institutions around the world. He has won two Guggenheim awards and has been

published in every magazine imaginable. Currently he works under a contract with *Vanity Fair* magazine.

STEVE FORREST has been working as a newspaper and magazine photographer for the past 12 years. His background is in reportage, and he has covered stories across Europe, the Middle East, and Africa. He has also worked on major cultural and heritage projects for the United Nations and the World Bank and is a regular contributor to the *New York Times* and various British newspapers. Forrest co-founded Workers' Photos in 2008, a London-based collective of talented photographers who have a long history working in both the private and social sectors, with the aim of producing striking and original images for clients.

STUART FRANKLIN was born in Britain in 1956 and studied photography and film at West Surrey College of Art and Design. He also holds a B.A. and a Ph.D. in geography from the University of Oxford. During the 1980s he worked as a correspondent for Sygma Agence Presse in Paris, before joining Magnum Photos in 1985. Franklin's coverage of the Sahel famine from 1984 to 1985 won him acclaim, but he is perhaps best known for his celebrated photograph of a man defying a tank in Beijing's Tiananmen Square in 1989, which won him a WPP award. Since 1990, Franklin has completed more than 20 assignments for National Geographic.

LEONARD FREED was born in Brooklyn, New York, in 1929, to working-class Eastern European Jewish parents. Freed's work explores societal violence and racial discrimination, and his coverage of the American civil rights movement brought him initial distinction. He pursued this concern in numerous books and films, examining German society and his own Jewish roots; his book on the Jews in Germany was published in 1961, and *Made in Germany,* about postwar Germany, appeared in 1965. Since joining Magnum Photos in 1972, he has done work for the major international press.

PAUL FUSCO Born in Leominster, Massachusetts, in 1930, Fusco worked as a photographer with the U.S. Army Signal Corps stationed in Korea from 1951 to 1953. After the war,

he studied photojournalism at Ohio University and worked in New York as a staff photographer with *Look* magazine. He joined Magnum Photos in 1974. Fusco's photography has been published widely in major U.S. magazines including *Time, Life, Newsweek,* and *New York Times Magazine*, and he has produced several books, including *RFK Funeral Train* and *Chernobyl Legacy*.

JEAN GAUMY Raised in the southwest of France, Gaumy began working as a writer and photographer for a local newspaper in Rouen while studying literature at university from 1969 to 1972. In 1973 he joined the Gamma photo agency; four years later, Magnum Photos. In 1975 he undertook an in-depth study of a French hospital, documenting the daily lives of doctors and patients. The following year he was the first photojournalist to be allowed inside a French prison; his work there resulted in a book in 1983: *Les Incarcérés (The Imprisoned)*. Since the 1980s Gaumy has written and directed several acclaimed, prize-winning documentary films.

BURT GLINN studied literature at Harvard University, where he edited and photographed for the *Harvard Crimson* college newspaper. Later, Glinn worked for *Life* magazine before becoming a freelancer. In 1951 Glinn became one of the first Americans to enter Magnum Photos. In collaboration with the writer Laurens van der Post, Glinn published *A Portrait of All the Russias* and *A Portrait of Japan*.

ERICH HARTMANN was born in Munich and was 16 years old when he went with his family in 1938 to Albany, New York, as a refugee from Nazi Germany. He enlisted in the U.S. Army, serving in England, France, Belgium, and Germany. At the end of the war he moved to New York City, where he worked as an assistant to a portrait photographer and then as a freelancer. Hartmann first became known to the wider public through his work for *Fortune* magazine in the 1950s. His poetic approach to science, industry, and architecture shone through the photo essays "Shapes of Sound," "The Building of Saint Lawrence Seaway," and "The Deep North."

DAVID ALAN HARVEY Raised in Virginia, Harvey discovered photography at the age of

11. He has documented Maya culture, the Mexican cowboy pilgrimage to the statue of Cristo Rey, and life in Spain, Belize, Honduras, and Chile. The author of *Cuba, Divided Soul, Fotografi,* and *Tell It Like It Is*, Harvey is an NPPA Magazine Photographer of the Year. His work has been exhibited at the Museum of Modern Art in New York, Nikon Gallery, and the Corcoran Gallery of Art. He has shot more than 40 essays for *National Geographic* magazine.

THOMAS HOEPKER studied art history and archaeology, then worked as a photographer for *Münchner Illustrierte* and *Kristall* between 1960 and 1963. He joined *Stern* magazine as a photo-reporter in 1964. He later worked as cameraman and producer of documentary films for German television. Hoepker worked as art director for *Stern* in Hamburg between 1987 and 1989, when he became a full member of Magnum Photos. Specializing in reportage and color features, he received the prestigious Kulturpreis of the Deutsche Gesellschaft für Photographie in 1968. A retrospective exhibition, showing 230 images from 50 years of work, toured Germany and other parts of Europe in 2007.

CHRIS JOHNS, a *National Geographic* magazine contributing photographer for 17 years, and now the publication's editor in chief, began his career as a staff member at the Topeka *Capital-Journal,* and was named the NPPA's Newspaper Photographer of the Year in 1979. He is well known for his photographs of wildlife and Africa. As a photographer, Johns delivered a firsthand look at the Zambezi River, documented Africa's endangered wildlife, and gave readers insight into the culture of the Bushmen. His books include *Wild at Heart: Man and Beast in Southern Africa* and *Hawaii's Hidden Treasures,* which focuses on the islands' ongoing extinction crisis.

LYNN JOHNSON was a shy girl who spent a lot of high school poring over books in the library. One day, she happened upon a book of photographs by Dorothea Lange and other documentary photographers who had worked for the Farm Security Administration. It changed her life. Since then, this shy girl has climbed the radio antenna atop Chicago's John Hancock Tower, clambered around scaffoldings with steel workers, and lived among fishermen on Long Island and guerrillas in Vietnam. Johnson's gripping

photo essays of a family struggling with AIDS, of children coping with the brain death of their mother, and many others are honest and sensitive glimpses into the lives of ordinary people dealing with extraordinary circumstances, and are classics of the genre.

RHODRI JONES was born in Gwynedd, Wales, and currently is based in Italy. He traveled widely in Europe, South America, and East Africa and began working as a professional photographer in 1989 in Central America. In the 1990s Rhodri was one of the first Western photographers to document life in Albania. His work has been published in two books, *Made in China* and *Return*, a poetic look at his native Wales. Exhibitions featuring Jones's work have been held in several countries, including a large exhibit of his Welsh work entitled "Return" at the National Library of Wales in Cardiff.

CATHERINE KARNOW Born and raised in Hong Kong, San Francisco-based photographer Karnow shoots for *National Geographic, Smithsonian,* French and German *GEO,* and other international publications. She has covered Australian Aborigines; victims of Agent Orange in Vietnam; Greenwich, Connecticut, high society; and Thai pop culture. In 1994, she was the only non-Vietnamese photojournalist to accompany Gen. Vo Nguyen Giap on his historic first return to the forest encampment in the northern Vietnam highlands, from which he plotted the battle of Dien Bien Phu. She also gained unprecedented access to Prince Charles for her 2006 *National Geographic* feature, "Not Your Typical Radical".

ED KASHI has documented social and political issues in more than 60 countries. The multi-award-winning photojournalist spent much of the 1990s photographing Jewish settlers in the West Bank and eight years producing *Aging in America: The Years Ahead,* which includes a book, a documentary, a website, and an exhibition. The project won POYi and WPP awards; *American Photo* called the book one of the year's best. Other books include *When Borders Bleed: The Struggle of the Kurds.*

ROBB KENDRICK has photographed sumo wrestlers and Sherpa, the base of Antarctica, and the top of Mount Everest, but the pictures he most likes making are tintypes,

cutting edge when Mathew Brady was documenting the Civil War. Kendrick returned to wet plate photography to make the portraits in *Still: Cowboys at the Start of the Twenty-first Century* and *Revealing Character: Texas Tintypes,* winner of the National Cowboy & Western Heritage Museum's Western Heritage Award for Best Photography Book.

JOSEF KOUDELKA began in his teenage years to photograph his family and surroundings in the Czechoslovakian province of Moravia. Smuggled out of the country, his photographs were distributed by Magnum Photos and published in the international press under the anonymous initials P. P. He left Czechoslovakia for political asylum in 1970 and shortly thereafter joined Magnum. Koudelka has published more than a dozen books, including *Gypsies, Exiles, Chaos,* and most recently the retrospective volume *Koudelka.* He has won the Prix Nadar (1978), a Grand Prix National de la Photographie (1989), a Grand Prix Cartier-Bresson (1991), and the Hasselblad Foundation International Award in Photography (1992).

HIROJI KUBOTA After graduating in political science from Tokyo's University of Waseda in 1962, Kubota told his mother that he wanted to be a photographer. Soon after, he traveled to the United States to continue his studies. He became a freelance photographer in 1966, joining Magnum Photos in 1970. Kubota witnessed the fall of Saigon in 1975, refocusing his attention on Asia. It took him several years to get permission to photograph in China. Finally, between 1979 and 1984, Kubota embarked on a 1,000-day tour, during which he made more than 200,000 photographs. The book *China,* and exhibit appeared in 1985.

ERICH LESSING worked as a reporter and photographer for the AP upon his return to his birthplace of Vienna in 1947 after serving the British Army as an aviator and photographer. He became a full member of Magnum Photos in 1955. Lessing covered political events in North Africa and Europe and reported on the onset of the communist period in Eastern Europe for *Life, Época, Picture Post,* and *Paris-Match.*

GERD LUDWIG, a contract photographer for *National Geographic* magazine, worked extensively in Russia, Eastern Europe, and his homeland of Germany, documenting

social changes as they happened and their result in the years that followed. Among his books are *Broken Empire: After the Fall of the USSR* and *Seoul, Korea*, both with text by Fen Montaigne. His awards include several POYi Awards of Excellence, three Communication Arts Awards of Excellence, and a WPP Award of Excellence.

STEVE MCCURRY launched his photography career when, wearing native clothing, he crossed the Pakistan border into rebel-controlled Afghanistan just before the Russian invasion. When he emerged, he had rolls of film sewn into his clothes that contained some of the world's first images of the conflict. His coverage won the Robert Capa Gold Medal for Best Photographic Reporting from Abroad Showing Courage and Enterprise. He has won numerous awards including the NPPA Award for Magazine Photographer of the Year and an unprecedented four first prizes in the WPP contest.

PIOTR MALECKI was born in Koszalin, Poland, and is a photojournalist specializing in reportage and portait photography. He studied filmmaking in Poland and photography in Great Britain. In the 1990s he was a staff photographer at *Wprost*, a Polish weekly newsmagazine, then went freelance and now shoots self-assigned and commissioned photo features in Eastern Europe. In his reportage he portrays people in a natural way, telling their own individual stories. He also loves taking portraits where he often uses his surroundings to create strong composition, adding another dimension to the image.

SERGEY MAXIMISHIN spent his childhood in the Crimea and moved to Leningrad in 1982. His photographic career started while he served with the Soviet Army in Cuba in 1985. After graduating from Leningrad Politechnic with a degree in chemistry, he worked in the laboratory of the Hermitage State Art Collection. Between 1999 and 2003 he was a staff photographer on the newspaper *Izvestia*. He has been published widely in international and Russian newspapers and magazines and his work has been awarded two WPP awards and more than a dozen Russian Press Photo awards. Maximishin lives in St Petersburg.

SUSAN MEISELAS received her B.A. from Sarah Lawrence College and her M.A. in visual education from Harvard University. Her first major photographic essay focused on the lives of women doing striptease at New England country fairs. Meiselas joined Magnum Photos in 1976 and has worked as a freelance photographer since then. She is best known for her coverage of the insurrection in Nicaragua and her documentation of human rights issues in Latin America, which were published widely throughout the world. She has produced two books, *Carnival Strippers* and *Nicaragua, June 1978-July 1979*, and served as an editor and contributor to the book *El Salvador: The Work of Thirty Photographers*.

WAYNE MILLER Born in Chicago in 1918, Miller worked part-time as a photographer while studying banking at the University of Illinois. After serving as a lieutenant in the U.S. Navy, Miller won two consecutive Guggenheim Fellowships. His work, which has won renown, includes *Chicago's South Side, 1946-1948*. Miller joined Magnum Photos in 1958.

FERNANDO MOLERES was born in Bilbao in 1963 and worked as a psychiatric nurse for several years. In 1990 he traveled to South Africa and made his first photo report, a story about ghettos. Resolutely freelance, he has remained faithful to his ideas and stories, most notably in his project on child labor, on which he worked for more than six years in 30 countries. The book *Children at Work* was published in collaboration with the International Labour Organization and has been exhibited in 17 cities around the world. Moleres, who has won two WPP awards, has now embarked on a long-term project on monastic life.

MICHAEL "NICK" NICHOLS was born in Alabama in 1952. His first exposure to photography came when he was assigned to the photography unit as an Army draftee in the early 1970s. Nichols specializes in photographing wildlife in remote places, under conditions so extreme (he once got hepatitis, typhoid, and two kinds of malaria simultaneously) that *Paris-Match* called him the "Indiana Jones of photography." A *National Geographic* staff photographer, Nichols holds four first-place WPP awards, as well as POYi and Wildlife Photographer of the Year awards. His photographs have been featured in six books, including *Last Place on Earth*, which followed Mike Fay's 1,200-mile Megatransect expedition.

RANDY OLSON goes wherever the *National Geographic* magazine sends him. Over ten years, assignments included the Siberian Arctic, Samoa, Iraq, India, Thailand, Newfoundland, Guyana, Republic of Georgia, Australia, Turkey, and Pakistan. In the Sudan he photographed and brought food to people who had nothing to eat in a forest housing parasites that dine on people. Olson, one of two photographers to win both Newspaper Photographer of the Year and Magazine Photographer of the Year from POYi, also won the Robert F. Kennedy Award.

GEORGE OSODI is a freelance photographer based in London. He studied business administration before starting to work as a photographer for the *Comet* newspaper in Lagos between 1999 and 2002. From 2002 until 2008 Osodi worked as a staff photographer for the Associated Press Agency in Nigeria. He has covered assignments for both local and international media, and his photographs have been published in the *New York Times, Time, Guardian, USA Today, Der Spiegel, Courrier International,* and many more publications. He joined Panos Pictures in 2008.

MARTIN PARR, born in Epsom, England, in 1952, studied photography at Manchester Polytechnic. He earned an international reputation for his oblique approach to social documentary and for innovative imagery. He became a member of Magnum Photos in 1994. In 2002 Phaidon published the monograph *Martin Parr.* A large retrospective of Parr's work was initiated by the Barbican Art Gallery in London and has since been shown in the Museo Nacional de Arte Reina Sofía in Madrid, the Maison Européenne de la Photographie in Paris, and the Deichtorhallen in Hamburg.

GUEORGUI PINKHASSOV A young photography enthusiast, Pinkhassov studied cinematography at the Superior Institute of Cinematography in Moscow. After serving in the military, he worked in a camera crew and later as a still photographer for the film studio Mosfilm. Pinkhassov moved to Paris in 1985 and joined Magnum Photos in 1988. Pinkhassov works regularly for the international press, including *Geo, Actuel,* and *New York Times Magazine.* His book *Sightwalk* explores individual details, through reflection of particular kinds of light, often approaching abstraction.

MARK POWER, born in Harpenden, England, in 1959, took up photography by chance, after studying painting at Brighton Polytechnic. He worked in the editorial market until 1992, when he began teaching. Power's work has been seen in numerous solo and group exhibitions across the world and he has published four books: *The Shipping Forecast* (1996), *Superstructure* (2000), *The Treasury Project* (2002), and *26 Different Endings* (2007). He is a professor of photography at the University of Brighton.

ESPEN RASMUSSEN lives in Oslo, Norway, and works as a picture editor for the largest Norwegian daily newspaper, *VG.* Since 2004 he has worked with Médecins Sans Frontières. His awards include two WPP awards, three POYi awards, and the Norwegian Picture of the Year. In recent years he has covered events such as the Darfur crisis, the Asian tsunami, the Maoist conflict in Nepal, the funeral of Pope John Paul II, and the earthquake in Pakistan. His images have appeared in magazines such as *Time, National Geographic, Der Spiegel,* and *The Economist.* He joined Panos Pictures in 2007.

ELI REED was born in New Jersey in 1946 and studied pictorial illustration at the Newark School of Fine and Industrial Arts. In 1982 he was a Neiman Fellow at Harvard University. Reed's special reports include a long-term study on Beirut (1983-87), which became his first book, the highly acclaimed *Beirut, City of Regrets;* the ousting of "Baby Doc" Duvalier in Haiti (1986); U.S. military action in Panama (1989); the Walled City in Hong Kong; and perhaps most notably, his book *Black in America,* covering the 1970s through the 1990s, which includes images from the Crown Heights riots and the Million Man March.

STÉPHANE REMAEL is a photojournalist based in Paris. He studied at "The 75," a high school specializing in photography, in Brussels. An independent photographer since 1992, he is a co-founder of the Oeil Public agency, of which he was a member from 1996 and 2008. Remael likes to approach news events from a slightly oblique angle by investigating such people as Darfur refugees in France, the Chinese population excluded from their own Olympic Games, and the victims of 9/11. He has done work on such subjects as the conditions of detainees in Bolivian prisons, the French in their leisure time, and the food crisis in Nepal.

REZA spent two decades as a print correspondent in the Middle East before he became a professional photographer with assignments from *National Geographic* magazine. Now published and exhibited internationally, Reza was awarded the 1996 Hope Prize for his work with Rwandan refugees. France made him Chevalier de l'Ordre du Mérite, Spain gave him the Principe de Asturias Medal, and the University of Missouri-Columbia awarded him the Medal for Distinguished Service in Journalism.

JOHANN ROUSSELOT Born in Brussels in 1971, Rousselot studied photography at "The 75." Rousselot has been a member of l'Oeil Public agency since 2001 and has won awards including the 2003 French Kodak Photography Award for his coverage of youth in the Balkans region and grants for his projects on the new economic face of India and the dazzling worldwide expansion of American evangelicals.

GILLES SABRIÉ is an independent photographer based in Beijing. After years working in television, he switched careers to embrace documentary photography and has focused particularly on documenting social changes in China, where he settled three years ago. Besides chronicling major events such as the Beijing Olympics, and the Sichuan earthquake, Sabrié has produced several widely published images such as 175 Meters (about the Three Gorges Dam). He has also been published in the *New York Times, Newsweek, Time, Focus,* and *L'Espresso*. He is a regular contributor to the French daily *Libération* and runs a photo blog, "Un oeil sur la Chine," for *Le Monde*.

LISE SARFATI obtained a master's degree in Russian studies from the Sorbonne and was the official photographer of the Académie des Beaux-Arts in Paris. Sarfati moved to Russia and photographed there for ten years. She received grants from both the Fiacre and Villa Medicis. She received the Prix Niépce in Paris and the Infinity Award from the International Center of Photography in New York for her work.

JOEL SARTORE has kept company with wolves and searched in vain for an ivory-billed woodpecker. The longtime *National Geographic* magazine contributor focuses on nature, endangered species, especially the small and unsung, the environment, and life in America, which is epitomized in his book about his home state, *Nebraska: Under a Big Red Sky*. Other books include *Photographing Your Family* and *Face to Face with Grizzlies*. Sartore has an NPPA award and several POYi awards.

PAUL SMITH was born in Leicester, England, and studied design and photography at the Newport School of Documentary Photography. During the 1990s Smith traveled widely and became increasingly fascinated by and involved with Latin America and South America. In 1993 he joined Panos Pictures, and in 1999 he decided to move to Colombia, where he has been based ever since. His work has been exhibited in Colombia and throughout Europe on subjects ranging from street children in South America to the porous border between Mexico and the United States.

CHRIS STEELE-PERKINS, born in Rangoon in 1947, moved to London with his family at age two. At the University of Newcastle-upon-Tyne, he studied psychology and worked for the student newspaper. In 1971 Steele-Perkins moved on to freelance photography in London. He joined Magnum Photos in 1979 and worked in Africa, Central America, and Lebanon, as well as continuing to take photographs in Britain. He has published *The Pleasure Principle, Afghanistan, Fuji,* a highly personal diary *Echoes,* and *Tokyo Love Hello*.

GEORGE STEINMETZ, an explorer-photographer who has averaged a *National Geographic* story a year for 20 years, likes telling the untold, the new, and the obscure. Among his subjects: technological breakthroughs, scientific explorations, China as photographed from above, and Indonesia's tree house people. A Stanford graduate with a degree in geophysics, Steinmetz has won many photography honors, including two WPP first-place awards in science and technology, along with POYi, Overseas Press Club, and Alfred Eisenstadt awards.

MARIA STENZEL was raised in Ghana, the Netherlands, and New York. She has taken pictures in Borneo, Tibet, and Kenya, but the place she likes best is the very deep south—Antarctica. On her first trip—traveling by icebreaker—she found herself surrounded by story possibilities from wildlife to science and history. The photographs from her fourth trip—this time to the Sandwich Islands—won a top National Magazine Award and another from WPP.

DENNIS STOCK, born in New York City in 1928, evokes the spirit of America through his portraits of Hollywood stars, and is also known for his portraits of jazz musicians and California in the 1960s. Having joined Magnum Photos in 1951, Stock has lectured, conducted workshops, and produced and displayed work almost every year since the 1950s.

AMY TOENSING, a Detroit-based photojournalist and contributor to *National Geographic* magazine, is drawn to everyday life and small cultures. A former *New York Times* photographer and winner of a POYi award for excellence, Toensing is known for capturing an insider's view of the people she photographs, from Muslim teenage girls in a Western country to the residents of remote Monhegan Island off the coast of Maine and the stratified people of the kingdom of Tonga.

ABBIE TRAYLER-SMITH grew up in southern Wales and gave up a legal career for a life of taking pictures. Self-taught in photography, she became a staff photographer for London's *Daily Telegraph* newspaper in 2001. Her work has taken her from photographing Haile Selassie's final burial in Ethiopia and the forgotten war in Sudan to intimately documenting the fate of refused asylum seekers living rough on the streets of London. Her work has been exhibited by a number of campaigns launched by nonprofit organizations and most recently in London's HOST gallery. She has won numerous awards in national press photo competitions in the United Kingdom.

TYRONE TURNER left his hometown New Orleans to study international relations at Georgetown University, in Washington D.C. Turner's *National Geographic* assignments have taken him back home, photographing Louisiana's troubled bayous before documenting the ravages of Hurricane Katrina and the rebuilding of New Orleans. Turner has produced award-winning photographs for national and international publications such as *Time, Newsweek, U.S. News & World Report,* and the *Los Angeles Times.* He recently received a grant to document the issue of juveniles tried as adults in the United States.

JOHN VINK studied photography at the fine arts school of La Cambre in Brussels, in 1968. Vink has dedicated much time to long-term projects, focusing on Italy between 1984 and 1988, refugees in the world from 1987 to 1993, and currently Cambodia, where he documents land and other social issues. In 1986 he was awarded the prestigious W. Eugene Smith Grant in Humanistic Photography for *Waters in Sahel,* a two-year documentary project on water management involving migrant and sedentary populations of Niger, Mali, Burkina Faso, and Senegal.

AMI VITALE'S goal is to "show how the majority of people live on this planet." Vitale is not comfortable parachuting in and leaving soon after. To get a nuanced story, she settles in as she did in Guinea-Bissau, Africa, and India, where she spent more than five years. She received recognition from WPP, NPPA, POYi, and Photo District News, and received the Daniel Pearl Award and Inge Morath grant by Magnum Photos.

CARY WOLINSKY began working as a news and magazine photographer for the *Boston Globe* in 1968 while completing a degree in journalism at Boston University. By 1972 he was providing photo-stories on a freelance basis to many national magazines, including *National Geographic, Smithsonian,* and *Newsweek.* After becoming a contract photographer with *National Geographic* in the mid-1980s, Wolinsky came to specialize in assignments that require in-depth research and global coverage. Among his photographic essays published by *National Geographic* are "Silk, The Queen of Textiles," "Sichuan: Where China Changes Course," "Fabric of History: Wool," and "Inside the Kremlin." ∎

Illustrations Credits

Cover, Jodi Cobb; 4, Johann Rousselot/Oeil Public; 6-7, China Photos/Getty Images; 8-9, Amy Toensing; 10-11, Spencer Platt/Getty Images; 12-13, David Alan Harvey/Magnum Photos; 14-15, Szilard Kosticsak/epa/CORBIS; 20, Julien Daniel/Oeil Public; 24-25, Larry Price; 26, David Alan Harvey; 27, Ami Vitale; 28-29, Eve Arnold/Magnum Photos; 30-31, Sergey Maximishin/Panos Pictures; 32-33, Ami Vitale; 34-35, Randy Olson; 36, Joel Sartore/NationalGeographicStock.com; 38-39, Phillippe Brault/Oeil Public; 40-41, Joel Sartore/NationalGeographicStock.com; 42-43, Elliott Erwitt/Magnum Photos; 44-45, Jodi Cobb; 46-47, Mia Song/Star Ledger/CORBIS; 48-49, Amy Toensing; 50-51, David Alan Harvey/Magnum Photos; 52-53, David Alan Harvey; 54-55, Eve Arnold/Magnum Photos; 56-57, Leonard Freed/Magnum Photos; 58, Gerd Ludwig; 59, Ami Vitale; 60-61, Lynn Johnson; 62-63, Randy Olson; 64-65, Jodi Cobb/NationalGeographicStock.com; 66-67, Joel Sartore; 68-69, Adam Pretty/Getty Images; 70-71, Annie Griffiths Belt/NationalGeographicStock.com; 72-73, Eli Reed/Magnum Photos; 74-75, David Alan Harvey/Magnum Photos; 76, Jodi Cobb; 77, Ian Berry/Magnum Photos; 78-79, Albert Moldvay; 80-81, Abbie Trayer-Smith/Panos Pictures; 82-83, Chien-Chi Chang/Magnum Photos; 84-85, Mike Hettwer; 86, Ami Vitale; 87, Ami Vitale; 88-89, KEENPRESS/NationalGeographicStock.com; 90-91, Michael Nichols, NGP; 92-93, Per-Anders Pettersson/Getty Images; 95, Julien Daniel/Oeil Public; 98, Steve Forrest/Panos Pictures; 102-103, Rhodri Jones/Panos Pictures; 104-105, John Vink/Magnum Photos; 106, Stephane Remael/Oeil Public; 107, Stephane Remael/Oeil Public; 108-109, B. Anthony Stewart; 110-111, Vanessa Vick/The New York Times/Redux Pictures; 112-113, Stephanie Diani; 114-115, David Goodman/CORBIS; 116-117, Holly Wilmeth/Aurora Photos; 118-119, Sam Abell; 120-121, George Osodi/Panos Pictures; 122, James Estrin/The New York Times/Redux Pictures; 123, Damon Winter/The New York Times/Redux Pictures; 124-125, Joel Sartore/NationalGeographicStock.com; 126-127, Maria Stenzel; 128-129, ChinaFotoPress/Getty Images; 130-131, Mark Power/Magnum Photos; 132-133, Ates Turner/epa/CORBIS; 134-135, Stuart Franklin/Magnum Photos; 136-137, Stuart Franklin/Magnum Photos; 138-139, Daniel R. Westergren; 140-141, George Osodi/Panos Pictures; 142-143, Robb Kendrick Photography; 144-145, Michael Nichols, NGP; 146-147, REZA; 148-149, Ami Vitale; 150-151, Catherine Karnow; 152, Paula Bronstein/Getty Images; 153, Gilles Sabrié; 154-155, Chris Steele/Magnum Photos; 156-157, Bruno Barbey/Magnum Photos; 158-159, Josef Koudelka/Magnum Photos; 160, Chris Steele-Perkins/Magnum Photos; 161, George Steinmetz; 162-163, AP/Wide World Photos; 164-165, Fernando Moleres/Panos Pictures; 166-167, Tino Soriano/NationalGeographicStock.com; 168-169, Sisse Brimberg; 170-171, Gerd Ludwig; 172-173, Alain Nogues/CORBIS; 174, Eli Reed/Magnum Photos; 175, Eli Reed/Magnum Photos; 176-177, Gueorgui Pinkhassov/Magnum Photos; 178-179, Brian Liu; 180-181, J Carrier; 182-183, Jay Dickman; 184-185, Stuart Franklin/Magnum Photos; 186-187, Pablo Corral Vega; 188, Joel Sartore; 189, Joel Sartore; 190-191, Chris Johns, NGS; 192-193, Steve McCurry; 194-195, David Alan Harvey; 196-197, Stephane Remael/Oeil Public; 198-199, Hiroji Kubota/Magnum Photos; 200-201, Jodi Cobb/NationalGeographicStock.com; 202-203, Susan Meiselas/Magnum Photos; 204-205, Burt Glinn/Magnum Photos; 206-207, Bruno Barbey/Magnum Photos; 208-209, Paul Chesley/NationalGeographicStock.com; 210-211, Paul Fusco/Magnum Photos; 212, David Burnett; 213, Joel Sartore/NationalGeographicStock.com; 214-215, Tyrone Turner; 216-217, Chien-Chi Chang/Magnum Photos; 218-219, Stuart Franklin/Magnum Photos; 222, Martin Parr/Magnum Photos; 226-227, Erich Lessing/Magnum Photos; 228-229, Gerd Ludwig; 230, Henri Cartier-Bresson/Magnum Photos; 231, Jean Gaumy/Magnum Photos; 232-233, William Albert Allard/NationalGeographicStock.com; 234-235, Sam Abell; 236, Espen Rasmussen/Panos Pictures; 237, Johann Rousselot/Oeil Public; 238-239, Erich Hartmann/Magnum Photos; 241, Larry Fink; 243, Martin Parr/Magnum Photos; 244-245, Burt Glinn/Magnum Photos; 246-247, Jonathan Blair; 248-249, Chien-Chi Chang/Magnum Photos; 250, Bruno Barbey/Magnum Photos; 251, William Albert Allard; 252-253, David Alan Harvey; 254-255, Cary Sol Wolinsky; 256, Johann Rousselot/Oeil Public; 258-259, Chris Johns/NationalGeographicStock.com; 260-261, Elliott Erwitt/Magnum Photos; 262-263, Catherine Karnow; 264-265, Thomas Hoepker/Magnum Photos; 266-267, David Butow/Redux Pictures; 268-269, Catherine Karnow; 271, William Albert Allard; 272-273, Johann Rousselot/Oeil Public; 274, Dennis Stock/Magnum Photos; 275, Wayne Miller/Magnum Photos; 276-277, Piotr Malecki/Panos Pictures; 278-279, Lise Sarfati/Magnum Photos; 280-281, Julien Daniel/Oeil Public; 282, Ed Kashi; 284-285, Paul Smith/Panos Pictures; 287, Johann Rousselot/Oeil Public; 288-289, David Alan Harvey. ∎

live, laugh, celebrate

Ferdinand Protzman

Published by the National Geographic Society

John M. Fahey, Jr., *President and Chief Executive Officer*

Gilbert M. Grosvenor, *Chairman of the Board*

Tim T. Kelly, *President, Global Media Group*

John Q. Griffin, *Executive Vice President; President, Publishing*

Nina D. Hoffman, *Executive Vice President;*
 President, Book Publishing Group

Prepared by the Book Division

Barbara Brownell Grogan, *Vice President and Editor in Chief*

Marianne R. Koszorus, *Director of Design*

Carl Mehler, *Director of Maps*

R. Gary Colbert, *Production Director*

Jennifer A. Thornton, *Managing Editor*

Meredith C. Wilcox, *Administrative Director, Illustrations*

Staff for This Book

Jane Menyawi, *Project and Illustrations Editor*

Melissa Farris, *Art Director*

Barbara Brownell Grogan, Judith Klein, Olivia Garnett, *Text Editors*

Mike Horenstein, *Production Manager*

Marshall Kiker, *Illustrations Specialist*

Melina Mara, *Contributor*

Manufacturing and Quality Management

Christopher A. Liedel, *Chief Financial Officer*

Phillip L. Schlosser, *Vice President*

Chris Brown, *Technical Director*

Nicole Elliott, *Manager*

Rachel Faulise, *Manager*

The National Geographic Society is one of the world's largest nonprofit scientific and educational organizations. Founded in 1888 to "increase and diffuse geographic knowledge," the Society works to inspire people to care about the planet. It reaches more than 325 million people worldwide each month through its official journal, *National Geographic*, and other magazines; National Geographic Channel; television documentaries; music; radio; films; books; DVDs; maps; exhibitions; school publishing programs; interactive media; and merchandise. National Geographic has funded more than 9,000 scientific research, conservation and exploration projects and supports an education program combating geographic illiteracy. For more information, visit nationalgeographic.com.

For more information, please call 1-800-NGS LINE (647-5463)
or write to the following address:
National Geographic Society
1145 17th Street N.W.
Washington, D.C. 20036-4688 U.S.A.
Visit us online at www.nationalgeographic.com

For information about special discounts for bulk purchases, please contact National Geographic Books Special Sales: ngspecsales@ngs.org

For rights or permissions inquiries, please contact National Geographic Books Subsidiary Rights: ngbookrights@ngs.org

Library of Congress Cataloging-in-Publication Data

Protzman, Ferdinand.
 Live, laugh, celebrate / Ferdinand Protzman.
 p. cm.
 Includes bibliographical references.
 ISBN 978-1-4262-0506-4
 1. Festivals--Pictorial works. 2. Parties--Pictorial works. I. Title.
GT3932.P76 2009
394.2--dc22

 2009032690

ISBN: 978-1-4262-0506-4
Printed in USA
09/RRDW-CML/1